the Adobe® photoshop® cc book for digital photographers

W9-CLA-100

2017 RELEASE

Scott Kelby

EDITOR, *PHOTOSHOP USER* MAGAZINE

THE ADOBE PHOTOSHOP CC **BOOK** FOR DIGITAL PHOTOGRAPHERS
2017 RELEASE

The Adobe Photoshop CC Book for Digital Photographers Team

MANAGING EDITOR
Kim Doty

COPY EDITOR
Cindy Snyder

ART DIRECTOR
Jessica Maldonado

PHOTOGRAPHY BY
Scott Kelby

Published by
New Riders

Composed in Avenir, Myriad Pro, and Helvetica by Kelby Media Group, Inc.

Trademarks
All terms mentioned in this book that are known to be trademarks or service marks have been appropriately capitalized. New Riders cannot attest to the accuracy of this information. Use of a term in this book should not be regarded as affecting the validity of any trademark or service mark.

Photoshop is a registered trademark of Adobe Systems, Inc.
Macintosh is a registered trademark of Apple, Inc.
Windows is a registered trademark of Microsoft Corp.

Warning and Disclaimer
This book is designed to provide information about Photoshop for digital photographers. Every effort has been made to make this book as complete and as accurate as possible, but no warranty of fitness is implied.

The information is provided on an as-is basis. The author and New Riders shall have neither the liability nor responsibility to any person or entity with respect to any loss or damages arising from the information contained in this book or from the use of the discs, electronic files, or programs that may accompany it.

THIS PRODUCT IS NOT ENDORSED OR SPONSORED BY ADOBE SYSTEMS INCORPORATED, PUBLISHER OF ADOBE PHOTOSHOP.

ISBN 13: 978-0-134-54511-0
ISBN 10: 0-134-54511-7
9 8 7 6 5 4 3 2 1

http://kelbyone.com
www.newriders.com

*This book is dedicated to Jessica Maldonado,
one of my favorite designers ever, and one of
the most talented, dedicated, and hardworking
people I've ever had the pleasure of working with.*

ACKNOWLEDGMENTS

I've been writing books for 20 years now, and I still find that the thing that's the hardest for me to write in any book is the acknowledgments. It also, hands down, takes me longer than any other pages in the book. For me, I think the reason I take these acknowledgments so seriously is because it's when I get to put down on paper how truly grateful I am to be surrounded by such great friends, an incredible book team, and a family that truly makes my life a joy. That's why it's so hard. I also know why it takes so long—you type a lot slower with tears in your eyes.

To my remarkable wife, Kalebra: We've been married 27 years now, and you still continue to amaze me, and everyone around you. I've never met anyone more compassionate, more loving, more hilarious, and more genuinely beautiful, and I'm so blessed to be going through life with you, to have you as the mother of my children, my business partner, my private pilot, Chinese translator, and best friend. You truly are the type of woman love songs are written for, and as anyone who knows me will tell you, I am, without a doubt, the luckiest man alive to have you for my wife.

To my son, Jordan: It's every dad's dream to have a relationship with his son like I have with you, and I'm so proud of the bright, caring, creative man you've become. I can't wait to see the amazing things life has in store for you, and I just want you to know that watching you grow into the person you are is one of my life's greatest joys.

To my precious little girl, Kira: You have been blessed in a very special way, because you are a little clone of your mom, which is the most wonderful thing I could have possibly wished for you. I see all her gifts reflected in your eyes, and you're now getting to the age where you're starting to realize how blessed you are to have Kalebra as your mom. One day—just like Jordan—you will realize it on an entirely different level, and then you'll know what an incredible gift God has blessed you with in her.

To my big brother Jeff, who has always been, and will always be, a hero to me. So much of who I am, and where I am, is because of your influence, guidance, caring, and love as I was growing up. Thank you for teaching me to always take the high road, for always knowing the right thing to say at the right time, and for having so much of our dad in you.

I'm incredibly fortunate to have the production of my books handled in-house by two extraordinary people, whose talent, passion, and work ethic are an inspiration to everyone around them—my lead editor Kim Doty and book designer Jessica Maldonado (to whom this book is dedicated). I don't know how I'd ever get a book done without this dream team of creatives. They keep me on track, calm, and smiling with their 100% can-do attitude and the talent and drive to pull it off. I'm also very grateful to still have the wonderful Cindy Snyder working on my books, even though we don't get to see her every day (but, we all miss seeing her—especially around birthdays [inside joke]). I feel so blessed to have this incredible team behind me, and I couldn't be more proud of what you have accomplished, and what you continue to do every single day. Thank you.

A big thanks to my Executive Assistant Lynn Miller, who generally herds me like sheep to keep me focused and on track so I have time to write books, spend time with my family, and have a life outside of work.

Thanks to my awesome Editor/Publisher at Peachpit and New Riders, the marvelous Nancy Davis, who despite being a Michigan football fan, has been a joy to work with, and whose commitment to producing great books has done the brand proud. Oh yeah, one last thing. #rolltide! (Sorry, I couldn't help myself.)

Thanks to my friends at Adobe: Winston Henderickson, Bryan O'Neil Hughes, Mala Sharma, Terry White, Julieanne Kost, Tom Hogarty, Scott Morris, Sharad Mangalick, Russell Preston Brown, Jeff Tranberry, Bryan Lamkin, and the amazing engineering team at Adobe (I don't know how you all do it).

I owe a debt of gratitude and will never forget: Barbara Rice, Jill Nakashima, Nancy Aldrich-Ruenzel, Sara Jane Todd, Rye Livingston, Addy Roff, Jennifer Stern, Deb Whitman, Kevin Connor, John Nack, John Loiacono, Cari Gushiken, Jim Heiser, and Karen Gauthier.

I want to thank all the gifted photographers who've taught me so much over the years, including: Moose Peterson, Joe McNally, Anne Cahill, Vincent Versace, Cliff Mautner, Dave Black, Bill Fortney, David Ziser, Helene Glassman, Kevin Ames, and Jim DiVitale.

Thanks to my mentors, whose wisdom and whip-cracking have helped me immeasurably, including John Graden, Jack Lee, Dave Gales, Judy Farmer, and Douglas Poole.

Most importantly, I want to thank God, and His Son Jesus Christ, for leading me to the woman of my dreams, for blessing us with two amazing children, for allowing me to make a living doing something I truly love, for always being there when I need Him, for blessing me with a wonderful, fulfilling, and happy life, and such a warm, loving family to share it with.

OTHER BOOKS BY SCOTT KELBY

The Lightroom Mobile Book

Professional Portrait Retouching Techniques for Photographers Using Photoshop

The Digital Photography Book, parts 1, 2, 3, 4, and 5

The Best of The Digital Photography Book Series

Light It, Shoot It, Retouch It: Learn Step by Step How to Go from Empty Studio to Finished Image

It's a Jesus Thing: The Book for Wanna Be-lievers

The Adobe Photoshop Lightroom Book for Digital Photographers

How Do I Do That in Lightroom?

Professional Sports Photography Workflow

Photoshop for Lightroom Users

ABOUT THE AUTHOR

Scott Kelby

Scott is Editor, Publisher, and co-founder of *Photoshop User* magazine, Editor of *Lightroom Magazine*, and co-host of the influential weekly photography talk show, *The Grid*. He is President of KelbyOne, the online education community for creative people.

Scott is a photographer, designer, and award-winning author of more than 80 books, including *The Lightroom Book for Digital Photographers*, *Professional Portrait Retouching Techniques for Photographers Using Photoshop*, *How Do I Do That In Lightroom?*, *Light It, Shoot It, Retouch It*, and *The Digital Photography Book*, parts 1, 2, 3, 4, and 5. The first book in this series, *The Digital Photography Book*, part 1, has become the top-selling book on digital photography in history.

For six years straight, Scott has been honored with the distinction of being the world's #1 best-selling author of photography technique books. His books have been translated into dozens of different languages, including Chinese, Russian, Spanish, Korean, Polish, Taiwanese, French, German, Italian, Japanese, Dutch, Swedish, Turkish, and Portuguese, among others.

He is a recipient of the prestigious ASP International Award, presented annually by the American Society of Photographers for "…contributions in a special or significant way to the ideals of Professional Photography as an art and a science," and the 2015 HIPA Special Award for his worldwide contributions to photography education.

Scott is Training Director for the Adobe Photoshop Seminar Tour and Conference Technical Chair for the annual Photoshop World Conference. He's featured in a series of Adobe Photoshop and Lightroom online courses at KelbyOne.com and has been training photographers and Adobe Photoshop users since 1993.

For more information on Scott, visit him at:

His daily blog: **http://scottkelby.com**
Instagram: **@scottkelby**
Twitter: **http://twitter.com/scottkelby**
Facebook: **www.facebook.com/skelby**

www.kelbyone.com

CONTENTS

Chapter 3 **069**

The Adjustment Bureau
camera raw's adjustment tools

Chapter 4 **087**

Lens
correcting lens problems

CONTENTS

CONTENTS

CONTENTS

Seven Things You'll Wish You Had Known Before Reading This Book

It's really important to me that you get a lot out of reading this book, and one way I can help is to get you to read these seven quick things about the book that you'll wish later you knew now. For example, it's here that I tell you about where to download something important, and if you skip over this, eventually you'll send me an email asking where it is, but by then you'll be really aggravated, and well…it's gonna get ugly. We can skip all that (and more) if you take two minutes now and read these seven quick things. I promise to make it worth your while.

(1) You don't have to read this book in order.

I designed this book so you can turn right to the technique you want to learn, and start there. I explain everything as I go, step-by-step, so if you want to learn how to remove dust spots from a RAW image, just turn to page 52, and in a couple of minutes, you'll know. I did write the book in a logical order for learning Photoshop, but don't let that tie your hands—jump right to whatever technique you want to learn—you can always go back, review, and try other stuff.

(2) Practice along with the same photos I used here in the book.

As you're going through the book, and you come to a technique like "Creating the Tone-Mapped HDR Look," you might not have an HDR-bracketed set of shots hanging around, so in those cases, I usually made the images available for you to download so you can follow along with the book. You can find them at **http://kelbyone.com/books/cc17** (see, this is one of those things I was talking about that you'd miss if you skipped this and went right to Chapter 1).

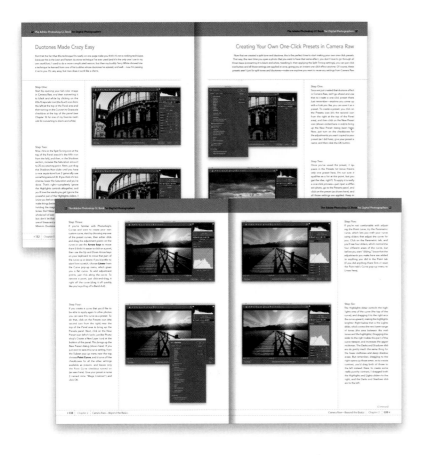

(3) Photography is evolving, Photoshop is evolving, and this book has to, too.

The photographer's workflow in Photoshop has evolved greatly over time and, in this edition of this book, you'll wind up doing a *lot* of your processing and editing in Adobe Camera Raw (whether you shoot in RAW, JPEG, or TIFF—it works for all three). That's because, for years now, Adobe has been adding most of Photoshop's new features for photography directly into Camera Raw itself. Since today's photography workflow in Photoshop is based around Camera Raw, nearly half of the book is on working in Camera Raw, and I wanted you to know that up front. (After all, you don't want to buy an outdated Photoshop book that used a 2006 workflow—you want one for today's workflow.) This affects other old-school features like Photoshop's Curves feature, which was actually in the original version of Photoshop 1.0 (released back in 1990 and has hardly changed much since). Today we really don't use Curves very often, and if we do, we use the Tone Curve in Camera Raw instead (which I do cover here in the book). However, even though the old version of Curves isn't covered here in the book, I did provide a color correction chapter that uses it on the book's downloads page (ya know, just in case you want to go "old school"). You can find it at the web address just mentioned in #2.

(4) I included a chapter on my CC workflow, but don't read it yet.

At the end of this book, I included a special chapter detailing my own Photoshop CC workflow. But, please don't read it until you've read the rest of the book, because it assumes that you've read the book already, and understand the basic concepts, so it doesn't spell everything out (or it would be one really, really long drawn-out chapter).

(Continued)

(5) The intro pages at the beginning of each chapter are not what they seem.

The chapter introductions are designed to give you a quick mental break between chapters, and honestly, they have little to do with what's in the chapter. In fact, they have little to do with anything, but writing these quirky chapter intros has become kind of a tradition of mine (I do this in all my books), so if you're one of those really "serious" types, I'm begging you—skip them and just go right into the chapter because they'll just get on your nerves. However, the short intros at the beginning of each individual project, up at the top of the page, are usually pretty important. If you skip over them, you might wind up missing stuff that isn't mentioned in the project itself. So, if you find yourself working on a project, and you're thinking to yourself, "Why are we doing this?" it's probably because you skipped over that intro. So, just make sure you read it first, and then go to Step One. It'll make a difference—I promise.

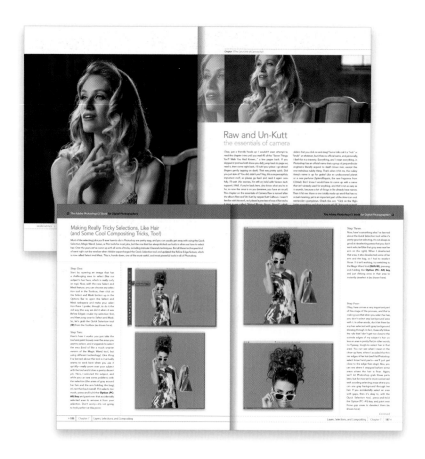

(6) There are things in Photoshop CC and in Camera Raw that do the exact same thing.

For example, there's a Lens Corrections panel in Camera Raw, and there's a Lens Correction filter in Photoshop, and they are almost identical. In my own workflow, if I can do the exact same task in Camera Raw or Photoshop, I always choose to do it in Camera Raw, because (a) it's faster (there are no progress bars in Camera Raw—everything happens in real time), (b) it's non-destructive (so I can always change my mind later), and (c) if you shot in RAW, it applies the edits to the RAW 16-bit image, which has a wider tonal range, and even heavy amounts of editing will do less visible damage to the image. So, if I'm showing you something in Camera Raw that can also be done in Photoshop, I'll mention it, but I'll only show it in Camera Raw (since that's how I do it).

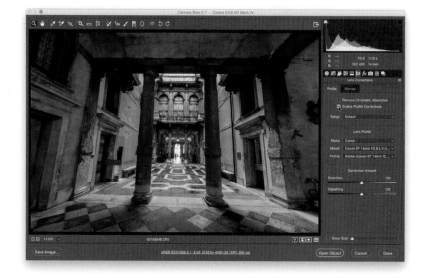

(7) Where's the Adobe Bridge stuff?

Adobe hasn't really updated Bridge for years now. Well, I guess that's not exactly true. They removed some stuff, and moved some stuff around, but outside of that—that's pretty much it. I'm thinking the future of Bridge is not bright, and since it hasn't really changed in years (and it's slower than an asthmatic three-toed sloth covered in molasses, going uphill on a sand dune), I'm no longer including it here in the book, but if you're brand new to Photoshop, you don't use Lightroom, and you think you might need Bridge (please, rethink it), I did write two entire chapters just on Bridge and put them on the book's download site for you to download for free. You'll find these at **http://kelbyone.com/books/cc17**, along with two other bonus chapters on printing and editing video (see, I care).

(8) Each chapter includes my "Photoshop Killer Tips"!

Hey, I thought you said it was "Seven Things"? Well, consider this eighth a "bonus thing," because it's about another bonus I included in this edition of the book. At the end of every chapter is a section I call "Photoshop Killer Tips" (named after the book of the same name I did a number of years back). These are those time-saving, job-saving, "man, I wish I had known that sooner" type tips. The ones that make you smile, nod, and then want to call all your friends and "tune them up" with your new status as a Photoshop guru. These are in addition to all the other tips, which already appear throughout the chapters (you can never have enough tips, right? Remember: He who dies with the most tips, wins!). So, there you have it, seven (or so) things that you're now probably glad you took a couple minutes to read. Okay, the easy part is over—turn the page and let's get to work.

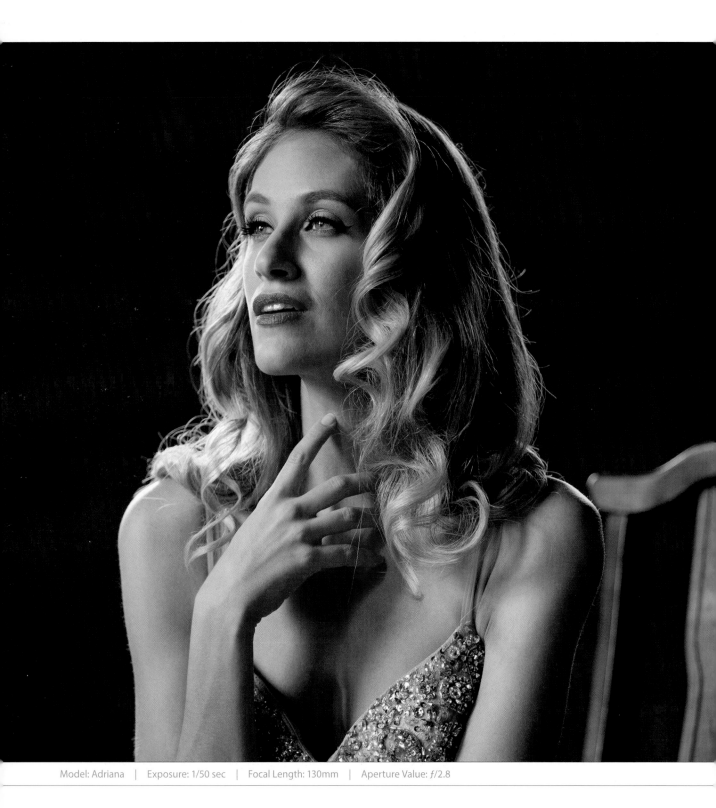

Model: Adriana | Exposure: 1/50 sec | Focal Length: 130mm | Aperture Value: ƒ/2.8

Raw and Un-Kutt
the essentials of camera

Okay, just a friendly heads up: I wouldn't even attempt to read this chapter intro until you read #5 of the "Seven Things You'll Wish You Had Known…" a few pages back. If you skipped it (and we both know you did), jump back to page xvi, read it, then come right back. I'll hold your place—go ahead (fingers gently tapping on desk). That was pretty quick. Did you just skim it? You did, didn't you? Hey, this is imperceptibly important stuff, so please go back and read it again carefully. I'll wait. (No worries, I'm still on hold with Verizon tech support.) Well, if you're back here, you know what you're in for, so now the onus is on you (ewwww, you have an onus!). This chapter on the essentials of Camera Raw is named after the album Raw and Un-Kutt by rapper Kutt Calhoun. I wasn't familiar with his work, so I played a preview of one of his tracks (I think it was called "Naked [Boom, Boom, Boom]", which coincidentally was almost the name of this chapter before I even heard of that song). Anyway, whoa nelly! He certainly seems very upset about something. But I digress. Before we get too deep into this, I'm going to call Adobe out on something. You know that little knobby thing on the Camera Raw sliders that you click on and drag? Some folks call it a "nub" or "knob" or whatever, but it has no official name, and personally, I feel this is a travesty. Everything, and I mean everything, in Photoshop has an official name that a group of perpendicular engineers literally argued to death blows over, except this one nebulous nubby thing. That's when it hit me, this nubby thing's name is up for grabs! Like an undiscovered planet or a new perfume (Splendifiquois, the new fragrance from L'Oréal). But I knew I would have to come up with a name that isn't already used for anything, and that's not as easy as it sounds, because a lot of things in life already have names. Then it hit me: there is one totally made-up word that has no actual meaning, yet is an important part of the American rock vernacular—pompitous. Check this out: "Click on the High-lights pompitous and drag it over to +0.25." It sounds so legit! Yes, it shall be pompitous from now on. So let it be known; so let it be done. And remember, it was I, "Maurice," who came up with this. (Well…"some people call me Maurice. 'Cause I speak of the pompitous of love.") Dang, this word works for anything! (Stop bragging, you sound so pompitous).

How to Open Different Types of Images in Camera Raw

Although Adobe Camera Raw was originally created to process photos taken in your camera's RAW format, you can also use it to process your JPEG and TIFF photos. A big advantage of using Camera Raw that many people don't realize is that it's just plain easier and faster to make your images look good using Camera Raw than with any other method. Camera Raw's controls are simple, they're instantaneous, and they're totally undoable, which makes it hard to beat. But first, you've got to open your images in Camera Raw for processing.

Opening RAW Images:

Since Camera Raw was designed to open RAW images, if you double-click on a RAW image (whether in Bridge or just in a folder on your computer), it will launch Photoshop and open that RAW image in Camera Raw (its full official name is Adobe Camera Raw, but here in the book, I'll just be calling it "Camera Raw" for short, because...well...that's what I call it). *Note:* If you double-click on what you know is a RAW image and it doesn't open in Camera Raw, make sure you have the latest version of Camera Raw—images from newly released cameras need the latest versions of Camera Raw to recognize their RAW files.

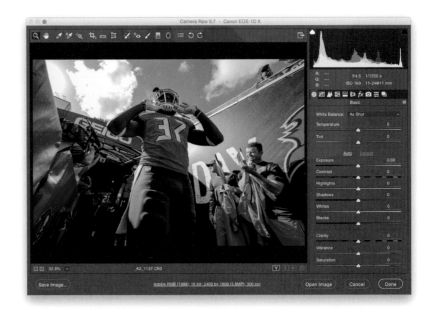

Opening JPEG & TIFF Images from Bridge:

If you want to open a JPEG or TIFF image from Bridge, it's easy: either click on an image and press **Command-R (PC: Ctrl-R)** or Right-click on it and, from the pop-up menu, choose **Open in Camera Raw**.

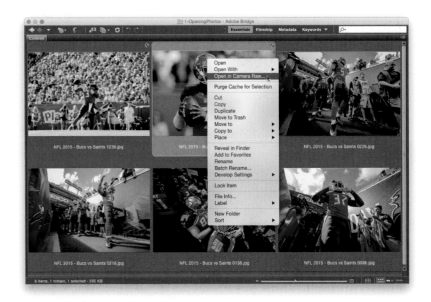

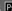

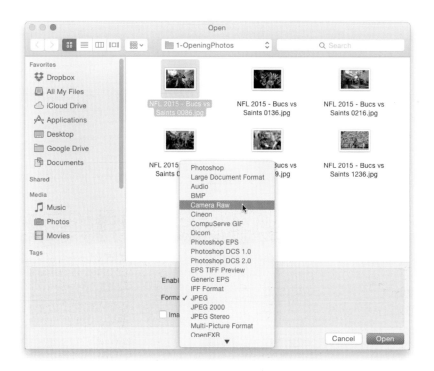

Opening JPEG & TIFF Images from Your Computer:

If you want to open a JPEG or TIFF image from your computer, then here's what you do: On a Mac, go under Photoshop's File menu and choose **Open**. When the Open dialog appears, click on your JPEG (or TIFF, but we'll use a JPEG as our example) image, and in the Format pop-up menu, it will say JPEG. You need to click-and-hold on that menu, and then choose **Camera Raw**, as shown here. Now, click the Open button, and your JPEG image will open in Camera Raw. In Windows, just go under Photoshop's File menu and choose **Open As**, then navigate your way to that JPEG or TIFF image, change the pop-up menu near the bottom right to **Camera Raw**, and click Open.

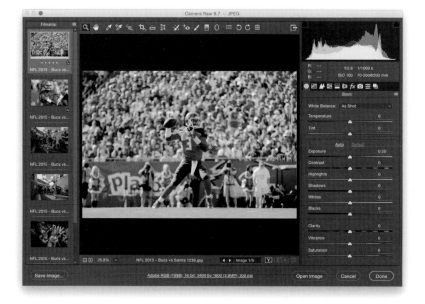

Opening Multiple Images:

You can open multiple RAW photos in Camera Raw by selecting them first (either in Bridge or in a folder on your computer), then just double-clicking on any one of them, and they'll all open in Camera Raw and appear in a filmstrip along the left side of the Camera Raw window (as seen here). If the photos are JPEGs or TIFFs, in Bridge, select 'em first, then press Command-R (PC: Ctrl-R). You won't be able to open multiple JPEGs or TIFFs from a Mac Finder or Windows Explorer window; you'll need to use Bridge to open them (just use the Path Bar in Bridge to navigate to where those images are located).

(Continued)

Editing JPEG & TIFF Images in Camera Raw:

One thing about editing JPEGs and TIFFs in Camera Raw: When you make adjustments to a JPEG or TIFF and you click the Open Image button, it opens your image in Photoshop (as you'd expect). However, if you just want to save the changes you made in Camera Raw without opening the photo in Photoshop, then click the Done button instead (as shown here), and your changes will be saved. But there is a big distinction between editing JPEG or TIFF images and editing a RAW image. If you click the Done button, you're actually affecting the real pixels of the original JPEG or TIFF, whereas, if this were a RAW image, you wouldn't be (which is another big advantage of shooting in RAW). If you click the Open Image button, and open your JPEG or TIFF in Photoshop, you're opening and editing the real image, as well. Just so you know.

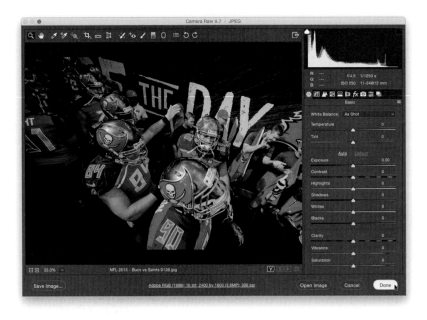

The Two Camera Raws:

Here's another thing you'll need to know: there are actually two Camera Raws—one in Photoshop, and a separate one in Bridge. The advantage of having two Camera Raws comes into play when you're processing (or saving) a lot of RAW photos—you can have them processing in Bridge's version of Camera Raw, while you're working on something else in Photoshop. If you find yourself using Bridge's Camera Raw most often, then you'll probably want to press **Command-K (PC: Ctrl-K)** to bring up Bridge's Preferences, click on General on the left, and then turn on the checkbox for Double-Click Edits Camera Raw Settings in Bridge (as shown here). Now, double-clicking on a photo opens RAW photos in Bridge's Camera Raw, rather than Photoshop's.

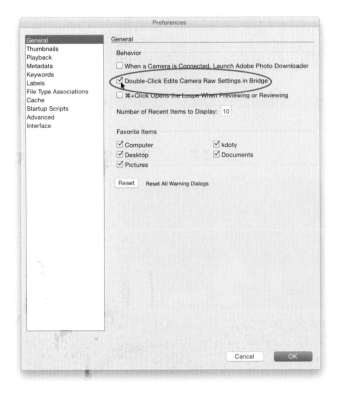

Miss the JPEG Look?
Try Applying a Camera Profile

If you've ever wondered why RAW images look good on your camera's LCD, but look flat when you open them in Camera Raw, it's because what you see on your LCD is a JPEG preview (even though you're shooting in RAW), and your camera automatically adds color correction, sharpening, etc., to them. When you shoot in RAW, you're telling the camera, "Turn all that color enhancement and sharpening off—just leave it untouched, and I'll process it myself." But, if you'd like that JPEG-processed look as a starting place for your RAW photo editing, camera profiles can get you close.

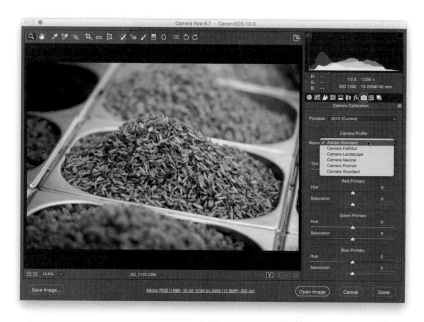

Step One:

Click on the Camera Calibration icon (the third icon from the right) near the top of the Panel area, and in the Camera Profile section, click-and-hold on the Name pop-up menu, and you'll see a list of camera profiles available for your particular camera (it reads the embedded EXIF data, so it knows which brand of camera you use). For example, if you shoot Canon, you'll see a list of the in-camera picture styles (shown here) you could have applied to your image if you had taken the shot in JPEG mode (if you shoot in RAW, Camera Raw ignores those in-camera profiles, as explained above). If you shoot Nikon, or another camera brand, you'll see a slightly different list, but it does the same type of thing.

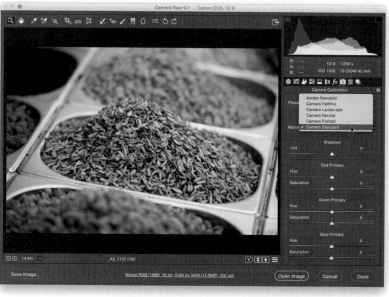

Step Two:

The default profile will be Adobe Standard. Now, ask yourself this: "Does the word 'Standard' ever mean 'Kick Butt?'" Not usually, which is why I suggest you try out the different profiles in this list and see which ones you like. At the very least, I would change it to Camera Standard (as shown here), which I think usually gives you a better starting place.

(Continued)

Step Three:

Depending on the individual photo you're editing, Camera Standard might not be the right choice, but as the photographer, this is a call you have to make (in other words, it's up to you to choose which one looks best to you). I usually wind up using either Camera Standard or Camera Landscape for images taken with a Canon camera, because I think Landscape looks the most like the JPEGs I see on the back of my camera. But again, if you're not shooting Canon, Landscape might not be one of the available choices (Canons and Nikons have five picture styles). If you don't shoot Canon or Nikon, or one of a handful of other cameras, then you'll only have Adobe Standard, and possibly Camera Standard, to choose from, but you can create your own custom profiles using Adobe's free DNG Profile Editor utility, available from Adobe at http://kel.by/dngprofile.

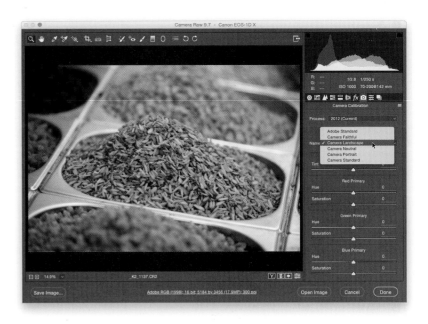

Step Four:

Here's a before/after with only one thing done to this photo: I chose Camera Landscape (as shown in the pop-up menu in Step Three). Again, this is designed to replicate the color looks you could have chosen in the camera, so if you want to have Camera Raw give you a similar look as a starting point, give this a try. Also, since Camera Raw allows you to open more than one image at a time (in fact, you can open hundreds at a time), you could open a few hundred images, then click on the icon to the right of Filmstrip, at the top left, choose Select All, then change the camera profile for the first-selected image, and then all the other images will have that same profile automatically applied. Now, you can just click the Done button.

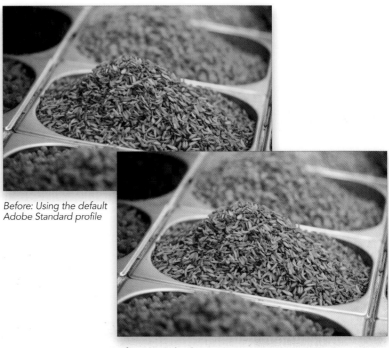

Before: Using the default Adobe Standard profile

After: Using the Camera Landscape profile

Using Camera Raw Like It's a Filter

Okay, I'm starting off with this particular feature because the ability to reopen any currently open image in Camera Raw had been at the top of my Photoshop wish list for years. Before this was possible, if you had an image open in Photoshop and you wanted to re-edit it in Camera Raw, you had to save the image and close it. Then, you'd have to go to the Open dialog, find the image on your computer, change the Format to Camera Raw, and then open it. Now, it's finally just a one-click process (like applying any other filter).

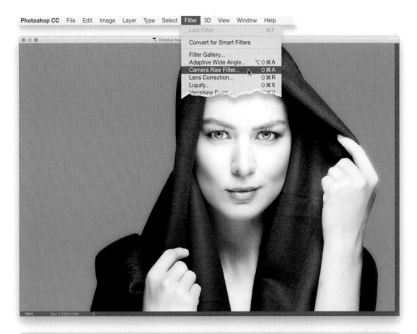

Step One:

When you have an image already open in Photoshop and want to edit it in Camera Raw, just go under the Filter menu and choose **Camera Raw Filter** (as shown here).

Step Two:

The Camera Raw window opens, and now you can make any changes you'd like. When you're done, just click OK, and you're back in Photoshop with your Camera Raw changes applied. Just a heads up: if your image is already open in Photoshop, even if it was shot in RAW format on your camera, it's no longer a RAW photo at this point, so it doesn't go back and reopen the RAW version—it takes the 8- or 16-bit photo you have already open in Photoshop and it opens that in Camera Raw. This isn't a bad thing, and works as expected, but I just thought I'd address it in case you were wondering.

Setting the White Balance

If you've ever taken a photo indoors, chances are it came out with kind of a yellowish tint. Unless you took the shot in an office, and then it probably had a green tint. If you took a shot of somebody in the shade, the photo probably had a blue tint. Those are white balance problems, and if we properly set our white balance in the camera, we won't see these color problems (the photos will just look normal), but since most of us shoot with our cameras set to Auto White Balance, we're going to run into them. Luckily, we can fix them pretty easily.

Step One:
The white balance is usually the very first thing I adjust in my own Camera Raw workflow, because getting the white balance right will eliminate 99% of your color problems right off the bat. At the top of the Basic panel (on the right side of the Camera Raw window), are the White Balance controls. If you look to the right of the words "White Balance," you'll see a pop-up menu (shown circled here in red), and by default it shows you the "As Shot" white balance (you're seeing the white balance you had set in your camera when you took the shot). I had been shooting indoors under regular indoor lighting, so my white balance had been set to Tungsten, but then I went into a room with natural light and didn't change my white balance, so the first few shots came out with a bluish tint (as seen here—yeech!) and that's why the white balance is way, way off.

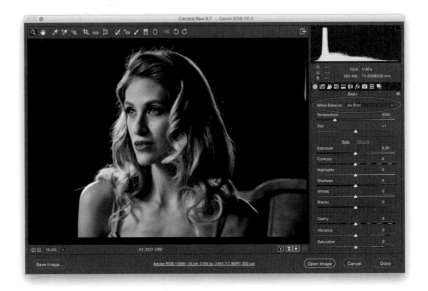

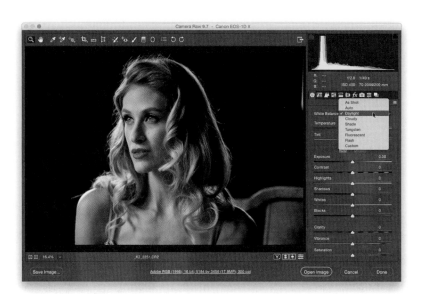

Step Two:

There are three ways to change the white balance in your photo, and the first is to simply choose one of the built-in White Balance presets. Fairly often, that's all you need to do to color correct your image. Just click on the White Balance pop-up menu, and you'll see a list of white balance settings you could have chosen in the camera. Just choose the preset that most closely matches what the lighting situation was when you originally took the photo (for example, if you took the shot in the shade of a tree, you'd choose the Shade preset). Here, I tried each preset and Daylight seemed to look best—it removed the bluish tint. (*Note:* This is the one main area where the processing of RAW and JPEG or TIFF images differs. You'll only get this full list of white balance presets with RAW images. With JPEGs or TIFFs, your only choices are As Shot or Auto white balance.)

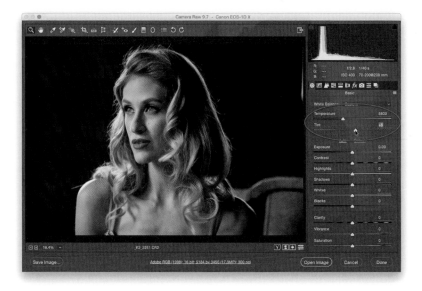

Step Three:

The second method is to use the Temperature and Tint sliders (found right below the White Balance preset menu). The bars behind the sliders are color coded so you can see which way to drag to get which kind of color tint. What I like to do is use the built-in presets to get close (as a starting point), and then if my color is just a little too blue or too yellow, I drag in the opposite direction. So, in this example, the Daylight preset was close, but she was still a little too blue, so I dragged the Temperature slider a little bit toward yellow and the Tint slider a tiny bit toward green.

(Continued)

Step Four:

Just a couple of other quick things about manually setting your white balance using the Temperature and Tint sliders: If you move a slider and decide you didn't want to move it after all, just double-click directly on the little slider "nub" itself, and it will reset to its previous location. By the way, I generally just adjust the Temperature slider, and rarely have to touch the Tint slider. Also, to reset the white balance to where it was when you opened the image, just choose **As Shot** from the White Balance pop-up menu (as shown here).

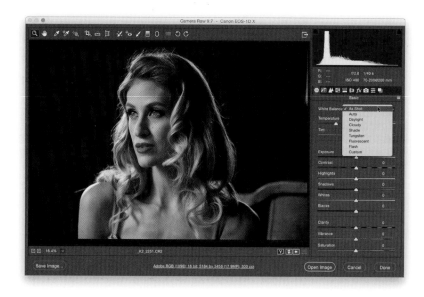

Step Five:

The third method is my personal favorite, and the method I use the most often, and that is setting the white balance using the White Balance tool **(I)**. This is perhaps the most accurate because it takes a white balance reading from the photo itself. You just click on the White Balance tool in the toolbar at the top of the window (it's circled in red here), and then click it on something in your photo that's supposed to be a light gray (that's right—you properly set the white balance by clicking on something that's light gray). So, take the tool and click it once on the strap on her dress (as shown here) and it sets the white balance for you. If you don't like how it looks, then just click on a different light gray area.

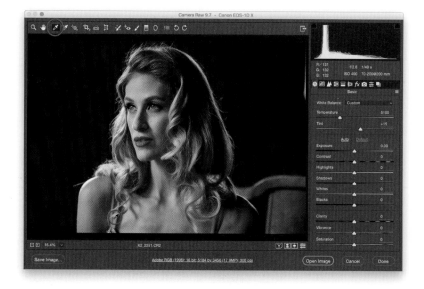

TIP: Quick White Balance Reset

To quickly reset your white balance to the As Shot setting, just double-click on the White Balance tool up in the toolbar.

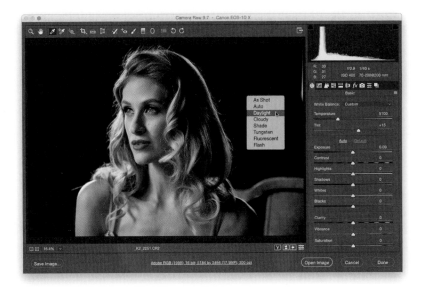

Step Six:

Now, here's the thing: although this can give you a perfectly accurate white balance, it doesn't mean that it will look good. White balance is a creative decision, and the most important thing is that your photo looks good to you. So don't get caught up in that "I don't like the way the white balance looks, but I know it's accurate" thing that sucks some people in—set your white balance so it looks right to you. You are the bottom line. You're the photographer. It's your photo, so make it look its best. Accurate is not another word for good. By the way, you can just Right-click on your image to access the White Balance pop-up menu (as shown here).

Step Seven:

Here's a before/after so you can see what a difference setting a proper white balance makes (by the way, you can see a quick before/after of your white balance edit by pressing the letter **P** on your keyboard to toggle the preview on/off).

TIP: Using the Gray Card

To help you find that neutral light gray color in your images, I've included an 18% gray card in the back of this book (it's perforated, so you can tear it out). Once your lighting is set, just have your subject hold it while you take one shot. Then, open that image in Camera Raw, and click the White Balance tool on the card in your image to instantly set your white balance. Now, apply that same white balance to all the other shots taken under that same light (more on how to do that coming up in the next chapter).

Before: The As Shot white balance has a bluish tint

After: With one click of the White Balance tool, everything comes together

Seeing a Before/After in Camera Raw

Before Photoshop CC, Camera Raw's ability to show you a before/after preview of your changes was clunky at best, and totally confusing at worst, mostly because toggling on/off the Preview checkbox didn't show you a full before/after of your image, it only turned on/off the changes you made in the current panel. Luckily, in CC, they borrowed a feature from Lightroom and gave us before/after previews that have a lot of options and make sense.

Step One:

If you've made some adjustments, and want to see what your image looked like before you made them (the "before" image), just press the **P** key on your keyboard. This is probably the Before view I use the most in my own workflow. To return to your After image, press P again. If you'd like to see a side-by-side Before/After view, either click on the Before/After preview icon (circled here in red) or press the **Q** key to get the view you see here, with the Before image on the left, and the After image, with the tweaks you applied (here, I made some basic adjustments and used the Adjustment Brush to do some minor retouching) on the right. *Note:* Each time you press Q, it toggles to a different preview view.

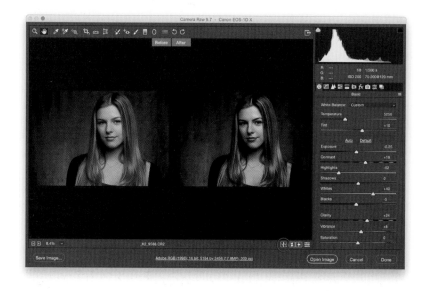

Step Two:

One thing I don't like about this side-by-side view is that while it works great on tall, vertical images, for wide orientation images like this, the previews are really small. Luckily, you can fix that: once you're in this view, just press **Command-+** (plus sign; **PC: Ctrl-+**) to zoom in on your image like you see here. Each time you press that shortcut, it zooms in tighter. Once you're zoomed in tight, you can reposition your image by simply clicking on either image (your cursor changes to the Hand tool) and dragging the image any way you want. To zoom back out, press **Command--** (minus sign; **PC: Ctrl--**) until you're zoomed out enough.

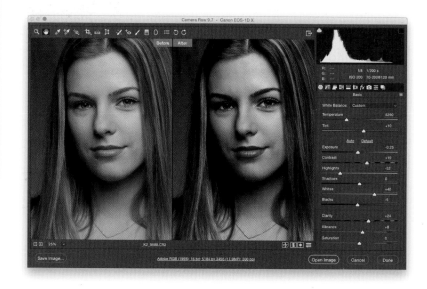

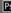

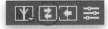

Step Three:

Another preview option is a split-screen that shows the left half of the image as the Before and the right half as the After (as seen here). Once you're in this mode, you can literally swap sides, so the After is on the left and the Before is on the right (so instead of a Before/After, you have an After/Before). To do that, click on the icon to the right of the Before/After icon (it's shown circled in red here, at the bottom) below the bottom-right corner of your image preview, and it swaps the two. If you click the next icon to the right of it, it copies the current settings to the Before image. The final icon (on the far right), lets you toggle on/off the changes made in just the current panel (like the old way previews worked in Camera Raw). By the way, if you click-and-hold on the first icon (the one that looks like the letter "Y"), a pop-up menu appears (seen here) that lets you choose the different before/after previews by name.

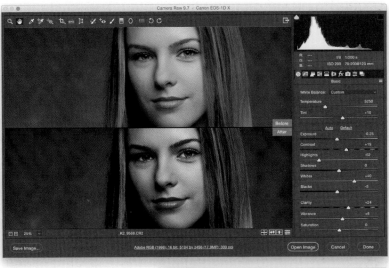

Step Four:

If you press Q again, it toggles you to the Before/After Top/Bottom preview (as seen here, which looks kinda creepy, since her Before head is growing out of her After head). If you press Q one last time, you get a top/bottom split view. Anyway, besides all this, you have a reasonable amount of control over how all this is displayed by going to that pop-up menu we saw back in Step Three and choosing **Preview Preferences** to bring up the dialog you see here below. The first column lets you hide (by turning off) any of the pre-view mode checkboxes you don't care about (I only use the left/right side-by-side myself). In the second column, you get to choose whether you want to see a solid line divider between your before/after previews, and if you want to see the words Before and After onscreen.

Letting Camera Raw Auto-Correct Your Photos

If you're not quite comfortable with manually adjusting each image, Camera Raw does come with a one-click Auto function, which takes a stab at correcting the overall exposure of your image (including contrast, highlights, shadows, etc.), and at this point in Camera Raw's evolution, it's really not that bad. If you like the results, you can set up Camera Raw's preferences so every photo, upon opening in Camera Raw, will be auto-adjusted using that same feature. You also now have the option to add individual Auto corrections, and we'll take a look at how to do that, too.

Step One:
Once you have an image open in Camera Raw, you can have Camera Raw take a stab at setting the overall exposure (using the controls in the Basic panel) for you by clicking on the Auto button (shown circled in red here). In older versions of Camera Raw, this Auto correction feature was…well…let's just say it was less than stellar, but it has gotten much better since then, and now it does a somewhat decent job (especially if you're stuck and not sure what to do), so click on it and see how it looks. If it doesn't look good, no sweat—just press **Command-Z (PC: Ctrl-Z)** to Undo.

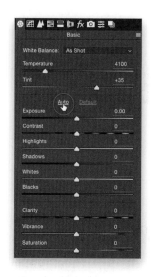

Step Two:
You can set up Camera Raw so it automatically performs an Auto Tone adjustment each time you open a photo—just click on the Preferences icon up in Camera Raw's toolbar (it's the third icon from the right), and when the dialog appears, turn on the checkbox for Apply Auto Tone Adjustments (shown circled here), then click OK. Now, Camera Raw will evaluate each image and try to correct it. If you don't like its tonal corrections, then you can just click on the Default button, which appears to the right of the Auto button (the Auto button will be grayed out because it has already been applied).

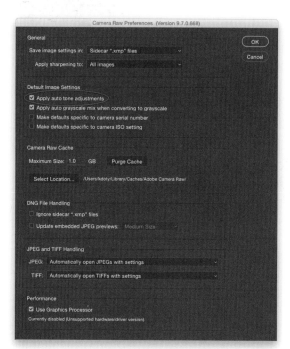

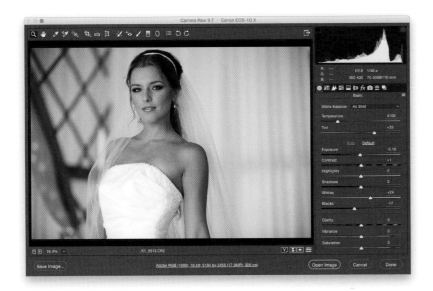

Step Three:

While the Auto button can do a pretty good job at making a proper exposure, sometimes it's absolutely dreadful. Say you have an image that's intentionally kinda dark, like a low-key image or when you shot someone on a black background. When you click on the Auto button, it tries to make it a daylight shot and it's just a disaster. Here, though, it made it a little bit darker, but it's not too bad.

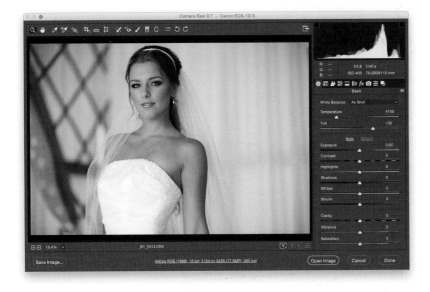

Step Four:

Now, here's the problem: when you hit Auto, it's applying Auto Shadows, Auto Highlights, Auto everything. But, what Adobe added here in Camera Raw (well, hid here; this one's buried) is the option to add individual Auto corrections, like Auto Temperature and Auto Tint, and a way for you to set the white point and black point automatically (which we'll look at more later in this chapter). So, it's kinda like an Auto White Balance and an Auto Levels, but they're all separate. For example, you can add a separate Auto correction for Tint and a separate one for Temperature. You don't have to do them both; you can do one or the other. Same thing with Whites and Blacks. I've set this back to the default, here, so we can try this out.

(Continued)

Step Five:

So, let's start with the Whites and Blacks. All you have to do is press-and-hold the Shift key, double-click on the Whites slider knob, and it sets the white point for you. Done. Set. Do the same with the Blacks slider. Boom—it sets the blacks. Look at the difference with just those two; it does a nice job.

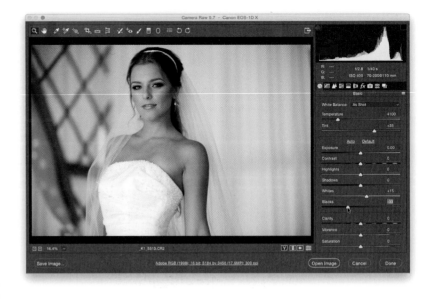

Step Six:

If you want Auto White Balance, just go up, press-and-hold the Shift key, and double-click on the Temperature slider knob. If you need to adjust the Tint, do the same there. If it does something you don't like, release the Shift key, double-click on the knob, and it will return to the default. So, you can't ever mess things up. I think this is a very hidden, but very powerful, little tool here.

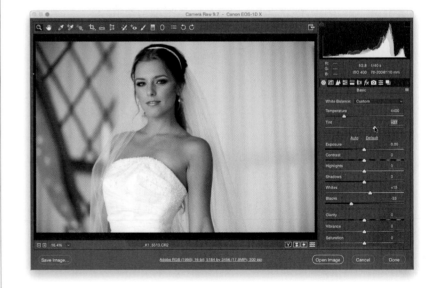

My Editing Your Images Cheat Sheet

Here's a quick look at the sliders in Camera Raw's Basic panel (this isn't "official"—it's just how I think of them). By the way, although Adobe named this the "Basic" panel, I think it may be one of the most misnamed features in all of Camera Raw. It should have been called the "Essentials" panel, since this is probably where you'll spend most of your time editing images. Also, something handy to know: dragging any of the sliders to the right brightens or increases its effect; dragging to the left darkens or decreases its effect.

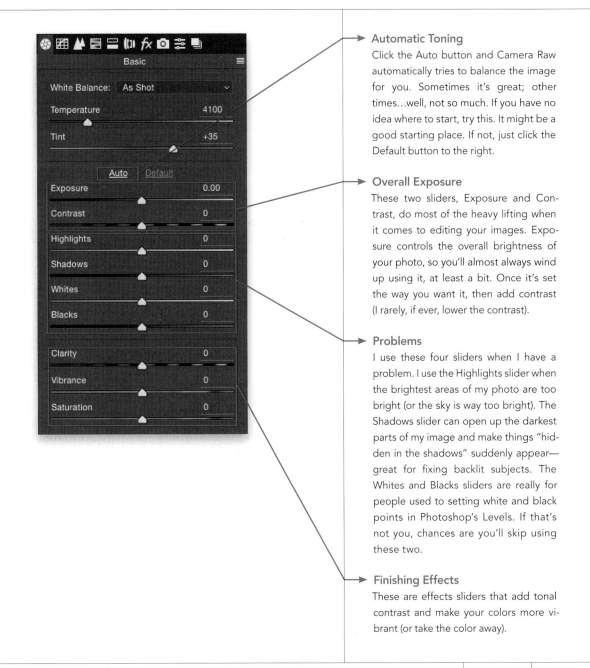

Automatic Toning

Click the Auto button and Camera Raw automatically tries to balance the image for you. Sometimes it's great; other times…well, not so much. If you have no idea where to start, try this. It might be a good starting place. If not, just click the Default button to the right.

Overall Exposure

These two sliders, Exposure and Contrast, do most of the heavy lifting when it comes to editing your images. Exposure controls the overall brightness of your photo, so you'll almost always wind up using it, at least a bit. Once it's set the way you want it, then add contrast (I rarely, if ever, lower the contrast).

Problems

I use these four sliders when I have a problem. I use the Highlights slider when the brightest areas of my photo are too bright (or the sky is way too bright). The Shadows slider can open up the darkest parts of my image and make things "hidden in the shadows" suddenly appear—great for fixing backlit subjects. The Whites and Blacks sliders are really for people used to setting white and black points in Photoshop's Levels. If that's not you, chances are you'll skip using these two.

Finishing Effects

These are effects sliders that add tonal contrast and make your colors more vibrant (or take the color away).

Setting Your White Point and Black Point

One way to get the most out of your image editing is to expand the tonal range of your photo by setting your white point and black point (this is something Photoshop users have done for many years using Photoshop's Levels control). We do this using the Whites and Blacks sliders. We increase the whites as far as we can without clipping the highlights, and increase the blacks as far as we can without clipping the deepest shadows too much (although, I personally don't mind a little shadow clipping), which expands the tonal range big time.

Step One:
Here's the original image and you can see it looks pretty flat. When you see a flat-looking shot like this, it's a perfect candidate for expanding its tonal range by setting the white and black points (right in the Basic panel, below Highlights and Shadows).

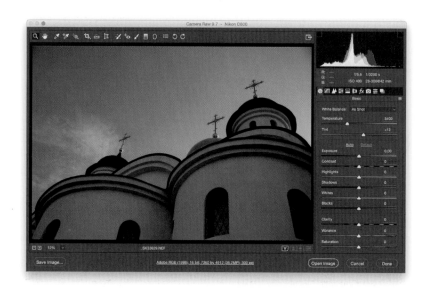

Step Two:
Start by dragging the Whites slider to the right until you see the "White Triangle of Death" (errrr, I mean the white triangle-shaped clipping warning) up in the top-right corner of the histogram (at the top of the Panel area) and back it off a bit until the triangle turns solid black again. That's as far as you want to take it. Any farther and you can damage (clip) the highlights (see page 23 for more on clipping highlights). You can do the same things with the Blacks slider, but to add more blacks (and expand the range), drag to the left until you see the shadow clipping warning (in the top-left corner of the histogram) turn white. I think some things should actually be solid black in a photo, so if I clip the shadows a bit but the photo looks better to me, I go with it. Just sayin'. Anyway, I'm clipping the shadows a bit here and it still looks good to me.

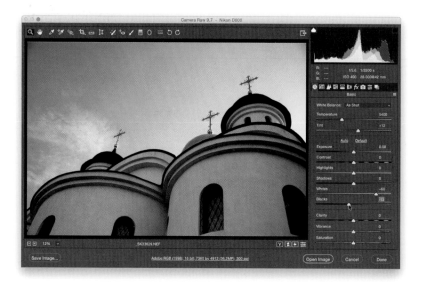

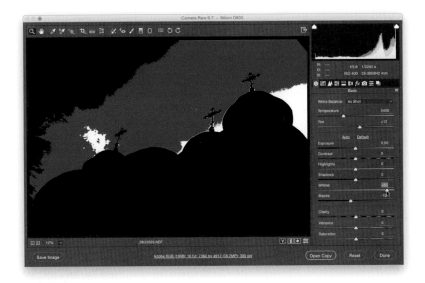

Step Three:

To get an onscreen preview of any clip-ping press-and-hold the Option (PC: Alt) key before you drag either the Whites or Blacks sliders. When you do this with the Whites slider, the image turns black (as seen here). As you drag to the right, any areas that start to clip in individual channels (not as critical) start to appear in that color. So, if you're just clipping the Red channel, you'll see areas appear in red, or if they're yellow or blue (as seen here), you're just clipping those channels. I pretty much let that go for the most part, but if I see areas start to appear in white (all three channels are clipping. Ack!), I know I've gone too far and I back it off to the left a little. If you press-and-hold the Option key with the Blacks slider, it's the opposite. The image turns solid white and as you drag the Blacks slider to the left, any parts that become solid black start to appear in either the color of the channel that's clipping, or in black if all the channels are clipping.

Step Four:

Now that I've gone over the manual way to set your white and black points, and how to use the Option (PC: Alt) key to keep you from clipping, here's what I do: I let Camera Raw automatically set them for me. That's right, it can automatically set both for you, and it's pretty good at pushing the sliders as far out as they can go without clipping (it does, though, sometimes clip the shadows a bit, but, again, you know how I feel about that). Here's how you have it set them auto-matically): Just press-and-hold the Shift key, then double-click on the Whites slider knob and it sets your white point; double-click on the Blacks slider knob and it sets your black point. Yes, it's that easy, and that's what I use in my own workflow. By the way, if you Shift-double-click on either one and it doesn't move, then it's already set as far as it should go.

Adjusting the Overall Brightness

The next thing I fix (after adjusting the white balance and setting the white and black points) is the photo's exposure. But, because we've already expanded the image's tonal range, adjusting the Exposure slider is usually just a small tweak—moving it one way or the other to make the midtones a little bit brighter or a little bit darker. If you set the white and black points first, this is almost like "fine-tuning" the exposure. If you didn't already set them, then this becomes your main exposure adjustment since it controls such a large part of the midtones, including the upper shadow areas and lower highlight areas.

Step One:

For this image, you can see that when I shot it, I totally trashed the exposure—it's way overexposed (I was shooting indoors at a high ISO, and then went outside and forgot to lower it back down).

Step Two:

The first thing we'll want to do is set the white and black points by pressing-and-holding the Shift key, then double-clicking on the Whites slider knob to set the white point, and then double-clicking on the Blacks slider knob to set the black point (we just looked at this in the previous technique).Now, to darken the overall brightness of the image, drag the Exposure slider to the left until the exposure looks good to you. Here, I dragged it to the left down to –1.10. One way I knew I had an exposure problem back in Step One (other than seeing that it was obviously overexposed) was to look in the upper-right corner of the histogram, where you'll see a highlight clipping warning (I call it the "White Triangle of Death"). This lets you know parts of the image have gotten so bright there's no detail, and sometimes just lowering the Exposure amount will fix the problem. But, when that doesn't work, you'll need to adjust the Highlights slider a bit (see page 23 for more on correcting highlights)—it works great in conjunction with the Exposure slider.

Step Three:

Of course, the Exposure slider doesn't just darken—it brightens, too, which is a good thing because this image is way too dark (underexposed). By the way, all the sliders here in the Basic panel start at zero and allow you to add more or less of a particular adjustment, depending on which way you drag. For example, if you were to drag the Saturation slider to the right, it makes the colors in your image more vivid; if you drag it to the left, it removes color (the farther you drag to the left, the more color it removes until you're left with a black-and-white image). Anyway, let's look at fixing this horribly underexposed image (I don't have a fancy reason why I underexposed it this time. I just messed up).

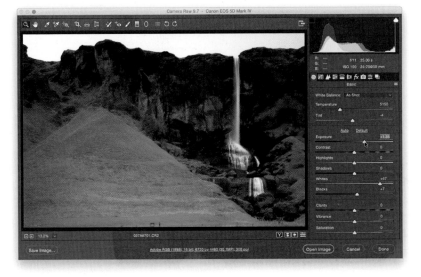

Step Four:

To make the image brighter, first set your white and blank points, and then simply drag the Exposure slider to the right until the overall brightness looks good to you. In this case, I had to drag it over to +1.35. Of course, there's a lot more to do to these images to get them looking the way we want them to (see page 26, where we'll go further with the first image), but because we've started by setting the overall brightness first, we're now at a really good starting point for tweaking things like contrast, highlights, and shadows (stuff you'll learn in the rest of this chapter).

Adding Contrast

If I had to point to the biggest problem I see in most people's images (we get hundreds sent to us each month for "Blind Photo Critiques" on our weekly photography talk show, *The Grid*), it's not white balance or exposure problems, it's that their images look flat (they lack contrast, big time). It's the single biggest problem, and yet it's about the easiest to fix (or it can be a bit complex, depending on how far you want to take this). I'll cover a simple method here and a more advanced method in the next chapter.

Step One:

Here's our flat, lifeless image. Before we actually apply any contrast (which makes the brightest parts of the image brighter and the darkest parts darker), here's why contrast is so important: when you add contrast, it (a) makes the colors more vibrant, (b) expands the tonal range, and (c) makes the image appear sharper and crisper. That's a lot for just one slider, but that's how powerful it is (in my opinion, perhaps the most underrated slider in Camera Raw).

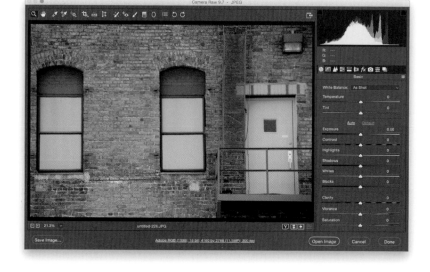

Step Two:

Here, all I did was drag the Contrast slider to the right (to +85), and look at the difference. It now has all the things I mentioned above: the colors are more vibrant, the tonal range is greater, and the whole image looks sharper and snappier. This is such an important tweak, especially if you shoot in RAW mode, which turns off any contrast settings in your camera (the ones that are applied when you shoot in JPEG mode), so RAW images look less contrasty right out of the camera. Adding that missing contrast back in is pretty important and, it's just one slider. By the way, I never drag it to the left to reduce contrast—I only drag it to the right to increase it.

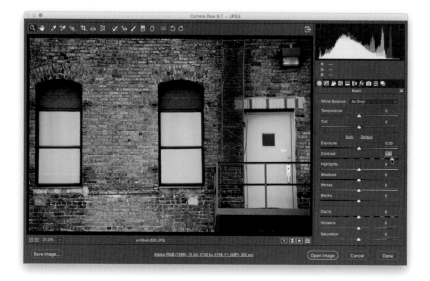

Dealing With Highlight Problems (Clipping)

One potential problem we have to keep an eye out for is highlight clipping. That's when some of the highlights in an image got so bright (either when you took the shot, or here in Camera Raw when you made it brighter) that there's actually no detail in those parts of the image at all. No pixels whatsoever. Just blank nothingness. This clipping happens in photos of nice cloudy skies, white jerseys on athletes, bright, cloudless skies, and a dozen other places. It happens, and it's our job to fix it so we keep detail throughout our image. Don't worry, the fix is easy.

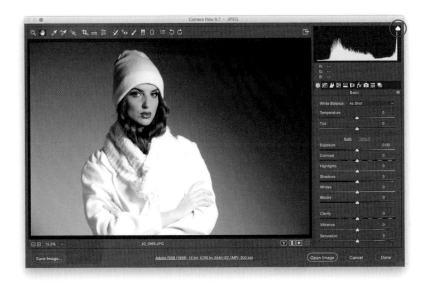

Step One:

Here's a studio shot, and not only is our subject wearing a white coat, but I overexposed the image a bit when I shot it. That doesn't necessarily mean we have clipping (see the intro above for what clipping means), but Camera Raw will actually warn us if we do. It tells us with a white triangle-shaped highlight clipping warning (shown circled here in red), which appears in the upper-right corner of the histogram. That triangle is normally black, which means everything's okay—no clipping. If it turns red, yellow, or blue, it means there's some clipping but only in a particular color channel, so I don't sound the alarm for that. But, if it's solid white (like you see here), we have a problem we need to fix.

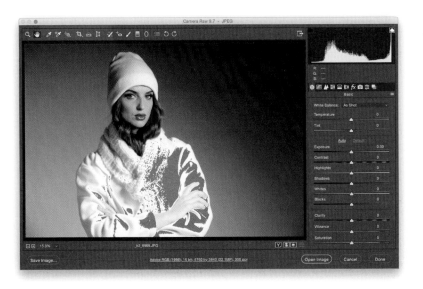

Step Two:

Okay, now we know we have a problem somewhere in our image, but exactly where? To find out exactly where the image is clipping, go up to that white triangle and click directly on it (or press the letter **O** on your keyboard). Now, any areas that are clipping in the highlights will appear in bright red (as seen here, where parts of her jacket are clipping badly). Those areas will have *no* detail whatsoever (no pixels, no nuthin') if we don't do something about it.

(Continued)

Step Three:

Sometimes just lowering the Exposure amount will do the trick and the clipping goes away and, in this case, the photo was overexposed a bit anyway, so let's start there. Here, I dragged the Exposure slider to the left (to –0.40) to darken the overall exposure and while that looks decent now, the clipping problem is still there big time. Now, because the photo was already a bit too bright, darkening the exposure actually helped the photo look better, but what if your exposure was okay? Then, dragging the Exposure slider to make the image darker would just make the image too dark (underexposed), so that's why we need something different—something that just affects the highlights and not the entire exposure. We want our clipping problem to go away; we generally don't want just a darker photo.

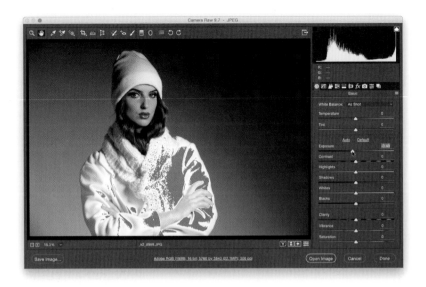

Step Four:

Let's put the Highlights slider to work. When you have a clipping problem like this, it's your first line of defense. Just drag it to the left a bit until you see the red onscreen clipping warning go away (as seen here, where I dragged to –30). The warning is still turned on, but dragging the Highlights slider to the left fixed the clipping problem and brought back the missing detail, so now there are no areas that are clipping. I use this Highlight slider *a lot* on shots with bright skies and puffy clouds.

TIP: This Rocks for Landscapes

Next time you have a blah sky in a landscape or travel shot, drag the Highlights slider all the way to the left. It usually does wonders with skies and clouds, bringing back lots of detail and definition. Really an incredibly handy little tip.

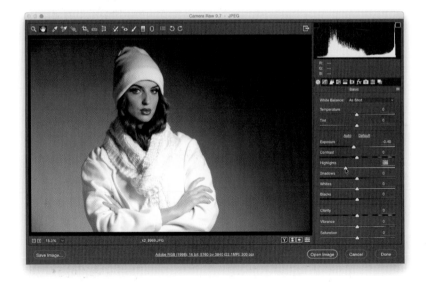

Opening Up the Shadows
(Like "Fill Light" on a Slider)

When you've got a subject that's backlit (so they look almost like a silhouette), or part of your image is so dark all the detail is getting lost in the shadows, help is just one slider away. The Shadows slider does an amazing job of opening up those dark shadow areas and putting some light on the subject (almost like you had a flash to add in a bit of fill light).

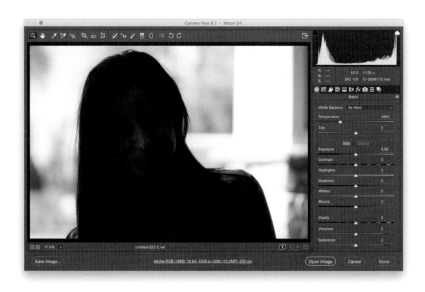

Step One:

In this image, you can see the subject is backlit. While our eyes do an amazing job of adjusting for scenes like this with such a wide range of tones, as soon as we press the shutter button and take the shot, we wind up with a backlit image where our subject is in the shadows (like you see here). As good as today's cameras are (and they are the most amazing they've ever been), they still can't compete with the incredible tonal range of what our eyes can see. So, don't feel bad if you create some backlit shots like this, especially since you're about to learn how easy it is to fix them. (*Note:* You can also fix this problem using Photoshop's Shadows/Highlights adjustment, but it's much easier to do it here in Camera Raw.)

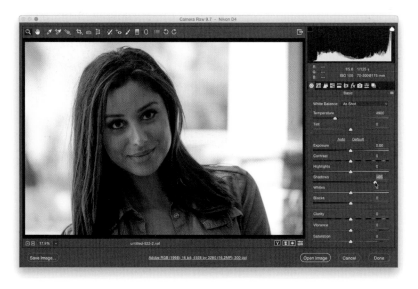

Step Two:

Just go to the Shadows slider, drag it to the right, and as you do, just the shadow areas of your photo are affected. As you can see here, the Shadows slider does an amazing job of opening up those shadows and bringing out detail in the image that was just hidden in the shadows. *Note:* Sometimes, if you really have to drag this slider way over to the right, the image can start to look a little flat. If that happens, just increase the Contrast amount (dragging to the right), until the contrast comes back into the photo. You won't have to do this very often, but at least when it happens you'll know to add that contrast right back in to balance things out.

Putting It All Together
(A Quick Start-to-Finish Tweak)

Okay, we're nearly done looking at the main sliders we use to edit our images here in Camera Raw's Basic panel. But, before we uncork the next chapter of adjustments, I thought it might be good for you to see how all these sliders we looked at in this chapter work together. So, go download this image and follow along (the download link is in the "Seven Things You'll Wish You Had Known…" part up front that you skipped). I think this will really help you see how all these adjustments work together.

Step One:

Remember this image from earlier in the chapter (from the Exposure technique)? We're going to do more than just fix the overall brightness now. Here's something that I do that might help you when you're sitting there in front of Camera Raw looking at an image that needs help: each step of the way, ask yourself, "What do I wish were different in this image?" Once you know what it is you want to do next, the controls are all right here in Camera Raw, so that's the easy part. The hard part is really sitting back and analyzing the image and asking yourself that question after every step. I can tell you what I wish was different here. I wish it wasn't so bright, so we'll start there.

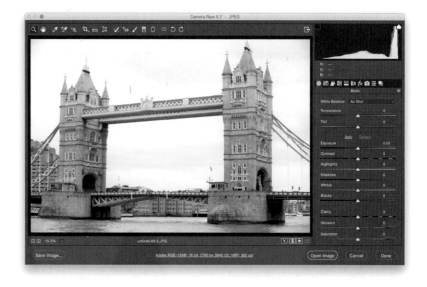

Step Two:

First, set the white and black points by Shift-double-clicking on the Whites slider knob and then the Blacks slider knob. To make the overall image darker, drag the Exposure slider to the left until it looks good. I didn't drag it quite as far as I did earlier (I dragged it to –0.90, here) because now I have more sliders I can use for particular areas. Next, the image looks kinda flat to me, so lets add more contrast by dragging the Contrast slider a little to the right (to +55). Then, I'm going to use that tip I mentioned in the Highlights technique back on page 23, and enhance the cloudy skies by dragging the Highlights slider to the left to –30. Now the sky doesn't look as light and bright and the clouds have more detail.

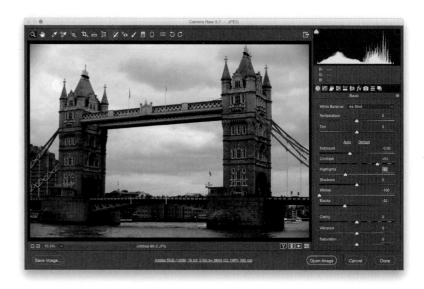

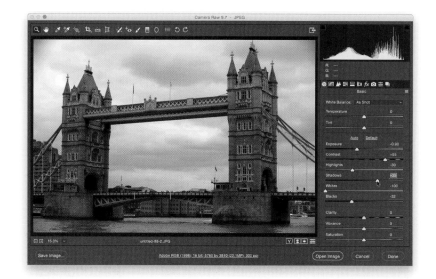

Step Three:

Looking at the image back in Step Two, there's a lot of detail in the bridge and in the buildings alongside the river, but it's kind of lost in the shadows. So, I'm going to bring out the detail in those areas by dragging the Shadows slider to the right (here, I dragged it to +35). I knew when I first looked at the image that I'd be opening up these shadows (I use the Shadows slider a lot), and that's why I didn't drag the Exposure slider as far to start with. Okay, so far, so good, but there are some finishing moves that could help this image be more colorful and enhance the detail and texture over-all. *Note:* I cover these "finishing moves" sliders more in the next chapter, as well.

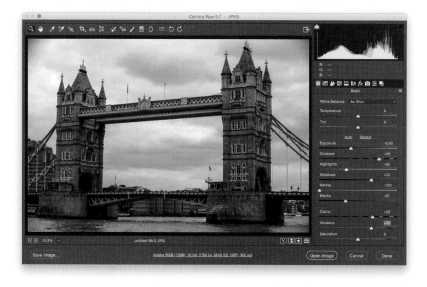

Step Four:

To bring out the texture in the bridge, buildings, and river, I increased the Clarity a bit (cityscapes like this love Clarity and, honestly, I could have pushed it a lot farther than +38. It probably could have easily gone to +50 and not looked bad. Maybe higher. Photos with lots of fine detail like this love Clarity and Sharpening). Lastly, the color in the image is very muted and, under that cloudy sky, I don't want to make the colors "pop," but I would like to make the colors in the image a bit more vibrant. So, I dragged the Vibrance slider to +35. That whole process will take you just a minute or so. The thinking part takes a lot more than the dragging sliders part. There are still some things I'd definitely add to finish this photo off and again, I'll cover them more in the next chapter. Hey, it's something to look forward to. :)

Photoshop Killer Tips

Skipping the Camera Raw Window Altogether

If you've already applied a set of tweaks to a RAW photo, you probably don't need the Camera Raw editing window opening every time you open the file. So, just press-and-hold the Shift key when you double-click on the RAW file in Bridge, and the image will open in Photoshop, with the last set of edits already applied, skipping the Camera Raw window altogether. If you didn't apply any tweaks in Camera Raw, it just opens with the Camera Raw defaults applied. Either way, it's a big time saver.

Handy Shortcuts for Blend Modes

Most people wind up using the same handful of layer blend modes—Multiply, Screen, Overlay, Hard Light, and Soft Light. If those sound like your favorites, you can save yourself some time by jumping directly to the one you want using a simple keyboard shortcut. For example, to jump directly to Screen mode, you'd press **Option-Shift-S (PC: Alt-Shift-S)**, for Multiply mode, you'd press **Option-Shift-M (PC: Alt-Shift-M)**, and so on. To run through the different shortcuts, just try different letters on your keyboard.

Seeing Image Size

The size of your photo (and other information) is displayed below the Preview area of Camera Raw (in white underlined text). When you drag out a cropping border, the size info for the photo automatically updates to display the dimensions of the currently selected crop area.

Don't Get Fooled by the Default Button

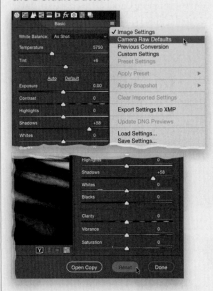

If you've edited your image in Camera Raw, and then you decide you want to start over, clicking the Default button in the Basic panel (it's to the left of the Auto button) won't return your image to how it looked when you opened it. Instead, to get back to the original way your image looked when you first opened it in Camera Raw, go to the Camera Raw flyout menu and choose **Camera Raw Defaults**. You can also press-and-hold the Option

(PC: Alt) key, and the Cancel button will change to a Reset button.

Deleting Multiple Images While Editing in Camera Raw

If you have more than one image open in Camera Raw, you can mark any of them you want to be deleted by selecting them (in the Filmstrip on the left side of Camera Raw), then pressing the Delete key on your keyboard. A red "X" will appear on those images. When you're done in Camera Raw, click on the Done button, and those images marked to be deleted will be moved to the Trash (PC: Recycle Bin) automatically. To remove the mark for deletion, just select them and press the Delete key again.

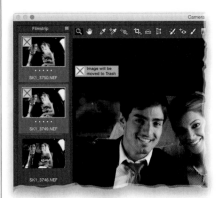

Cool Raw Retouching Trick

There's a pretty common retouching technique in Photoshop for reducing hot spots (shiny areas on a subject's face), which uses the Healing Brush to completely remove the hot spot, then under the Edit menu, you choose Fade Healing Brush, and lower the Opacity there. A little hint of the hot spot comes back, so it looks

Photoshop Killer Tips

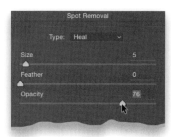

more like a highlight than a shine (it actually works really well). You can do something similar in Camera Raw when using the Spot Removal tool (set to Heal) by removing the hot spot (or freckle, or wrinkle) and then using the Opacity slider in the Spot Removal options panel.

Get a Larger Preview Area

If you have multiple images open in Camera Raw, and need more room to see the preview of the image you're currently working on, just double-click right on that little divider that separates the Filmstrip from the Preview area, and the Filmstrip tucks in over to the left, out of the way, giving you a larger preview. To bring it back, just double-click on that divider again (it's now over on the far-left side of the Camera Raw window) and it pops back out.

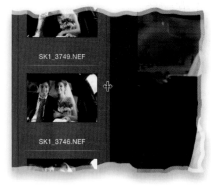

Rate Your Images in Camera Raw

You don't have to be in Bridge to add or change star ratings. If you've got multiple images open, you can do it right in Camera Raw. Just press **Command-1, -2, -3 (PC: Ctrl-1, -2, -3)**, and so on, to add star ratings (up to five stars). You can also just click directly on the five little dots that appear below the thumbnails in the Filmstrip on the left.

Rule-of-Thirds Cropping

This one Adobe borrowed from Camera Raw's sister program Photoshop Lightroom, because (like in Lightroom) you can have the "Rule-of-Thirds" grid appear over your cropping border anytime by just clicking-and-holding on the Crop tool in the toolbar, then choosing **Show Overlay**.

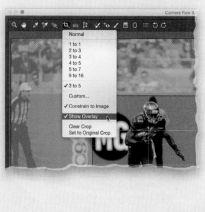

Jump to Full Screen Mode in Camera Raw

If you want to see your image in Camera Raw as large as possible, just press the **F key**, and Camera Raw expands to Full Screen mode, with the window filling your monitor, giving you a larger look at your image.

Shortcut for Viewing Sharpening

The best zoom magnification to view your sharpening in Camera Raw is a 100% view, and the quickest way to get there is to just double-click the Zoom tool.

Don't Know Where to Start When Editing an Image? Try Auto Levels or Curves

Adobe greatly improved the results of the Auto button found in the Levels

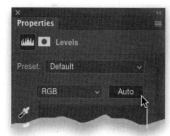

and Curves adjustment layer settings in the Properties panel, as well as in the Levels and Curves adjustment dialogs. It often actually makes a pretty decent starting point for editing your image, especially if you have a tricky image and you're not sure where to start.

Location: City of Arts and Sciences, Valencia, Spain | Exposure: 2 sec | Focal Length: 14mm | Aperture Value: *f*/7.1

Beyond the Reach
camera raw—beyond the basics

Just so you know, it has been a tradition of mine, going back about 80 books or so, to name each chapter after a movie title, song title, or TV show, and this one is named after a 2014 movie starring Michael Douglas (who plays a "high-rolling corporate shark") and Jeremey Irvine (who plays the other guy), and while I felt this wasn't a bad name for the chapter, I think it may be a pretty bad movie overall. This is based on a review I read from the *New York Daily News'* Joe Neumaier, who wrote: "The title of this turgid chase drama couldn't be more apt; almost everything escapes its aim." This led me to one solid conclusion: do not invite Joe Neumaier to review this, or any of my books, ever, so help me God. First, he used the term "turgid," which quite honestly, I had to Google because I thought it might be another word the Steve Miller Band made up, but it is actually a real word, and according to Google (which is the unequivical bottom line for stuff like this), it means "swollen and distended." Ouch! Joe really didn't like that movie. Now, Michael Douglas (world famous actor who has won not just one, but two Academy Awards), has numerous advantages over me, as someone who is not only not Michael Douglas, but only has only one Oscar, and that was for Best Performance by an Actor in a Supporting Role for my screen debut as Armani Yogamat, the Tunisan Roomba salesmen, in the critically acclaimed indie film *Eat. Spray. Lunch* (it didn't do the numbers the studio had hoped for, which is why its sequel, *Drink. Spay. Neuter,* went straight to DVD). I was asked to reprise my role as Armani Yogamat for the sequel, but I was already in dress rehearsals for the Broadway musical adaptation of *The Grand Budapest Marriott* and had to pass on the project. Anyway, if Joe can totally carpet bomb a classy high-end thriller from multi-Oscar winner Michael Douglas and that other guy, there's no way I would ever want him reviewing or reading any of my books, or even causally walking past a bookstore in the mall where my books are sold, rented, or shared with other food court employees/actors.

Editing Multiple Photos at Once

One of the biggest advantages of using Camera Raw is that it enables you to apply changes to one photo, and then easily apply those exact same changes to a bunch of other similar photos taken in the same approximate setting. It's a form of built-in automation, and it can save you an incredible amount of time when editing your shoots.

Step One:

The key to making this work is that the photos you edit are all shot in similar lighting conditions, or all have some similar problem. In Bridge, start by selecting the images you want to edit (click on one, press-and-hold the Command [PC: Ctrl] key, then click on all the others). If they're RAW images, just double-click on any one of them and they open in Camera Raw, but if they're JPEG or TIFF images, you'll need to select them, and then either press **Command-R (PC: Ctrl-R)** or click on the Open in Camera Raw icon at the top of the window.

Step Two:

When the images open in Camera Raw, you'll see a filmstrip along the left side of the window with all the images you selected. Now, there are two ways to do this and, while neither one is wrong, I think the second method is faster (which you'll see in a moment). We'll start with the first: Click on an image in the Filmstrip, then make any adjustments you want to make this one image look good (here, I tweaked the White Balance, Exposure, Contrast, Highlights, Whites, and Blacks).

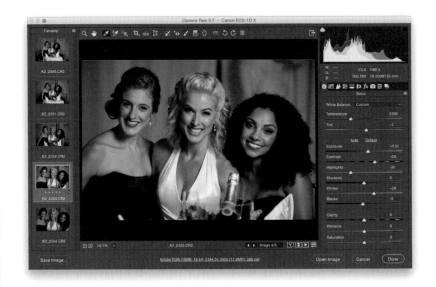

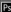

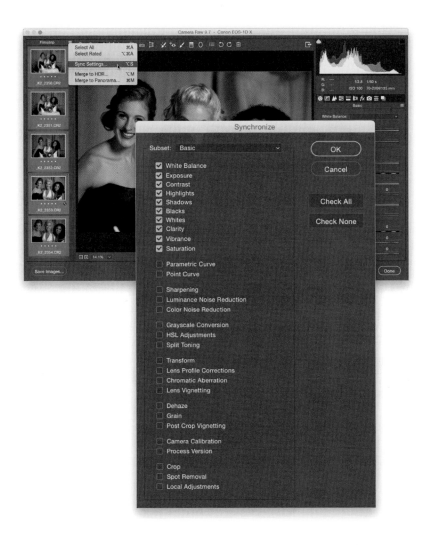

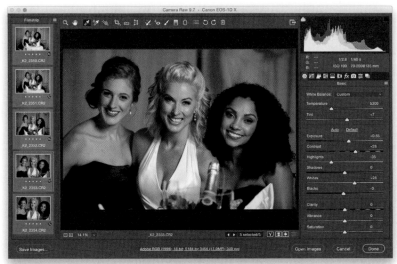

Step Three:
Once you've got one of the photos looking good, press **Command-A (PC: Ctrl-A)** or click on the icon to the right of Filmstrip, at the top left, and choose **Select All** to select all the photos (even though it selects the rest of the photos, you'll notice that the image you edited is actually the "most selected" image, with a highlight border around it). Now go back under that same menu and choose **Sync Settings** to bring up the Synchronize dialog (seen here). It shows you a list of all the things you could copy from this "most selected" photo and apply to the rest of the selected photos. Choose **Basic** from the Subset pop-up menu at the top, and it unchecks all the other stuff, and leaves just the Basic panel checkboxes turned on.

Step Four:
When you click the OK button, it applies the Basic panel settings from the "most selected" photo to all the rest of the selected photos (if you look in the Film-strip, you'll see that all the photos have had those settings adjusted). Okay, so why don't I like this method? Although it does work, it takes too many clicks, and decisions, and checkboxes, which is why I prefer the second method.

TIP: Editing Only Select Photos
If you only want certain photos to be affected, and not all the ones open in Camera Raw, then in the Filmstrip, Command-click (PC: Ctrl-click) on only the photos you want affected, and then choose Sync Settings.

(Continued)

Step Five:

In the second method, as soon as Camera Raw opens, choose Select All from the Filmstrip's flyout menu to select all your images, then go ahead and make your changes. As you make the changes to your "most selected" photo, all the others are updated with your new settings almost instantly, so you don't have to remember which settings you applied—when you move one slider, all the images get the same treatment, so you don't need the Synchronize dialog at all. Try out both methods and see which one you like, but if you feel the need for speed, you'll probably like the second one much better.

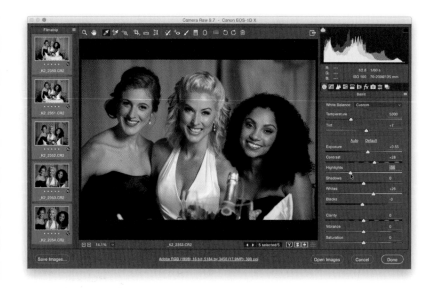

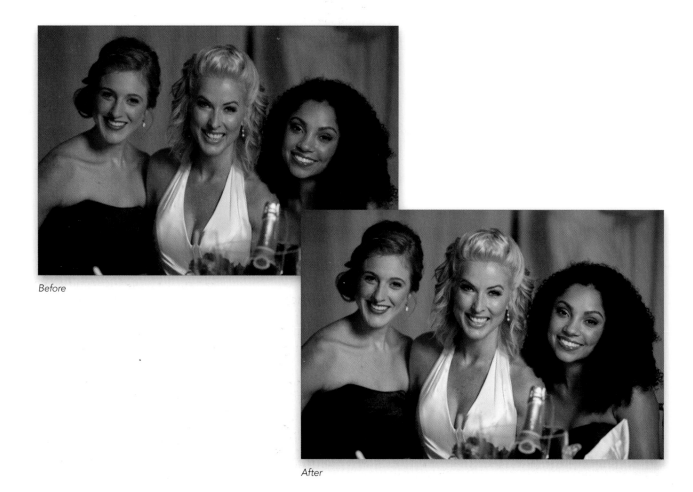

Before

After

Bring Out Detail and Texture Using Clarity

This is one of my favorite features in Camera Raw, and whenever I show it in a class, it never fails to get "Oooohs" and "Ahhhhs." I think it's because it's just one simple slider, yet it does so much to add "snap" to your image. The Clarity slider (which is well-named) basically increases the midtone contrast in a way that gives your photo more punch and impact, without actually sharpening the image. I add lots of Clarity anytime I want to enhance the texture in an image, and it works great on everything from landscapes to cityscapes, from travel photos to portraits of men—anything where emphasizing texture would look good.

Step One:

The Clarity slider is found in the bottom section of the Basic panel in Camera Raw, right above the Vibrance and Saturation sliders. (Although its official name is Clarity, I heard that at one point Adobe engineers considered naming it "Punch" instead, as they felt using it added punch to the image.) To clearly see the effects of Clarity, first zoom in to a 100% view by double-clicking on the Zoom tool up in the toolbar (it looks like a magnifying glass). In the example shown here, I only zoomed to 25% so you could see more of the image.

Step Two:

Using the Clarity control couldn't be easier—drag the slider to the right to increase the amount of punch (midtone contrast) in your image (compare the top and bottom images shown here). Here, I dragged it over to +100, which is something you really couldn't get away with in earlier versions of Camera Raw (you'd get horrible halos around everything), but now you can crank that puppy up and it looks awesome! Any image I edit where I want to emphasize the texture (landscapes, cityscapes, sports photos, etc.) gets between +25 and +50 Clarity, but now you can crank it up even higher in most cases (as seen here).

(Continued)

Step Three:

Of course, there are subjects where you don't want to emphasize texture (like women and children), and in those cases, I don't apply any positive Clarity. However, you can also use the Clarity control in reverse—to soften skin. This is called adding negative Clarity, meaning you can apply less than 0 (zero) to reduce the midtone contrast, which gives you a softening effect, but you don't want to apply it to the entire image, so you'd use the Adjustment Brush to apply it (more on the Adjustment Brush in Chapter 3). Here's an original image without any negative Clarity applied.

Step Four:

Here, I've taken the Adjustment Brush (again, lots on how to use this in Chapter 3), and I set the Clarity all the way to the left, to –100, for super-soft skin softening. To balance all that softness, I also increased the Sharpness amount to +25 (more on this soon, too), and then I painted over just her skin, being careful to avoid any areas that should stay nice and sharp, like her eyes, eyebrows, nostrils, lips, hair, and the edges of her face. Take a look at how much softer our subject's skin looks now. Now, if you need to soften up some skin really quickly, and you're not super-fussy about how it looks, negative Clarity can do the trick.

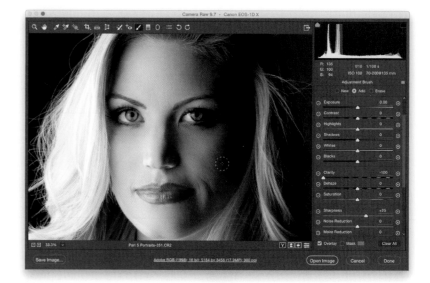

Adjusting Contrast Using Curves

The much-improved Contrast slider (which we looked at in the last chapter) in Camera Raw will still only take you so far, but luckily there's Curves, which is a powerful ally in your fight against flat-looking photos. While I've got you here, there's another feature from regular Photoshop that made its way into Camera Raw: the ability to edit individual R, G, and B channels with Curves. Okay, I don't use this feature, but somebody could really have some fun with it (for cross-processing effects, if nothing else).

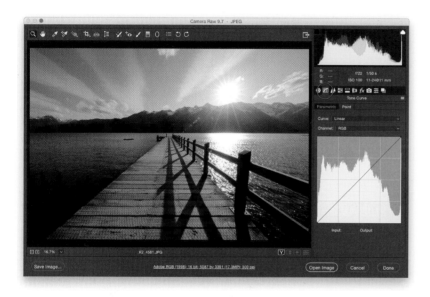

Step One:

After you've done all your exposure adjustments in the Basic panel, and you feel you need more contrast (hey, it's possible), it's time to head for the Tone Curve panel (click on the second icon from the left, near the top of the Panel area, shown circled here in red). There are two different types of curves available here: the Point curve and the Parametric curve. We'll start with the Point curve, so click on the Point tab at the top of the panel. Here's what this photo looks like with no added contrast in the Point curve (notice that the Curve pop-up menu above the curve is set to Linear, which is a flat, unadjusted curve). *Note:* In earlier versions of Camera Raw, RAW images had the default curve set to Medium Contrast (since your camera didn't add any contrast), but now, just like when you shoot in JPEG, no additional contrast will be added by default.

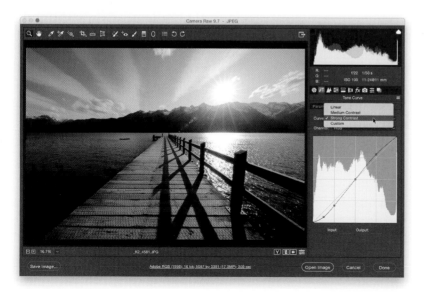

Step Two:

If you want more contrast, choose **Strong Contrast** from the Curve pop-up menu (as shown here), and you can see how much more contrast this photo now has, compared with Step One. The difference is the Strong Contrast settings create a steeper curve, and the steeper the curve, the more contrast it creates.

(Continued)

Step Three:

If you're familiar with Photoshop's Curves and want to create your own custom curve, start by choosing any one of the preset curves, then either click-and-drag the adjustment points on the curve or use the **Arrow keys** to move them (I think it's easier to click on a point, then use the Up and Down Arrow keys on your keyboard to move that part of the curve up or down). If you'd prefer to start from scratch, choose **Linear** from the Curve pop-up menu, which gives you a flat curve. To add adjustment points, just click along the curve. To remove a point, just click-and-drag it right off the curve (drag it off quickly, like you're pulling off a Band-Aid).

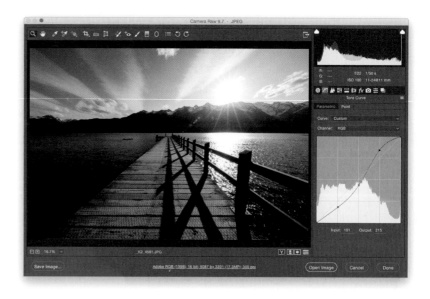

Step Four:

If you create a curve that you'd like to be able to apply again to other photos, you can save this curve as a preset. To do that, click on the Presets icon (the second icon from the right) near the top of the Panel area to bring up the Presets panel. Next, click on the New Preset icon (which looks just like Photo-shop's Create a New Layer icon) at the bottom of the panel. This brings up the New Preset dialog (shown here). If you just want to save this curve setting, from the Subset pop-up menu near the top, choose **Point Curve**, and it turns off the checkboxes for all the other settings available as presets, and leaves only the Point Curve checkbox turned on (as seen here). Give your preset a name (I named mine "Mega Contrast") and click OK.

Step Five:

If you're not comfortable with adjusting the Point curve, try the Parametric curve, which lets you craft your curve using sliders that adjust the curve for you. Click on the Parametric tab, and you'll see four sliders, which control the four different areas of the curve, but before you start "sliding," know that the adjustments you make here are added to anything you did in the Point tab (if you did anything there first—I reset the Point tab's Curve pop-up menu to Linear here).

Step Six:

The Highlights slider controls the highlights area of the curve (the top of the curve), and dragging it to the right arcs the curve upward, making the highlights brighter. Right below that is the Lights slider, which covers the next lower range of tones (the area between the midtones and the highlights). Dragging this slider to the right makes this part of the curve steeper, and increases the upper midtones. The Darks and Shadows sliders do pretty much the same thing for the lower midtones and deep shadow areas. But remember, dragging to the right opens up those areas, so to create contrast, you'd drag both of those to the left instead. Here, to create some really punchy contrast, I dragged both the Highlights and Lights sliders to the right, and the Darks and Shadows sliders to the left.

(Continued)

Step Seven:

Another advantage of the Parametric curve is that you can use the region divider controls (under the curve) to choose how wide a range each of the four sliders covers. So, if you move the far-right region divider to the right, it expands the area controlled by the Lights slider. Now the Highlights slider has less impact, flattening the upper part of the curve, so the contrast is decreased. If I drag that same region divider control back to the left instead (shown here), it expands the Highlights slider's area, which steepens the curve and increases contrast.

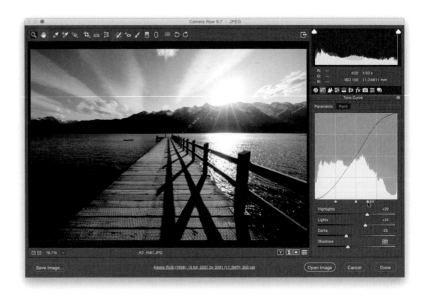

Step Eight:

If all of this makes you a bit squeamish, have I got a tool for you: it's called the Targeted Adjustment tool (or TAT for short) and you'll find it up in the toolbar at the top of the window (it's the fifth tool from the left, shown circled here). Just move the tool over the part of the image you want to adjust, then drag upward to lighten that area, or downward to darken it (this just moves the part of the curve that represents that part of the image). A lot of photographers love the TAT, so make sure you give it a try, because it makes getting that one area you want brighter (or darker) easier. Now, there is one caveat (I've been waiting to use that word for a while), and that is: it doesn't just adjust that one area of your photo—it adjusts the curve itself. So, depending on the image, other areas may get lighter/darker, too, so just keep an eye on that while you're adjusting. In the example shown here, I clicked-and-dragged downward to darken the dock, and the curve adjusted to make that happen automatically.

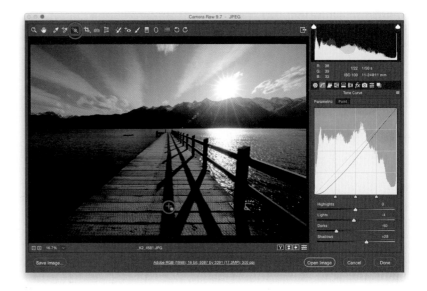

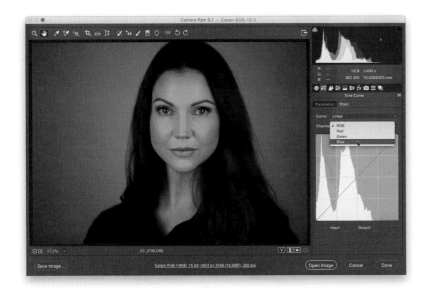

Step Nine:

Before we finish up with curves, there's another feature in Camera Raw we'll look at, and that's the ability to tweak the individual RGB curves in the Point curve. Although this works great for creating cross-processing effects (which we'll cover in a moment), you'll probably wind up using it most for fixing tough white balance problems (like a color cast that just won't go away). You choose which channel you want to adjust by going to the Point tab, and then choosing the individual channel from the Channel pop-up menu (as shown here, where I'm choosing Blue to help me remove a color cast from the background and her skin—the background is supposed to be solid gray, and her skin isn't supposed to be bluish).

Step 10:

So, now that you have just the Blue channel selected (notice that the Curve readout is now tinted blue, as well, as a visual cue to you that you're adjusting just this one channel), how do you know which part of the curve to adjust? You can get Camera Raw to tell you exactly which part to adjust. Move your cursor over the background area you want to affect, press-and-hold the **Command (PC: Ctrl) key**, and your cursor temporarily changes into the Eyedropper tool. Click once on your image and it adds a point to the curve that corresponds to the area you want to adjust. Now, click on that curve point and drag at a 45° angle down toward the bottom-right corner, and it removes the blue from the background (as seen here).

(Continued)

Step 11:

If you want to use these RGB curves to create a cross-processing effect (a classic darkroom technique from the film days, but still popular today, especially in fashion photography), it's actually fairly easy. There are dozens of different combinations, but here's one I like: Start by choosing **Red** in the Point tab's Channel pop-up menu, and create kind of a steep S-curve shape by clicking three times along the diagonal curve (once in the center, once at the next grid line above, and once below), so the points are evenly spaced along the line. Now, leave the center point where it is, drag the top point straight upward, and drag the bottom point straight down to create the curve you see here at the far left. Then, switch to the Green channel and make another three-point S-curve, but one that's not as steep (as seen here, in the center). Lastly, go to the Blue channel, don't add any points, and just drag the bottom-left point straight upward along the left edge (as seen here at the right) and drag the top-right point down along the right edge.

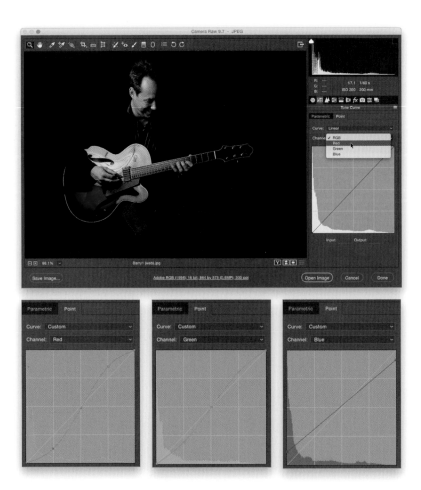

Step 12:

Of course, based on the particular image you use, you might have to tweak these settings a bit (usually, it's the amount you drag in the Blue channel, but again, it depends on the photo you're applying it to). If you come up with a setting you like, don't forget to save it as a preset in the Preset panel (just like you did with your Mega Contrast curve earlier).

Sharpening in Camera Raw

If you shoot in JPEG, your digital camera applies sharpening to your photo right in the camera itself, so no sharpening is automatically applied by Camera Raw. But if you shoot in RAW, you're telling your camera to ignore that sharpening, and that's why, when you bring a RAW image into Camera Raw, by default, it applies some sharpening, called "capture sharpening." In my workflow, I sharpen twice: once here in Camera Raw, and once more right before I output my final image from Photoshop (called "output sharpening"). Here's how to apply capture sharpening in Camera Raw:

Step One:
When you open a RAW image in Camera Raw, by default, it applies a small amount of sharpening to your photo (not the JPEGs or TIFFs, only RAW images). You can adjust this amount (or turn it off altogether, if you like) by clicking on the Detail icon (it's the third icon from the left) at the top of the Panel area, or using the keyboard shortcut **Command-Option-3 (PC: Ctrl-Alt-3)**. At the top of this panel is the Sharpening section, where by a quick glance you can see that sharpening has already been applied to your photo. If you don't want any sharpening applied at this stage (it's a personal preference), then simply click-and-drag the Amount slider all the way to the left to lower the amount of sharpening to 0 (zero), and the sharpening is removed.

Step Two:
If you want to turn off this automatic, by default sharpening (so capture sharpening is only applied if you go and manually add it yourself), first set the Sharpening Amount slider to 0 (zero), then go to the Camera Raw flyout menu and choose **Save New Camera Raw Defaults** (as shown here). Now, RAW images taken with that camera will not be automatically sharpened.

(Continued)

Step Three:

Before we charge into sharpening, there's one more thing you'll want to know: if you don't actually want sharpening applied, but you'd still like to see what the sharpened image would look like, you can sharpen just the preview, and not the actual file. Just press **Command-K (PC: Ctrl-K)** while Camera Raw is open, and in the Camera Raw Preferences dialog, choose **Preview Images Only** from the Apply Sharpening To pop-up menu (as shown here), and then click OK to save this as your default. Now the sharpening only affects the preview you see here in Camera Raw, but when you choose to open the file in Photoshop, the sharpening is not applied.

Step Four:

If you've been using Camera Raw for a while now, you probably remember back to older versions of Photoshop where you had to view your image at 100% to really see any effects of the sharpening. They pretty much fixed that back in CS5, so it's not as necessary to be at a 100% size view, but it still seems to me to render the most accurate view of the sharpening. The quickest way to jump to that 100% view is to double-click directly on the Zoom tool in the toolbar (shown circled here). (*Note:* You'll see a message about zooming to 100% at the bottom of the Detail panel, but it'll disappear after you zoom in to 100%.)

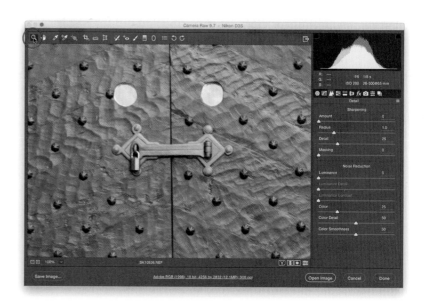

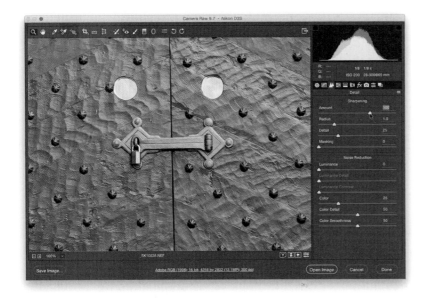

Step Five:

Dipping into the realm of the painfully obvious, dragging the Amount slider to the right increases the amount of sharpening. Compare the image shown here, with the one in Step Four (where the Sharpening Amount was set to 0), and you can see how much sharper the image now appears, where I dragged it to 100.

Step Six:

The next slider down is the Radius slider, which determines how far out the sharpening is applied from the edges being sharpened in your photo. This pretty much works like the Radius slider in Photoshop's Unsharp Mask filter, which is probably why the default is 1 (because that's probably where we'll leave it most of the time). I use less than a Radius of 1 if the photo I'm processing is only going to be used on a website, in video editing, or somewhere where it's going to be at a very small size or resolution. I only use a Radius of more than 1 when: (1) the image is visibly blurry, (2) it has lots of detail (like this photo, where I pushed the Radius to 1.2), so it can take some serious sharpening, or (3) the image needs some "emergency" sharpening. If you decide to increase the Radius amount above 1 (unlike the Unsharp Mask filter, you can only go as high as 3 here), just be careful, because if you go too much above 1, your photo can start to look fake, oversharpened, or even noisy, so be careful out there.

(Continued)

Step Seven:

The next slider down is the Detail slider, which determines how much of the edge areas are affected by sharpening. You'll apply lower amounts of Detail if your photo is slightly blurred, and higher amounts if you really want to bring out texture and detail (which is why this slider is aptly named). So, how much Detail you apply depends on the subject you're sharpening. With an image like this one, with lots of metal and texture, it's an ideal candidate for a high amount of Detail (as are most landscapes, city-scapes, motorcycle shots—stuff with lots of edges), so I dragged the slider to the right (all the way to 60), until the detail really came out.

Step Eight:

I'm going to change photos to show you the Masking slider. This one's easier to understand, and for many people, I think it will become invaluable. Here's why: When you apply sharpening, it gets applied to the entire image evenly. But what if you have an image where there are areas you'd like sharpened, but other softer areas that you'd like left alone (like the photo here, where you want to keep her skin soft, but have her eyes, lips, etc., sharpened)? If we weren't in Camera Raw, you could apply the Unsharp Mask filter to a duplicate layer, add a layer mask, and paint away (cover) those softer areas, right? Well, that's kind of what the Masking slider here in Camera Raw does—as you drag it to the right, it reduces the amount of sharpening on non-edge areas. The default Masking setting of 0 (zero) applies sharpening to the entire image. As you drag to the right, the non-edge areas are masked (protected) from being sharpened.

Step Nine:

All four sliders in the Sharpening section of the Detail panel let you have a live preview of what the sharpening is affecting—just press-and-hold the Option (PC: Alt) key as you drag; your screen will turn grayscale, and the areas that the slider you're dragging will affect appear as edge areas in the Preview area. This is particularly helpful in understanding the Masking slider, so press-and-hold the Option key and drag the Masking slider to the right. When Masking is set to 0, the screen turns solid white (because sharpening is being evenly applied to everything). As you drag to the right, in the preview (shown here), the parts that are no longer being sharpened turn black (those areas are masked). Any areas you see in white are the only parts of the photo receiving sharpening (perfect for sharpening women, because it avoids sharpening their skin, but sharpens the things you want sharp, like the eyes, hair, eyebrows, lips, edges of her face, and so on). Below is a before/after of our door shot, with these settings—Amount: 110, Radius: 1, Detail: 60, Masking: 0.

Before

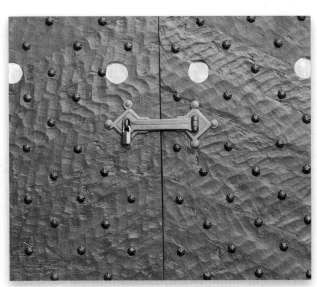

After

Adjusting or Changing Ranges of Color

In the next chapter, you're going to learn how to paint an adjustment over any part of your image, but sometimes you need to affect an entire area (like you need the entire sky bluer, or the sand warmer, or a piece of clothing to be an entirely different color). In those cases, where you're adjusting large areas, it's usually quicker to use the HSL adjustments, which not only let you change color, but also let you change the saturation and the lightness of the color. It's more powerful, and handier than you might think.

Step One:

Here's the original image of some washed-out buildings. What I'd like to do is tweak their color so they really stand out. You tweak individual colors, or ranges of color, in the HSL/Grayscale panel, so click on its icon at the top of the Panel area (it's the fourth one from the left—circled here in red). Now, click on the Saturation tab (as shown here) to bring up the Saturation sliders (which control the intensity of the colors).

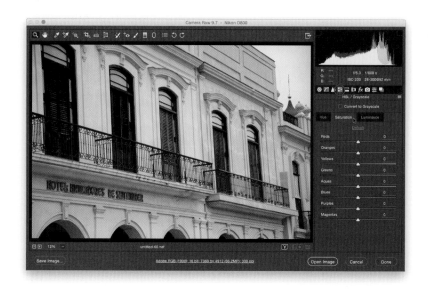

Step Two:

We'll start by bringing some richness and depth back into the yellow building. You can just drag the Yellows slider to the right, and it will get yellower (the color will get more intense), but most of the time, the color your eye sees (yellow, in this case) is made up of more than just that color. So, rather than guessing, and messing with the individual sliders I recommend grabbing the Targeted Adjustment tool (**T**; or TAT, for short) from the toolbar up top (it's the fifth tool from the left), then clicking it on the building, and dragging straight upward. As you do this, it knows which sliders control that area, and it moves them for you (in this case, it moved the Yellows slider quite a bit, but it also moved the Oranges slider a little, too). Since the other buildings also have these colors, it made their colors a bit more vivid, as well.

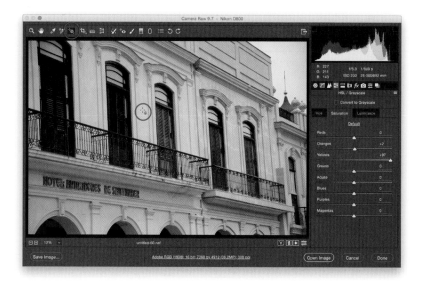

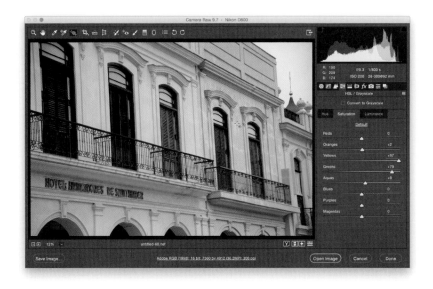

Step Three:

By the way, dragging upward with the TAT increases the saturation amounts, and dragging downward decreases them. Just so you know. Okay, now that the yellows and oranges are looking better, let's work on the greens. So, take the TAT, click it on the green building, and drag straight upward to increase the color saturation (intensity) of those greens. Go look at the sliders, and you'll see it moved the Greens and Aquas sliders (so that color was mostly made up of greens, although it made a slight adjustment to the aquas, too), but beyond that, the TAT knows the right percentage of each, which is why using it gives you such an advantage (in fact, I don't use these HSL sliders without using the TAT).

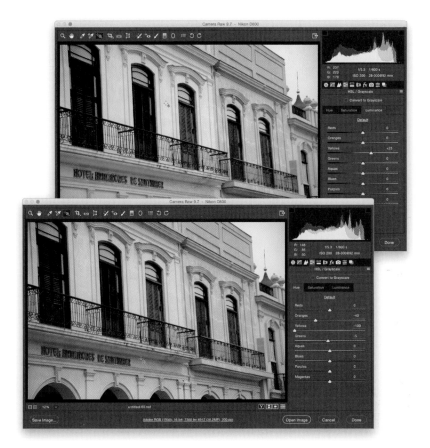

Step Four:

If you think the colors look too dark, then all you have to do is click on the Luminance tab (it controls how bright the colors appear), click on a dark area of yellow, and drag upward (as shown here on top, where I clicked-and-dragged on the yellow building), and now the colors are a little brighter (compare it with what you see in Step Three). If your colors were too bright, you'd drag downward. So, that's how it works for tweaking Saturation and Luminance. However, if you want to actually change a color (and not just tweak the existing color), then click on the Hue tab. The controls are the same: click your TAT on the yellow building and drag downward to change the color (as I did here on the bottom, where it's now orange, and the building on the right is a pale orange). Again, you could always drag the sliders around, and eventually you'd find out which slider controls which part of the image, but I think you can see why Adobe invented the TAT—to make our lives in this panel easier.

Removing Spots, Blemishes, and Other Distracting Stuff

If you have spots on your images, or simple blemishes on your subject's face, you can fix a lot of that type of stuff right here in Camera Raw using the Spot Removal tool. While this does borrow some "healing" power from Photoshop's Healing Brush, and you can even paint strokes with it, it's not nearly as precise as the Healing Brush (which is just nothing short of magic). So, use this tool for quick spots, dust, and blemishes and leave all the detailed heavy lifting for the real Healing Brush in Photoshop. You'll thank me later.

Step One:

Here's the image we want to retouch. Our subject has a dark circle on the left, under his eye, that we want to remove (something we definitely would not have been able to do easily in previous versions of Camera Raw), as well as some small blemishes. Get the Spot Removal tool **(B)** from the toolbar up top (shown circled here in red). By the way, I think they totally should rename this tool now that it works more like the Healing Brush, and it does more than just remove spots.

Step Two:

Double-click on the Zoom tool in the toolbar to jump to a 100% view, so we can see an up-close view of the area where we want to remove the dark circle. Now, take the Spot Removal tool and just paint a stroke over the dark circle you want to remove and, as you do, you'll see an outline showing the area you're healing as you paint.

TIP: More Realistic Retouching

If you need to remove a guy's wrinkles, and you remove them completely, it will probably look a bit unrealistic, but you can adjust the Opacity slider (in the panel on the right) to bring back a tiny bit of the original wrinkle. So, you're actually reducing the wrinkles, rather than totally removing them.

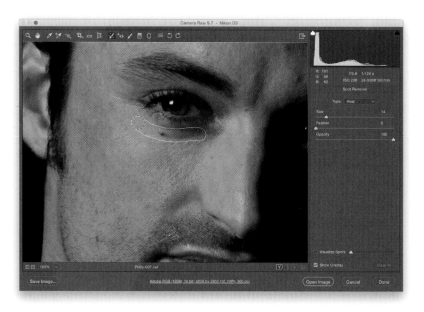

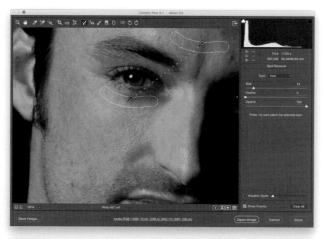

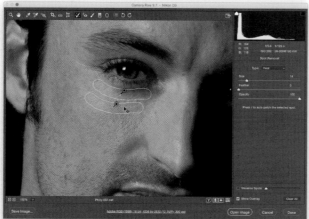

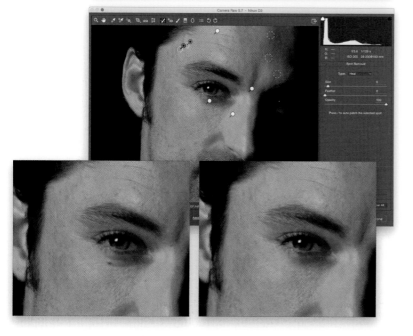

Step Three:

When you finish your stroke, you'll see two edit pins: (1) the area with the red pin is the area you're healing, and (2) the area with the green pin is the area that the Spot Removal tool chose to sample the texture it's going to use to make your retouch. Usually this sample area is pretty close to the area you're trying to fix, but sometimes it does what it did here—it chooses an area far enough away that it doesn't actually create a perfect match (in this case, the direction and type of skin found on the forehead are a lot different than the skin texture and direction under his eye). That's okay, we can easily make the Spot Removal tool choose a different area to sample from.

Step Four:

Take your cursor, click inside the green sample area, and just drag it somewhere else on your subject's face that's a better match (here, I dragged it below and to the left of the area we painted over). Once you drag it over a new area, let go of the mouse button for just a moment and it draws a preview of how this sample area looks (that way, you can see if moving it actually helped or not). If it doesn't look good, just drag the green sample area somewhere else and let go of the mouse button again for a quick preview of how it looks now.

Step Five:

Once the eye looks better, go around the face and click on the blemishes to remove them. When you release the mouse button, a second circle appears to show you the area the tool chose to sample from. If you need to move it, just click-and-drag it. That's pretty much all there is to it.

Finding Spots and Specks the Easy Way

There is nothing worse than printing a nice big image, and then seeing all sorts of sensor dust, spots, and specks in your image. If you shoot landscapes or travel shots, it is so hard to see these spots in a blue or grayish sky, and if you shoot in a studio on seamless paper, it's just as bad (maybe worse). I guess I should say: it used to be bad. Now, it's absolutely a breeze, thanks to a feature in Camera Raw that makes every little spot and speck really stand out so you can remove them fast!

Step One:

In this image, you can see some spots and specks in the sky. I can see five or six pretty clearly, but it's the spots that you can't see clearly at this size that "Getcha!"

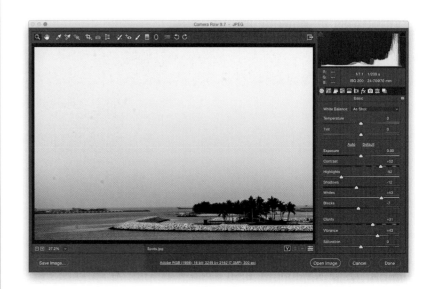

Step Two:

Click on the Spot Removal tool up in the toolbar (**B**; it's shown here circled in red), and at the bottom of its panel, there's a checkbox for Visualize Spots. Turn that checkbox on and it gives you an inverted view of your image. Now, slowly drag the Visualize Spots slider to the right and, as you do, the spots will start to clearly appear (I didn't drag too far with this image, but you can sure see the spots there). Next, just take the Spot Removal tool and, right on the image (with the Visualize Spots option still on), click once right over each spot to remove them until they're all gone.

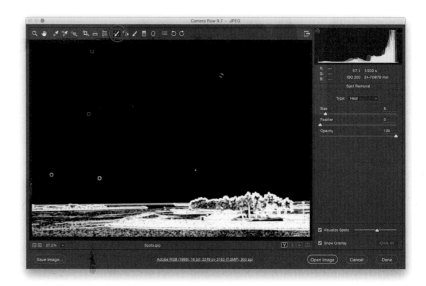

Removing Haze or Fog

Anyone who shoots underwater photography, or takes a shot at an aquarium, or just shoots on foggy or hazy days will so love this. It cuts through haze amazingly well (and it doesn't just add the same ol' contrast, it has its own brand of contrast that works particularly well for this type of stuff).

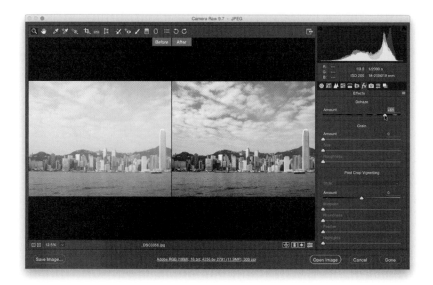

Step One:

There are a couple ways to remove haze from your photos, and one way is to remove it from the entire photo. So, open a foggy or hazy image in Camera Raw, then click on the Effects icon (it's the fourth one from the right) at the top of the Panel area. At the top of the panel options, under Dehaze, just drag the Amount slider to the right until the haze goes away, as shown here (I know, this is pretty amazing technology).

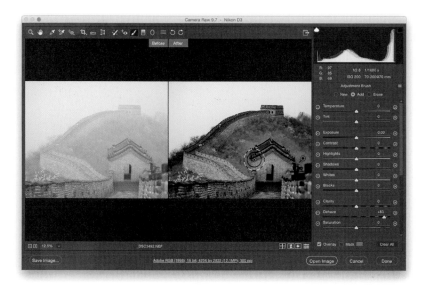

Step Two:

Another way is to selectively choose where you want to remove it using the Adjustment Brush (we'll look at the Adjustment Brush more in Chapter 3). Open your hazy image in Camera Raw, then get the Adjustment Brush **(K)** from the toolbar. In the options panel, click on the + (plus sign) button to the right of Dehaze, which resets all the sliders to zero and sets the Dehaze amount to +25. Now, just paint over areas that are hazy or foggy in the image (as shown here). Once you're done paining, if needed, increase the Dehaze amount by dragging it to the right (as I did here).

Reducing Noise

Photoshop CC has arguably the best noise reduction feature out there, primarily because it applies the noise reduction to the 16-bit RAW photo, whereas almost every third party plug-in you might be using applies it after it's converted to an 8-bit photo, and the results are pretty darn great. So much so, that I no longer use any third party plug-ins for noise reduction. Yes, it's that good, and it's simple to use.

Step One:

Open your noisy image in Camera Raw (the Noise Reduction feature works best on RAW images, but you can use it on JPEGs and TIFFs, as well). The image shown here was shot at a high ISO using a Canon 5D Mark III, which didn't do a very good job in this low-light situation, so you can see a lot of color noise (those red, green, and blue spots) and luminance noise (the grainy looking gray spots).

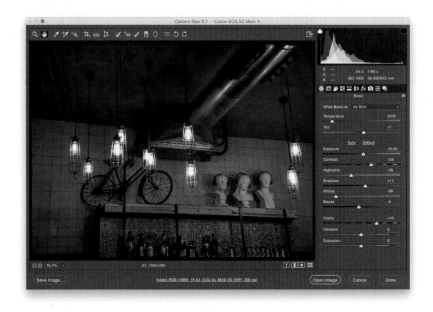

Step Two:

Sometimes it's hard to see the noise until you really zoom in tight, so zoom in to at least 100%, and there it is, lurking in the shadows (that's where noise hangs out the most). Click on the Detail icon (it's the third icon from the left at the top of the Panel area) to access the Noise Reduction controls. I usually get rid of the color noise first, because that makes it easier to see the luminance noise (which comes next). Here's a good rule of thumb to go by when removing color noise: start with the Color slider over at 0 (as shown here) and then slowly drag it to the right until the moment the color noise is gone. *Note:* A bit of color noise reduction is automatically applied to RAW images—the Color slider is set to 25. But, for JPEGs or TIFFs, the Color slider is set to 0.

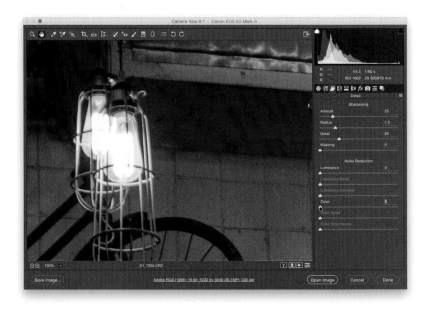

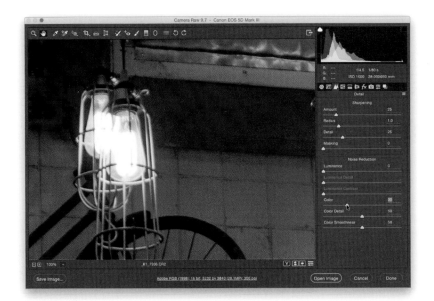

Step Three:

So, click-and-drag the Color slider to the right, but remember, you'll still see some noise (that's the luminance noise, which we'll deal with next), so what you're looking for here is just for the red, green, and blue color spots to go away. Chances are that you won't have to drag very far at all—just until that color noise all turns gray. If you have to push the Color slider pretty far to the right, you might start to lose some detail, and in that case, you can drag the Color Detail slider to the right a bit, though honestly, I rarely have to do this for color noise.

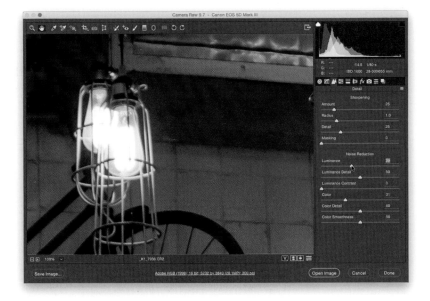

Step Four:

Now that the color noise is gone, all that's left is the luminance noise, and you'll want to use a similar process: just drag the Luminance slider to the right, and keep dragging until the visible noise disappears (as seen here). You'll generally have to drag this one farther to the right than you did with the Color slider, but that's normal. There are two things that tend to happen when you have to push this slider really far to the right: you lose sharpness (detail) and contrast. Just increase the Luminance Detail slider if things start to get too soft (but I tend not to drag this one too far and will generally bump up the Sharpening Amount at the top of the panel to bring back original detail), and if things start looking flat, add the missing contrast back in using the Luminance Contrast slider (I don't mind cranking this one up a bit, except when I'm working on a portrait, because the flesh tones start to look icky). You probably won't have to touch either one all that often, but it's nice to know they're there if you need them.

(Continued)

Step Five:

The last slider, the Color Smoothness slider, works with the Color Detail slider, and you use it to make sure the colors don't shift. Dragging it to the right ensures your colors stay intact (but, don't go too high or the colors can end up desaturating), and dragging it to the left ensures the colors blend more. So, if you know the colors need to be right on (like for a web catalog), drag to the right, but if the color's looking a little chunky, drag it to the left. Here's the final image, zoomed back out, and you can see the noise has been pretty much eliminated, but even with the default settings (if you're fixing a RAW image), you're usually able to keep a lot of the original sharpness and detail. A zoomed-in before/after of the noise reduction we applied here is shown below.

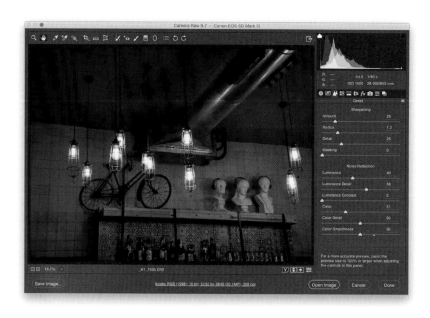

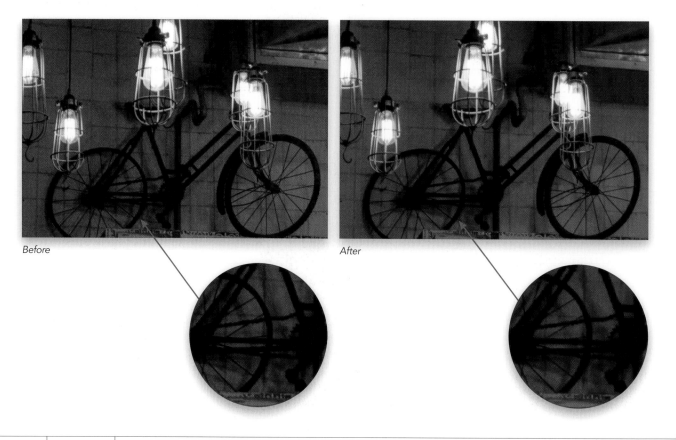

Before

After

Cropping and Straightening

There's a distinct advantage to cropping your photo here in Camera Raw, rather than in Photoshop itself, and that is you can return to Camera Raw later and bring back the uncropped version of the image. This even holds true for JPEG and TIFF photos, as long as you haven't overwritten the original JPEG or TIFF file. To avoid overwriting, when you save the JPEG or TIFF in Photoshop, just change the filename (that way the original stays intact). With RAW images, you don't have to worry about that, because it doesn't let you overwrite the original.

Step One:

The Crop tool **(C)** is the sixth tool from the left in the toolbar. By default, you click-and-drag it out around the area you want to keep, and like in Photoshop, you have access to a list of preset cropping ratios. To get them, click-and-hold on the Crop tool and a pop-up menu will appear (as shown here). The Normal setting gives you the standard drag-it-where-you-want-it cropping. However, if you choose one of the cropping presets, then your cropping is constrained to a specific ratio. For example, choose the 2 to 3 ratio, click-and-drag it out, and you'll see that it keeps the same aspect ratio as your original uncropped photo.

Step Two:

Here's the 2-to-3-ratio cropping border dragged out over my image. The area to be cropped away appears dimmed, and the clear area inside the border is how your final cropped photo will appear. If you want to see the cropped version before you leave Camera Raw, just switch to another tool in the toolbar. (Note: If you draw a set size cropping border and want to switch orientation, click on the bottom-right corner and drag down and to the left to switch from wide to tall, or up and to the right to switch from tall to wide.)

(Continued)

Step Three:

If you re-open your cropped photo again in Camera Raw, you'll see the cropped version. To bring back the cropping border, just click on the Crop tool. To remove the cropping altogether, press the **Esc** or **Delete (PC: Backspace) key** on your keyboard (or choose **Clear Crop** from the Crop tool's pop-up menu). If you want an aspect ratio that isn't in the presets (like 3 to 5, for example), choose **Custom** from the Crop tool's pop-up menu to bring up the dialog you see here. Just enter your aspect ratio, click OK, and it will now appear in the pop-up menu.

Step Four:

Here, we're going to create a custom crop so our photo winds up having a 3-to-5 aspect ratio, so type in your custom size, click OK, click-and-drag out the cropping border, and the area inside it will be a 3-to-5 ratio. Click on any other tool in the toolbar or press **Return (PC: Enter)**, and you'll see the final cropped image. If you click the Open Image button, the image is cropped to your specs and opened in Photoshop. If, instead, you click the Done button, Camera Raw closes and your photo is untouched, but it keeps your cropping border in place for the future.

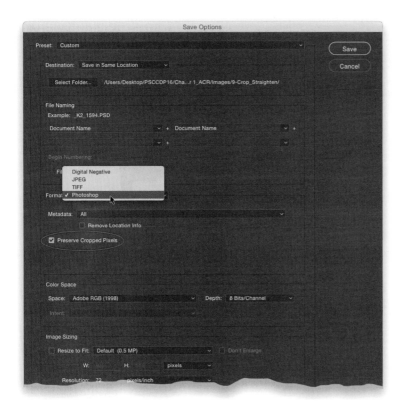

Step Five:

If you save a cropped JPEG or TIFF photo out of Camera Raw (by clicking the Done button), the only way to bring back those cropped areas is to reopen the photo in Camera Raw. However, if you click the Save Image button and you choose **Photoshop** from the Format pop-up menu (as shown), a new option will appear called Preserve Cropped Pixels. If you turn on that checkbox before you click Save, when you open this cropped photo in Photoshop, it will appear to be cropped, but the photo will be on a separate layer (not flattened on the Background layer). So the cropped area is still there—it just extends off the visible image area. You can bring that cropped area back by clicking-and-dragging your photo within the image area (try it—use the Move tool **[V]** to click-and-drag your photo to the right or left and you'll see what I mean).

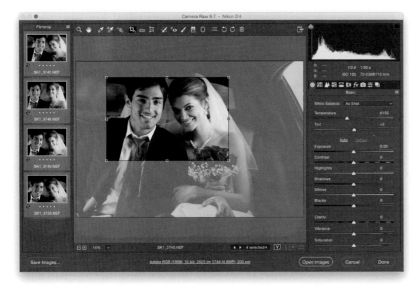

Step Six:

If you have a number of similar photos you need to crop the same way, you're going to love this: First, select all the photos you want to crop in Camera Raw (either in Bridge or on your computer), then open them all in Camera Raw. When you open multiple photos, they appear in a vertical filmstrip along the left side of Camera Raw (as shown here). Click on the icon to the right of Filmstrip and choose **Select All** from the pop-up menu, and then crop the currently selected photo as you'd like. As you apply your cropping, look at the Filmstrip and you'll see all the thumbnails update with their new cropping instructions. A tiny Crop icon will also appear in the bottom-left corner of each thumbnail, letting you know that these photos have been cropped in Camera Raw.

(Continued)

Step Seven:

Another form of cropping is actually straightening your photos using the Straighten tool. It's a close cousin of the Crop tool because what it does is essentially rotates your cropping border, so when you open the photo, it's straight. In the Camera Raw toolbar, choose the Straighten tool (it's immediately to the right of the Crop tool and shown circled here in red). Now, click-and-drag it along the horizon line in your photo (as shown here. You can also double-click on the tool itself, or double-click on the image). When you release the mouse button, a cropping border appears and that border is automatically rotated to the exact amount needed to straighten the photo (as shown in Step Eight).

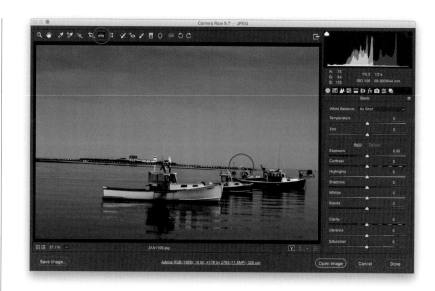

Step Eight:

You won't actually see the straightened photo until you switch tools, press **Return (PC: Enter)**, or open the photo in Photoshop (which means, if you click Save Image or Done, Camera Raw closes, and the straightening information is saved along with the file. So if you open this file again in Camera Raw, you'll see the straightened version, and you won't really know it was ever crooked). If you click Open Image instead, the straightened photo opens in Photoshop. Again, if this is a RAW photo (or if it's a JPEG or TIFF and you clicked the Done button), you can always return to Camera Raw and remove this cropping border to get the original uncropped photo back.

TIP: Canceling Your Straightening

If you want to cancel your straightening, just press the Esc key on your keyboard, and the straightening border will go away.

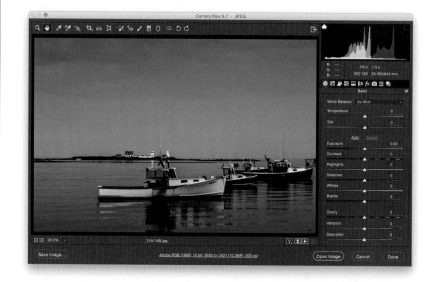

The Advantages of Adobe's DNG Format for RAW Photos

Adobe created DNG (an open archival format for RAW photos) because, at this point in time, each camera manufacturer has its own proprietary RAW file format. If, one day, one or more manufacturers abandon their proprietary format for something new (like Kodak did with their Photo CD format), will we still be able to open our RAW photos? With DNG, it's not proprietary—Adobe made it an open archival format, ensuring that your negatives can be opened in the future, but besides that, DNG brings another couple of advantages, as well.

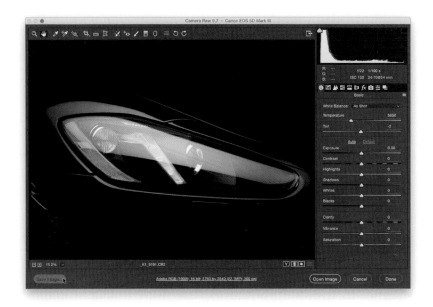

Step One:

There are three advantages to converting your RAW files to Adobe DNG: (1) DNG files are generally about 20% smaller. (2) DNG files don't need an XMP sidecar file to store Camera Raw edits, metadata, and keywords—the info's embedded into the DNG file, so you only have one file to keep track of. And, (3) DNG is an open format, so you'll be able to open them in the future (as I mentioned in the intro above). If you have a RAW image open in Camera Raw, you can save it as an Adobe DNG by clicking the Save Image button (as shown here) to bring up the Save Options dialog (seen in the next step). *Note:* There's really no advantage to saving TIFF or JPEG files as DNGs, so I only convert RAW photos.

Step Two:

When the Save Options dialog appears, in the middle of the dialog, from the Format pop-up menu, choose **Digital Negative** (shown here). Once you choose Digital Negative, a new set of options appears at the bottom of the dialog (seen in Step Three).

(Continued)

Step Three:

The Embed Fast Load Data checkbox uses a smaller embedded RAW preview that makes switching between images faster (I turn this feature on). Below that is a somewhat controversial option, but if used in the right way, I think it's okay. It uses a JPEG-like lossy compression (meaning there is a loss in quality), but the trade-off (just like in JPEG) is that your file sizes are dramatically smaller (about 25% of the size of a full, uncompressed RAW file). So, if there's a loss of quality, why would you use this? Well, I wouldn't use it for my best images from a shoot—ones I might print, or a client might see—but what about the hundreds the client rejected or you don't like? Those might (it's your call) be candidates to be compressed to save drive space. It's something to consider. If you do want to do it, turn on that checkbox, then choose (from its pop-up menu) which option is most important to you: saving the same physical dimensions (pixel size) or file size (megapixels). Once you've made your choices, click Save, and you've got a DNG.

TIP: Setting Your DNG Preferences

With Camera Raw open, press **Command-K (PC: Ctrl-K)** to bring up Camera Raw's Preferences dialog. There are two preferences in the DNG File Handling section: Choose Ignore Sidecar ".xmp" Files only if you use a different RAW processing application (other than Camera Raw or Lightroom), and you want Camera Raw to ignore any XMP files created by that application. If you turn on the Update Embedded JPEG Previews checkbox (and choose your preferred preview size from the pop-up menu), then any changes you make to the DNG will be applied to the preview, as well.

Choosing How Your RAW Images Will Appear in Photoshop

After you're done editing your image in Camera Raw, your next stop is probably Photoshop, right? Well, you get to choose "how" your image comes over, and by that I mean you get to choose the size (physical dimensions), the color space, bit depth (8 or 16 bits/channel), and stuff like that. But, if you've been searching for a preferences button for these, you'll be searching a while, 'cause Adobe did their best to hide them. Here's how to find them, and set them your way:

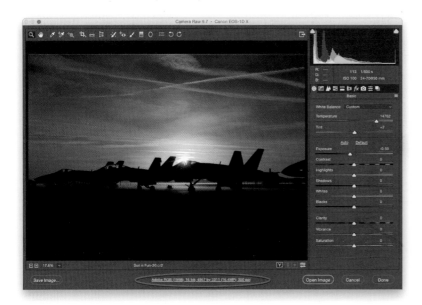

Step One:

If you look directly below your image, you'll see a line of underlined white text (it's circled in red here). The text itself looks like EXIF camera data. There's nothing really here to let you know that this is actually where you click to bring up the dialog for choosing your preferences for how your photo is going to look when it opens in Photoshop. If that wasn't stealthy enough for ya, Adobe didn't name these "Preferences." They call them "Workflow Options" just to throw you off the scent. Anyway, now that you know that's what's really under there, go ahead and click that button/link/thingy.

Step Two:

This brings up the Workflow Options dialog (seen here). Near the top, you get to choose which color space you want your image to open with from the Space pop-up menu (seen here). You generally want to choose the color space that matches what you've chosen in Photoshop for your color space. So, if you have your Photoshop color space set to Adobe RGB (1998) or sRGB, then you'd want to choose the same color space here (or you'll have a profile mismatch). For most folks, this is an easy choice—just have it match what your Photoshop color space is set to.

(Continued)

Step Three:

To the right of the Space pop-up menu, you can choose what bit depth you want your photo to open as (either 8 or 16 bits/channel). The choice is yours (just so you know, most of the time I work in 8-bit mode, unless I see some banding in the sky or some other problem, in which case I'll go back to Camera Raw and reopen it as 16-bit, but that happens pretty rarely). Right under that, you have the option of messing with the Image Sizing. I say this is an option because if you leave that Resize to Fit checkbox turned off, it doesn't re-size your image—it just opens the image in its native (original) size. However, if you need to make it smaller, or fit a particular width, height, pixel dimension, and so on, you can choose one of those options from the pop-up menu and then type in the size and/or resolution you want.

Step Four:

Below that is your Output Sharpening, which is sharpening that is applied before your image is opened in Photoshop. Personally, I don't turn this feature on at this stage of the game. I sharpen manually later on using the Unsharp Mask filter. However, if you do want to add some sharpening right from the get-go, turn on the checkbox, then choose the final destination for this image (whether it will be seen just on a screen, like on a webpage, or whether instead it will be printed on glossy or matte paper). Then, you get to choose the level of sharpening from the Amount pop-up menu. By the way, in my experience the Low setting should be named "None"; the Standard (medium) setting should be "Low"; and the High setting should be named "Medium, but just barely." At the bottom of the dialog is a checkbox to have your image appear in Photoshop as an editable smart object (meaning, you can double-click on its thumbnail and it will reopen the original RAW file right back here in Camera Raw for re-editing).

Step Five:

If you find yourself switching between a couple of different settings (for example, let's say you print some of your images, and you use Adobe RGB [1998] at 16 bits/channel at the image's native size with sharpening set to High, but then the rest you post to your online portfolio, so for those you use sRGB at 8 bits/channel at 1200 pixels on the long edge with Standard sharpening), luckily you don't have to type all that in each time you switch. You can have all those settings just one click away by creating a Workflow preset. Start by entering all the settings you want, then go under the Preset pop-up menu at the top of the dialog and choose **New Workflow Preset**, as shown here. A little naming dialog will appear (shown here at the bottom) where you can type in a name, then click OK.

Step Six:

Now, your newly created Workflow preset will appear in the Presets menu, and when you choose it, it enters all those settings for you. You can create as many presets as you'd like, so any recurring settings are just one click away. When you're done, click OK and now those settings are your new default settings, so when you click Open Image in the Camera Raw window, all your photos processed in Camera Raw will open in Photoshop using those settings (and they'll stay like that until you change 'em).

Calibrating for Your Particular Camera

Some cameras seem to have their own "color signature," and by that I mean that every photo seems to be a little too red, or every photo is a little too green, etc. You just know, when you open a photo from that camera, that you're going to have to deal with the slight color cast it adds. Well, if that's the case, you can compensate for that in Camera Raw, and then set that color adjustment as the default for that particular camera. That way, any time you open a photo from that camera, it will automatically compensate for that color.

Step One:

To calibrate Camera Raw so it fixes a persistent color cast added by your camera, open a typical photo taken with that camera in Camera Raw, and then click on the Camera Calibration icon (it looks like a camera and is the third icon from the right at the top of the Panel area). So, let's say that the shadow areas in every photo from your camera appear slightly too red. In the Camera Calibration panel, drag the Red Primary Saturation slider to the left, lowering the amount of red in the entire photo. If the red simply isn't the right shade of red (maybe it's too hot and you just want to tone it down a bit), drag the Red Primary Hue slider until the red color looks better to you (dragging to the right makes the reds more orange).

Step Two:

To have Camera Raw automatically apply this calibration each time a photo from that particular camera is opened in Camera Raw, go to Camera Raw's fly-out menu (in the top right of the panel), and choose **Save New Camera Raw Defaults** (as shown here). Now, when you open a photo from that camera (Camera Raw reads the EXIF data so it knows which camera each shot comes from), it will apply that calibration. *Note:* You can adjust your blues and greens in the same way.

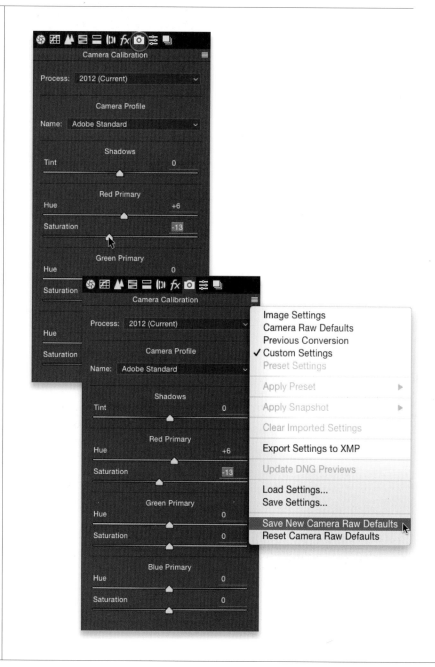

Photoshop Killer Tips

Don't Use the Reduce Noise Filter in Photoshop

There are two different places you can reduce noise in Photoshop: The Noise Reduction controls in Camera Raw rock, however the Reduce Noise filter in Photoshop (under the Filter menu, under Noise) does not. We used to joke that the sliders weren't connected to anything, and if they were, it was a blur filter. My advice—only use the Noise Reduction in the Detail panel of Camera Raw, and avoid the other altogether.

Rotating Your Images

Finally, a shortcut that makes perfect sense: To rotate your image to the left, press **L**; to rotate to the right, press **R**. The nice thing is, once you learn one, you'll never forget the other.

Making Camera Raw Full Screen

To have Camera Raw expand to fill your entire screen, click the Full Screen mode icon at the top of the window or just press the **F key**.

Avoiding Noise Problems

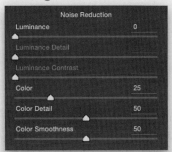

If there's noise in your photo, chances are it's in the shadow areas, so keep this in mind when you're editing your images. If you open up the shadows a lot (using the Shadows slider, Blacks, or in some cases, even the Exposure slider), any noise that was already in the image is going to become magnified. If you can't avoid opening up those shadows, just make sure you use Camera Raw's Noise Reduction to reduce the visible amount.

Tip for Wacom Tablet Users Who Use Their Tablet in Their Lap

Back in CS4, Adobe introduced Fluid Canvas Rotation, which lets tablet users who work with their tablet in their lap rotate the screen to match the current angle of their tablet (you turn this on by clicking on the Hand tool, choosing the Rotate View tool, and then clicking-and-dragging that within your image to rotate the canvas). There was only one problem, though:

when you rotated the canvas, it rotated your brushes, too (which wouldn't happen in real life). Luckily, now when your canvas rotates, your brushes stay intact.

Get Automatic Auto Corrections

The Auto correction one-click fix feature got dramatically better in previous versions of Photoshop. So, now it's to the point where the Auto button is pretty decent. Not great, not amazing, but decent. Anyway, if you want to have Camera Raw automatically apply an Auto correction to every photo you open (to get a better starting point for your editing), then click on the Preferences icon in Camera Raw's toolbar (it's the third icon from the right), and in the Default Image Settings section, turn on the Apply Auto Tone Adjustments checkbox. Now, every image will get an automatic correction as soon as it's opened.

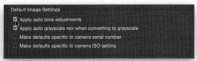

The Hidden Trash Can

If you're wondering why you've never seen the Trash icon in Camera Raw (where you can click to delete files), it's because it only appears when you have multiple images open there (it appears at the end of the toolbar). Click on it, and it marks your selected image(s) for deletion. Click the Done button, and it deletes that image (well, it moves it to the Trash on a Mac, or Recycle Bin on a PC).

Location: Monaco | Exposure: 1/1000 sec | Focal Length: 28mm | Aperture Value: ƒ/5.6

The Adjustment Bureau
camera raw's adjustment tools

If there is a better name for a chapter all about Camera Raw's adjustment tools than "The Adjustment Bureau," I'd sure like to know what it is, because in my naming world, it doesn't get much more "on the money" than this. I typed the word "adjustment" in a web browser and the first thing that came up was the hit movie *The Adjustment Bureau* (starring Tom Hanks and Meg Ryan). By the way, if you haven't seen it, it was actually a pretty good movie, despite kind of a flat performance from Sean Connery, who played the role of Nathan Detroit (a no-nonsense Texas deputy who was quick with a joke, or to light up your smoke, but there's someplace that he'd rather be). Anyway, the film takes place in the sprawling factory where Adobe makes Photoshop, which (and this is well-documented in real life) is an abandoned missile silo in Fairview Park, Ohio, just a stone's throw from Westlake and North Olmsted (good people up there). Of course, my favorite part of the film is when they're about to launch the Photoshop CC 2017 release. But, to do that, two Adobe engineers had to turn their keys at the same time and, of course, one of the engineers couldn't find his key, and then Tom Hanks shows up with a big ol' dog that slobbers all over the place, and the dog winds up finding the key, but then swallows it, and well…the scene is just hilarious. Of course, a lot of the humor was lost in the French foreign release of the film, which was titled *Avoir un Nom à Coucher Dehors* (which roughly translates to "avoid the crunchy appetizers," which some felt was partially to blame for its poor box office showing in Marseille). The problem arose when the producers of the French release decided to use subtitles rather than dubbing the film in French because, of course, there's no way the guy entering the subtitles could know the French word for Photoshop features like the "pompitous." So, he just used short four-letter English words he heard in the preview of the rap song "Naked (Boom Boom Boom)" by Kutt Calhoun, and they slapped the movie with an NC-17 rating which pretty much killed the film. That's why, to this day, Tom Hanks movies have been banned in France. True story (ask anyone). C'est vrai!

Dodging, Burning, and Adjusting Individual Areas of Your Photo

One of my favorite features in Camera Raw is the ability to make non-destructive adjustments to individual areas of your photos (Adobe calls this "localized corrections"). The way they've added this feature is pretty darn clever, and while it's different than using a brush in Photoshop, there are some aspects of it that I bet you'll like better. We'll start with dodging and burning, but we'll add more options in as we go.

Step One:

This photo has two areas that need completely different adjustments: (1) the sky needs to be darker with more vibrant colors, and (2) the rock formation needs to be brighter and punchier. So, get the Adjustment Brush from up in the toolbar (it's shown circled here in red) or just press the letter **K** on your keyboard. However, I recommend that you do all the regular edits to your photo in the Basic panel first (exposure, contrast, etc.), just like normal, before you grab the brush.

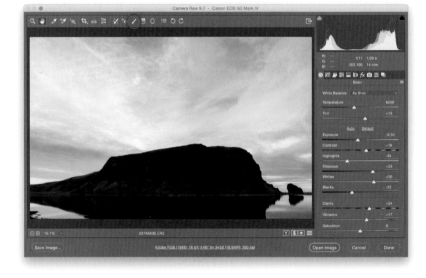

Step Two:

Once you click on the brush, an Adjustment Brush panel appears on the right side of the window, with most of the same sliders you have in the Basic panel (except for Vibrance), along with some extra ones (like Sharpness, Noise Reduction, Moire Reduction, and Defringe). Let's start by darkening the sky. With the Adjustment Brush, you (1) choose what kind of adjustment you want first, then (2) you start painting, and then (3) you tweak the amount of your adjustment after the fact. So, start by clicking on the – (minus sign) button to the left of the Exposure slider, which resets all the sliders to 0 and lowers the Exposure (the midtones control) to –0.50, which is a decent starting place.

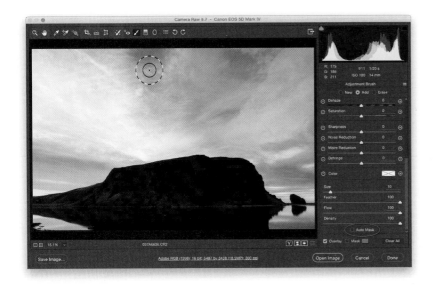

Step Three:

At the bottom of the Adjustment Brush panel, there is a really amazing Adjustment Brush feature called "Auto Mask," which helps to keep you from accidentally painting on things you don't want to paint on (so it's great around the edges of things). But, when you're painting over something like a big sky, it actually slows things down because it keeps trying to find an edge. So, I leave the Auto Mask checkbox turned off for stuff like this, and here, I'll just avoid getting close to the edges of the rock (for now, anyway). Go ahead and paint over the sky (with Auto Mask turned off), but of course, avoid getting too close to the rock—just stick to open areas of sky (as seen here). Notice how it gets darker as you paint?

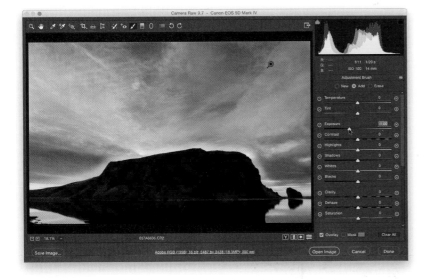

Step Four:

Once you've painted in most of the sky (but avoided the edges of the rock), now you can tweak how dark it is. Try lowering the Exposure to –1.00 (as shown here) and the area you painted over gets a lot darker. This is what I meant by "you tweak it after the fact." Also, you see that red pin in the top right of the image? That represents this one adjustment (you can have more than one, which is why you need a way to keep track of them. More on this coming up).

TIP: Deleting Adjustments

If you want to delete any adjustment you've made, click on the adjustment's pin to select that adjustment (the center of the pin turns black), then press the Delete (PC: Backspace) key on your keyboard.

(Continued)

Step Five:

Okay, now that "glow" around the edges of the rock where we haven't painted is starting to get on my nerves, so let's deal with that before we tweak our settings any more. When we're getting near the edges is when you want to turn Auto Mask back on (shown here). That way, you can paint right up against them, filling in all those areas, without accidentally painting over the rock. The key to using Auto Mask is simple—don't let that little + (plus sign) inside the inner circle of your brush stray over onto the rock, because that's what determines what gets affected (if that + crosses over onto the rock, it starts painting over it). It's okay if the outer circle crosses right over the rock—just not that + (see how the brush here is extending over onto the top of the rock, but it's not getting darker? That's Auto Mask at work).

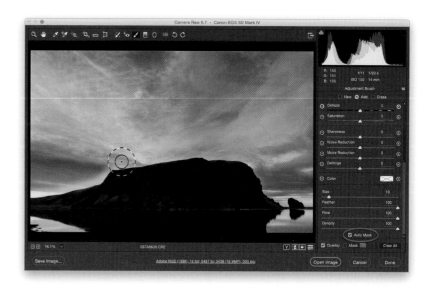

Step Six:

So, how do you know if you've really painted over the entire area you wanted to adjust? How do you know whether you've missed a spot? Well, if you turn on the Mask checkbox at the bottom of the panel, it puts a tint over the area you painted (as seen here, where I changed my tint color to red by clicking on the color swatch to the right of the checkbox), so you can see if you missed anything. If you don't want this on all the time, just press the letter **Y** on your keyboard to toggle it on and off. You can also hover your cursor over any inactive pin and it will temporarily show the masked area for that pin. Now that you know where you painted, you can go back and paint over any areas you missed.

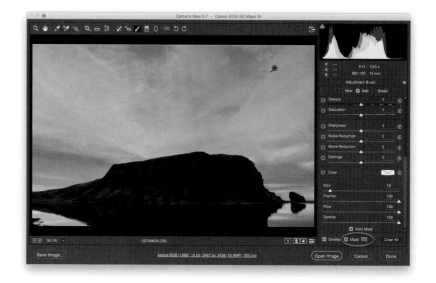

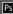

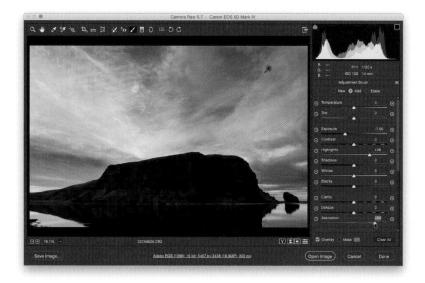

Step Seven:

Now, let's unlock a little more of the Adjustment Brush's power by adjusting more sliders. That's right, once you've painted over (masked) an area, you can adjust any of the other sliders and they affect just the area you painted over (here, they'll just affect the sky). Starting at the top, let's make it a bit darker by lowering the Exposure amount to –1.05, then increase the Highlights to around +48 to bring out some detail in the clouds. Now, head down to Saturation and crank that up a bit (I took it up to +64), and that cloudy sky gets much more vibrant (as seen here). Yeah, that's just like I remember it (wink). The ability to paint over one area, and stack up a number of adjustments on just that area, is what gives this tool so much power.

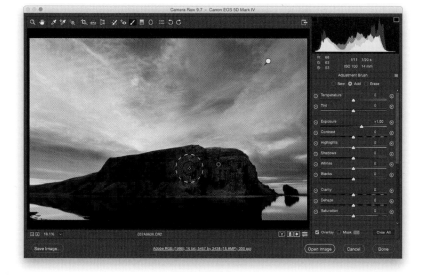

Step Eight:

Next, let's work on the rock formation. First, click on the New radio button at the top of the panel, so we can paint over a new area (otherwise, the rock would get the same settings we used on the sky). Then, click the + button to the right of Exposure twice to reset all the other sliders to 0 and bump up the Exposure amount to +1.00 (twice the one-click amount). Now, with Auto Mask turned on, paint over the rock (as shown here), which lightens those areas because you increased the Exposure amount by quite a bit. Also, notice there are now two pins, and the sky's pin is now white, letting you know it's no longer active. If you wanted to adjust the sky again, you'd click on its pin, and all the sky settings would come back.

(Continued)

Step Nine:

Finish painting over the rest of the rock, along with its reflection and the little rock on the right, and then let's add some "juice" to them. First, decrease the Exposure amount a bit (here, I dragged it down to +0.85), then increase the Contrast to +53. Open the shadow areas by dragging the Shadows slider a little to the right (here, I went to +8), and then increase the Highlights (to +39). Let's add some punch by adding Clarity (drag it over to around +61), and then bring out the green in the rock by increasing the Saturation to +64 and decreasing the Tint to –35. Now the rock is really starting to pop, but you can see that I let the little + in the middle of the brush extend off the top left of the rock a bit, and it started to affect the sky, which looks bad. So, we'll have to deal with that next.

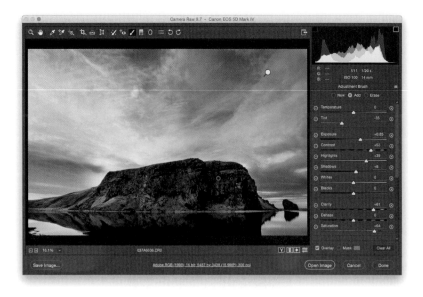

TIP: Choosing What to Edit

If you have multiple pins and you drag a slider, Camera Raw will adjust whichever pin is currently active (the red-and-black one). To choose which adjustment you want to edit, click on the pin to select it, then make your changes.

Step 10:

If you make a mistake, or need to erase something that spilled over, just press-and-hold the **Option (PC: Alt) key** and the brush switches to Erase mode. Now, just paint the area where you spilled over and it erases the spillover (as shown here). You can also switch to Erase mode by clicking on the Erase radio button at the top of the Adjustment Brush panel. When you switch this way, you get to choose the Size, Feather, Flow, and Density of the Erase brush (more on this in just a moment), so it's at least good to click on the radio button, choose your preferred brush size, then from that point on, just press-and-hold the Option key to get it when you need it.

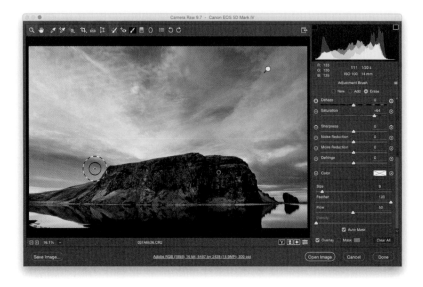

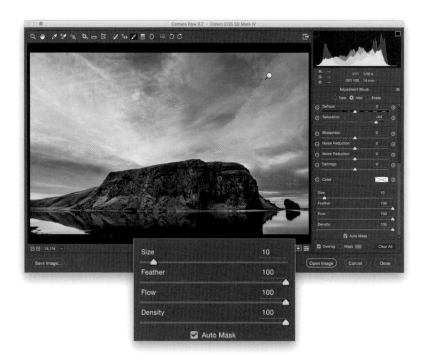

Step 11:

Here are a few other things about the Adjustment Brush you'll want to know: At the bottom of the panel, the Feather slider controls how soft the brush edges are—the higher the number, the softer the brush (I paint with a soft brush about 90% of the time). For a hard-edged brush, set the Feather slider to 0. The default brush settings are designed to have it build up as you paint, so if you paint over an area and it's not dark enough, paint another stroke over it. This build-up amount is controlled by the Flow and Density sliders. The Density slider kind of simulates the way Photoshop's airbrush capabilities work with its Brush tools, but the effect is so subtle here that I don't ever change it from its default setting of 100. The Flow slider controls the amount of paint that comes out of the brush (I leave the Flow set at 100 most of the time these days, but if I decide I want to "build up," then I lower it to 50). Below is a before/after, which shows how useful dodging and burning with the Adjustment Brush can be.

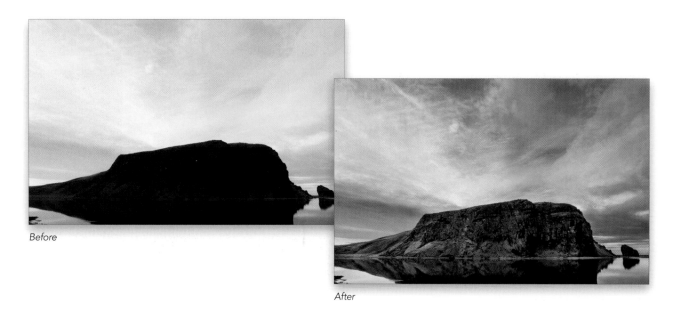

Before

After

Retouching Portraits in Camera Raw

One of the main things we've always had to go to Photoshop for was retouching portraits, but now, by using the Spot Removal tool, along with the Adjustment Brush, we can do a lot of simple retouching jobs right here in Camera Raw, where they're completely non-destructive and surprisingly flexible.

Step One:
In the portrait shown here, we want to make three retouches: (1) we want to remove any blemishes and soften her skin, (2) we want to lighten the whites of her eyes, brighten her eyes in general, and add contrast, and (3) we want to sharpen her eyes, eyebrows, and eyelashes.

Step Two:
We'll start with removing blemishes. First, zoom in on her face, then get the Spot Removal tool **(B)** from the toolbar up top (it's shown circled here in red) and set your brush Size to where it's just slightly larger than the blemish you want to remove. Now, move your cursor over the blemish and just click. Don't paint a stroke or anything—just click once and it's gone. If the removal doesn't look quite right, it just means that Camera Raw chose a bad place to sample clean skin from to make its repair. So, click on the green sample circle and drag it to a nearby area and it redoes the retouch (as shown here). Now, remove the rest of the blemishes with just a single click each, adjusting the position of their green sample circles, if necessary.

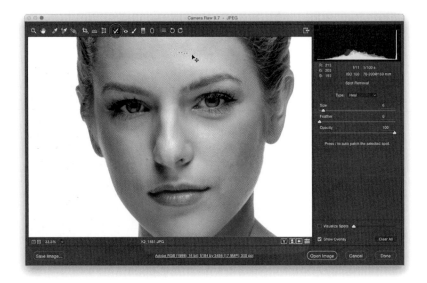

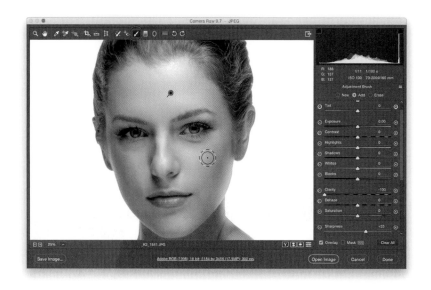

Step Three:

Next, let's do some skin softening. Click on the Adjustment Brush (shown circled here) in the toolbar, then click the – (minus sign) button to the left of Clarity four times to set the Clarity amount at –100 (this is called "negative clarity" by people who love to give everything a name). Now, increase the Sharpness slider to +25 and you're ready to go. Increase the size of your brush (by using either the Size slider or the **Right Bracket key** on your keyboard), and then paint over her skin to soften it (as shown here), but be careful to avoid any areas that should stay sharp and retain lots of detail, like her eyebrows, eyelids, lips, nostrils, hair, etc. While you're painting, you might not feel like it's really doing that much, but press the **P key** to toggle the preview on/off, and you'll see that it's doing a lot more than you might think. Of course, once you're done painting, if you think you've applied too much softening, just raise the Clarity (try –75 or –50; I ended up raising it to –50).

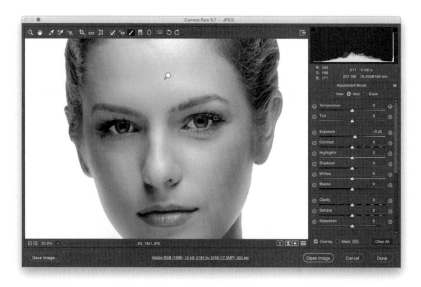

Step Four:

Let's work on the eyes next. Click the New radio button at the top of the panel (to work on a new area), then reset the Clarity and Sharpness sliders to 0 by double-clicking directly on the slider knobs. Now, drag the Exposure slider a little to the right (I started at +35), decrease the size of your brush, then paint over the whites of her eyes (as shown here). Once that looks good (I lowered the Exposure to +25), click the New radio button again and zero out the sliders, so we can work on adding contrast and brightness to her irises.

(Continued)

Step Five:

To add more contrast, we're really going to crank up the Contrast slider (here, I dragged it over to +73), but to brighten and enhance the texture of the irises a bit at the same time, increase the Exposure to +85 and the Clarity to +18, then paint directly over the irises, and see how much better they look (I ended up decreasing the Exposure to +55)! Lastly, let's sharpen the eyes, eyelashes, and eyebrows. Click the New button once again, reset all the sliders to 0 (just click the + [plus sign] button to the right of Sharpness and it resets them all and moves Sharpness up to +25). Now, paint over her pupils and irises (but not out all the way to the edge of the iris), then paint over her eyelashes and eyebrows to help make them look sharper and crisper, completing the retouch (a before/after is shown below).

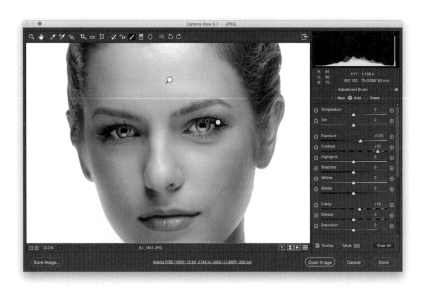

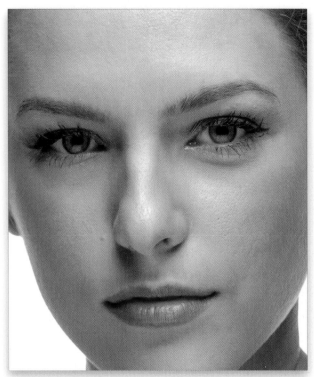

Before

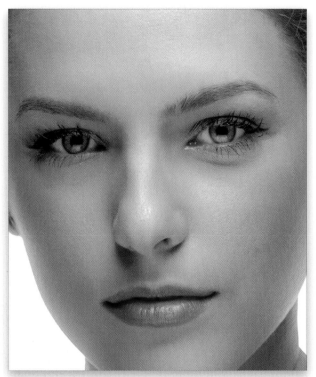

After

Fixing Skies (and Other Stuff)
with the Graduated Filter

The Graduated Filter (which acts more like a tool) lets you recreate the look of a traditional neutral density gradient filter (these are glass or plastic filters that are dark on the top and then graduate down to fully transparent). They're popular with landscape photographers because you're either going to get a photo with a perfectly exposed fore-ground, or a perfectly exposed sky, but not both. However, with the way Adobe implemented this feature, you can use it for much more than just neutral density gradient effects (although that probably will still be its number one use).

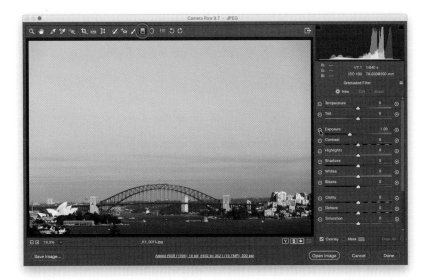

Step One:

Start by selecting the Graduated Filter **(G)** up in the toolbar (it's shown circled in red here). When you click on it, its options panel appears (shown here) with a set of effects you can apply that are similar to the ones you can apply using the Adjustment Brush. Here we're going to replicate the look of a traditional neu-tral density gradient filter and darken the sky. Start by dragging the Exposure slider to the left, or just click on the – (minus sign) button two times to get to –1.00 (as shown here).

Step Two:

Press-and-hold the Shift key (to keep your gradient straight), click at the top center of your image, and drag straight down until you reach the bridge's road-way (as shown here). Generally, you want to stop dragging the gradient before it reaches the horizon line, or it will start to darken your properly exposed fore-ground (but we didn't have that problem here). You can see the darkening effect it has on the sky and the photo already looks more balanced. *Note:* Just let go of the Shift key to drag the gradient in any direction.

(Continued)

Step Three:

The green pin shows the top of your gradient; the red pin shows the bottom. In this case, we'd like the sky a little darker still, so drag the Exposure slider to the left a bit to darken the midtones in the sky. What's nice about this tool is, like the Adjustment Brush, once we've dragged out the Graduated Filter, we can add other effects to that same area. So, if you wanted the sky to be bluer, you could click on the Color swatch, at the bottom of the panel, and when the Color Picker appeared, click on a blue color to complete your effect (I didn't have to do that here).

TIP: Gradient Tips

You can reposition your gradient after the fact—just click-and-drag downward on the line connecting the green and red pins to move the whole gradient down. Click-and-drag either pin to rotate your gradient after it's in place. You can also have more than one gradient (click on the New radio button at the top of the panel) and to delete a gradient, just click on it and press the Delete (PC: Backspace) key.

Before

After

Fixing Color Problems (or Adding Effects)
by "Painting" White Balance

Camera Raw lets us paint with white balance, and of all the things that have been added to Camera Raw over the years, believe it or not, this is one of the ones you'll probably wind up using the most. It's pretty common to have a natural light photo where part of the photo is in shadows, which usually means the parts in daylight have one color, and the parts in shadows are usually bluish (especially if you use Auto White Balance, which most of us do, because it works pretty well for most situations). Here's how to paint with white balance to make all the color in your image consistent:

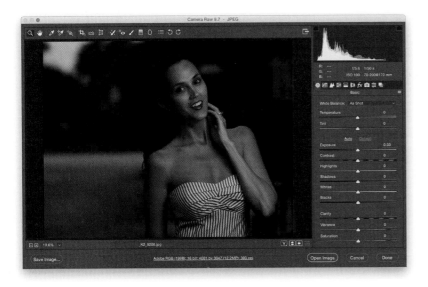

Step One:

Here's a location portrait, where our subject has a nice warm skin tone (partially because I put a orange gel over the off-camera flash), but take a look at the background behind her—it's in the shade and that makes it look blue (like it was taken at dawn), even though it was taken at sunset. If I try to warm up the white balance, she is going to turn really yellow. Luckily, now we can adjust the white balance in just one area.

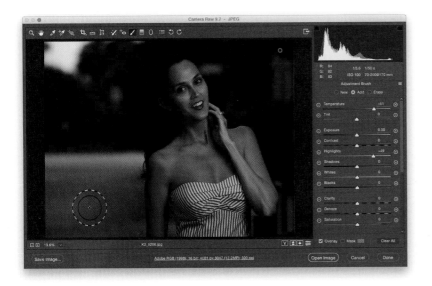

Step Two:

Get the Adjustment Brush **(K)**, click on the + (plus sign) button to the right of Temperature (this resets all the other sliders to 0 and sets the Temperature to +25), and start painting over this bluish background area (as shown here). Once you've painted over it, you can adjust the Temperature slider (drag to the right to warm up the color and make this area less blue, as I did here where I dragged it to +51, or to the left if the default setting of +25 makes things too warm). This is the beauty of using the Adjustment Brush for this—once you paint over the bluish area, you can "dial in" just the right amount of white balance correction by dragging the slider after you've painted. Now the background looks more neutral. I also increased the Highlights a bit to finish it up.

Reducing Noise in Just the Shadow Areas

If you shoot at a high ISO (like 800 or above), you're going to see some noise in your image (depending on your camera's make and model, of course), but the area where it's going to show up the most is in the shadow areas (that's where noise tends to be its worst, by far). Worse yet, if you have to brighten the shadow areas, then you're really going to see the noise big time. Well, as good as Camera Raw's noise reduction works, like any noise reduction, the trade-off is it makes your photo a bit softer (it kind of blurs the noise away). This technique lets you paint noise reduction just where you need it, so the rest of the image stays sharp.

Step One:

We'll start by brightening up the floor and walls in this image. This shot was taken at ISO 6400, so when we brighten up those areas, it's going to exaggerate any noise in those shadow areas big time, but at least now we can do something about it. Start by getting the Adjustment Brush **(K)**, double-click on the + (plus sign) button to the right of Shadows (this resets all the other sliders to 0), then drag the Shadows slider to around +53, and paint over the floor and walls. Even after that, they're still a bit too dark, so try brightening the Highlights by dragging that slider over to +57 and increase the Exposure to +0.20. Lastly, drag the Clarity slider over to +28 (to enhance the texture). It definitely looks better now (well, to me anyway), but if you look at the inset, you now see lots of noise that was once hidden in those shadows.

Step Two:

Now, zoom in to 100%, so you can really see the noise in these shadow areas, and drag the Noise Reduction slider to the right as you keep an eye on the amount of noise in your image. Keep dragging until you find that sweet spot, where the noise has been reduced but these shadow areas haven't gotten too blurry (remember, it's noise reduction, not noise removal). This noise reduction only affects those floor and wall areas where you painted, and the rest of the image keeps its original sharpness.

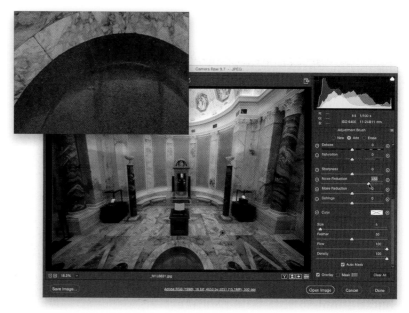

How to Get More Than 100%
Out of Any Adjustment Brush Effect

Let's say you feel like a particular part of your photo needs more Clarity, so you've set the Clarity slider to 100 and painted over that part of your image. You look at that area and think, "Even though I painted with the slider at 100%, I still need more!" (Basically, you need your amp to go to 11. :) Here's what to do:

Step One:

Here's the image we want to work on, and our goal is to bring out extra detail in the headlamps of the car. So, go ahead and get the Adjustment Brush **(K)**, click on the + (plus sign) button to the right of the Clarity slider (to reset all the other sliders to 0), and then drag just that Clarity slider way over to +100. Next, fully paint over just the headlamps. Now, if you think they still need more detail to really make them "pop," but you've already painted with your Clarity maxed out at +100, what do you do? You can't drag the slider over to +200 or anything like that, right?

Step Two:

All you need to do is press Command-Option (PC: Ctrl-Alt) and click-and-drag on the edit pin to make another copy of the adjustment (so you have two pins on this area now: the original pin where you applied 100% Clarity, and now a second pin with another 100% Clarity on top of that). Basically, you've got 200% Clarity applied on those headlamps. Of course, this doesn't just work for Clarity—it works for any of the sliders here in the Adjustment Brush panel.

Photoshop Killer Tips

Painting a Gaussian Blur

Okay, technically it's not a Gaussian blur, but in Camera Raw, you can paint with a blur effect by lowering the Sharpness amount (in the Adjustment Brush options panel) below 0 (actually, I'd go all the way to –100 to get more of a Gaussian-type

blur look). This is handy if you want to add a blur to a background for the look of a more shallow depth of field, or one of the 100 other reasons you'd want to blur something in your photo.

Why There Are Two Cursors

When you use the Adjustment Brush, you'll see there are two brush cursors displayed at the same time, one inside the other. The smaller one shows the size of the brush you've selected; the larger (dotted-line circle) shows the size of the feathering (softening) you've applied to the brush.

How to Set the Color to None

Once you pick a color using the Adjustment Brush's Color Picker, it's not really obvious how to reset the color to None (no color). The trick is to click on the Color swatch (near the bottom of the Adjustment Brush options panel) to reopen the Color Picker, then drag the Saturation slider down to 0. Now, you'll see the X over the Color swatch, letting you know it's set to None.

How to See Just One of Your Layers

Just **Option-click (PC: Alt-click)** on the Eye icon beside the layer you want to see, and all the others are hidden from view. Even though all the other layers are hidden, you can scroll through them by pressing-and-holding the **Option (PC: Alt) key**, and then using the **Left** and **Right Bracket keys** to move up/down the stack of layers. Want to bring them all back? Just Option-click on that Eye icon again.

Painting Straight Lines

If you want to paint a straight line using the Adjustment Brush, you can use the same trick we use with Photoshop's Brush tool: just click once where you want the line to start, press-and-hold the Shift key, then click once where you want the straight line to end, and the Adjustment Brush will draw a perfectly straight line between the two. Really handy when working on hard edges, like the edge of a building where it meets the sky.

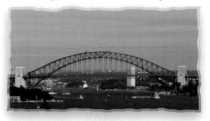

Save a "Jump Back" Spot

If you're familiar with Photoshop's History panel, and how you can make a snapshot at any stage of your editing, so you can jump back to that look with just one click, well…good news: you can do that in Camera Raw, too! You can save a snapshot while you're in any panel by pressing **Command-Shift-S (PC: Ctrl-Shift-S)**. Then you can jump back to how the image looked when you took that snapshot by clicking on it in the Snapshots panel.

Photoshop Killer Tips

Starting Over from Scratch

If you've added a bunch of adjustments using the Adjustment Brush, and you realize you just want to start over from scratch, you don't have to click on each one of the edit pins and hit the Delete (PC: Backspace) key. Instead, click on the Clear All button in the bottom-right corner of the Adjustment Brush options panel.

Changing Brush Size with Your Mouse

If you Right-click-and-hold with the Adjustment Brush in Camera Raw, you'll see a little two-headed arrow appear in the middle of your brush. This lets you know you can drag side-to-side to change the size of your Adjustment Brush (drag left to make it smaller and right to make it bigger).

Seeing Paint as You Paint

Normally, when you paint with the Adjustment Brush, you see the adjustment (so if you're darkening an area, as you paint, that area gets darker), but if you're doing a subtle adjustment, it might be kind of hard to see what you're actually painting (and if you're spilling over into an area you don't want darkened). If that's the case, try this: turn on the Mask checkbox (at the bottom of the Adjustment Brush options panel). Now, when you paint, it paints in white (the default mask color, which you can change by clicking on the color swatch to the right of the checkbox), so you can see exactly the area you're affecting. When you're done, just press the **Y key** to turn the Mask checkbox off. This one's worth a try.

Add Your Own Color Swatches

When you click on the Color swatch in the Adjustment Brush panel, you see that there are five color swatches in the bottom-right corner of the Color Picker. They're there for you to save your most-

used colors, so they're one click away. To add a color to the swatches, first choose the color you want from the color gradient, then press-and-hold the Option (PC: Alt) key and when you move your cursor over any of those five color swatches, it will change into a paint bucket. Click that little bucket on any one of the swatches, and it changes the swatch to your currently selected color.

Hiding the Edit Pins

To temporarily hide the edit pins that appear when you use the Adjustment Brush, just press the **V key** on your keyboard (it toggles the pins' visibility on/off).

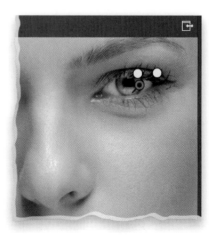

Location: Rijksmuseum Research Library, Amsterdam, Netherlands | Exposure: 1/5 sec | Focal Length: 14mm | Aperture Value: ƒ/8

Lens
correcting lens problems

Okay, this title is a little short, but you have to admit that the title "Lens," from the Alanis Morissette single of the same name, is a pretty good one. I mean, you can't expect that there would be a song named "Lens Correction," unless it was from Adobe Records. But, I figured there really wouldn't be a record company called Adobe Records, but son-of-a-gun, I did a search and on the website Discogs .com, I found a reference to two songs from Adobe Records. One of them was from the famous Athens, Georgia–based band REM, which ironically is an acronym for Rasterize Extra Masks, which in Photoshop, you would use when you have a vector mask that has been added to a pixel-based layer, and you want to maintain the mask, but convert from paths to pixels, and combine the affected layers into a single merged layer. If that sounds complicated, it's only because I made it up, and that is part of what we all do when we don't know the answers to complicated Photoshop questions. Look, Photoshop is kinda "sticky" at times. There are things in

Photoshop that nobody knows what they do or if they're actually connected to anything. Even Adobe doesn't know. It's because Photoshop has been around for more than 25 years now, and over these years, some of the Photoshop engineers have added decoy commands and features just for laughs, figuring nobody would ever even try them for fear of damaging their computer. For example, under Photoshop's Image menu, under Mode, there's a menu item near the bottom called "Release Virus to OS." Seriously, who would ever choose that? Or under the Filter menu, under Stylize, there's a filter named "Erase Hard Drive." Really? Erase Hard Drive? Oh yeah, I'm choosing that one. Or how about under the File menu, where is says "Open." Come on! Who in their right mind would choose Open? Open what? Spyware? Malware? Flatware? Glassware? Not on your life. At some point, Adobe is going to have to go in there and clean this stuff up before somebody accidentally chooses "Quit," and then they're out of a job.

Automatically Fixing Lens Problems

Camera Raw can automatically apply corrections for common lens problems (like barrel and/or pin-cushion distortion, edge vignetting, and junk like that). It does this by reading the embedded camera data (so it knows which camera and lens you used), and then it searches through its own huge, built-in database of lens profiles to find a profile correction. Then, it applies that profile to fix the problem, and it does a pretty amazing job of it. It's really fast, and turning this feature on only takes one checkbox. But, what if you turn it on and it can't find a profile for your lens, or there's no EXIF data in your image (maybe you scanned it)? You're about to learn how to handle that, too.

Step One:
Open the image with a lens problem in Camera Raw. Now, if you've been using Photoshop for a while, you already know there's a Lens Correction filter found under Photoshop's Filter menu, and they've updated that with some of the same features as the Camera Raw version, but it's better to do the correction here because: (1) it's non-destructive, (2) there are some better options available in Camera Raw, and (3) it's faster. So I always fix lens problems here, rather than using the Photoshop filter.

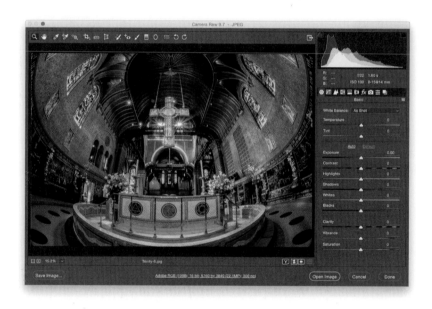

Step Two:
Click on the Lens Corrections icon (the fifth icon from the right at the top of the Panel area) and on the Profile tab, turn on the Enable Profile Corrections checkbox. Now, chances are that you're done. Boom. It's fixed. That's because, as I said above, it looks at the camera data embedded in the shot to find out which camera and lens you used, then it searches its internal database for a profile of that lens, and it immediately fixes the photo (as seen here). If it can't find a profile, it lets you know at the bottom of the panel (as seen in the next step). Also, I usually have to back down the amount of correction just a bit with fisheye lenses by dragging the Distortion slider a little bit to the left (as shown here).

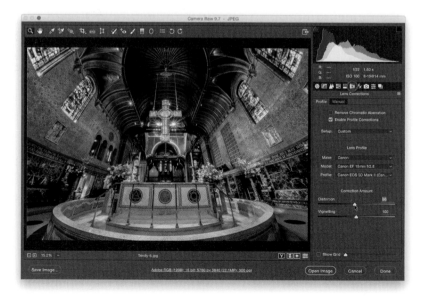

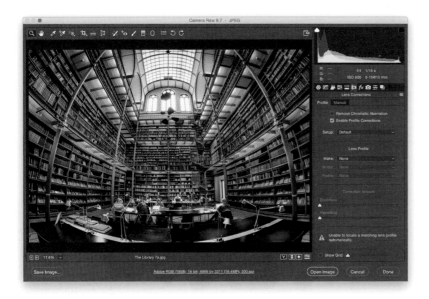

Step Three:

So, what happens in a case like this, where you open a photo and it can't find a profile automatically, or the image doesn't have any embedded EXIF data (for example, if you're trying to fix a scanned image, or an image you copied-and-pasted from another document)? Take a look at the photo here. Camera Raw couldn't find a profile for it, so in the Lens Profile section, the Make is set to None and the Model and Profile pop-up menus are grayed out. What this really means is that you have to help it out by telling it what equipment you used to take the photo (if you know), or you'll have to make your best guess (if you don't).

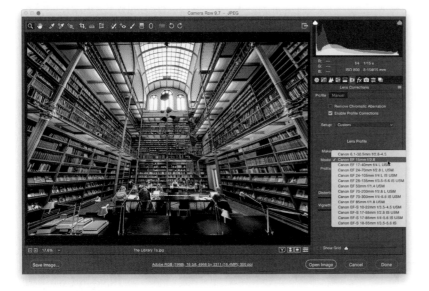

Step Four:

This was taken with a Canon, so from the Make field I chose Canon, and as soon as I did, it did the rest—it found a lens match and fixed the photo. Now, it's not always 100% sure it has the right lens match, so it gives you a list of lenses it thinks might be right. You can click on the Model pop-up menu, and you'll see a list of lenses it thinks it could be (as seen here). You can try out any of the other lenses listed there and see if it gives you a better result than the one that it chose for you (it does a surprisingly good job, so I usually wind up using the one it chose, but every once in a while I find a lens in that list I like better, even though sometimes I know it's not the actual lens I used). Here, I actually used the 15mm lens, so I chose that from the pop-up menu and then adusted the Distortion a bit.

Using Upright to Automatically Fix Lens Problems

This is one of the best features Adobe has added to Camera Raw in the past few years, and it keeps getting better as they roll out more CC updates. Essentially, Upright takes the automated lens correction process you started by enabling the lens correction, and it takes it up a big notch. But, don't worry—you just turn it on—it does all the heavy lifting.

Step One:

Here's a wide-angle image taken at 14mm, and you can see the problem—the interior of the building, columns, etc., are leaning back (it's larger at the bottom and narrower at the top). Luckily, fixing this type of stuff is just a couple of clicks away. Start by clicking on the Lens Corrections icon (the sixth one from the left) at the top of the Panel area, then click on the Profile tab, and turn on the Enable Profile Corrections checkbox (the Upright feature works better with this turned on first). The auto profile correction is already applied to the image here, but if you toggle this checkbox off/on, you'll see it's a pretty subtle correction at this point—it removed some vignetting in the corners, along with some of the barrel distortion (if you need to remove more distortion, click on the Manual tab and drag the Distortion slider to the right).

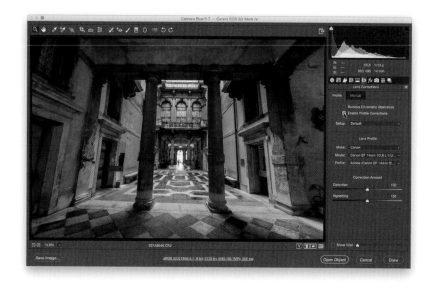

Step Two:

To get to the Upright controls click on the Transform tool in the toolbar, which brings up the Transform panel on the right. The one-click Upright auto corrections are in a row across the top. About 90% of the time, I just click on the "A" (Auto) button, as it usually gives the most natural-looking, balanced correction (as seen here. It's not perfect and, in fact, it might have over-corrected a bit, but it's fairly close). The other 10% of the time, I click on the one to the right, Level, which is simply an auto-straighten correction that works well (it's not 100%, though).

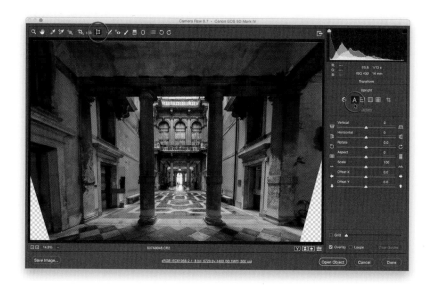

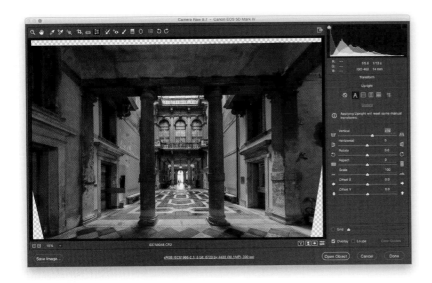

Step Three:

By the way, I rarely use the next two Upright options—Vertical and Full—because, to me, their corrections seem "too legalistic" and unnatural-looking for the most part. Usually, just clicking that Auto button is all I need to do. But, in this case, it seemed like it over-corrected a bit, and the bottom of the columns now look smaller than the top (see Step Two). So, I dragged the Vertical slider over to the right to +18 (as seen here) to make it look more balanced.

TIP: Should You Use Photoshop's Lens Correction Filter?

There's a Lens Correction filter in Photoshop that has some of the same features as Camera Raw, but I recommend doing the corrections here because: (1) it's non-destructive, (2) there are additional options here in Camera Raw, and (3) it's faster (no progress bars).

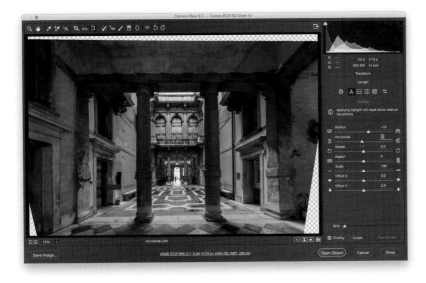

Step Four:

If there's anything else you need to tweak, use the sliders here in the Transform panel. If you're not sure what an individual slider does: (1) look at the icons to the left and right of the slider (it gives you a visual cue), then (2) simply drag the slider back and forth, and you'll instantly see the effect it has on your image (this works better than it sounds). When I took this shot, I wasn't perfectly centered with the scene, so I dragged the Horizontal slider just a little to the left (to –5) to flatten the perspective out a bit more. Again, you probably won't have to do this, but I thought I'd show you, just in case you run into stuff like this (and you will here and there). By the way, while we're here, the Aspect slider is pretty handy. If, after you drag one of these sliders, the image looks like it has been stretched upward and looks "too skinny," the Aspect slider will widen it out (and vice versa if it looks too wide).

(Continued)

Step Five:

Now, we need to crop away those blank areas that our correction left. We can have Camera Raw keep as much of the image intact as possible by clicking on the Crop tool in the toolbar, and choosing **Constrain to Image** (as shown here). Now, when we drag out the Crop tool, it will automatically snap to where we can crop without including any missing areas. You can see here how it automatically resized the crop to keep as much of the image as possible, but you can also see that we're losing a lot of the tile floor, so we'll look at another option. *Note:* We're not looking at the last Upright option—Guided—here because I cover it in the next technique, and I have to say, it's pretty awesome—definitely worth learning.

Step Six:

The other cropping option (and the one that I would probably go with for this image because we lost so much of the floor when using Constrain to Image) is to turn Constrain to Image off and, instead, drag the cropping border out to crop the blank areas on top, but leave the blank areas in the bottom corners. We'll try filling them in using Content-Aware Fill (see Chapter 9 for more). Now, click the Open Image button, get the Magic Wand tool **(Shift-W)**, and click in those two blank areas in the bottom corners to select them. Then, go under the Select menu, under Modify, chose **Expand**, and entered 4 pixels to help Photoshop make a better "fill." Next, chose **Fill** from the Edit menu, then choose **Content-Aware** from the Contents pop-up menu, and click OK. It did a pretty good job here, except for on the right, where it duplicated the fire extinguisher. But, that's easy enough to clone out, using the Clone Stamp tool (**S**; I ended up cloning out both, as seen in the After image on the next page. But, it's not an awesome clone job, so don't look too close).

Before

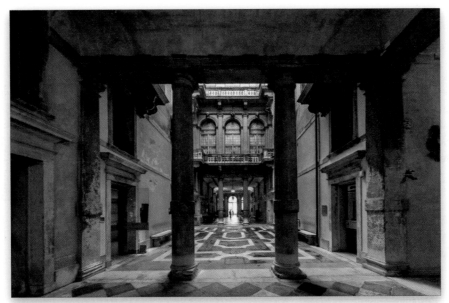

After: Here's the final image after the Upright corrections and cropping (and some sloppy cloning)

Guided Upright: When Camera Raw Needs You to Help a Bit

If you've tried the automated Upright corrections and none of them seemed to work quite right for your particular image, you might have to give Camera Raw a hand using a feature called "Guided Upright." The idea is you manually click-and-drag out straight lines over parts of the image that need to be horizontally and vertically straight. It'll then know what you're intending to have straightened, and it applies the correction based on where you place those lines (you can place up to four of them in your image).

Step One:

Here's our thoroughly messed up image with a pretty major lens distortion problem (taken many years ago with a cheap lens on a moving Gondola, so feel free to mentally insert any other excuses I could have used to justify how bad this looks, here). First, click on the Lens Corrections icon (the fifth icon from the right at the top of the Panel area) and on the Profile tab, turn on the Enable Profile Corrections checkbox (as shown here; Upright auto corrections work better when this is turned on first).

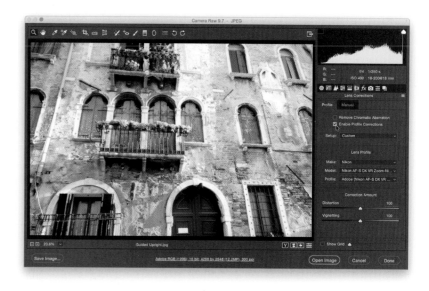

Step Two:

Now, press **Shift-T** or, if you're charging by the hour, click on the Transform tool in the toolbar (it's circled here in red), then click on the last icon on the right (also circled here) in the Upright section. What you're going to do is drag out two vertical lines to fix the vertical distortion and two horizontal lines to fix the horizontal. When you're done, the distortion should be gone (and your image won't look like it's being pinched or squished, like this one does). We'll start with the verticals. To keep the building from looking like it's leaning back, I dragged a line right along the pipe on the far left (you can see the red-dotted line on the right side of the pipe, here). Nothing happens, though, until you drag out the second line. So, I dragged a second vertical line along the pipe on the right side of the windows on the right side of the image (as shown here).

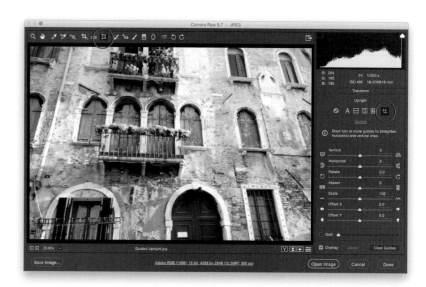

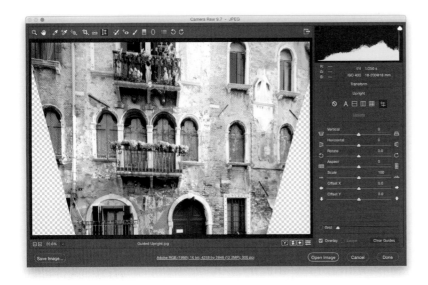

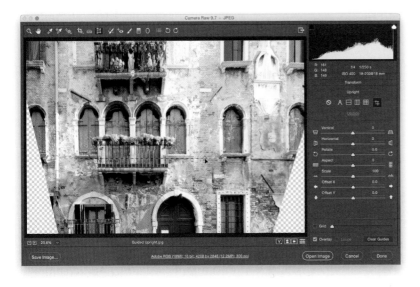

Step Three:

Once I released the mouse button after dragging out the second vertical line, it immediately applied a correction (as seen here). It's not looking great because it still needs the horizontal correction, and because there are now gaps on either side, but this will all be addressed in just a minute. For now, you're on the right track.

TIP: Try Adaptive Wide Angle

If you're not happy with the results you get from Guided Upright, try using Photoshop's Adaptive Wide Angle filter (found under the Filter menu). You use a similar tool to straighten your image there, and you might get better results (though, I rarely need to use it). Apply it as a smart filter, and you'll be able to go back and tweak the filter settings.

Step Four:

Let's now drag out the horizontal lines. You don't have to click anything or do anything special first because it already knows you've dragged out the two verticals—all that's left for you to do is drag out the horizontals, so it's all ready to go. Here, I dragged the first line out along the row of windows in the center (see the green-dotted line near the center of the image?). If you look at the previous step, you can see these windows were angled pretty badly, and here they're corrected. Well, they won't be completely corrected until you place a second horizontal line across the bottom of the window at the top of image. At that point, it flattens out the building. By the way, these lines are live, so if you need to reposition them (where you placed them doesn't look exactly right), you can simply click-and-drag them a little in either direction (as shown here) and it will redraw the correction. Or, click on one and hit the Delete (PC: Backspace) key to start over and drag out a new one instead. Your choice.

(Continued)

Step Five:

We still have some gaps, though not as large. This is a case where you have to decide whether you want to give Photoshop's Content-Aware Fill a shot at filling those gaps, or if you want to simply crop those areas away. Just for fun, I opened the image in Photoshop and tried Content-Aware Fill, even though I knew those gaps were pretty large (see Chapter 9 for more on using Content-Aware Fill). Let's just say the results were (ahem…) less than optimal, so we're going to have to crop this one down to hide those empty areas (by the way, you could crop them down quite a bit, and then let Content-Aware Fill fill much smaller areas, and your chances for success will be much greater. Hey, it's worth a shot, right? But, just so you know, when I tried this, one side looked okay and the other was…well…still less than optimal, but with a little cloning [okay, a lot of cloning], we could have gotten there. Either way, our best bet here is to crop).

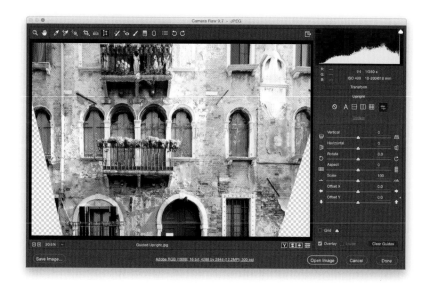

Step Six:

Click-and-hold on the Crop tool up in the toolbar and, from the pop-up menu that appears, choose **Constrain to Image** (as shown here). When you drag out your cropping border over the entire image it will now "snap" to where your crop is fully inside those gaps. So, when you crop, you'll have nothing but your image and no gaps.

Step Seven:

Now, take the Crop tool and click in the top-left corner, and then drag it out over the entire image and it will snap to fit (as seen here). To lock in your crop, press the **Return (PC: Enter) key**, and now you have the corrected image with no gaps on the sides. Take a look at the be-fore and after shown below to compare the two. Also note that while we had to crop away a reasonable amount, it still looks pretty good overall (I ended up cropping it a little more on the left and bottom in the After image).

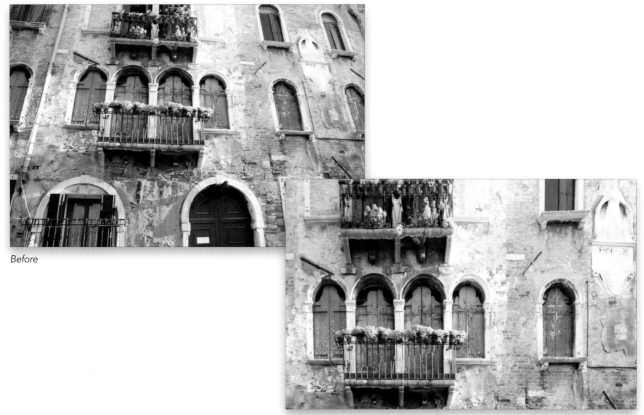

Before

After

Fixing Chromatic Aberrations (That Colored Edge Fringe)

Chromatic aberration is a fancy name for that thin line of colored fringe that sometimes appears around the edges of objects in photos. Sometimes the fringe is red, sometimes green, sometimes purple, blue, etc., but all the time it's bad, so we might as well get rid of it. Luckily, Camera Raw has a built-in fix that does a pretty good job.

Step One:

Open a photo that has signs of chromatic aberrations. If they're going to appear, they're usually right along an edge in the image that has lots of contrast (like along the edges of this structure).

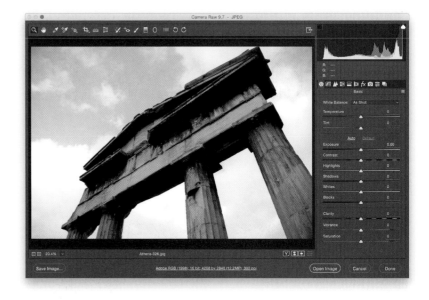

Step Two:

Press **Z** to get the Zoom tool and zoom in on an area where you think (or see) the fringe might be fairly obvious (here, I've zoomed in on the top right, and you can see thin red and green lines along the edges). To remove this, start by clicking on the Lens Corrections icon (the sixth icon from the left) at the top of the Panel area, then click on the Profile tab to get to the first chromatic aberration control.

Step Three:

In most cases, all you'll have to do is turn on the Remove Chromatic Aberration checkbox (as shown here) and you're done—Camera Raw removes the color fringe based on your lens' make and model, which it learns from the metadata embedded into the image at the moment you took the shot. However, if for some reason the image still needs more correction (the checkbox alone didn't do the trick, like with this image), then you can try getting rid of the fringe manually by clicking on the Manual tab and using the sliders in the Defringe section (seen in the next step. Just so you can see how this works, go ahead and turn off the Remove Chromatic Aberration checkbox).

Step Four:

We'll start by trying to remove the red line by dragging the Purple Amount slider to the right, and then also dragging the Purple Hue slider to the right until you see it's gone. In this case, it removed it nicely. You can do the same thing for the green aberration—drag the Green Amount slider to the right first, and if anything is left over, drag the Green Hue slider to dial in just the right hue, until it's completely gone. Again, I rarely have to go beyond turning on the Remove Chromatic Aberration checkbox, but at least now if it doesn't do the job for you, you'll know what to do instead.

Fixing Edge Vignetting

If you're looking at a photo and the corners of the photo appear darker, that's lens vignetting. Generally, I look at it this way: If it's just the corners, and they're just a little bit dark, that's a problem and I fix it. However, sometimes I want to focus the viewer's attention on a particular area, so I create a vignette, but I expand it significantly beyond the corners, so it looks like an intentional soft spotlight effect. We'll look at how to fix it here, and in the next chapter, we'll look at how to add it for effect.

Step One:

Here, you can see the dark areas in the corners (that's the bad vignetting). This is normally caused by the camera's lens, so don't blame yourself (unless you bought a really cheap lens—then feel free to give yourself as much grief as you can bear). To remove this vignetting from the corners, start by clicking on the Lens Corrections icon (the sixth icon from the left) at the top of the Panel area. In the Profile tab, turn on the Enable Profile Corrections checkbox and Camera Raw tries to remove the edge vignetting based on your lens' make and model (it learns this from your image's EXIF data. See page 88 for more on this). If the image still needs correcting, try the Vignetting slider under Correction Amount.

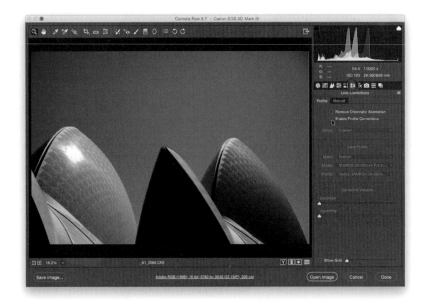

Step Two:

If the automatic way just isn't working, do it manually by clicking on the Manual tab. In the Vignetting section, click on the Amount slider and drag it to the right until the vignetting in the corners disappears. Once you move the Amount slider, the Midpoint slider beneath it becomes available. It determines how wide the vignetting repair extends into your photo, so drag it to the left to expand the lightening farther toward the center of your photo.

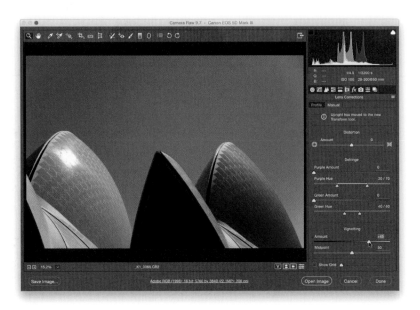

Photoshop Killer Tips

Working with Tabbed Documents

When working with multiple documents while using the Tabs features, to see any tabbed image, just click on its tab at the top of the image window or press **Ctrl-Tab** to cycle through them one by one. To turn tabbing off, go under the Photoshop (PC: Edit) menu, under Preferences, and choose

Workspace, then turn off the Open Documents as Tabs checkbox. Also, you'll probably want to turn off the Enable Floating Document Window Docking checkbox, too, or it will dock your single open image.

Setting Up Your Workspace

Photoshop comes with a number of built-in workspace layouts for different tasks with just the panels visible Adobe thought you'd need. You can find them by clicking on the pop-up menu at the right end of the Options Bar. To create your own

custom workspace layout, just click-and-drag the panels where you want them. To nest a panel (so they appear one in front of another), drag one panel over the other. When you see a blue outline appear, release the mouse button and it nests. More panels can be found under the Window menu. Once your panels are set up where you want them, go under the Window menu, under Workspace, and choose **New Workspace**, to save your layout so it's always one click away (it will appear in the pop-up menu). Also, if you use a workspace and change a panel's location, it remembers. That's okay, but you'd think that clicking on your workspace would return things to normal. It doesn't. Instead, you have to go into that pop-up menu and choose **Reset [your workspace name]**.

Getting Sharp Edges on Your Stroke Layer Effect

If you've applied a large stroke using the Stroke layer effect (under the Edit menu) or Stroke layer style (by clicking on the Add a Layer Style icon at the bottom of the Layers panel and choosing Stroke from the pop-up menu), you've probably already noticed that the edges start to get rounded, and the bigger you make the stroke, the rounder they get. So, what's the trick to nice, sharp straight edges? Just switch the Stroke position or location to Inside.

White Balance Quick Fix

If you have an image whose white balance is way off, and you didn't shoot it in RAW, try this: go under the Image menu, under Adjustments, and choose **Match Color**. When the Match Color dialog appears, just turn on the Neutralize checkbox in the Image Options section. It works better than you'd think for most white balance problems (plus, you can write an action to do all that for you).

Change Ruler Increments

If you want to quickly change the unit of measure in your ruler (say, from pixels to inches or from centimeters to millimeters), just Right-click anywhere inside the Rulers and choose your new unit of measurement from the pop-up menu that appears.

Using "Scrubby Sliders"

Anytime you see a numerical field in Photoshop (like the Opacity field in the Layers panel, for example), you can change the setting without typing in a number, or dragging the tiny slider. Instead. click directly on the word "Opacity" and drag left (to lower the opacity) or right (to increase it). This is very fast, and totally addictive, and if you're not using it yet, you've got to try it. There's no faster way to make quick changes (also, press-and-hold the Shift key while using it, and it goes even faster).

Location: Amsterdam, Netherlands | Exposure: 0.5 sec | Focal Length: 35mm | Aperture Value: ƒ/2.8

Special Effects
effects using camera raw

There it is. You are experiencing the magical unicorn, the holy grail, the crème de la crème of chapter titles—it's when you can find a title (in this case, the title of an entire album by Tech N9ne) that is exactly what the chapter is about. When I saw that, I immediately went online and completed the nomination form for inclusion in the Chapter Opener Hall of Fame (whose collection is permanently on exhibit at the Smithsonian's National Museum of American History in Washington, D.C. This collection contains archival records of all my chapter openers, including in-depth analysis of each intro's history, along with blueprints, cave drawings, and oral histories of some of the most insubstantial and incommunicable openers ever to grace these pages). Anyway, having one of your chapter openers accepted into the prestigious SNMOAH Chapter Opener Hall of Fame is, needless to say, quite an incompetence by itself, but the award presentation is just over the top (it's a black tie affair, held at the Meridian House in D.C., and hosted by a who's who of Hollywood, including Mike Johnson, Ann Johnson, their son Josh Johnson, their sitter Amy Williams, their lawn and pool maintenance guy Alan Clark, and the assistant branch manager of the closest Bank of America to their house, Bill "Scooter" Davis. So basically, it's Hollywood's elite rolling out the red carpet for yours truly). But, despite all the pomp and circumstance that goes with a prestigious induction into the Chapter Opener Hall of Fame, it's the free swag bag honorees get that everybody wants to get their hands on. Inside, you'll find an array of fabulous goodies, like: a $20 gift card to Applebee's, a light blue t-shirt with "Come to the nerd side. We have Pi" and the Pi symbol on it (size XL or S), a Geico Insurance key chain (pretty sweet, and useful), a beer koozie with a logo from a golf tournament, a Conair 1875-watt mid-size blow dryer (black with retactable cord), and a coupon for 50% off a $5 footlong at Subway (making it a $2.50 footlong). That's hard to beat. $2.50 for a footlong sandwich. Footlong! Seriously, where are you going to get a deal like that?

Adding Vignetting Effects

An edge vignette effect (where you darken all the edges around your image to focus the attention on the center of the photo) is one of those effects you either love or that drives you crazy (I, for one, love 'em). Here we're going to look at how to apply a simple vignette; one where you crop the photo and the vignette still appears (called a "post-crop" vignette); and how to use the other vignetting options.

Step One:
To add an edge vignette, start by clicking on the Lens Corrections icon (the sixth icon from the left) at the top of the Panel area, and then click on the Manual tab (as shown here).

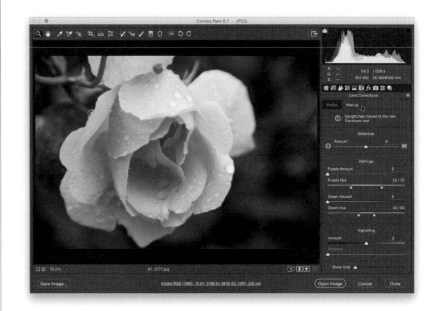

Step Two:
In the Vignetting section, you're going to drag the Amount slider to the left, and as you drag left, you'll start to see vignetting appear in the corners of your photo. But since it's just in the corners, it looks like the bad kind of vignetting, not the good kind, so you'll need to make the vignetting look more like a soft spotlight falling on your subject. Drag the Midpoint slider quite a bit to the left, which increases the size of the vignetting and creates a soft, pleasing effect that is very popular in portraiture, or anywhere you want to draw attention to your subject. That's it!

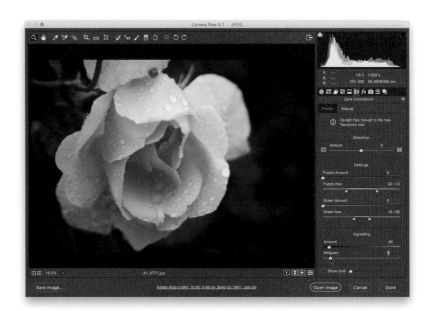

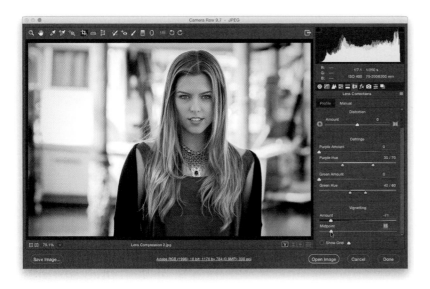

Step Three:

So far, adding the vignette has been pretty easy—you just drag a couple of sliders, right? But where you'll run into a problem is when you crop a photo, because you're also cropping the vignetting effect away, as well (after all, it's an edge effect, and now the edges are in a different place, and Camera Raw doesn't automatically redraw your vignette at the newly cropped size). So, start by applying a regular edge vignette (as shown here).

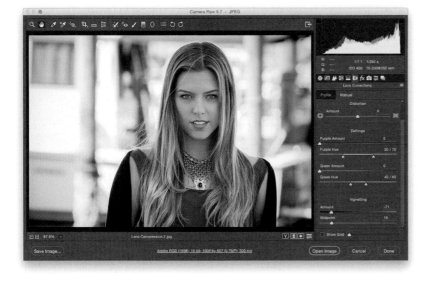

Step Four:

Now, let's get the Crop tool **(C)** from the toolbar, crop that photo in pretty tight, and you can see what the problem is—the vignette effect we just added is pretty much gone (the dark edges were cropped away).

(Continued)

Step Five:

Let's go add a post-crop vignette by clicking on the Effects icon (the fourth icon from the right) at the top of the Panel area and, under Post Crop Vignetting, dragging the Amount slider to the left to darken the edges. Then, use the Midpoint slider to choose how far into your image this vignetting will extend (as seen here). Now, at the top of the Post Crop Vignetting section is a pop-up menu with three different types of vignetting: Highlight Priority (which I think far and away looks the best, and the most like the original vignetting we applied back in Step Three), which tries to maintain the highlight details as the edges are darkened; Color Priority tries to maintain the color while the edges are darkened (it's okay, but not great); and Paint Overlay is an old method from CS4 that almost everybody hated (apparently somebody liked it, because it's still there). I would stay away from this one altogether.

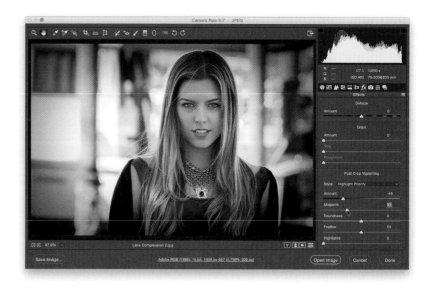

Step Six:

Below the Midpoint slider is the Roundness slider that gives you control over the roundness of the vignetting (lower the Feather amount to 0, so you can get a better idea of what the Roundness slider does). The farther to the right you drag, the rounder the shape gets, and when you drag to the left, it actually becomes more like a large, rounded-corner rectangle. The Feather slider determines how soft that oval you created with the Roundness slider becomes. I like it really soft, so it looks more like a spotlight, so I usually drag this slider quite a bit over to the right (here I dragged it over to 73, but I wouldn't hesitate to go higher, depending on how it looks on the photo).

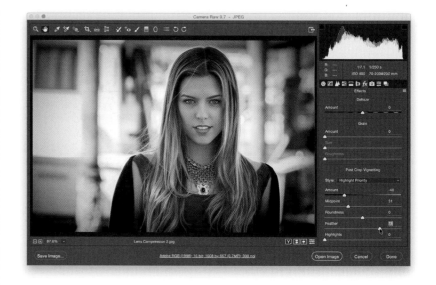

Adding Custom Vignettes & Spotlights

In the previous technique, we looked at adding edge vignettes in Camera Raw (where the outside edge around your image is darkened), but when we added them using those methods, your subject had to be right in the center, since it darkened evenly around the outside edges. With the Radial Filter, you can control placement of your vignette, so it's right where you want it, and you can have multiple sources of light, so you can also use it as a spotlight effect or to re-light your image after the fact.

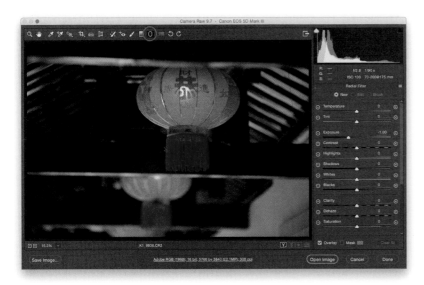

Step One:

Here, we want to focus the viewer's attention on the lamp that's in focus (using dramatic lighting) rather than the outside edges of the image. So, click on the Radial Filter tool **(J)** up in the toolbar (it's shown circled here in red). Since we want to darken the outside edges, click the – (minus sign) button to the left of the Exposure slider a couple times, so when we use the tool it will be easy to see the effect (we can always change the amount later).

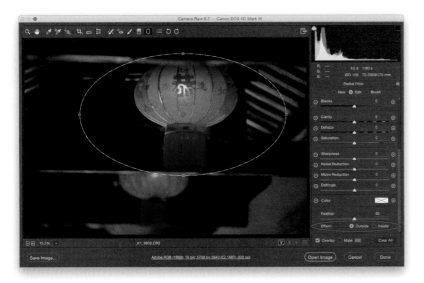

Step Two:

At the bottom of the options panel, you'll see an Effect option, which lets you choose whether it's the area inside the circle that gets affected or the area outside. In this case, we want what's inside to remain unchanged and everything outside it to be darker, so click the Outside radio button. Now, click-and-drag out the tool in the basic direction you want your oval (or circular) pool of light to appear. Here, I dragged it out over the center of the area I want to affect.

TIP: Repositioning as You Drag

As you're dragging out your oval, you can reposition it as you're dragging by pressing-and-holding the **Spacebar**. Try it. It's really handy.

(Continued)

Step Three:

Once your oval is in place, you can rotate it by moving your cursor outside the green overlay and clicking-and-dragging in the direction you want to go. To resize the oval, just click on any one of the little handles on the edges, and drag out or in. To move the oval, just click anywhere inside the overlay and drag it where you want it. While we're here, let's make the area outside of the "lit" area darker. Drag the Exposure slider to the left until it reads –1.75 (as seen here).

TIP: Two Handy Keyboard Shortcuts

Pressing the letter **V** hides the green overlay oval from view (press V again to get it back; you'll see I turned it off in the next step), and pressing the letter **X** swaps the Effect from Outside to Inside (so, instead of the outside being dark in this case, it makes the center dark and everything outside the oval unchanged).

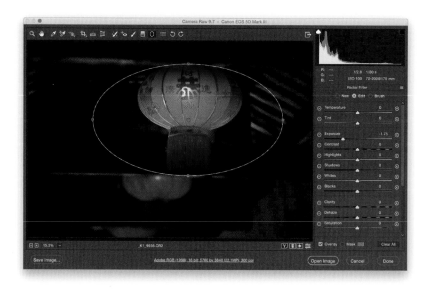

Step Four:

The nice thing about this filter is that you can do more than just adjust Exposure. For example, drag the Contrast slider over to the right (as I did here to +34) and this makes that outside area more contrasty. You could also lower the Saturation and then everything outside the oval would not only be darker, but black and white (or vice versa if you increased the Saturation). Now, I mentioned in the intro on the previous page that you could add multiple filters on the same image and that you could use it to effectively re-light an image. So, let's do that next.

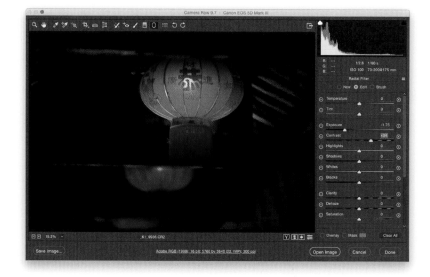

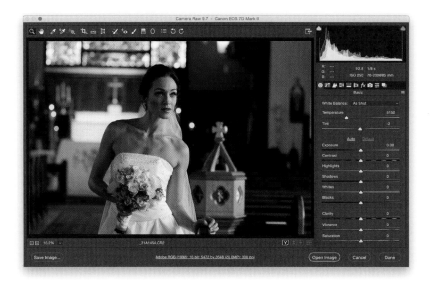

Step Five:

Here we're going to re-light this image using the Radial Filter. The viewer's eye is drawn to the brightest part of the image first, but unfortunately, in this shot, the light on our subject is not as bright as the light coming through the stained glass window and on the altar behind her, which draws your eye away from her face. The light on our subject is at least directional, nice, and soft—it's just not quite bright enough.

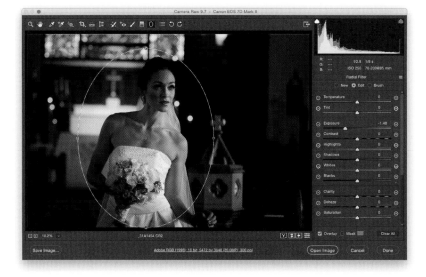

Step Six:

We'll start the same way we did the last one—by selecting the Radial Filter tool and dragging out an oval in the direction we want it. In this case, I want her to remain the same, but I want the area around her much darker. So, make sure the Outside Effect radio button is selected and drag the Exposure slider way over to the left to darken the area outside the oval (here I dragged it to –1.40).

TIP: Removing Ovals

If you want to remove an oval you've created, either click on it and hit the **Delete (PC: Backspace) key,** or move your cursor over the center point of the oval, press-and-hold the **Option (PC: Alt) key,** and your cursor will turn into a pair of scissors. Now, click on the center point of the oval to delete it. Also, just as a general rule, when you have this scissor tool, don't run. Sorry, I couldn't help myself.

(Continued)

Step Seven:

To add another oval, click the New radio button at the top of the Panel area (so Camera Raw knows you want to create a new pool of light), then at the bottom of the panel, switch the Effect to Inside (or use the shortcut I mentioned earlier: X). Now, we're going to use this oval to light her bouquet, which is getting a bit lost. So, drag out a small oval over her bouquet, but this time, you'll brighten this area by dragging the Exposure slider to the right a bit (as I did here, where I dragged to +1.10).

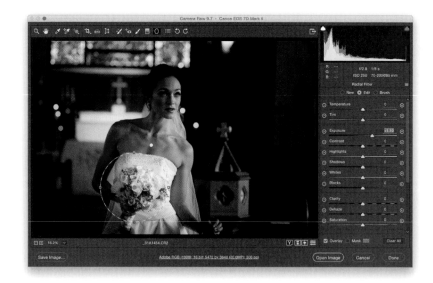

Step Eight:

We need another of the exact same oval to light her face a bit better. Rather than starting from scratch, we'll duplicate the second oval. Press-and-hold **Command-Option (PC: Ctrl-Alt)** and when your cursor changes into two small arrows, click-and-drag on the center of your second oval, release your mouse button and those keys, and a third oval (a duplicate of your second one) appears. Place it right on her face (as shown here) and rotate and resize it as necessary. Increase the Exposure a little (I set it to +1.15), and you could try increasing the Shadows to open up detail there (I increased it to +14). Remember, you can use any of the sliders in the panel. I also ended up making another duplicate of the oval over the flowers and placed it over her arm on the left (as seen in the next step) since it was looking a little too dark.

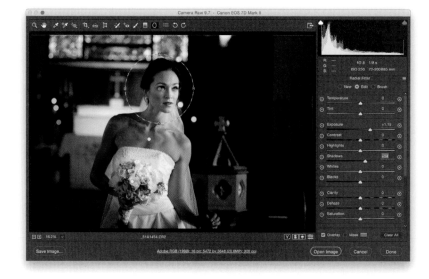

TIP: Controlling the Edge Blending

The softness of the transition between the center of your oval and the area being affected by the sliders is controlled by the Feather amount and, at a setting of 100, you get the softest, smoothest blending between the two. If you lower the Feather amount, the transition area becomes smaller and, of course, if you drag it to zero, it becomes a downright hard edge. Never had a use for that. Ever.

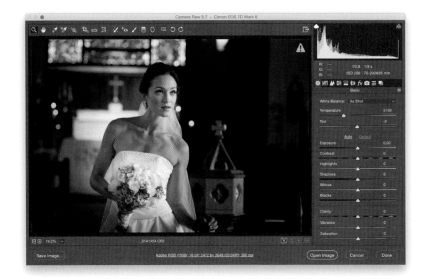

Step Nine:
One more thing to think about: What we've mostly done here is darken the area around our subject (well, except for those small areas we brightened). But, if we want to make her brighter overall, we'll need to go back to the Basic panel and drag the Exposure slider to the right (I didn't need to here). This would make her brighter, but also make the entire photo brighter at the same time. So, if the edges of the image then look too bright, you can go back to the Radial Filter tool, click on the first oval you made, and decrease (darken) the Exposure slider some more (that will only affect the area around her). I'm showing the before image below, as well, so you can see how dramatically we've re-lit the image using the Radial Filter.

Before

After

Stitching Panoramas Right in Camera Raw

We can now create panoramic images (stitching multiple frames into one very wide, or very tall shot) right in Camera Raw—no more trips over to Photoshop necessary. And, I gotta tell ya, I like the way Camera Raw does it better than Photoshop anyway. It's quick and easy and it does a great job. Here's how to start stitching your own panos:

Step One:

Start by selecting the images you want combined into a panorama (or pano, for short) in Bridge, and then press **Command-R (PC: Ctrl-R)** to open them in Camera Raw.

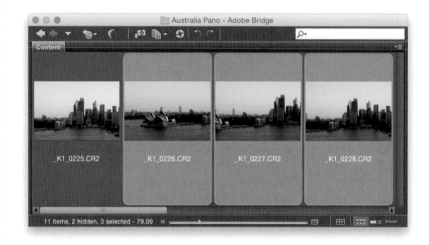

Step Two:

When the images open in Camera Raw, they'll appear in the Filmstrip along the left side of the window. If you want to make adjustments to the images before you create your pano, click on the little icon to the right of Filmstrip (up in the top left) and choose **Select All** (or just press **Command-A [PC: Ctrl-A]**), so any changes you make are automatically applied to all the selected images. Here, I decreased the Exposure (to –0.50), increased the Contrast (to +23), pulled back the Highlights (to –93) to bring back some color in the sky, and bumped up the Shadows (to +95) to see more detail. I also set the white and black points (by pressing-and-holding the Shift key and double-clicking on the Whites and Blacks slider knobs), then cranked up the Clarity (to +41) to accentuate the texture, and the Vibrance (to +30). Once you're done with your adjustments, with all the images still selected, go back under the Filmstrip's flyout menu, and choose **Merge to Panorama** (as shown here; or just press **Command-M [PC: Ctrl-M]**).

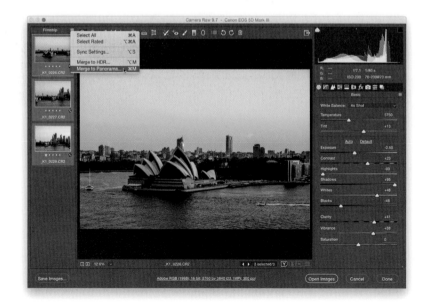

Step Three:

This will bring up the Panorama Merge Preview dialog, unless it can't stitch it together—maybe you didn't overlap each frame enough when you shot, or you tilted the camera too much so it just won't work. If that happens, you'll get an Error dialog (seen here) telling you, "I can't stitch this" (but in a much more formal way), and unfortunately there's not much you can do at that point except go reshoot the pano.

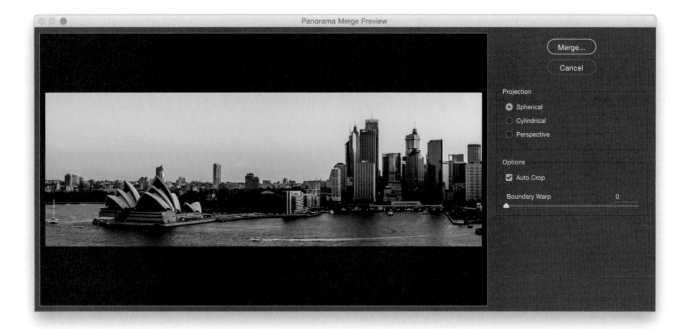

Step Four:

If it's able to stitch it together, you'll get a dialog telling you that it's merging the pano preview, and then the Panorama Merge Preview dialog will appear (seen here). By the way, the dialog is resizable, so you can click-and-drag the bottom right of it way out to the right to make it more like the shape of a horizontal pano.

(Continued)

Step Five:

In the Options section on the right, there's an option to automatically crop away any of the white gaps that normally appear around the edges of your image from the process of putting this all together into one image. If you'd like a more control of what gets cropped, keep the Auto Crop checkbox turned off and use the Boundary Warp slider to fill the canvas as much as you can. Then, turn on the Auto Crop checkbox to remove the remaining white gaps (when you're back in Camera Raw, after your pano is stitched, you can click on the Crop tool and it'll reveal the cropped away areas, so you can re-crop, if needed).

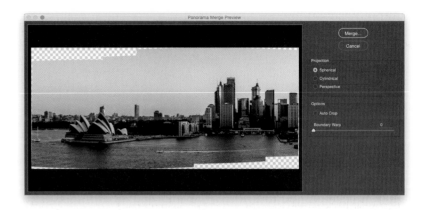

Step Six:

At the top of the options on the right you can choose your Projection (the method Camera Raw uses for creating your pano). Here's what these three do: Perspective assumes the center image that makes up the pano is the focal point, and it does whatever it needs to do (including tweaking, warping, bending, etc.) to the other images so they fit nicely with that center one. Cylindrical seems to work best with really wide panos, and it tries to keep the height of all the images consistent so your pano doesn't wind up with the "bowtie" effect—where the ends of the pano are tall and then they angle inward toward the center image like a real bowtie. Spherical is for stitching 360° panos (and is what I left it set at, as it gave me the best result). Okay, now you can click the Merge button and your final pano is rendered (it takes a minute. Or two. Or more).

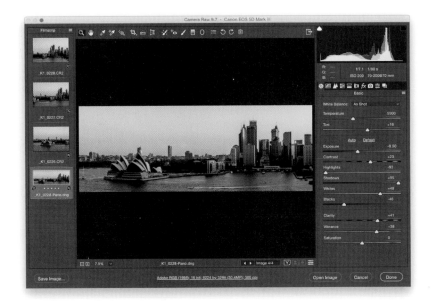

Step Seven:

When it's finished rendering, your final stitched pano appears as a (RAW) DNG file in Camera Raw's Filmstrip, and is saved in the same folder as the images you used to create the pano. You can continue tweaking the pano like you would any regular single image. *Note:* When your pano is created, Camera Raw adds the word "Pano" to the end of its filename (as seen here).

TIP: Making HDR Panos

If you shot bracketed images when you were making your pano, first use the Photo Merge HDR feature (see Chapter 8 for more on HDR) to combine each set of bracketed photos into individual HDR images, then select all the compiled HDR images, open them in Camera Raw, and choose Merge to Panorama from the Filmstrip's flyout menu to turn those into an HDR pano.

Double-Processing to Create the Uncapturable

As good as digital cameras have become these days, when it comes to exposure, the human eye totally kicks their butt. That's why we shoot so many photos where our subject is backlit, because with our naked eye we can see the subject just fine (our eye adjusts). But when we open the photo, the subject is basically in silhouette. Or how about sunsets, where we have to choose which part of the scene to expose for—the ground or the sky—because our camera can't expose for both? Well, here's how to use Camera Raw to overcome this exposure limitation:

Step One:
Open the photo you want to double-process. In this example, the camera properly exposed for the sky in the background, so the buildings and river in the foreground are dark. Of course, our goal is to create something more like what our eye sees, but our camera can't—a photo where the buildings, river, and sky are each exposed properly. Plus, by double-processing (editing the same RAW photo twice), we can choose one set of edits for the sky and another for the foreground, to create just what we want. (*Note:* Much of this can also be done using Camera Raw's Adjustment Brush. See Chapter 3 for more.)

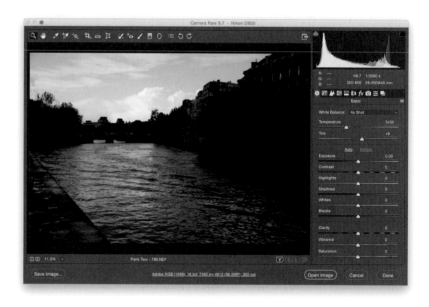

Step Two:
Let's start by making the foreground more visible. Drag the Shadows slider to the right (I dragged it to +37), and then bump up the Exposure slider, as well (here, I've dragged it over to +0.65). The buildings and river look kind of "flat" contrast-wise, so bump up the Contrast a bit, too (let's go to +45). Lastly, since the buildings are brick, and we want to accentuate their texture, let's crank the Clarity up to around +32, and then make the little bit of color that's there more vibrant by increasing the Vibrance to around +28. Now, press-and-hold the Shift key, and the Open Image button changes to Open Object (as seen here). Click it.

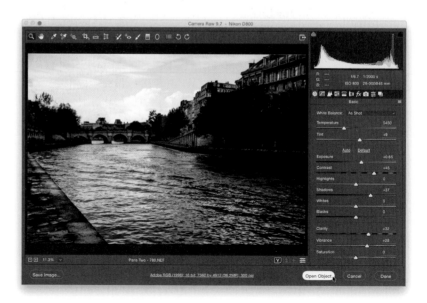

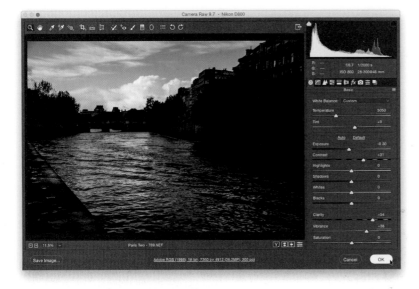

Step Three:

Clicking Open Object makes your image open in Photoshop as a smart object (you'll see the layer thumbnail has a little page icon in the bottom-right corner). Now we need a second version of this image, because the sky looks a bit too light in this version. In our second version of this RAW file, we'll focus on just the sky. If you were to duplicate the layer by dragging it onto the Create a New Layer icon, the double-processing wouldn't work. That's because the duplicate layer would be tied to the original layer, so any changes you made to the duplicate would also automatically be applied to the original layer. We need to be able to edit these two layers separately from each other. Basically, we need to break the link between the two layers. To do that, go to the Layers panel, Right-click on the layer, and from the pop-up menu that appears, choose **New Smart Object via Copy**. This gives you a duplicate layer, but breaks the link to the original layer.

Step Four:

Now, double-click directly on this duplicate layer's thumbnail and it opens this duplicate in Camera Raw. Here, you're going to expose for the sky, without any regard for how the foreground looks (it will turn really dark, but who cares—you've already got a version with it properly exposed on its own separate layer, right?). So, first click the Default button to reset the sliders to 0, then drag the Exposure slider over to the left (I went to –0.30), and drag the Contrast slider to +31 to help define the clouds. I also dragged the Temperature slider a little to the left (to 5050) to make the sky bluer, and lastly, I increased both the Clarity and Vibrance a bit (to +54 and +38, respectively). Once the sky looks good, click OK.

(Continued)

Step Five:

You now have two versions of your photo, each on a different layer—the brighter one exposed for the buildings and river in the foreground on the bottom layer, and the darker sky version on the layer directly on top of it—and they are perfectly aligned, one on top of the other. This is why we call it "double-processing," because you have two versions of the same image, each processed differently. Now what we need to do is combine these two different layers (with different exposures) into one single image that combines the best of both. It'll be easier if we have the image with the properly exposed foreground as our top layer, so click on that layer and drag it above the darker sky layer (as seen here). We'll combine the images with a layer mask, but rather than painstakingly painting it, we can cheat and use the Quick Selection tool **(W)**. So, get it from the Toolbox and paint over the sky, and it selects it for you in just a few seconds (as shown here).

Step Six:

Press **Command-Shift-I (PC: Ctrl-Shift-I)** to Inverse your selection, so the foreground is selected. Then, go to the Layers panel and click on the Add Layer Mask icon at the bottom of the panel (shown circled here in red). This converts your selection into a layer mask, which hides the light sky and reveals the new darker sky layer in its place (as seen here).

Step Seven:

Now, you're going to lower the Opacity of this top layer (the brighter foreground layer), so it blends in a little better with the darker sky layer. Here, I've lowered it to 80%, and the colors match better.

TIP: Always Opening Your Images as Smart Objects

If you always want your RAW-processed images to open as smart objects, click on the workflow options link at the bottom of the Camera Raw dialog (the white, underlined text below the Pre-view area), and when the dialog appears, turn on the Open in Photoshop as Smart Objects checkbox at the bottom.

Step Eight:

Now, we have a pretty common problem to deal with here: when we lightened the foreground, we ended up with a bit of noise (I zoomed in here to 100%, so you can see it better). Luckily, that's fairly easy to fix in Camera Raw. First, we'll have to go to the Layers panel and, from the flyout menu at the top right, choose **Flatten Image** to flatten the image down to one layer, and then save it.

(Continued)

Step Nine:

Now, go under the Filter menu and choose **Camera Raw Filter** to reopen the image in Camera Raw.

Step 10:

Go to the Detail panel (the third icon from the left at the top of the Panel area) and, under Noise Reduction, drag the Luminance slider to the right until the noise goes away (I dragged it to 20).

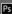

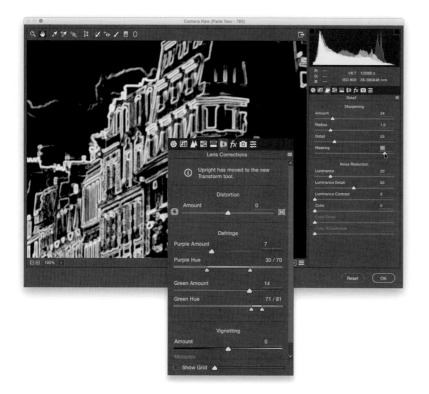

Step 11:

Getting rid of the noise made the edges a little soft, so go up to Sharpening and drag the Amount slider to the right a bit (here, I dragged it to 34). Then, to keep the sharpening only on the edges, press-and-hold the Option (PC: Alt) key and drag the Masking slider to the right. Finally, I went to the Lens Corrections panel (the fourth icon from the right at the top of the Panel area) and adjusted the Defringe sliders to remove the green and purple fringe appearing around some of the edges of the buildings. When you're done, click OK. You can see a before/after of our double-processed image below.

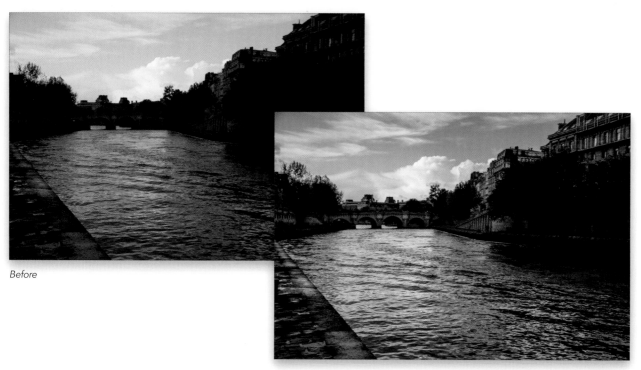

Before

After

Applying Selective Color in Camera Raw

There are some really nice special effects you can apply from right within Camera Raw itself, and some of these are easier to achieve here than they are by going into the rest of Photoshop and doing it all with layers and masks. Here is a special effect that is popular in portrait and wedding photography: drawing attention by turning everything black and white, but leaving one key object in full color (and while we photographers cringe at the sight of it, clients absolutely love it).

Step One:

For this effect (where we make one part of the image stand out by leaving it in color, while the rest of the image is black and white [I know it's cheesy, you know it's cheesy, but, again, clients love it]), we want to set up the Adjustment Brush so it paints in black and white. Start by getting the Adjustment Brush **(K)** from the toolbar, then in the Adjustment Brush options panel, click on the – (minus sign) button to the left of Saturation four times to reset all the other sliders to 0 and set the Saturation to –100. That way, whatever you paint over becomes black and white.

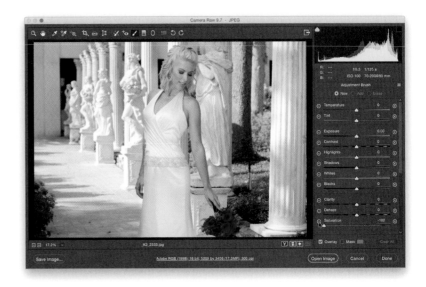

Step Two:

In just a moment, we're going to paint over most of the image, and this will go a lot faster if you turn off the Auto Mask checkbox near the bottom of the panel (so it's not trying to detect edges as you paint). Once that's off, make your brush nice and big (drag the Size slider to the right or press the **Right Bracket key**), and paint over most of the image, but make sure you don't get too close to the area right around the bouquet, as shown here, where I left about a ½" area untouched all around it.

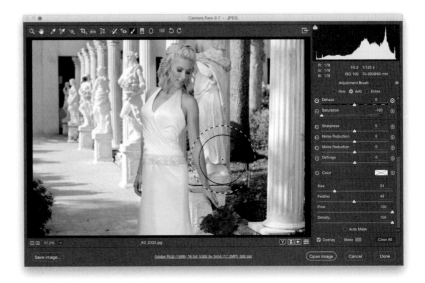

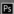

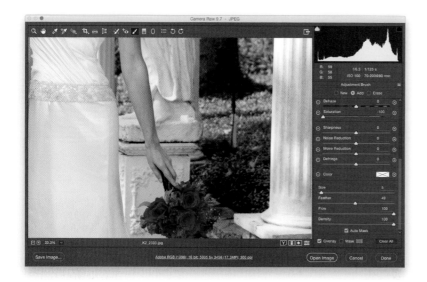

Step Three:

Now you'll need to do two things: (1) make your brush size smaller, and (2) turn on the Auto Mask checkbox. The Auto Mask feature is really what makes this all work, because it will automatically make sure you don't accidentally make the object in your image that you want to remain in color, black and white, as long as you follow one simple rule: don't let that little plus-sign crosshair in the center of the brush touch the thing you want to stay in color (in our case, it's the bouquet of flowers). Everything that little crosshair touches turns black and white (because we lowered the Saturation to –100), so your job is to paint close to the flowers, but don't let that crosshair actually touch the flowers. It doesn't matter if the edges of the brush (the round rings) extend over onto the flowers (in fact, they'll have to, to get in really close), but just don't let that little crosshair touch, and you'll be fine. This works amazingly well (you just have to try it for yourself and you'll see).

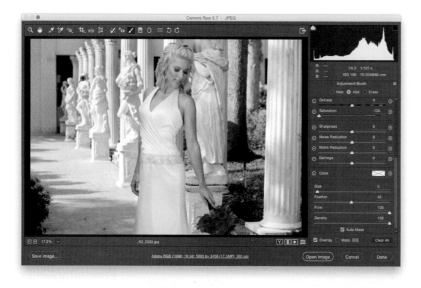

Step Four:

Here, we've painted right up close to the bouquet and yet the flowers and even the green stems are still in color because we were careful not to let that crosshair stray over onto them.

Wet Streets and Cobblestones

This one is a quickie that lets you turn a dry cobblestone or asphalt street into a wet cobblestone or asphalt street. I showed this technique on a live webcast I did about travel photography editing techniques, and a month later people were still asking about it. So, I wanted to include it here in the book. What I love best is that it's quick, easy, and it usually works.

Step One:

You need to do this one in Camera Raw, but don't worry, even if you didn't shoot your image in RAW (this image is a JPEG I shot on a trip to Iceland), you can still use Camera Raw to edit the shot. With the image open in Photoshop, go under the Filter menu and choose **Camera Raw Filter** to open the image in Camera Raw (as seen here). Go ahead and make any regular tweaks to the image while you're here in the Basic panel. Here, I increased the Exposure a little, and then Shift-clicked on the Whites and Blacks sliders to have Camera Raw automatically set the white and black points. I also increased the Vibrance a bit.

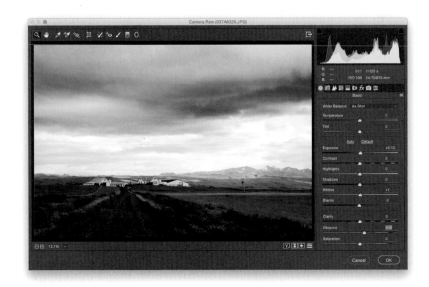

Step Two:

Click on the Adjustment Brush tool **(K)** up in the toolbar and in the Adjustment Brush panel on the right, click on the + (plus sign) button to the right of Contrast. This zeros out all the other sliders and increases the Contrast amount by +25. Go ahead and drag that slider to +100. Now, drag the Clarity slider to +100, too. That's it—that's the recipe. Paint over the surface you want to appear wet and, as you paint, the area looks wet and appears to add reflections like an actual wet street.

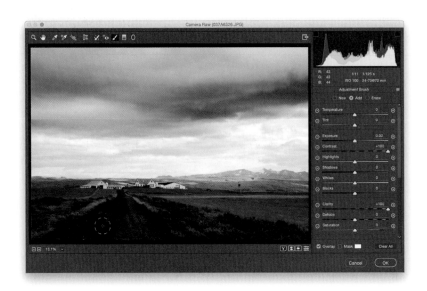

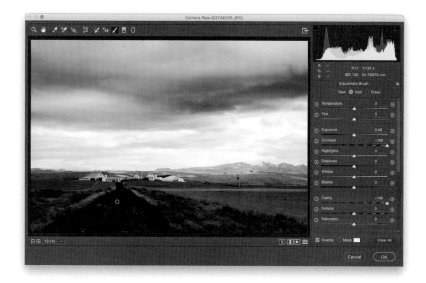

Step Three:

Don't forget to paint over any sidewalks and curbs in your photos, as well. Also, if you paint over the street and it doesn't look "wet" enough, just click on the New radio button at the top of the Adjustment Brush panel and start painting over the same area, but start in a different part of the street (that way, you're stacking this second pass of the look over the first coat of "wet"). By the way, if for any reason the street looks too bright from applying that much Clarity, just lower the Exposure slider a little bit for each pin, so it looks to have about the same brightness overall.

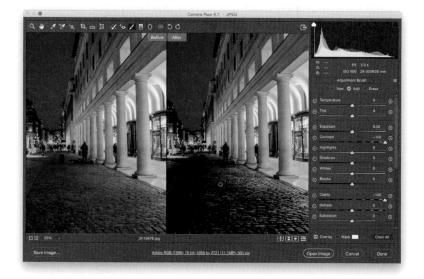

Step Four:

This technique looks particularly great on cobblestone streets, and I did a before/after here in Camera Raw so you can see an example. Okay, that's it. Instant wet streets.

Converting to Black and White

Although Photoshop has its own Black & White conversion adjustment layer, I never, ever use it, but that's only because it totally stinks (I don't know any pros who use it). I think you can create a much better black-and-white conversion using Camera Raw—it's much faster and looks infinitely better. Well, that is as long as you don't get suckered into using the HSL/Grayscale panel in Camera Raw, which is nothing more than the Black & White adjustment layer hiding in Camera Raw, trying to lure in some poor unsuspecting soul.

Step One:

We'll start by opening a color image in Camera Raw (as seen here). Converting from color to black and white is simple—just click on the HSL/Grayscale icon (the fourth one from the left) at the top of the Panel area, and then turn on the Convert to Grayscale checkbox at the top of the panel (as seen here). That's all you want to do here (trust me).

Step Two:

Once you click on that Convert to Grayscale checkbox, it gives you an incredibly flat conversion (like you see here), and you might be tempted to drag those color sliders around, until you realize that since the photo is already converted to black and white, you're kind of dragging around in the dark. So, the best advice I can give you is to get out of this panel just as fast as you can. It's the only hope for making this flat-looking grayscale image blossom into a beautiful butterfly of a B&W image (come on, I at least get five points for the butterfly metaphor).

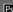

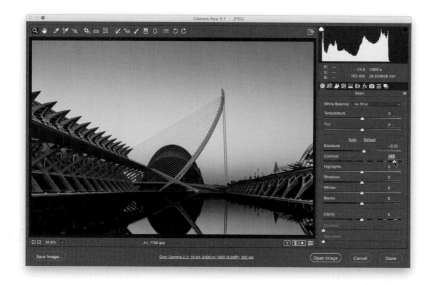

Step Three:

When you talk to photographers about great B&Ws, you'll always hear them talk about high-contrast B&Ws, so you already know what you need to do—you need to add lots of contrast. That basically means making the whites whiter and the blacks blacker. So, start in the Basic panel by adjusting the Exposure slider to start things off (here, I dragged it to +0.25), then add lots of contrast by dragging the Contrast slider way over to the right (here, I dragged to +83). That looks a little better, but we've got more to do!

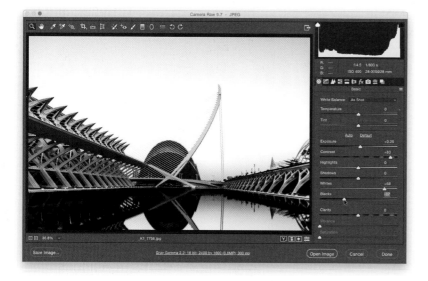

Step Four:

Now, let's set our white and black points. Start by dragging the Whites slider as far to the right as you can without clipping the highlights (in other words, drag until you see the white triangle in the top right of the histogram appear [that's the highlight clipping warning], then back it off just a tiny bit, until it turns black again). Here, I dragged it over to +68. Now, drag the Blacks slider to the left until it really starts to look nice and contrasty (as shown here, where I dragged to –37). Okay, it's starting to look a lot better, but we're not quite there yet.

(Continued)

Step Five:

The reflection is kind of dark, so drag the Shadows slider to the right to lighten those areas a bit (I dragged to +19). Then, increase the Clarity amount quite a bit, which adds midtone contrast and makes the image more punchy and a little brighter, too (here, I pushed it over to +35). Also, the sky looks really white, so let's pull back those highlights by dragging the Highlights slider to the left (here, I dragged to –67). I also pulled back the Whites a little to keep them from clipping.

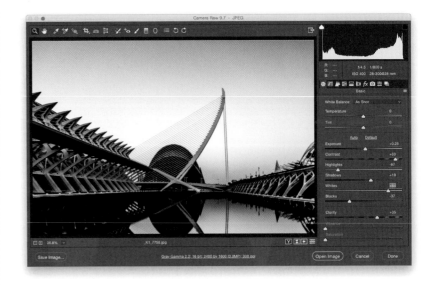

Step Six:

Now, if you feel like it could still be more contrasty (I do), then go to the Tone Curve panel (the second icon from the left, at the top of the Panel area) and choose **Medium Contrast** from the Curve pop-up menu at the top of the Point tab (as shown here). If you need more contrast, try Strong Contrast instead. A before/ after is shown on the next page. Pretty striking difference, eh?

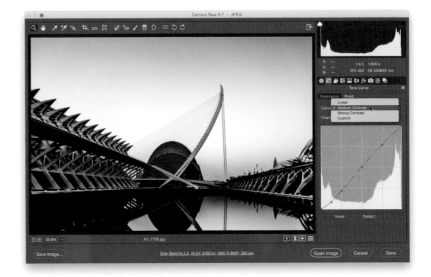

Before

After

Split Toning

Split toning is a traditional darkroom special effect where you apply one tint to your photo's highlights, and one tint to your photo's shadow areas, and you can even control the saturation of each tint and the balance between the two for some interesting effects. Although split-toning effects can be applied to both color and B&W photos, you probably see it most often applied to a B&W image, so here we'll start by converting the photo to black and white, then apply the split-tone effect.

Step One:

Start by opening your full-color image in Camera Raw, and then converting it to black and white by clicking on the HSL/Grayscale icon (the fourth icon from the left) at the top of the Panel area and turning on the Convert to Grayscale checkbox at the top of the panel (see Chapter 10 for one of my favorite methods for converting to black and white).

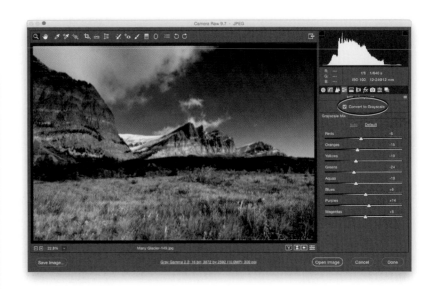

Step Two:

Now, click on the Split Toning icon (the fifth icon from the left) at the top of the Panel area. At this point, dragging either the Highlights or Shadows Hue slider does absolutely nothing because, by default, the Saturation sliders are set to 0. So, do yourself a favor and drag the Highlights Saturation slider over to around 25, so at least you can see what it looks like while you're dragging the Hue slider. As soon as you do this, you'll see the default tint color for Hue (which is kind of pinkish).

TIP: Seeing Your Colors

To temporarily see your hues at their full 100% saturation, just press-and-hold the Option (PC: Alt) key, then click-and-drag a Hue slider. It helps when picking your colors, if you don't feel like taking my advice and increasing the saturation (like I mentioned at the end of Step Two).

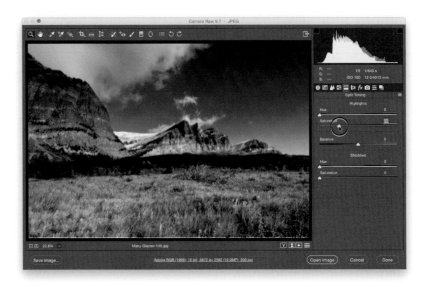

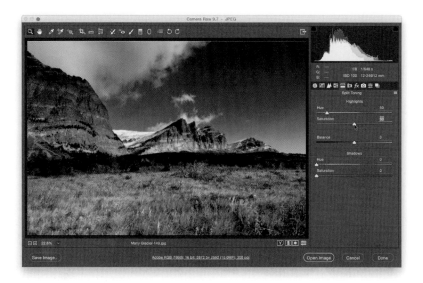

Step Three:

Now that you can see what's going on, click-and-drag the Highlights Hue slider until you find a highlight hue you like. For this image, I'm using a Hue setting of 50, and I also increased the Highlights Saturation amount to around 50 to make the tint a bit heavier.

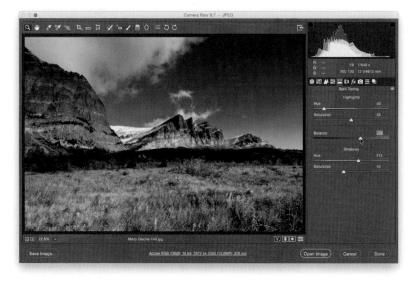

Step Four:

Let's add a teal tint to the shadows (a fairly popular spilt-tone combination) by dragging the Shadows Saturation slider to 40 (so you can see the shadows hue), then drag the Shadows Hue slider over to 215, and now you see that teal tint in the shadow areas. There is one more control—a Balance slider, which lets you control whether your split tone favors your highlight or shadow color. Just drag left, then back right, and you'll instantly see what this slider does (here, I dragged the Balance slider over to the right to +25, and you can see that the split tone now has more yellow in the highlight areas). If you do find a split-toning combination you like (hey, it could happen), I'd definitely jump to page 133 to find out how to turn that into a one-click preset, so you don't have to go through all this every time you want a quick split-tone effect.

Duotones Made Crazy Easy

Don't let the fact that this technique fits neatly on one page make you think it's not a rocking technique, because this is the best and fastest duotone technique I've ever used (and it's the only one I use in my own workflow). I used to do a more complicated version, but then my buddy Terry White showed me a technique he learned from one of his buddies whose duotones he adored, and well… now I'm passing it on to you. It's very easy, but man does it work like a charm.

Step One:

Start by opening your full-color image in Camera Raw, and then converting it to black and white by clicking on the HSL/Grayscale icon (the fourth icon from the left) at the top of the Panel area and then turning on the Convert to Grayscale checkbox at the top of the panel (see Chapter 10 for one of my favorite methods for converting to black and white).

Step Two:

Now, click on the Split Toning icon at the top of the Panel area (it's the fifth icon from the left), and then, in the Shadows section, increase the Saturation amount to 25 as a starting point. Next, just drag the Shadows Hue slider until you have a nice sepia-tone hue (I generally use something around 30. If you think it's too intense, lower the Saturation and you're done. That's right—completely ignore the Highlights controls altogether, and you'll love the results you get (ignore the powerful pull of the Highlights sliders. I know you feel on some level that they will make things better, but you are already holding the magical key to great duotones. Don't blow it!). That's it—that's the whole ball of wax (I told you it was easy, but don't let that fool you. Try printing one of these and you'll see what I mean). Mmmm. Duotone.

Creating Your Own One-Click Presets in Camera Raw

Now that we created a split tone and duotone, this is the perfect time to start making your own one-click presets. That way, the next time you open a photo that you want to have that same effect, you don't have to go through all those steps (converting it to black and white, tweaking it, then applying the Split Toning settings), you can just click one button and all those settings are applied at once, giving you an instant one-click effect anytime. Of course, these presets aren't just for split tones and duotones—make one anytime you want to reuse any settings from Camera Raw.

Step One:

Since we just created that duotone effect in Camera Raw, we'll go ahead and use that to create a one-click preset there. Just remember—anytime you come up with a look you like, you can save it as a preset. To create a preset, you click on the Presets icon (it's the second icon from the right at the top of the Panel area), and then click on the New Preset icon (shown circled here in red) to bring up the New Preset dialog (seen here). Now, just turn on the checkboxes for the adjustments you want copied to your preset (as I did here), give your preset a name, and then click the OK button.

Step Two:

Once you've saved the preset, it appears in the Presets list (since there's only one preset here, I'm not sure it qualifies as a list at this point, but you get the idea, right?). To apply it is really a one-click process—just open a different photo, go to the Presets panel, and click on the preset (as shown here), and all those settings are applied. Keep in mind, though, because the exposure is different for every photo, if you save a preset where you had to tweak the exposure a lot, that same exposure will be applied anytime you apply this preset. That's why you might want to save just the split-tone/duotone settings and not all the exposure stuff, too.

Photoshop Killer Tips

Why the Fill Dialog Shows Up Sometimes, but Not Others

If you have a flattened image (so, it's just a Background layer), and you make a selection and press the **Delete (PC: Backspace) key**, the Fill dialog appears (Content-Aware is selected in the Use pop-up menu, by default). But there are times when hitting Delete won't bring up the Fill dialog. Instead, if you have a multi-layered document, it will delete whatever is inside the selection on your current layer, making it transparent. (That's either, "Yikes!" or "Great!" depending on how you look at it.) Also, if you have only one single layer (that is not a Background layer), you'll again delete anything inside your selection and make it transparent. So, to bring up the Fill dialog in those instances, just use **Shift-Delete (PC: Shift-Backspace)** instead.

Move an Object Between Documents and Have It Appear in the Exact Same Place

If you have something on a layer in one document, and you want the object to appear in the exact same place in another open document, here's what you do: First, press-and-hold the Command (PC: Ctrl) key, go to the Layers panel, and click on the layer's thumbnail to put a selection around your object. Then, press **Command-C (PC: Ctrl-C)** to Copy that object into memory. Switch to the other

document, then go under the Edit menu, under Paste Special, and choose **Paste in Place**. Now it will appear in the exact same position in the other document (provided, of course, the other document is the same size and resolution). This also works with selected areas—not just layers.

Removing Red Eye

If you have a photo that has someone with the dreaded red-eye problem, it's a 15-second fix. Use the Zoom tool **(Z)** to zoom in tight on the eye, then get the Red Eye tool from the Toolbox (it's under the Spot Healing Brush, or press **Shift-J** until you have it). Click it once on the red area of the eye, and in just a second or two, the red is gone. If your first try doesn't select all the red, increase the Pupil Size up in the Options Bar. If the retouch doesn't look dark enough (the pupil looks gray, rather than black), just increase the Darken Amount up in the Options Bar.

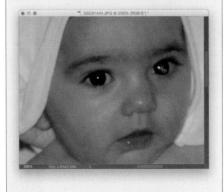

Dragged-and-Dropped Images Don't Have to Appear as Smart Objects

You can drag-and-drop images from Bridge right into open documents (and if there isn't a document open, it'll open as a new document), but by default it always drags in as a smart object. If you'd rather it didn't, press **Command-K (PC: Ctrl-K)** to bring up Photoshop's General Preferences, click on General on the left, then

turn off the checkbox for Always Create Smart Objects When Placing in the Options section.

Doing a Smooth Zoom In

Another way to zoom in on your image is to click-and-hold the Zoom tool (the magnifying glass icon) on the spot where you want to zoom, and it smoothly zooms in right on that spot. The only downside is that it does it so smoothly, it's actually slow. It does look cool, but again, it's slow. That's why clicking with the tool and dragging to the right works so much better (although it's not nearly as cool to show to your friends as the "slow zoom").

Assigning a Color Profile to Your RAW Image

If you shoot in RAW, your camera doesn't embed a color profile in the image (like it does with JPEG and TIFF images). You assign a color profile in Camera Raw, and if you're using Camera Raw for all your editing, and then you're just saving your file as

Photoshop Killer Tips

a JPEG for emailing or posting to the web, you're going to want to assign a color profile that keeps the colors looking like you saw in Photoshop. You do this by clicking on the white link beneath the Preview area in Camera Raw. This brings up the Workflow Options dialog, where you choose which color profile gets embedded into your image (you choose it from the Space pop-up menu). If you're emailing the image, or posting it on the web, choose **sRGB** as your color space—that way it pretty much maintains the colors that you saw while you were in Camera Raw (if you left it at ProPhoto RGB, or even Adobe RGB [1998], the colors on the web, or in the email, will probably look drab and washed out).

Shortcut for Changing UI Color

Back in Photoshop CS6, Adobe introduced the new "dark" color scheme (replacing the old light gray look that had been Photoshop's look since Photoshop 1.0). But, if you want a lighter or darker version of Photoshop's user interface, you

can press **Shift-F1** to make the interface one shade darker or **Shift-F2** to make it one shade brighter (you can press it more than once, depending on how light/dark your current interface is set). Also, if you're using a laptop, depending on how you have your laptop's preferences set, to make this shortcut work you might have to add the Fn key (so, Fn-Shift-F1 or Fn-Shift-F2).

Finding Your Best Images Fast

I mentioned in the last chapter that if you have multiple images open in Camera Raw, you can assign star ratings to photos just as if you were in Bridge (you even use the same shortcuts). Here's a tip to get

to them fast: from the Filmstrip's flyout menu, choose **Select Rated** and any images that have a star rating will be instantly selected for you, letting you get to your best images fast.

Get a Histogram for the Most Important Part of Your Photo

If you're editing a portrait in Camera Raw, the most important part is, of course, your subject, but the histogram in Camera Raw shows you a readout for the entire image (so if you shot your subject on a white background, the histogram isn't going to be much help in determining if the skin tone is

correct). To get around this, grab the Crop tool **(C)**, and drag out a cropping border tight right around your subject's face (but don't actually crop the image). With the cropping border in place, if you look at the histogram (in the top right of the window), it shows you a readout for just what's inside the cropping border—your subject's face. Very handy!

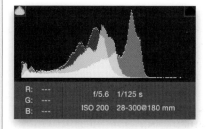

Right-Click to Choose Your Zoom

If you Right-click directly on your image in Camera Raw's Preview area, a pop-up menu with different zoom percentages will appear.

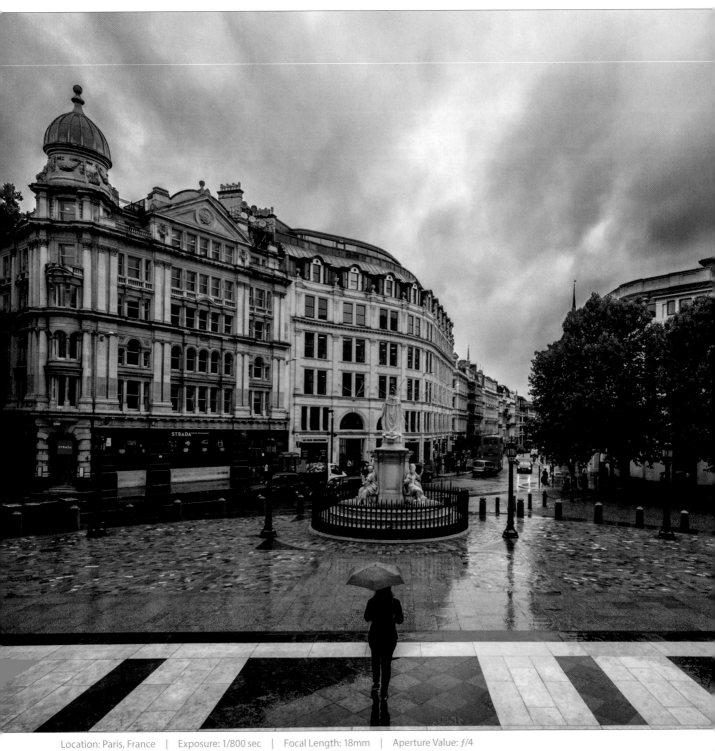

Location: Paris, France | Exposure: 1/800 sec | Focal Length: 18mm | Aperture Value: ƒ/4

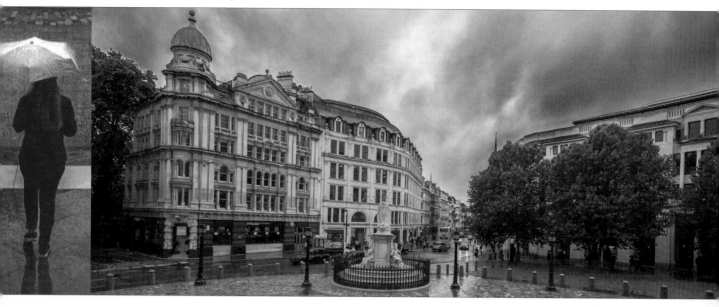

Scream of the Crop
how to resize and crop photos

You know what? If I were to go to Google or the iTunes Store (two of my most reliable sources for TV show, song, and movie titles), and type in "crop," do you know what I'm going to get? That's right, a bunch of results about corn and wheat. Now, I have to be straight with you—I hate corn. I don't know what it is about corn that I don't like (maybe its red color?), but I just never warmed up to it at all. It's probably because I don't like the smell of corn, and if you think about it, when it comes to which foods we like and which we don't like, we generally don't like any foods that smell bad to us. For example, when was the last time you put a big forkful of food up to your mouth and said, "Wow, this smells horrible!" and you actually ate it? Okay, outside of a fraternity prank, when was the last time? Really? You eat food that stinks? Wow, I never knew that about you. I'm a little surprised frankly, because up to this point, I thought we had kind of a simpatico thing going between us. I write ridiculous stuff, and you don't return the book for a refund, and you even skip entire chapters just to jump to the next chapter opener. I thought we were buds, but this…this really has me worried. What else haven't you told me? What? No way! Did you get sick? Oh man, that had to be bad. Did you call the cops? Why not? Oh. Then what? No way! What? What? What? Ewwwww! Look, I'm not sure we can go through any more of these chapter intros together. You're pretty messed up, and I'm not sure that reading these is good for you. You seem like you're in kind of a downward spiral. What? No, I am not judging you. Okay, I'm judging you, but no more than anyone else would who knew you did that, which by the way was pretty sick, and yes you should have called the cops, or a lawyer, or a podiatrist, or a taxidermist. So, corn, huh? All that, and you're totally okay with eating corn, even though it smells bad to you. Well, if it's any consolation, I don't eat wheat. I mean, where would you even buy a bushel of wheat? The tack shop? The Purina shop? Subway? Hey, I have a 50% off coupon!

Basic Cropping for Photos

Adobe completely overhauled cropping back in Photoshop CS6, and it was a big improvement (it was long overdue, since aside from a few minor enhancements, cropping had been essentially unchanged since Photoshop 1.0). Here, we'll cover the basic garden-variety cropping (and a new way of cropping), but since there are many different ways to crop a photo in Photoshop (and different reasons why you'd use one over another), we'll cover them all. If you're a Lightroom user, you'll be right at home with this cropping, because it works more like Lightroom's cropping.

Step One:

Press the letter **C** to get the Crop tool and you instantly see the first improvement over previous versions of the tool: you don't have to drag the cropping border out over your photo—it's automatically added around your image for you (yay!). Now, just grab one of the corner or side handles and start dragging inward to start cropping (as shown here) and it crops in toward the center of the image (the area to be cropped away will appear dimmed). If you want to keep the image proportions the same in your crop (I usually do), just press-and-hold the Shift key while you drag any of the cropping handles. Also, you can reposition your image within the border by clicking-and-dragging it.

Step Two:

The Rule of Thirds overlay grid that you see in Step One doesn't appear over your photo until you actually drag one of the cropping handles. If you see a different overlay, just click on the Overlay Options icon in the Options Bar (it's to the right of the Straighten tool) and you'll get a pop-up menu of the different overlays you can choose (if you're not sure which one you want, you can cycle through them by pressing the letter **O**). There are also three overlay settings in the menu: Always Show Overlay (once you start cropping, it's visible even when you're not cropping), Never Show Overlay, and Auto Show Overlay (my favorite—it only appears when you're actually cropping).

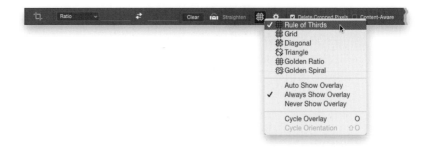

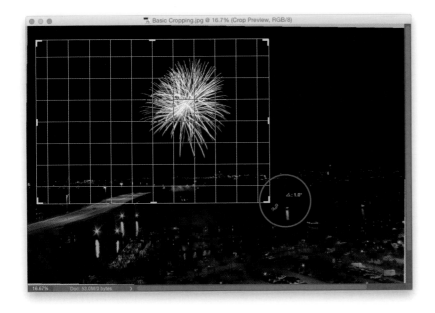

Step Three:

While you have the cropping border in place, if you need to rotate your photo, just move your cursor anywhere outside the border. When you do this, the cursor will change into a double-headed arrow. Just click, hold, and drag up (or down) and the image will rotate in the direction you choose (rather than the cropping border). This makes the process much easier (especially when you're trying to straighten a horizon line or a building). A little pop-up appears, too, with the angle of rotation (it's shown circled here in red).

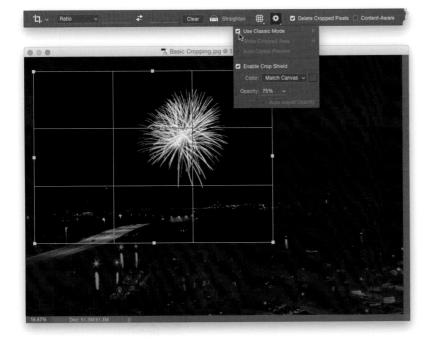

Step Four:

If you decide you want to return to the old way of rotating your crop (where the border rotates, rather than your image), click on the Set Additional Crop Options icon (it looks like a gear) in the Options Bar and turn on the Use Classic Mode checkbox (also known as "old school" or "ancient cropping" by today's hipster croppers), and then you're back to the old method. However, I really recommend giving this newer way a try—it takes a little getting used to, but once you do, you'll really find it useful. While we're in this options menu, when you're not in Classic mode, you have two options available here: (1) to turn off having your crop centered automatically (it's on by default), and we'll talk about the next one on the next page (it's a little more involved).

(Continued)

Step Five:

That other option (2) is more powerful than it sounds, because it pretty much brings one of the most popular cropping features of Lightroom over here to Photoshop. In Lightroom, it's called Lights Out cropping, and when you use this, it blacks out everything surrounding your crop area, so as you drag a cropping handle, you see exactly what the final image will look like without any distractions. If you click on the Set Additional Crop Options icon, you can toggle this on/off with the Show Cropped Area checkbox, but honestly it's quicker just to press the letter **H** on your keyboard (it's easy to remember—H for hide the distracting stuff; click on a cropping handle first or it'll switch to the Hand tool). Want to take it up a notch? Once you've hidden the extra stuff, hit the Tab key on your keyboard and everything else (the Toolbox, panels, Options Bar, etc.) hides temporarily, too (hit Tab again to unhide them). The other options here only kick in if you do have that dimmed, cropped away area visible (called the Crop Shield), and you can make it lighter or darker by changing the Opacity amount, or you can turn it off altogether by turning off the Enable Crop Shield checkbox.

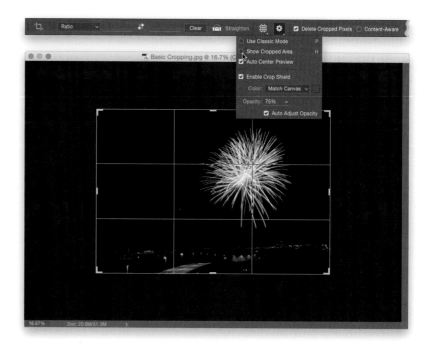

Step Six:

If you want to save some time, there's a list of preset standard cropping sizes in the pop-up menu at the left end of the Options Bar (seen here). Just choose the crop ratio you'd like (here, I chose a square 1:1 ratio), and your crop border automatically resizes to that size or ratio (as shown here).

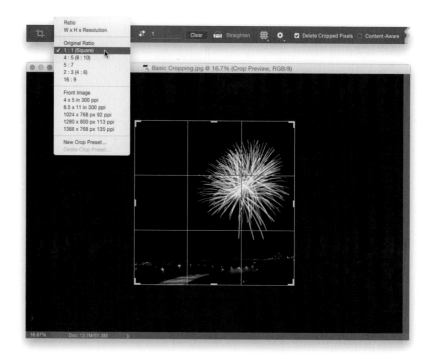

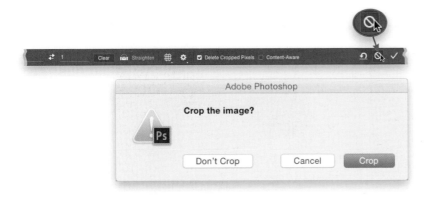

Step Seven:

If you decide at some point you don't want to crop the image at all, you can either press the **Esc key** on your keyboard, click on the "No!" symbol in the Options Bar (as shown here), or just click on a different tool in the Toolbox, which will bring up a dialog asking if you want to crop the image or not.

TIP: Flipping Your Crop Horizontal/Vertical

Want to flip the cropping border after you've clicked-and-dragged it out, so you can crop your wide photos with a tall crop that maintains the same aspect ratio (or vice versa)? Just press the letter **X** on your keyboard.

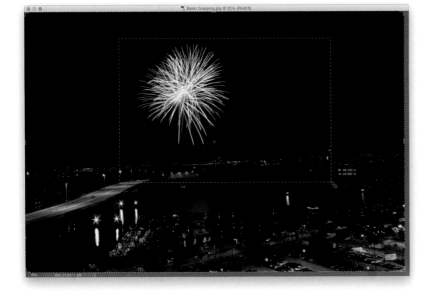

Step Eight:

So far, we've looked at the standard way of cropping—click on the tool and then drag the handles where you want them—but you can also use the freestyle way of cropping (like in previous versions of Photoshop) by taking the Crop tool itself and just clicking-and-dragging over the area you want to crop (as shown here). Don't let it freak you out that there's a cropping border already in place—just click-and-drag it out, and when you release the mouse button, it will display your new cropping border. Of course, now you can tweak the handles just like before.

(Continued)

Step Nine:

You can also add canvas area around your image using the Crop tool. One quick thing to check first: if you want a white background for your canvas area (and my guess is, most times you will), then before you even click on the Crop tool, press the letter **D** on your keyboard to set your Background color to white. Then, once you click on the Crop tool, make sure **Ratio** is selected in the pop-up menu at the left end of the Options Bar and click the Clear button to clear the Width and Height fields, otherwise the cropping border will be constrained to the aspect ratio of your image (in this case, we want the bottom section to be deeper than the sides and top). Now, grab a cropping handle and drag the border outward to add canvas area. Here, I clicked on the top-left cropping handle and dragged up and to the left (at a 45° angle), and it expanded the top and left side areas around my image.

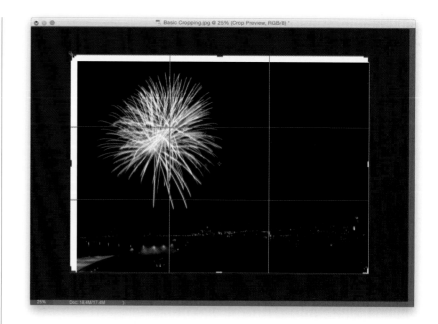

Step 10:

Here, I dragged the right side out and then dragged the bottom-center handle down a bit to add a fine art poster mat look around my image.

TIP: Skip Holding the Shift Key

You already know that to keep your cropping proportional, you press-and-hold the Shift key, right? Here's how to skip having to hold that key ever again, yet still keep it proportional: close any open images, grab the Crop tool, and then choose **Original Ratio** from the pop-up menu at the left end of the Options Bar. Now, it's your default setting. How cool is that?

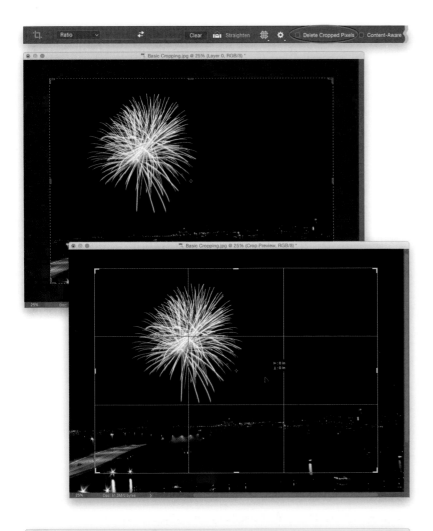

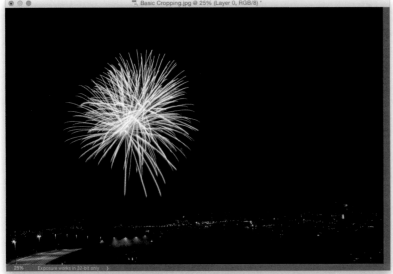

Step 11:

Before you actually commit to cropping your image, you have a decision to make. Luckily, it's probably a decision you'll make once, based on how you like to do things, so you won't have to make it every time. You get to decide if the part of your image that gets cropped away from view is: (a) gone forever, or (b) just hidden from view and, if necessary, can be brought back. You choose this by turning on/off the Delete Cropped Pixels checkbox up in the Options Bar (shown circled here in red). With it turned on, when you crop, the stuff outside the border is cropped away (and you get a smaller file size). If you turn it off, it keeps those areas in the file, even though you can't see them (well, not until you click on the Crop tool again and click-and-drag the cropping border back out). If you need the photo a specific size, but aren't happy with the way your first crop looks, you can move the image around with the Move tool **(V)**, or click on the cropping border while the Crop tool is active, then click on the image and move it.

Step 12:

Once you have the cropping border right where you want it, press the **Return (PC: Enter) key** to crop your image. The final cropped image is shown here, where we cropped off most of the foreground at the bottom.

Cropping to a Specific Size

If you're using one of the standard size or cropping ratio presets that appear in the Crop tool's pop-up menu, then you're set. However, there are only a few common sizes in that pop-up menu, so you're going to need to know (a) how to create custom sizes, and (b) how to save that custom size to the pop-up menu, so you don't have to build it from scratch again next time. Plus, I'm going to show you another way to crop an image that, well, I'm not proud of, but I know a lot of photographers that do it this way. (Now, I'm not saying that I've done it that way, but...well...I've done it that way. More times than I care to admit.)

Step One:
Here's the image I want to print as a wide 20x16" print (a very common size today, even though it's based on the size of traditional film, not digital images, so you have to crop just to make it fit). Start by clicking on the Crop tool **(C)** in the Toolbox, then from the pop-up menu at the left end of the Options Bar, choose **W x H x Resolution** (as shown here).

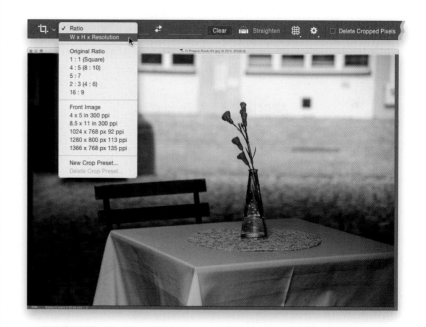

Step Two:
This adds a Resolution field to the Options Bar next to the Width and Height fields. Type in the custom size you want (in this case, 20x16" at a resolution of 240 ppi, which is pretty ideal for most color inkjet printing) and it resizes automatically. If you think you'll be using this size again (and chances are, you will), click on the pop-up menu and choose **New Crop Preset**, name it, click OK, and it adds this new size to that pop-up menu, so you don't have to recreate it every time. You can click-and-drag the photo left/right to get the part of it you want to appear inside the cropping border. Now press the **Return (PC: Enter) key** and it crops your image to that size.

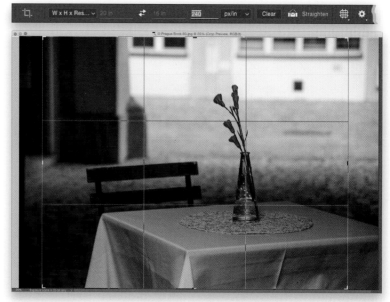

Step Three:
Okay, here's that (ahem) other method: Go under the File menu and choose **New** (or press **Command-N [PC: Ctrl-N]**). When the New Document dialog appears, enter 20 inches by 16 inches, and enter 240 for Resolution, then click OK to create a new blank document in the exact size and resolution you need (as seen here).

TIP: Cropping to Another Photo's Size
If you already have a photo that is the exact size and resolution that you'd like to apply to other images, you can use its settings as the crop dimensions. First, open the photo you'd like to resize, and then open your ideal-size-and-resolution photo. Get the Crop tool, and then from the pop-up menu at the left end of the Options Bar, choose Front Image. Photoshop will automatically input that photo's dimensions into the Crop tool's Width, Height, and Resolution fields. All you have to do is click back on the other image, and you'll see a cropping border that shares the exact same specs as your ideal-size photo.

Step Four:
Now, get the Move tool **(V)**, click on the image you want cropped to that size, and drag it onto that new blank document. While you still have the Move tool, click-and-drag the image around within the window so it's cropped the way you want it, then press **Command-E (PC: Ctrl-E)** to merge this layer with the Background layer, and you're set. As you can see, they both kind of do the exact same thing, so which one's right? The one you like best.

Creating Your Own Custom Crop Tools

Although it's more of an advanced technique, creating your own custom tools isn't complicated. In fact, once you set them up, they will save you time and money. We're going to create what are called "tool presets." These tool presets are a series of tools (in this case, Crop tools) with all our option settings already in place, so we can create a 5x7", 6x4", or whatever size Crop tool we want. Then, when we want to crop to 5x7", all we have to do is grab the 5x7" Crop tool preset. Here's how:

Step One:
Press the letter **C** to switch to the Crop tool, and then go under the Window menu and choose **Tool Presets** to bring up the Tool Presets panel. You'll find that five Crop tool presets are already there. (Make sure that the Current Tool Only checkbox is turned on at the bottom of the panel, so you'll see only the Crop tool's presets, and not the presets for every tool.)

Step Two:
Go up to the Options Bar and, with the pop-up menu set to **Ratio**, enter the dimensions for the first tool you want to create (in this example, we'll create a Crop tool that crops to a wallet-size image). In the Width field, enter 2 in, then press the **Tab key** to jump to the Height field, enter 2.5 in, and press Return (PC: Enter). *Note:* If you want to include the resolution in your tool preset, from the pop-up menu, choose **W x H x Resolution**. Enter your height, width, and resolution in the fields to the right of the pop-up menu, and press Return.

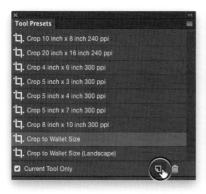 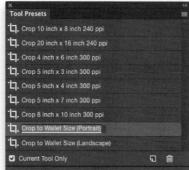

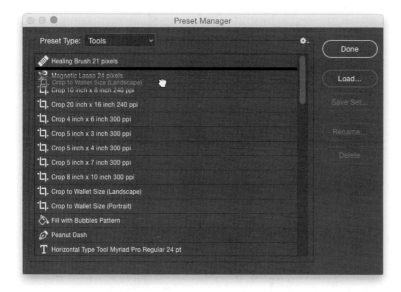

Step Three:

In the Tool Presets panel, click on the Create New Tool Preset icon at the bottom of the panel (to the left of the Trash icon). This brings up the New Tool Preset dialog, in which you can name your new preset. Name it, click OK, and the new tool is added to the Tool Presets panel. Continue this process of typing in new dimensions in the Crop tool's Options Bar and clicking on the Create New Tool Preset icon until you've created custom Crop tools for the sizes you use most. Make sure the name is descriptive (for example, add "Portrait" or "Landscape"). If you need to change the name of a preset, just double-click directly on its name in the panel, and then type in a new name.

Step Four:

Chances are your custom Crop tool presets won't be in the order you want them, so go under the Edit menu, under Presets, and choose **Preset Manager**. In the resulting dialog, choose **Tools** from the Preset Type pop-up menu, and scroll down until you see the Crop tools you created. Now just click-and-drag them to wherever you want them to appear in the list, and then click Done.

Step Five:

Now you can close the Tool Presets panel because there's an easier way to access your presets: With the Crop tool selected, just click on the Crop icon on the left end of the Options Bar. A tool preset picker will appear. Click on a preset, and your cropping border will be fixed to the exact dimensions you chose for that tool.

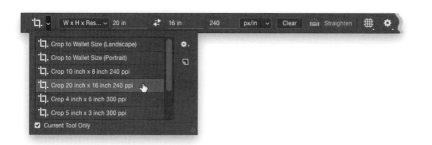

Custom Sizes for Photographers

Photoshop's dialog for creating new documents has a number of preset sizes. You're probably thinking, "Hey, there's a 4x6", 5x7", and 8x10"—I'm set." The problem is there's no way to switch the resolution of these presets (so the Portrait, 4x6 will always be a 300 ppi document). That's why creating your own custom new document sizes is so important. Here's how:

Step One:

Go under the File menu and choose **New** (or press **Command-N [PC: Ctrl-N]**). When the New Document dialog appears, click on Photo at the top of the dialog, and the preset sizes, which include 2x3", 4x6", 5x7", and 8x10" in both portrait and landscape orientation will appear. The only problem with these is that their resolution is set to 300 ppi by default. So, if you want a different size preset at less than 300 ppi, you'll need to create and save your own.

Step Two:

For example, let's say that you want a 5x7" set to landscape (that's 7" wide by 5" tall). First, click on Photo, then click on the Landscape, 5x7 preset (click on View All Presets in the middle of the preset area to see more presets). On the right side of the dialog, choose your desired Color Mode (below Resolution) and Color Profile (under Advanced Options), and then enter a Resolution (I entered 212 ppi, which is enough for me to have my image printed on a high-end printing press). Once your settings are in place, click on the Save Document Preset icon near the top right (as shown here).

Step Three:
This brings up the Save Document Preset field at the top right. In the field, enter a name for your preset (here, I named it the size with the resolution), and then click the Save Preset button.

TIP: Use New Document Templates
Below the Blank Document Presets, Adobe put a number of free templates for each type of new document. Click on one, then click on the See Preview button (on the right side of the dialog) to see if it's something you'd like to download.

Step Four:
Your new custom preset will now appear under the New Document dialog's Saved Blank Document Presets (click on Saved at the top of the dialog to see them). You only have to go through this once. Photoshop will remember your custom settings, and they will appear here from now on.

(Continued)

Step Five:

If you decide you want to delete a preset, it's simple—just open the New Document dialog, click on Saved, then click on the preset you want to delete. Click on the Trash can icon in its top-right corner (circled here in red), and it's gone!

TIP: Use the Old New Dialog

If you'd rather use the old New dialog, instead of the new redesigned one, you're in luck. You can switch back to the old dialog by going to Photoshop's General Preferences (**Command-K [PC: Ctrl-K]**) and turning on the Use Legacy "New Document" Interface checkbox (as shown here at the top). To get to the presets in the old dialog, choose **Photo** from the Document Type pop-up menu, then click on the Size pop-up menu (as shown here at the bottom).

Resizing Photos

If you're used to resizing scans, you'll find that resizing images from digital cameras is a bit different, primarily because scanners create high-res scans (usually 300 ppi or more), but the default settings for many digital cameras produce an image that is large in physical dimensions, but lower in pixels-per-inch (usually 72 ppi). The trick is to decrease the physical size of your digital camera image (and increase its resolution) without losing any of its quality. Here's the trick:

Step One:

Open the digital camera image that you want to resize. Press **Command-R (PC: Ctrl-R)** to make Photoshop's rulers visible. As you can see from the rulers, the photo is around 59" wide by 39" high.

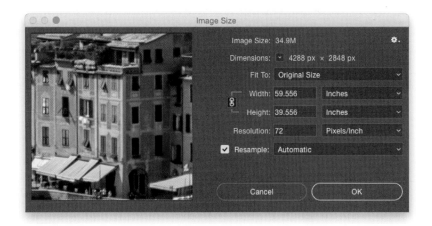

Step Two:

Go under the Image menu and choose **Image Size** (or press **Command-Option-I [PC: Ctrl-Alt-I]**) to bring up the Image Size dialog. As you can see here, the Resolution setting is 72 ppi. A resolution of 72 ppi is considered "low resolution" and is ideal for photos that will only be viewed onscreen (such as web graphics, slide shows, and so on), but it's too low to get high-quality results from a color inkjet printer, color laser printer, or for use on a printing press.

(Continued)

Step Three:

If we plan to output this photo to any printing device, it's pretty clear that we'll need to increase the resolution to get good results. I wish we could just type in the resolution we'd like it to be in the Resolution field (such as 200 or 240 ppi), but unfortunately this "resampling" makes our low-res photo appear soft (blurry) and pixelated. That's why we need to turn off the Resample checkbox (it's on by default). That way, when we type in a Resolution setting that we need, Photoshop automatically adjusts the Width and Height of the image down in the exact same proportion. As your Width and Height come down (with Resample turned off), your Resolution goes up. Best of all, there's absolutely no loss of quality. Pretty cool!

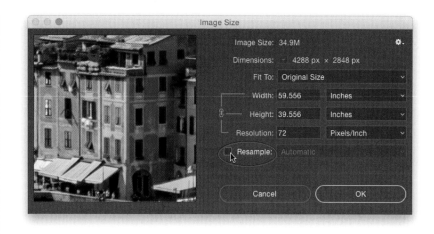

Step Four:

Here I've turned off Resample and I entered 240 in the Resolution field for output to a color inkjet printer. (I know, you probably think you need a lot more resolution, but you don't. In fact, I never print with a resolution higher than 240 ppi.) At a resolution of 240 ppi here, I can actually print a photo that is around 18 inches wide by around 12 inches high.

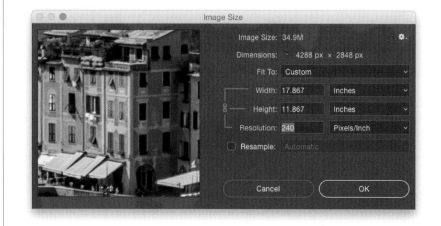

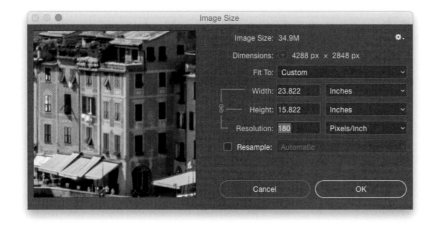

Step Five:

Here, I've lowered the Resolution setting to 180 ppi. (Again, you don't need nearly as much resolution as you'd think, but 180 ppi is pretty much about as low as you should go when printing to a color inkjet printer.) As you can see, the Width of my image is now almost 24" and the Height is now almost 16". Best of all, we did it without damaging a single pixel, because we were able to turn off Resample, which normally, with things like scans, we couldn't do.

Step Six:

When you click OK, you won't see the image window change at all—it will appear at the exact same size onscreen—but look at the rulers. You can see that it's now almost 16" high by almost 24" wide. Resizing using this technique does three big things: (1) it gets your physical dimensions down to size (the photo now fits easily on a 16x24" sheet); (2) it increases the resolution enough so you can output this image on a color inkjet printer; and (3) you haven't softened, blurred, or pixelated the image in any way—the quality remains the same—all because you turned off Resample. *Note:* Do not turn off Resample for images that you scan on a scanner—they start as high-res images in the first place. Turning Resample off like this is only for low-res photos taken with a digital camera.

Automated Saving and Resizing

If you have a bunch of images that you need resized, or converted from TIFFs to JPEGs (or from PSDs to JPEGs, for that matter), then you will love the built-in Image Processor. It's kind of hidden in a place you might not expect it (under the Scripts menu), but don't let that throw you—this is a really handy, and really easy-to-use, totally automated tool that can save you tons of time.

Step One:

Go under the File menu, under Scripts, and choose **Image Processor**. By the way, if you're working in Adobe Bridge (rather than Photoshop), you can Command-click (PC: Ctrl-click) on all the photos you want to apply the Image Processor to, then go under the Tools menu, under Photoshop, and choose Image Processor. That way, when the Image Processor opens, it already has those photos pegged for processing. Sweet!

Step Two:

When the Image Processor dialog opens, the first thing you have to do is choose the folder of photos you want it to "do its thing" to by clicking on the Select Folder button, then navigating to the folder you want and clicking Open (PC: OK). If you already have some photos open in Photoshop, you can click on the Use Open Images radio button (or if you chose Image Processor from Bridge, the Select Folder button won't be there at all—instead it will list how many photos you have selected in Bridge). Then, in the second section, decide whether you want the new copies to be saved in the same folder or copied into a different folder. No big whoop (that's a technical term).

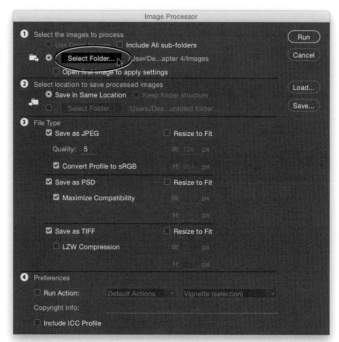

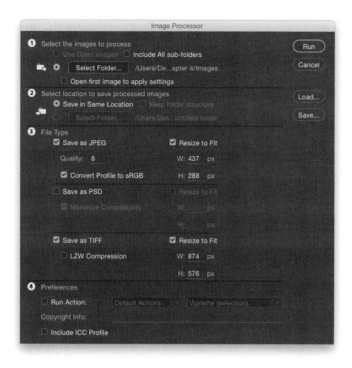

Step Three:

The third section is where the fun begins. This is where you decide how many copies of your original you're going to wind up with, and in what format. If you turn on the checkboxes for Save as JPEG, Save as PSD, and Save as TIFF, you're going to create three new copies of each photo. If you turn on the Resize to Fit checkboxes (and enter a size in the Width and Height fields), your copies will be resized, too (in the example shown here, I chose a small JPEG of each file, then a larger TIFF, so in my folder I'd find one small JPEG and one larger TIFF for every file in my original folder).

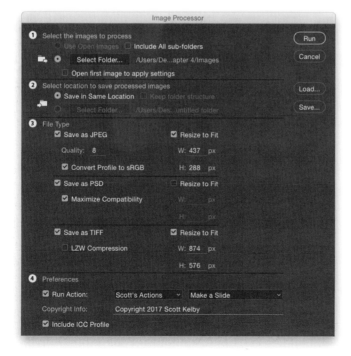

Step Four:

In the fourth section, if you've created an action that you want applied to your copies, you can also have that happen automatically. Just turn on the Run Action checkbox, then from the pop-up menus, choose which action you want to run. If you want to automatically embed your copyright info into these copies, type your info in the Copyright Info field. Lastly, there's a checkbox that lets you decide whether to include an ICC profile in each image or not (of course, I'm going to try to convince you to include the profile, because I included how to set up color management in Photoshop in the bonus Print chapter found on the book's companion webpage). Click the Run button, sit back, and let it "do its thing," and before you know it, you'll have nice, clean copies aplenty.

Resizing for Poster-Sized Prints

So, since you saw earlier how much resolution you need to have to create a decent-sized print, how do photographers get those huge poster-sized prints without having super-high-megapixel cameras? It's easy—they upsize the images in Photoshop, and the good news is that unless you need to resize your image by more than 300%, you can do this all right in Photoshop without having to buy a separate resizing plug-in (but if you need more than a 300% size increase, that's where those plug-ins, like OnOne Software's Resize, really pay off).

Step One:

Open the photo you want to resize, then go under the Image menu and choose Image Size or press **Command-Option-I (PC: Ctrl-Alt-I)**. When the Image Size dialog appears, to the right of the Width field, you'll see a pop-up menu where Inches is chosen. Click on that menu and choose **Percent** (as shown here). Both the Width and Height will change to Percent, because they're linked together by default. Then, turn on the Resample checkbox at the bottom.

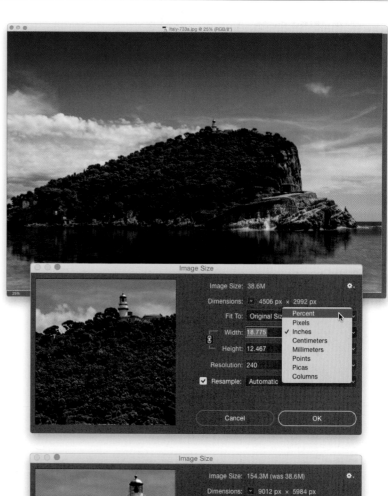

Step Two:

Now, type in either 200% or 300% (although there is some debate about this, it seems to work best if you move up/down in 100% increments) in the Width field (again, since they're linked, the Height field will automatically change to the same number).

Step Three:

At the bottom of the dialog is a pop-up menu that decides which algorithm is used to upsize your photo. The default is Automatic, and I use that for most everyday resizing stuff, but when it comes to jumping in big increments, like 200% or 300%, I switch to **Bicubic Smoother** (which Adobe says is "best for enlargement"), as shown here.

Step Four:

Vincent Versace breaks this rule. According to Vincent's research, the key to his resizing technique is to not use the sampling method Adobe recommends (Bicubic Smoother), but instead to choose Bicubic Sharper, which he feels provides better results. So, which one is the right one for you? Try both on the same image (that's right—just do a test print), and see if you can see a visible difference. Here's the final image resized to around 38x25" (you can see the size in the rulers by pressing **Command-R [PC: Ctrl-R]**).

Straightening Crooked Photos

Adobe has been tweaking the way we straighten images for the past few versions of Photoshop. It now has the fastest and easiest way yet, and it's built right into the Crop tool's options.

Step One:
Open the photo that needs straightening, click on the Crop tool **(C)** in the Toolbox, and then click on the Straighten tool up in the Options Bar.

Step Two:
Now, find something in your photo that's supposed to be straight or relatively straight. Click-and-drag the Straighten tool horizontally along this straight edge in your photo, starting from the left and extending to the right (as shown here).

Step Three:

When you release the mouse button, your photo rotates the exact amount to perfectly straighten the photo. One nice feature here is that it automatically resizes the cropping border, so that when you lock in your crop, you don't have any gray gaps in the corners (if you ignore the cropping border, and look at the whole image now, see those triangular gray areas? Those would be white if Photoshop didn't crop in like this). Now, just press the **Return (PC: Enter) key** to lock in your straightening, and it straightens and crops the image down to just what you see inside the cropping border (the final straightened image is shown here below).

Making Your Photos Smaller (Downsizing)

There's a different set of rules we use for maintaining as much quality as possible when making an image smaller, and there are a few different ways to do just that (we'll cover the two main ones here). Luckily, maintaining image quality is much easier when sizing down than when scaling up (in fact, photos often look dramatically better—and sharper—when scaled down, especially if you follow these guidelines).

Downsizing photos where the resolution is already 300 ppi:

Although earlier we discussed how to change image size if your digital camera gives you 72-ppi images with large physical dimensions (like 24x42" deep), what do you do if your camera gives you 300-ppi images at smaller physical dimensions (like 12x8" at 300 ppi)? Basically, you turn on the Resample checkbox (in the Image Size dialog under the Image menu), then simply type in the desired size (in this example, we want a 6x4" final image size), and click OK (don't change the Resolution setting, just click OK). The image will be scaled down to size, and the resolution will remain at 300 ppi. IMPORTANT: When you scale down using this method, it's likely that the image will soften a little bit, so after scaling, you'll want to apply the Unsharp Mask filter to bring back any sharpness lost in the resizing (go to Chapter 11 to see what settings to use).

Making one photo smaller without shrinking the whole document:
If you're working with more than one image in the same document, you'll re-size a bit differently. To scale down a photo on a layer (like this photo of some bottles on a mantle, which is on its own layer), first click on that photo's layer in the Layers panel, then press **Command-T (PC: Ctrl-T)** to bring up Free Transform (it puts little handles around your image on that layer, kind of like what the Crop tool does). Press-and-hold the Shift key (to keep the photo proportional), grab a corner handle, and drag inward to shrink the image. When the size looks good, press **Return (PC: Enter)**. If the image looks softer after resizing it, apply the Unsharp Mask filter (again, see Chapter 11 for settings) to bring that sharpness back.

TIP: Reaching the Free Transform Handles
If you drag an image from one open document to another (like I did here, where I dragged the photo with the bottles over onto the photo with just one bottle), there's a pretty good chance you'll have to resize the dragged image, so it fits within your other image. And, if the image is larger (as in this case), when you bring up Free Transform, you won't be able to reach the resizing handles (they'll extend right off the edges of the document). Luckily, there's a trick to reaching those handles: just press **Command-0 (PC: Ctrl-0)**, and your window will automatically resize so you can reach all the handles—no matter how far outside your image area they once were. Two things: (1) This only works once you have Free Transform active, and (2) it's Command-0—that's the number zero, not the letter O.

(Continued)

Resizing problems when dragging between documents:

This one gets a lot of people, because at first glance it just doesn't make sense. You have two documents open, and they look approximately the same size (as seen here, at top), but when you drag the Eiffel Tower photo onto the blank document, it appears really small (as seen below). Why? Although the documents appear to be the same size, they're not. The Eiffel Tower photo is a low-resolution, 72-ppi (pixels per inch) image, but the blank document is a high-resolution, 300-ppi image. The tip-off that you're not really seeing them at the same size is found in each photo's title bar. Here, the Eiffel Tower image is displayed at 100%, but the Untitled-1 document is displayed at only 25% (so, it's much larger than it appears). The key is that when you're dragging images between documents, they need to be the same size and resolution.

TIP: Automated Cropping & Straightening

Want to save time the next time you're scanning prints? Try gang scanning (fitting as many photos on your flatbed scanner as you can and scanning them as one big single image), and then you can have Photoshop automatically straighten each individual image and place it into its own separate document. You do this by going under the File menu, under Automate, and choosing **Crop and Straighten Photos**. No dialog will appear. Instead, Photoshop will look for straight edges in your photos, straighten the photos, and copy each into its own separate document.

Resizing Just Parts of Your Image Using "Content-Aware" Scaling

We've all run into situations where our image is a little smaller than the area where we need it to fit. For example, if you resize a digital camera image so it fits within a traditional 8x10" image area, you'll have extra space either above or below your image (or both). That's where Content-Aware Scaling comes in— it lets you resize one part of your image, while keeping the important parts intact (basically, it analyzes the image and stretches, or shrinks, parts of the image it thinks aren't as important). Here's how to use it:

Step One:

Create a new document at 8x10" and 240 ppi. Open an image, get the Move tool **(V)**, and drag-and-drop it onto the new document, then press **Command-T (PC: Ctrl-T)** to bring up Free Transform (if you can't see all the handles, press **Command-0** [zero; **PC: Ctrl-0**]). Press-and-hold the Shift key, then grab a corner point and drag inward to scale the image down, so it fits within the 8x10" area (as shown here on top), and press **Return (PC: Enter)**. Now, in the image on top, there's white space above and below the photo. If you want it to fill the 8x10 space, you could use Free Transform to stretch the image to do so, but you'd get a stretched version of the SUV (seen at bottom). This is where Content-Aware Scale comes in.

(Continued)

Step Two:

Go under the Edit menu and choose **Content-Aware Scale** (or press **Command-Option-Shift-C [PC: Ctrl-Alt-Shift-C]**). Grab the top handle, drag straight upward, and notice that it stretches the sky upward, but pretty much leaves the SUV intact. Grab the bottom handle and drag downward, and it again stretches the sky. When you've dragged far enough, press **Return (PC: Enter)** to lock in your change. (*Note:* The button that looks like a person in the Options Bar tells Content-Aware Scale that there are people in the photo, so it tries to avoid stretching anything with a skin tone.)

Step Three:

There are two more controls you need to know about: First, if you try Content-Aware Scale and it stretches your subject more than you want, get the Lasso tool **(L)** and draw a selection around your subject (as shown here), then go under the Select menu and choose **Save Selection**. When the Save Selection dialog appears, just click OK and press **Command-D (PC: Ctrl-D)** to Deselect. Then bring up Content-Aware Scale again, but this time, go up in the Options Bar and choose your selection from the Protect pop-up menu (as shown here) to tell Photoshop where your subject is. Now you can drag up or down to fill the empty space with the least possible stretching. There's also an Amount control up in the Options Bar, which determines how much stretching protection is provided. At its default of 100%, it's protecting as much as possible. At 50%, it's a mix of protected resizing and regular Free Transform, and for some photos that works best. The nice thing is the Amount control is live, so as long as your handles are still in place, you can lower the Amount and see live onscreen how it affects your resizing.

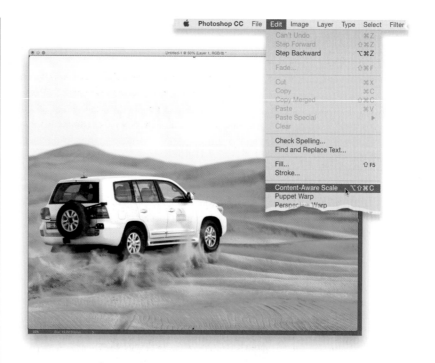

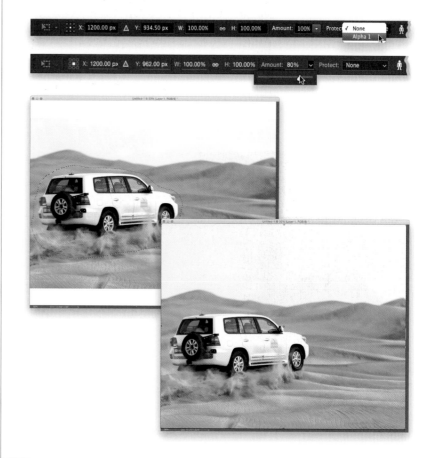

Need Help Finding What You're Looking For?
Use Photoshop's New Search Feature

Adobe added a new search feature, and it's especially cool for times when you know something's in Photoshop, but you just don't know where. Beyond that, once you find what you're looking for, you can even launch the tool or feature right from the search dialog (I know, pretty sweet!). But, it doesn't just search tools and features, it has tutorials, tips, and it can even search Adobe Stock images.

Step One:

To bring up the search, press **Command-F (PC: Ctrl-F)**. When the dialog appears, just type in what you're looking for (I entered "crop" here), and the results show up instantly in a pop-down menu (as shown here).

Tip: New Last Filter Shortcut

Command-F (PC: Ctrl-F) used to belong to Last Filter (which you used to reapply a filter). Its new shortcut is **Command-Control-F (PC: Ctrl-Alt-F)**. If that drives you nuts, you can change this shortcut back in the Keyboard Shortcuts dialog, under the Edit menu.

Step Two:

At the top of the dialog, you can click on the options to narrow down your search, instead of seeing all of the search results. So, if you were just looking to find out where the Trim command was in Photoshop, you'd click on Photoshop (as shown here). If you wanted to learn more about cropping, you'd click on Learn, and if you wanted to find some stock images of crops (hey, ya never know), you'd click on Stock (also shown here). It's a pretty handy new feature. Just press the **Esc key** to close the search dialog.

Photoshop Killer Tips

Instant Background Layer Unlocking

This is one of those little tips that just makes you smile. To instantly turn your Background layer into a regular layer without having a dialog pop up first, just click-and-drag the little lock icon to the right of the word "Background" straight into the trash (thanks to Adobe's Julieanne Kost for sharing this one).

Get Your Channel Shortcuts Back

Back in CS3, and all earlier versions of Photoshop, you could look at the individual color channels for a photo by pressing **Command-1**, **Command-2**, **Command-3**, and so on (on a PC, you'd use **Ctrl-1**, **Ctrl-2**, etc., instead). In CS4, they changed the shortcuts, which totally bummed out a lot of longtime users, but you have the option of bringing those glory days of channel shortcuts back to the pre-CS4 era. Go under the Edit menu, choose **Keyboard Shortcuts**, then near the top of the dialog, turn on the Use Legacy Channel Shortcuts checkbox.

Set Defaults in Layer Styles

You can set your own custom defaults for layer styles like Drop Shadow or Glow. All you have to do is create a new layer in the Layers panel by clicking on the Create a New Layer icon, then choose the layer style you want from the Add a Layer Style icon's pop-up menu (like Outer Glow, for example). In the Layer Style dialog, enter your own settings (like changing the glow from yeech yellow to white, or black, or anything but yeech yellow), then click on

the Make Default button near the bottom of the dialog. To return to the factory default (yeech) settings, click the Reset to Default button.

How to Know If You Used the "Blend If" Sliders on a Layer

Photoshop adds an icon on the right of any layer where you've adjusted the Blend If sliders in the Blending Options of the Layer Style dialog. The icon looks like two little overlapping squares, but it's more

than an icon—it's a button. Double-click on it and it brings up the Blend If sliders in the Layer Style dialog.

Layer Mask from Layer Transparency

Here's a nice time saver: you can make the transparent areas of any layer into a mask in just one step: go under the Layer menu, under Layer Mask, and choose **From Transparency**.

One Click to Close All Your Tabs

If you're using the Tabs feature (all your documents open as tabs), then you'll definitely want to know this tip: to close all your open tabs at once, just Right-click on any tab and choose **Close All**.

Seeing Your Final Crop in Camera Raw

When you crop a photo in Camera Raw, you can see the final cropped image without having to open the image in Photoshop. Once your cropping border is in place,

Photoshop Killer Tips

just change tools and you'll see the cropped version (in some previous versions, the cropped away area was still visible; it was just dimmed).

Save 16-Bit to JPEG

Back in CS4, if you worked with 16-bit photos, when you went to the Save dialog to save your photo, there was no option to save your image as a JPEG, because JPEGs have to be in 8-bit mode, so you'd have to close the dialog, convert to 8-bit, then go and Save again. That has changed and JPEG is now a choice, but what it does is makes a copy of the file, which it converts to 8-bit, and saves that instead. This leaves your 16-bit image still open onscreen and unsaved, so keep that in mind. If you want to save the 16-bit version separately, you'll need to save it as a PSD or TIFF like before. For me, once I know it has saved an 8-bit JPEG, I don't need the 16-bit version any longer, so I close the image and click the Don't Save button, but again, that's just me.

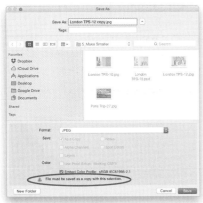

Lens Corrections Grid

If you're using the Distortion slider in Camara Raw's Lens Corrections panel to do things like straighten buildings or flatten rounded horizon lines, press **Shift-G** and an alignment grid appears over your image to help you line things up. To hide it again, press Shift-G again.

Assign a Keyboard Shortcut to the Color Picker

You can assign a keyboard shortcut to bring up the Foreground (or Background) Color Picker (this is handier than it sounds). Go under the Edit menu, under Keyboard Shortcuts, and from the Shortcuts For pop-up menu, choose **Tools**. Then scroll down near the bottom, and you'll see Foreground Color Picker and Background Color Picker. Click on whichever one you want, and type in the shortcut you want. I have to tell you up front: most of the good shortcuts are already taken (in fact, almost all combinations of shortcuts are already taken), but my buddy Dave Cross came up with a good idea. He doesn't use the Pen tool all that much, so he used the letter P (for Picker). When you enter "P," it's going to warn you that it's already being used for something else, and if you click the Accept and Go to Conflict button at the bottom left, it assigns P to the Color Picker you chose, and then sends you to

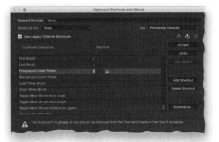

the Pen tool to choose a new shortcut. If you don't need to assign one to the Pen tool (you don't use it much either), then just leave it blank and click OK.

Visual Way to Change Your Brush Size and Softness

This is incredibly handy, because you can actually see and control the exact size and amount of softness for your current brush tip. Press-and-hold Option-Ctrl (PC: Alt-Ctrl) then click-and-drag (PC: Right-click-and-drag) up/down to control the softness/hardness of the brush, and left/right to control the size.

Location: Sydney Opera House, Sydney, Australia | Exposure: 1/2000 sec | Focal Length: 116mm | Aperture Value: f/6.3

Layers of Light
layers, selections, and compositing

I only found one movie that would work here, *Layer Cake*, and I used that one already in a previous edition of this book, so I can't go to that well again, so I'm going with the well-named album *Layers of Light* by Nils Landgren and Esbjörn Svensson. I don't always do this, but I took a few minutes to listen to some of their album. It's rare that I find an album that doesn't have the Explicit Lyrics warning on every single song, so that was a good start. I listened to the first few tracks in the iTunes Store, which included "Song from the Valley," "Calling the Goats," and "Kauk" (don't pronounce that last one out loud), but by far their most popular song (according to iTunes anyway) is the first one. I gave it a listen, and I thought, as a fellow musician and piano player myself, that I might offer my own brief review here in the book, rather than on iTunes. It's because I want to speak from the heart, and to the artists directly, which I feel is much more meaningful than speaking to the general public, who are simply wondering if they should plunk down the $8.99 for the album. I think it's more personal to address the artists themselves. I picture us meeting at sunset in a small cafe in Sweden, where we would share a nice glass of 2010 Francois LeClerc Gevrey Chambertin Burgundy. With the crackling from a roaring fire, and the muted chatter from the other guests enjoying the sunset on a crisp fall night as our background, I would let Nils and Esbjörn know how much I feel they need to sell their gear. All of it. Immediately. The instruments, all their recording gear, that piano—every lick of it—and never play another note again. It was that bad. I want to let them know it sounded like a cat was walking across their piano, playing random notes, while someone boiled a live lobster nearby, as plates came crashing off the walls. I would tell them to destroy any tapes, copies of the albums, and any trace that might lead anyone back to their "music" because… well…okay, I can't keep this up. Their album was actually pretty great. Really great, in fact, but you have to admit, I had you going there for a second. Rest assured, in reality, their songs are beautiful. Now, come and join me as I raise a glass to Nils and Esbjörn, as I toast the name of their third track so loudly in the cafe that the manager comes over and asks me to leave.

Working with Layers

Layers are one of the main features in Photoshop because they do so much. A layer lets you add something on top of your image and position it wherever you'd like. For example, say you'd like to add a graphic or type to a wedding book page, or you'd like to blend two photos together for a fine art effect, you can do this with layers. Plus, we use layers for everything from fixing problems (see Chapter 9) to special effects (see Chapter 10). Here are the basics on how layers work:

Step One:

Open an image and it will appear as the Background layer (it's just a regular flat ol' image). To add some text above the image, get the Horizontal Type tool **(T)** from the Toolbox, then click on your image and start typing. It will type in whatever font and size is selected in the Options Bar. If you want to change the font or size, highlight your type, then go up to the Options Bar, choose a new font from the font pop-up menu (I chose the font Cezanne Regular, here) and a large font size from the font size pop-up menu (I chose 60 pt), then click anywhere outside the text box to set the type. Reposition it anywhere you'd like using the Move tool **(V**; the topmost tool in the Toolbox).

Step Two:

If you look at the black type in Step One, most of it is pretty hard to read, so let's put a white bar behind the type so it all stands out. To add a new blank layer above your type layer, click on the Create a New Layer icon at the bottom of the Layers panel (it's circled here in red). Now, get the Rectangular Marquee tool **(M)** from the Toolbox and click-and-drag out a thin, wide rectangle from side to side. Press the letter **D**, then **X** to set your Foreground color to white, and then press **Option-Delete (PC: Alt-Backspace)** to fill this selection with white (as seen here). Press **Command-D (PC: Ctrl-D)** to Deselect.

Step Three:

Unfortunately, this white bar now covers up our type when we actually want it behind our type. That's because layers are added to the stack from the bottom up. Take a look at the Layers panel in the previous step. There, we have the Background layer (that's on the bottom), and then on top of that we have a type layer. When it was only those two layers, you could see the type because it was stacked above the Background layer in the Layers panel. But once you added another layer on top, and filled your selection with white, it covered whatever was below it—the type layer and the photo of our bride and groom. To get that white bar below our type layer, go to the Layers panel, and click-and-drag the white bar layer (Layer 1) down below the type layer (as seen here). The stacking order is now: the background image, then the white bar, and the type layer on top.

Step Four:

Now, if you look at the image in Step Three, you can see that the solid white bar covers up part of the image of the couple. That's because it's a solid object and solid objects cover up what's below them in the Layers panel. However, layers all have an opacity setting, so if you want your object to be a little see-through, or a lot, you can lower the opacity amount for that layer. Make sure that layer is active (highlighted), then just go up to the Opacity field near the top right of the Layers panel (where it says 100%), click on the little down-facing arrow to its right, and the Opacity slider appears. Drag it down to around 30% (as shown here) and now you can see through to the bride and groom on the Background layer.

(Continued)

Step Five:

Next, let's open and add another image and subtly blend them together (here, it's the bride's bouquet with her ring). We'll need to select the entire image first, before copying it into memory, so go under the Select menu and choose **All** (or press **Command-A [PC: Ctrl-A]**). Once you have a selection around the image, press **Command-C (PC: Ctrl-C)** to Copy the photo into memory.

Step Six:

Switch back to our photo of the bride and groom and press **Command-V (PC: Ctrl-V)** to Paste the copied image on top of whatever your last active layer was. If needed, press **Command-T (PC: Ctrl-T)** to enter Free Transform, press-and-hold the Shift key to keep things proportional, and then click-and-drag a corner handle to resize the image. Press **Return (PC: Enter)** to lock in the transformation. In this case, the last layer we worked on was the white bar layer, so it appears in the stack of layers right above the white bar layer. However, we're going to want it to appear right above our photo of the bride and groom (so we can blend the two photos together and still have the white bar and type layers above them). So, go to the Layers panel, and click-and-drag this layer down in the layer stack right above the Background layer (as seen here). To get this image to blend with the bride and groom photo on the layer below it, I could just lower the opacity of this layer, but it doesn't make for a very interesting blend. That's where the layer blend modes come in.

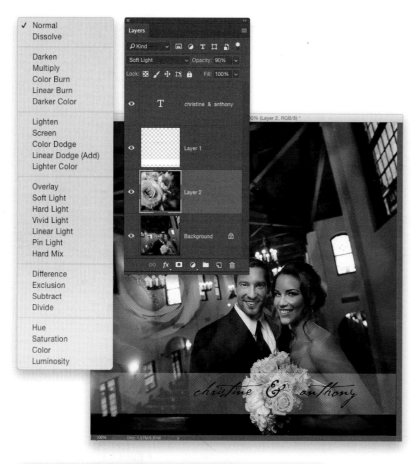

Step Seven:

There are a whole bunch of layer blend modes (you can find them in the pop-up menu near the top left of the Layers panel—they're all seen here on the far left), and they determine how the current layer blends with the layer (or layers) below it. Some blend in a way that makes the combination of layers much brighter (like Screen mode) or much darker (like Multiply mode). So, which one is the "right" one for these two images? Who knows? That's why we use a keyboard shortcut to try them all out, and then we just stop when we find one that looks good to us. The shortcut is **Shift-+ (plus sign)**. Each time you press this, it changes to the next blend mode in the pop-up menu, so when you see one you like, stop. Yes, it's that easy. Here, I stopped at Soft Light, then lowered the opacity of this layer to 90% because the effect seemed too strong.

Step Eight:

There's still a little problem, here, though. The bouquet layer is appearing right over their faces. I'd rather have their faces appear like they do in the Background layer, but luckily we can choose which parts of our layers are visible by using a layer mask. To add one, click on the Add Layer Mask icon at the bottom of the Layers panel (it's the third icon from the left), and it adds a white thumbnail mask to the right of your image thumbnail in the Layers panel. Since it's white, you'll paint in the opposite color—black. So, get the Brush tool **(B)** from the Toolbox, choose a large, soft-edged brush from the Brush Picker up in the Options Bar, and paint over their faces (as seen here). It basically cuts a hole in the bouquet layer, so you can see their original faces on the layer below. Easy peasy. And now we have a nice image for their wedding album.

Selecting Square, Rectangular, or Round Areas

Selections are an incredibly important feature in Photoshop. They're how you tell Photoshop to affect only specific areas of your photos. Whether it's moving part of one photo into another or simply trying to draw more attention to or enhance part of a photo, you'll have so much more control if you know how to select things better. For starters, Photoshop includes quick and easy ways to make basic selections (square, round, rectangular). These are probably the ones you'll use most, so let's start here.

Step One:

To make a rectangular selection, choose (big surprise) the Rectangular Marquee tool from the Toolbox or press the **M key**. Adobe's word for selection is "marquee." (Why? Because calling it a marquee makes it more complicated than calling it what it really is—a selection tool—and giving tools complicated names is what Adobe does for fun.)

Step Two:

We're going to start by selecting a rectangle shape, so click your cursor in the upper-left corner of the door and drag down and to the right until your selection covers the entire left side of the door, then release the mouse button. That's it! You've got a selection and anything you do now will affect only the selected rectangle (in other words, it will only affect the left side of the door).

Step Three:
To add another area to your current selection, just press-and-hold the **Shift key**, and then draw another rectangular selection. In our example here, let's go ahead and select the rest of the door, too. So press-and-hold the Shift key, drag out a rectangle around the other side of the door, and release the mouse button. Now the entire door is selected.

Step Four:
Now let's make an adjustment and you'll see that your adjustment will only affect your selected area. Click on the Create New Adjustment Layer icon at the bottom of the Layers panel, and choose **Hue/Saturation** from the pop-up menu. In the Properties panel, drag the Hue slider all the way to the left to change the color of the door to a green color. Notice how just the color of the door is changing and nothing else in the image? This is why selections are so important—they are how you tell Photoshop you only want to adjust a specific area. You can also drag the Saturation or Lightness sliders, too, but I'm just going to move the Saturation to the right a little, here. Also, you'll notice your selection goes away when you add the adjustment layer, but if you ever want to deselect something, just press **Command-D (PC: Ctrl-D)**.

(Continued)

Step Five:

Okay, you've got rectangles, but what if you want to make a perfectly square selection? It's easy—the tool works the same way, but before you drag out your selection, you'll want to press-and-hold the Shift key. Let's try it: open another image, get the Rectangular Marquee tool, press-and-hold the Shift key, and then draw a perfectly square selection (around the center area inside of this fake instant photo, in this case).

Step Six:

While your selection is still in place, open a photo that you'd like to appear inside your selected area and press **Command-A (PC: Ctrl-A)**; this is the shortcut for Select All, which puts a selection around your entire photo at once. Then press **Command-C (PC: Ctrl-C)** to copy that photo into Photoshop's memory.

Step Seven:
Switch back to the instant photo image, and you'll notice that your selection is still in place. Go under the Edit menu, under Paste Special, and choose **Paste Into**. The image held in memory will appear pasted inside your square selection. If the photo is larger than the square you pasted it into, you can reposition the photo by just clicking-and-dragging it around inside your selected opening.

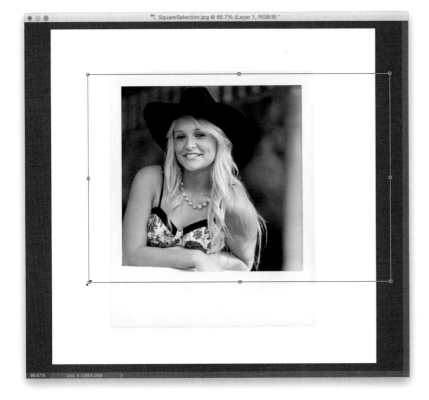

Step Eight:
You can also use Free Transform (press **Command-T [PC: Ctrl-T]**) to scale the pasted photo in size. Just grab a corner point (press **Command-0** [zero; **PC: Ctrl-0**] if you don't see them), press-and-hold the Shift key (to keep things proportional), and drag inward or outward. When the size looks right, press the **Return (PC: Enter) key** and you're done. Now, on to oval and circular selections…

(Continued)

Step Nine:

Open an image with a circle shape you want to select (a bowl here), and then press **Shift-M** to switch to the Elliptical Marquee tool (pressing Shift-M toggles you between the Rectangular and Elliptical Marquee tools by default). Now, just click-and-drag out a selection around your circle. Press-and-hold the Shift key as you drag to make your selection perfectly round. If your round selection doesn't fit exactly, you can reposition it by moving your cursor inside the border of your round selection and clicking-and-dragging to move it into position. You can also press-and-hold the Spacebar to move the selection as you're creating it. If you want to start over, just deselect, and then drag out a new selection. *Hint:* With circles, it helps if you start dragging before you reach the circle, so try starting about ¼" to the top left of the circle.

Step 10:

While we're at it, let's check out another little tip with selections. In our example, we've selected the bowl because it's simple and easy to select. But really, the background is the area we'd like to fix here. It's just a little bright and I think it'll look better if it's a bit darker. No sweat. Just go under the Select menu and choose **Inverse** (or press **Command-Shift-I [PC: Ctrl-Shift-I]**) and Photoshop will select everything else *but* what you put a selection around in the previous step.

Step 11:
Now let's adjust the area around the bowl. Click on the Create New Adjustment Layer icon and choose **Levels**. In the Properties panel, drag the black (shadows) slider beneath the histogram to the right to around 24, then drag the gray (midtones) slider to the right to around 0.89 to add more contrast to the background. That's it. Remember, to simply make ovals or rectangles, just start dragging. However, if you need a perfect circle (or square), then hold down the Shift key.

Before

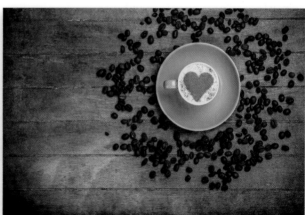

After

Saving Your Selections

If you've spent 15 or 20 minutes (or even longer) putting together an intricate selection, once you deselect it, it's gone. (Well, you might be able to get it back by choosing Reselect from the Select menu, as long as you haven't made any other selections in the meantime, but don't count on it. Ever.) Here's how to save your finely-honed selections and bring them back into place anytime you need them.

Step One:
Open an image and then put a selection around an object in your photo using the tool of your choice. Here I used the Quick Selection tool **(W)** to select the sky and the water, then went under the Select menu and chose **Inverse** to select the buildings. Then, I clicked on the tops of the buildings to add them to the selection. If you select too much, just press-and-hold the **Option (PC: Alt) key** and click in the areas you want to deselect. To save your selection once it's in place (so you can use it again later), go under the Select menu and choose **Save Selection**. This brings up the Save Selection dialog. Enter a name in the Name field and click OK to save your selection.

Step Two:
Now you can get that selection back (known as "reloading" by Photoshop wizards) at any time by going under the Select menu and choosing **Load Selection**. If you've saved more than one selection, they'll be listed in the Channel pop-up menu—just choose which one you want to "load" and click OK. The saved selection will appear in your image.

Softening Those Harsh Edges

When you make an adjustment to a selected area in a photo, your adjustment stays completely inside the selected area. That's great in many cases, but when you deselect, you'll see a hard edge around the area you adjusted, making the change look fairly obvious. However, softening those hard edges (thereby "hiding your tracks") is easy—here's how:

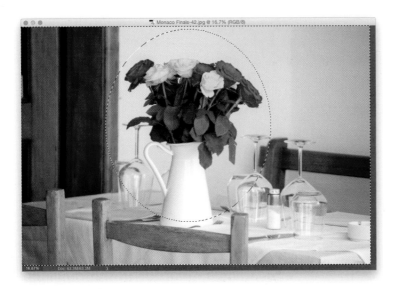

Step One:

Let's say you want to darken the area around the flowers and vase, so it looks almost like you shined a soft spotlight on them. Start by drawing an oval selection around them using the Elliptical Marquee tool (press **Shift-M** until you have it). Make the selection big enough so the flowers, vase, and the surrounding area appear inside your selection. Now we're going to darken the area around them, so go under the Select menu and choose **Inverse** (or just press **Command-Shift-I [PC: Ctrl-Shift-I]**) This inverses the selection so you'll have everything but the flowers and vase selected (you'll use this trick often).

Step Two:

Click on the Create New Adjustment Layer icon at the bottom of the Layers panel, and choose **Levels**. In the Properties panel, drag the gray (midtones) slider beneath the histogram to the right to about 0.54. You can see the harsh edges around the oval, and it looks nothing like a soft spotlight— it looks like a bright oval. That's why we need to soften the edges, so there's a smooth blend between the bright oval and the dark surroundings.

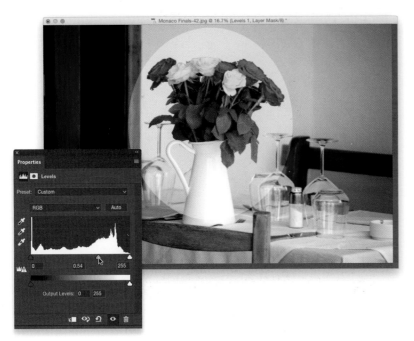

(Continued)

Step Three:

Press **Command-Option-Z (PC: Ctrl-Alt-Z)** three times so your photo looks like it did when you drew your selection in Step One (your oval selection should be in place—if not, drag out another oval). With your selection in place, go under the Select menu, under Modify, and choose **Feather**. When the Feather Selection dialog appears, enter 150 pixels (the higher the number, the more softening effect on the edges) and click OK. That's it—you've softened the edges. Now, let's see what a difference that makes.

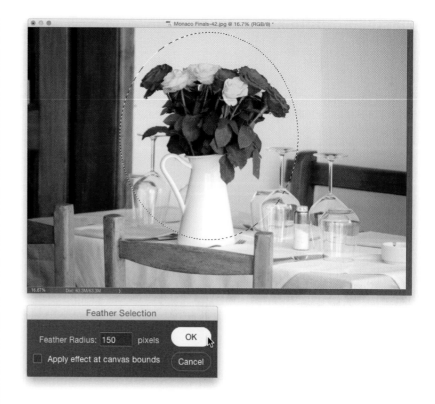

Step Four:

Go under the Select menu and choose Inverse again. Add a Levels adjustment layer again, drag the midtones Input Levels slider to around 0.54, and you can see that the edges of the area you adjusted are soft and blending smoothly, so it looks more like a spotlight. Now, this comes in really handy when you're doing things like adjusting somebody with a face that's too red. Without feathering the edges, you'd see a hard line around the person's face where you made your adjustments, and it would be a dead giveaway that the photo had been adjusted. But add a little bit of a feather (with a face, it might only take a Feather Radius of 2 or 3 pixels), and it will blend right in, hiding the fact that you made an adjustment at all.

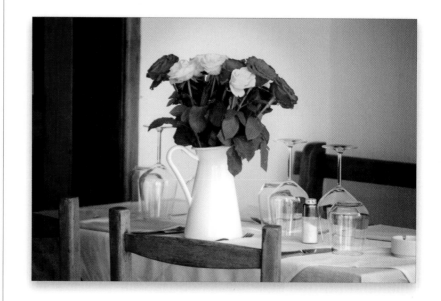

Easier Selections with the Quick Selection Tool

This is another one of those tools in Photoshop that makes you think, "What kind of math must be going on behind the scenes?" because this is some pretty potent mojo for selecting an object (or objects) within your photo. What makes this even more amazing is that I was able to inject the word "mojo" into this introduction, and you didn't blink an eye. You're one of "us" now….

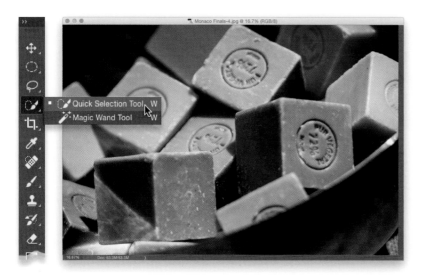

Step One:

Open the photo that has an object you want to select (in this example, we want to select one of the squares of soap). Go to the Toolbox and choose the Quick Selection tool (or just press the **W**, for Wow, **key**).

Step Two:

The Quick Selection tool has an Auto-Enhance checkbox up in the Options Bar. By default, it's turned off. My line of thinking is this: when would I ever not want an enhanced (which in my book means better) selection from the Quick Selection tool? Seriously, would you ever make a selection and say, "Gosh, I wish this selection looked worse?" Probably not. So go ahead and turn on the Auto-Enhance checkbox, and leave it that way from now on.

(Continued)

Step Three:

Take the Quick Selection tool and simply paint squiggly brush strokes inside of what you want to select. You don't have to be precise, and that is what's so great about this tool—it digs squiggles. It longs for the squiggles. It needs the squiggles. So squiggle.

Step Four:

If the selection includes areas you don't want (like part of the soap on the left and part of the bowl, in this example), press-and-hold the **Option (PC: Alt) key** and you'll see the center of the brush has a minus sign in it. That means it's in Subtract mode. Just go ahead and paint over those areas to deselect them (as shown here).

Step Five:

Now that we've got it selected, we might as well do something to it, eh? How about this: let's change its color. Click on the Create New Adjustment Layer icon at the bottom of the Layers panel and choose **Hue/Saturation**. In the Properties panel, drag the Hue slider to the right to around +130 and the Saturation slider to around +35 to choose a nice pinkish-red color. In the After image below, you'll see that I also changed the colors of two of the other soaps (by clicking on the Background layer, selecting them, and then adding a Hue/Saturation adjustment layer to each of their selections).

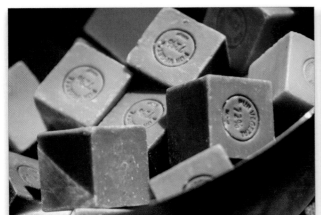

Before

After

Making Really Tricky Selections, Like Hair (and Some Cool Compositing Tricks, Too!)

Most of the selecting jobs you'll ever have to do in Photoshop are pretty easy, and you can usually get away with using the Quick Selection, Magic Wand, Lasso, or Pen tools for most jobs, but the one that has always kicked our butts is when we have to select hair. Over the years we've come up with all sorts of tricks, including intricate Channels techniques. But all these techniques kind of went right out the window when Adobe supercharged the Quick Selection tool and updated the Refine Edge feature, which is now called Select and Mask. This is, hands down, one of the most useful, and most powerful tools in all of Photoshop.

Step One:

Start by opening an image that has a challenging area to select (like our subject's hair here, which is really curly on top). Now, with the new Select and Mask feature, you can choose any selection tool in the Toolbox, then click on the Select and Mask button up in the Options Bar to open the Select and Mask taskspace and make your selection there. I prefer, though, to do it the old way (the way we did it when it was Refine Edge)—make my selection first, and then jump over to Select and Mask. So, let's grab the Quick Selection tool **(W)** from the Toolbox (as shown here).

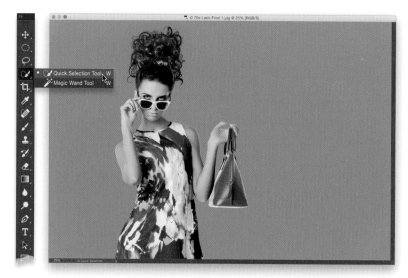

Step Two:

Here's how it works: you just take the tool and paint loosely over the areas you want to select, and it expands to select the area (kind of like a much smarter version of the Magic Wand tool, but using different technology). One thing I've learned about this tool is it actually seems to work best when you use it quickly—really zoom over your subject with the tool and it does a pretty decent job. Here, I selected the subject, and while you can see some problems with the selection (the areas of gray around her hair and the arm holding the bag), it's not that bad overall. If it selects too much, press-and-hold the **Option (PC: Alt) key** and paint over that accidentally selected area to remove it from your selection. Don't worry—it's not going to look perfect at this point.

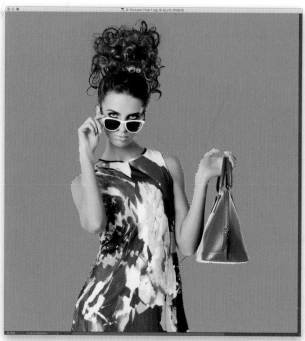

Step Three:

Now, here's something else I've learned about the Quick Selection tool: while it's pretty good at selecting, it's not always as good at deselecting areas that you don't want selected (like that gray area near her arm on the right). When I deselected that area, it also deselected some of her arm and the bag, so I had to reselect those. If it isn't working, try switching to the Magic Wand tool (**Shift-W**), pressing-and-holding the **Option (PC: Alt) key**, and just clicking once in that area to instantly deselect it (as shown here).

Step Four:

Okay, here comes a very important part of this stage of the process, and that is making sure that when you select her hair, you don't select any background area with it. In other words, don't let there be any hair selected with gray background showing through. In fact, I basically follow the rule that I don't get too close to the outside edges of my subject's hair un-less an area is pretty flat (in other words, no flyaway, tough-to-select hair in that area). You can see what I mean in the close-up here, where I avoided the thin-ner edges of her hair (we'll let Photoshop select those hard parts—we'll just get close to the edge then stop). Also, you can see where I stopped before some areas where the hair is finer. Again, we'll let Photoshop grab those parts later, but for now we're most concerned with avoiding selecting areas where you can see gray background through her hair. If you accidentally select an area with gaps, then it's okay to, with the Quick Selection tool, press-and-hold the Option (PC: Alt) key, and paint over those gap areas to deselect them (as shown here).

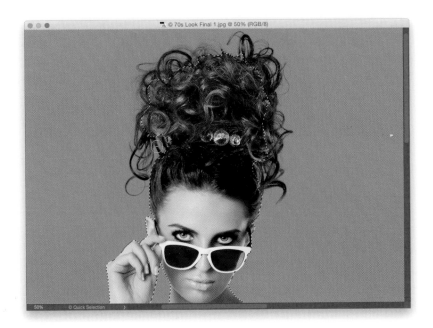

(Continued)

Step Five:

Once your selection looks pretty decent, it's time to unlock the real selection power (the Quick Selection tool is just the warm-up act). Go up to the Options Bar and click on the Select and Mask button (shown circled here). This is where the magic happens.

TIP: Want to Use the Old Refine Edge Dialog?

After you make a selection with any selection tool, press-and-hold the Shift key and choose Select and Mask from the Select menu.

Step Six:

If you're familiar with using the old Refine Edge dialog, you'll see that the new Select and Mask taskspace has all the same features—Adobe pretty much just moved it to this new taskspace, but added some cool new features. For example, you can choose the Quick Selection tool, Lasso tool, or Polygonal Lasso tool (it's nested beneath the Lasso tool) from the Toolbox and make your selection here now. But, like I mentioned, I prefer making the selection the old way, before coming into this taskspace. You still have a number of choices for how you can view your selected image (including just the standard old marching ants), which you choose from the View pop-up menu in the Properties panel, and there are three views in particular that I use the most. One is the new Onion Skin view (**O**; shown here. We'll look at the other two in a moment). In this view, you'll see the parts of your image that are selected appear in full-color, and the parts that aren't appear transparent. Right below the View pop-up menu, you have a Transparency slider, which you can lower to see the areas you need to add to your selection. With this set at 100%, you'll see just the basic selection, so I usually work with this set to around 25% (just drag it back and forth and you'll see what it does).

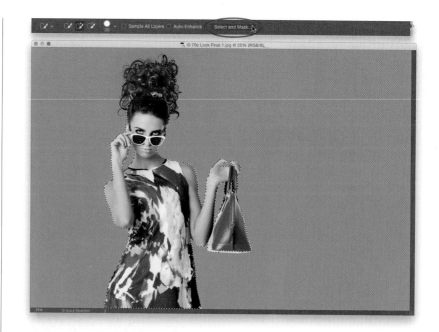

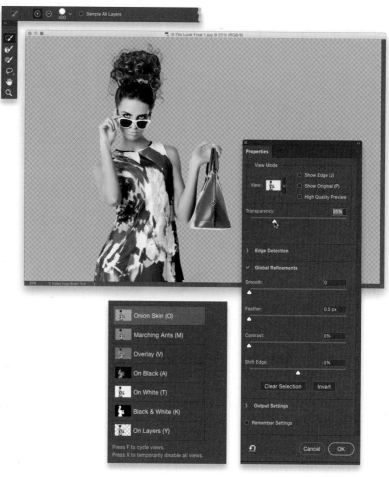

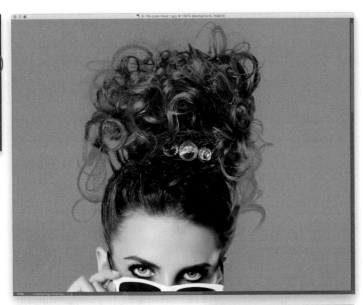

Step Seven:

The second view that I use, and it's actually the one that I use the most, is Overlay view. So, choose that one from the View pop-up menu (or just press **V**). In this view, again, the parts that are selected appear in full-color, but the parts that aren't appear in red. If you see the background color showing through (in our case, gray), you've got a problem (and we do here, in a few places). You need to tell Photoshop exactly where the problem areas are, so it can better define those areas. You do that with the Refine Edge Brush tool (**R**; shown circled here). Select it from the Toolbox and then just take your cursor and simply paint over the areas where you see the background peeking through (as shown here), and it redefines those areas (use the **Bracket keys** to the right of the letter P on your keyboard to resize your brush). This is what picks up that fine hair detail.

TIP: See a High-Res Preview

If you want to see a high-res preview as you're painting your mask, turn on the High Quality Preview checkbox in the View Mode section. If you find it's running too slow, just keep the checkbox turned off.

Step Eight:

As you look around her hair, if you see parts of it that are tinted red, those parts aren't selected. So, just paint a stroke or two over those areas (like I'm doing here), and they become full-color (letting you know they're added to your selection) as Photoshop refines those edge areas where you're painting. If it's not coming out perfect as you paint, give it a second or two. Photoshop has to do some math here redefining those areas, so when you release your mouse button, things should come together pretty well. Here, I've gone over some areas that were tinted red on the left side of her hair, and you can see those areas are now appearing in color.

(Continued)

Step Nine:

Continue painting over any red areas of hair to add them to the selection. When things start looking good, switch back over to Onion Skin view and raise the Transparency up to see how things are looking. As you can see here, it has done a pretty good job of redefining those wispy areas of hair and adding them to the selection. If there are any areas that aren't looking too good, you can switch back to Overlay view, press-and-hold the **Option (PC: Alt) key** to put the Refine Edge Brush in Subtract mode and paint over those areas to remove them from the selection. Then, just release the Option key and try painting over them again.

Step 10:

Now, let's switch to the third View mode that I use, which is Black & White **(K)**. This view shows your selection as a standard layer mask, and I primarily use this view for clean-up. Anything here that's not solid white will end up transparent. So, while it's okay for the edges of the hair to be transparent, we need to make sure that our subject is solid white (and the background is solid black). So, once you're in this view, zoom in and look for any areas that aren't solid white that need to be (like here, on her face and hand, in the overlay). Get the Brush tool **(B)** from the Toolbox, and then paint over those areas to add them to your selection.

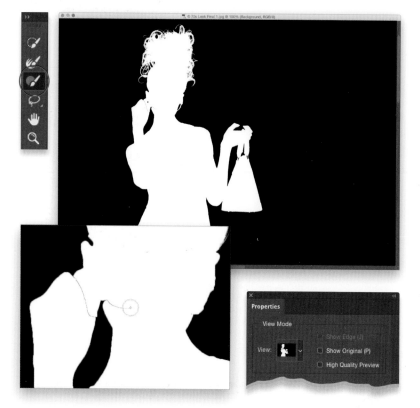

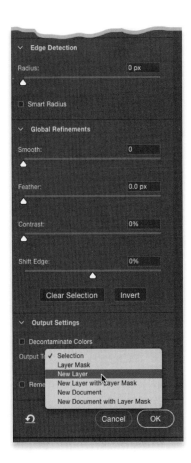

Step 11:

Before we finish up here in Select and Mask, I wanted to mention that while I used to use the features in the Edge Detection section when they were in Refine Edge, I find that I no longer really use them (Smart Radius is the edge technology that knows the difference between a soft edge and a hard edge, so it can make a mask that includes both). I also recommend avoiding the Global Refinements section sliders in the center of the dialog altogether, because you'll spend too much time fussing with them, trying to make them work. (I figure you want me to tell you when to avoid stuff, too.) Down at the bottom of the dialog, there's a Decontaminate Colors checkbox, which basically desaturates the edge pixels a bit. So, when you place this image on a different background, the edge color doesn't give you away. Just below that, you get to choose what the result of all this will be: will your selected subject be sent over to a new blank document, or just a new layer in this document, or a new layer with a layer mask already attached, etc.? Here, let's make a new layer in the same document, so choose **New Layer** and click OK.

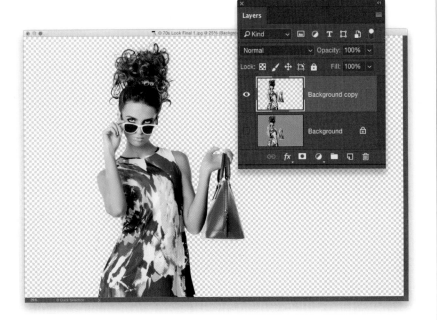

Step 12:

When you click OK, your image will now appear on a transparent layer (as seen here). You can also see it does a pretty amazing job. It won't get every little thin, wispy hair strand, but it gets most of the important ones, and I've got a couple tricks coming up next that will help a bit more.

(Continued)

Step 13:

Now, here's a trick I stumbled upon years ago when making composites. This trick gives you more detail and brings back some of those lost wisps of hair by building up some pixels. It's going to sound really simple and it is. Just press **Command-J (PC: Ctrl-J)** to duplicate your layer (the one with your subject). That's it. Just duplicate your subject layer, and it has a "building up" effect around the edges of her. Suddenly, it looks more defined, and it fills in some of the weaker wispy areas. If for any reason it looks like too much, at the top of the Layers panel, just lower the Opacity of this duplicate layer until it looks right. Next, merge this duplicate layer with your original subject layer by pressing **Command-E (PC: Ctrl-E)**.

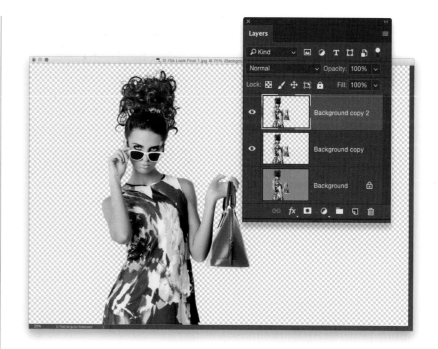

Step 14:

Another trick that I use to fill in areas and bring back more detail is done using the History Brush tool **(Y)**, or as I like to call it, "Undo on a Brush." So, go ahead and get it from the Toolbox. What this brush does is basically undoes anything you've done and brings back the original image wherever you paint with it. Do you know how handy this is for compositing?! Just look around your image and if you see any areas that didn't perfectly mask and have out dropped out a little, just paint them back in. Be careful when you're painting, though, to not paint any gray background in—keep your brush small. So, while you may not be able to get every single little piece of hair, if something drops out, it's nice to know that you can grab this brush and paint it right back in. It's a huge help. One important thing to keep in mind when using this brush: if you change the size of this document, or crop it, etc., you won't be able to go back to the original state, because it's changed So, you'll want to use this brush before doing anything like that.

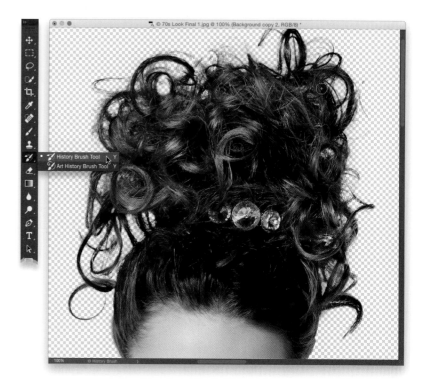

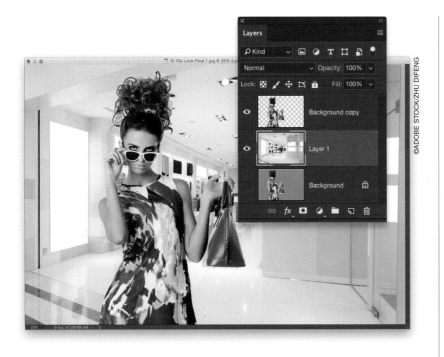

Step 15:

Next, open the background image you want to use in your composite. Press **Command-A (PC: Ctrl-A)** to select it, then press **Command-C (PC: Ctrl-C)** to Copy it into memory. Switch back over to our subject image, and then press **Command-V (PC: Ctrl-V)** to Paste it into this document. It will appear on its own layer above our selected subject layer, so just click-and-drag it beneath the subject layer in the layer stack (as seen here). If needed, press **Command-T (PC: Ctrl-T)** to bring up Free Transform and resize the background (just press **Command-0** [zero, **PC: Ctrl-0**] to get the control handles), and then press **Return (PC: Enter)** to lock in your transformation.

Step 16:

Depending on the background and your selection, you may see a white fringe around your subject (here, there's some on her wrist on the right and on the handles of the bag). To remove the fringe, click back on the subject layer in the Layers panel to make it the active layer, then go under the Layer menu, under Matting (it's at the very bottom of the menu), and choose **Defringe**. When the Defringe dialog appears (shown here), enter 1 (use 2 pixels for a higher-megapixel image), click OK, and that fringe is gone! (Photoshop basically replaces the outside edge pixels with a new set of pixels that is a combination of the background it's sitting on and your subject's edge, so the fringe goes away.)

(Continued)

Step 17:

Now, she looks a little warm for the background, so let's desaturate her a little. Start by Command-clicking (PC: Ctrl-clicking) on the layer thumbnail for her layer to put a selection around her. Then, click on the Create New Adjustment Layer icon at the bottom of the Layers panel and choose **Hue/Saturation** from the pop-up menu. This adds a Hue/Saturation adjustment layer, but with your selection (our subject) already masked on the layer mask, so the adjustment will only affect what is inside the selection. In the Properties panel, from the pop-up menu set to Master, choose **Yellows** and then drag the Saturation slider to the left a bit, until she blends with the background better (here, I dragged to –48). That's it.

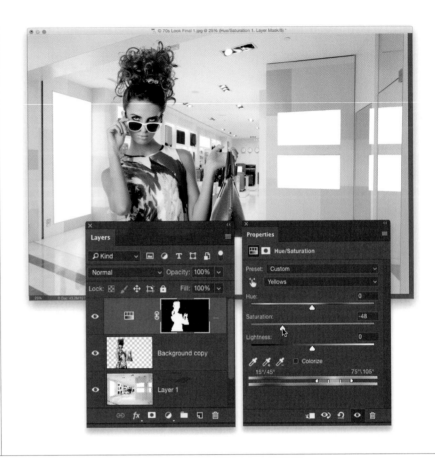

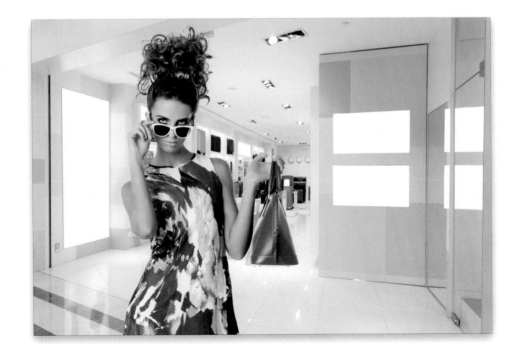

Photoshop Killer Tips

Hide All Your Panels Fast

If you want to focus on your photo, and temporarily hide your Toolbox, Options Bar, and all your panels, just press the **Tab key**. Press it again to bring them all back.

Putting Your Drop Shadow Right Where You Want It

If you're adding a drop shadow behind your photo using a Drop Shadow layer style (choose **Drop Shadow** from the Add a Layer Style icon's pop-up menu), you don't have to mess with the Angle or Distance fields whatsoever. Instead, move your cursor outside the Layer Style dialog—over into your image area—and just click-and-drag the shadow itself right where you want it.

Deleting Layers

To delete a layer, click on the layer in the Layers panel and (a) drag it onto the Trash icon at the bottom of the panel, (b) click on the Trash icon (but then it'll ask if you really want to delete the layer), or (c) hit the **Delete (PC: Backspace) key** on your keyboard.

Getting Rid of Your Empty Layers Fast

Photoshop has a built-in script that will go through your Layers panel and remove any empty layers (layers with nothing on them) automatically (once you get a large multi-layered project going, you wind up with more of these than you'd think). To have Photoshop tidy things up for you, go under the File menu, under Scripts, and choose **Delete All Empty Layers**.

Removing Noise from Cell Phone Photos

Since Photoshop is a pro tool, most of us probably wouldn't even think of using Camera Raw's built-in Noise Reduction feature to remove the noise from our cell phone camera's photos, but...why not?

Cell phone photos are notorious for color noise, which Camera Raw cleans up really well. Try it one time, and I'll bet you'll use it more than you ever dreamed (to open a cell phone photo in Camera Raw, just find it on your computer in Bridge, then Right-click on it and choose **Open in Camera Raw**).

Using the HUD Pop-Up Color Picker

If you've ever thought, "There's got to be an easier way to pick colors than clicking on the Foreground color swatch every time," you're gonna love this: it's a pop-up color picker (Adobe calls it the HUD [Heads-Up Display], because you keep your eyes on the image, instead of looking over and

down at the Foreground/Background color swatches). First, choose a Brush tool, then press **Command-Option-Control (PC: Alt-Shift)** and **click (PC: Right-click)** on your image. It brings up a simplified color picker where you can choose your color (I find it easier to choose the hue first, from the bar on the right, then choose the tint and saturation of the color from the box on the left).

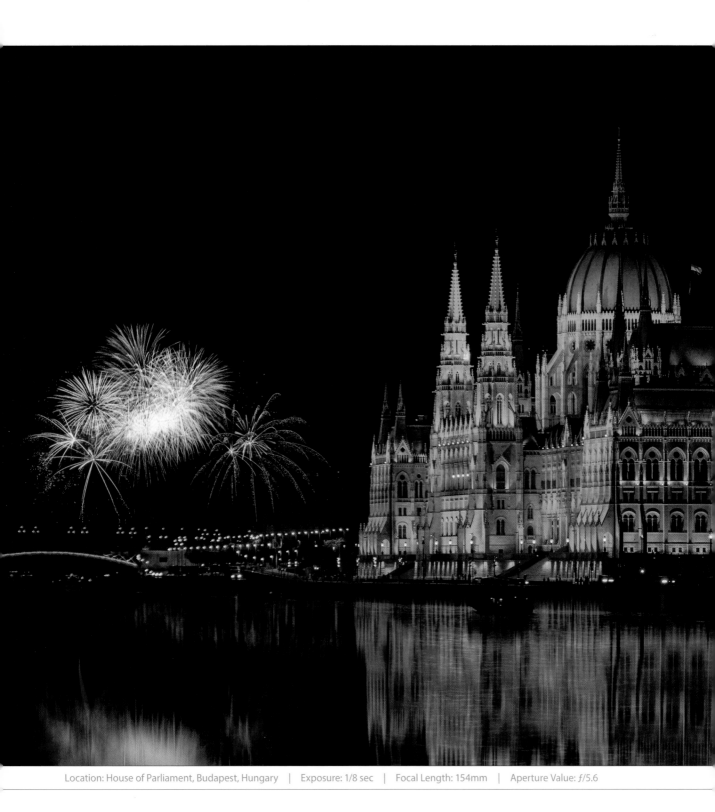

Location: House of Parliament, Budapest, Hungary | Exposure: 1/8 sec | Focal Length: 154mm | Aperture Value: ƒ/5.6

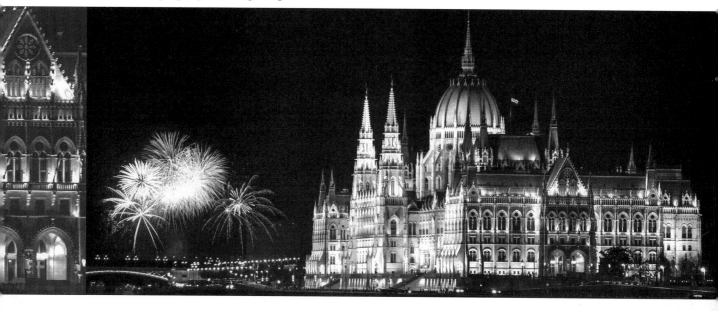

HDR
creating high dynamic range images

Did I really find a band named HDR? I did. I am not making this up (do your own search in the iTunes Store—it will take you all of 15 seconds). They also had an album titled *We Are HDR*, which would have made a great name if I hadn't already used it in a previous edition of this book, so I'm straight up going with their name instead. Now, I'm guessing they're not photographers, and I'm guessing that HDR in the way that they're using it doesn't stand for "high dynamic range," like it does in Photoshop. Of course, I could do a bit of simple research (visiting the band's website, for example) and find out what their acronym stands for, but I thought it might be fun for us (and by "us," of course, I mean "me") to come up with a few guesses (I swear, I have not looked up their site and don't know what their HDR acronym means, but I have to tell you in advance, if I learn that HDR isn't an acronym and is just short for "harder," as in hard rock, I'm going to be mighty cranky). Here are a few of my guesses: Hair Done Right (come on, that's not bad). How about Heathrow Departures Ramp? Or Hallucinogenic Drug Reaction? Or, maybe Hollywood Door Rats, or even

Helpful Discount Rewards? (Okay, I seriously doubt they named their rock band Helpful Discount Rewards. Just sayin'.) What if they were one of those creepy death metal bands? Then they could be Hacksaw Death Rigormortis or Horrifying Disease Relapse. Hey, all of those would work (stop snickering), but now I'm going to go to their site and find out what it really means. Hang tight for a sec. Okay, I'm back. It took me about 20 minutes (on their Facebook page, Myspace page, Twitter, etc.) until I found an actual site, and there, I uncovered their name. After all the awesome names I came up with, prepared to be underwhelmed with their real name: it's Housse De Racket. I am not making this up. Now, I can't swear with 100% certainty that this is the same drinking and rocking and partying L.A.-based HDR band that I first found, because there were three of them. This HDR band is a techno band taping their videos on a rooftop in Paris, and there's only two of them. Either way, it's a band. They're named HDR. I'm using it for the chapter name (but apparently, my real gift is naming bands with either two or three people).

Creating 16-Bit HDR Images in Camera Raw

Camera Raw lets you take a series of shots that were bracketed in-camera and combine them into a single 16-bit HDR image (something we used to have to jump to Photoshop for in the past). But, I want to tell you up front—it doesn't create the traditional tone-mapped HDR "look" (like Photoshop's HDR Pro does). In fact, the 16-bit HDR will look a lot like the normal exposure. But, when you edit it, this 16-bit image has increased highlight range and better low noise results when you really have to open up the shadows, so the image has a greater tonal range overall to work with from the start. Plus, the final HDR image is a RAW image.

Step One:

Select your bracketed shots in Bridge, and then press **Command-R (PC: Ctrl-R)** to open them in Camera Raw. Here, you'll see that I selected three shots: the regular exposure, one shot that is two stops underexposed, and one shot that is two stops overexposed. Now, click on the little icon to the right of Filmstrip (up in the top left) and choose **Select All** (or just press **Command-A [PC: Ctrl-A]**) to select all three images. Then, go back under the same menu and choose **Merge to HDR** (as shown here; or just press **Option-M [PC: Alt-M]**).

Step Two:

After 20 or 30 seconds (or so) the HDR Merge Preview dialog will appear (as seen here) with a preview of the combined HDR image. Like I said in the intro, it'll probably look very much like the normal exposure. But, depending on the image, it can have more detail or it can look brighter in the shadow areas, but it won't look a whole lot different (with Camera Raw's brand of 16-bit HDR, you don't really see the benefits until you "tone" the image back in Camera Raw).

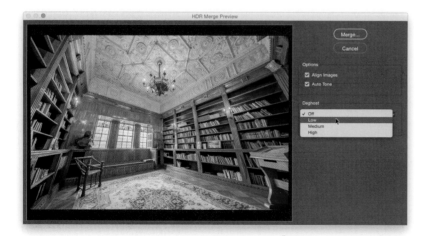

Step Three:

Before you click Merge, I recommend turning the Auto Tone checkbox on/off to see how it looks (this is the same Auto option found in Camera Raw's Basic panel, and covered in Chapter 1). In nearly all the HDR images I've tested (and it's a bunch), Auto Tone has looked at least a little, if not a lot, better, so it's worth toggling it on/off to see what you think. You can see the difference here between this auto-toned image and the one with Auto Tone turned off in Step Two. If you ask me, this one looks quite a bit better (and I usually leave Auto Tone turned on when I'm processing my own HDR images). While we're talking checkboxes, the Align Images checkbox is on by default, but what it helps with (mostly) are shots you handheld while bracketing. If the alignment is off a little (or a lot), it'll fix that automatically. If you shot your HDR on a tripod, it doesn't need to align anything, so you can skip it and it'll process faster.

Step Four:

The Deghost feature helps if something was moving in your photo (like someone walking in your frame, who now appears like a semi-transparent ghost, but it doesn't look cool, it looks like a mistake). By default, Deghost is turned off (only turn it on if you have visible ghosting). To turn it on, from its pop-up menu, choose either Low (for mild deghosting), Medium (for more), or High (if there's a lot of ghosting in the image), and it does a pretty amazing job of basically pulling a non-moving area from one of the three bracketed exposures and seamlessly displaying it, rather than the ghosted movement. I always start with the Low setting and only move up to Medium or High if the ghosting is still visible. By the way, when you turn this on, it has to rebuild the preview again, so it'll take a few seconds (and you'll see an exclamation point icon in the top right of the image).

(Continued)

Step Five:

If you want to see the areas that are being deghosted in your image, you can turn on the Show Overlay checkbox (beneath the Deghost pop-up menu) and after a few seconds (it has to rebuild a new preview), the areas that are being deghosted will appear in red (there isn't anything moving in this image, which was shot on a tripod, so I turned the Show Overlay checkbox back off, and then chose Off from the pop-up menu, again).

TIP: Less Bracketed Images Is More

For the type of math Camera Raw's Merge to HDR does, you don't need a lot of bracketed images. In fact, according to Adobe, not only are three bracketed images enough (one normal, one two stops under, one two stops over), you can even skip the normal exposure and just use two images and have lots of detail (versus using more bracketed images). Pretty wild, I know.

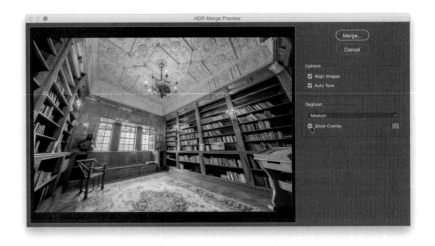

Step Six:

So far, you're looking at a preview of how your merged HDR will look, but it's just a preview. When you're finished making your checkbox choices, click the Merge button, it'll ask you where you want to save your image, and then it starts processing the actual HDR image. It takes a minute or so (depending on how many bracketed images you used, the size of your images, the speed of your computer, etc.). When it's done merging, this new 16-bit HDR appears as a RAW DNG file in Camera Raw's Filmstrip (as seen here; you read that right—your combined HDR image is a RAW file, which is pretty amazing unto itself).

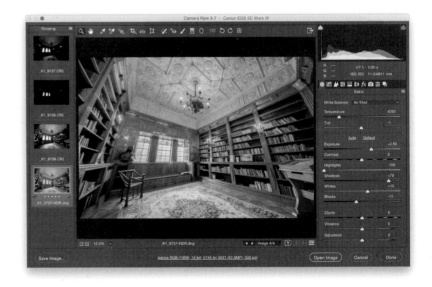

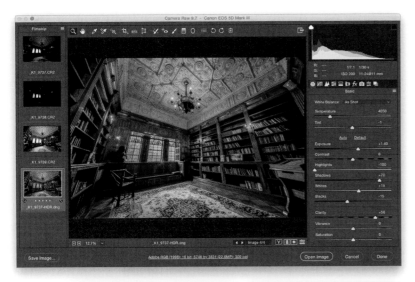

Step Seven:

Now, normally, you can drag the Exposure slider to +5.00 or –5.00. Well, because of the hugely expanded tonal range in 16-bit images, that range is now +10.00 (as seen in the inset below on the left) or –10.00. Hopefully, you'll never take an image whose exposure is off by 10 stops, so I'm just letting you know the 16-bit HDR image has a greatly expanded range, and that helps us by giving us some highlight headroom and better results when it comes to noise when you open up the shadow areas a lot. Okay, now we can start toning the image, and in this particular image, there's just not that much to do (especially since we already applied an Auto Tone earlier). All I did here was lowered the Exposure to +1.40 because it was a bit too bright, cranked up the Clarity amount to +58 (wood loves clarity—it really makes it "pop"), then I went to the Detail panel, and in the Sharpening section, I increased the Amount to 50 (as seen in the inset below on the right). That's it, your first 16-bit HDR image in Camera Raw.

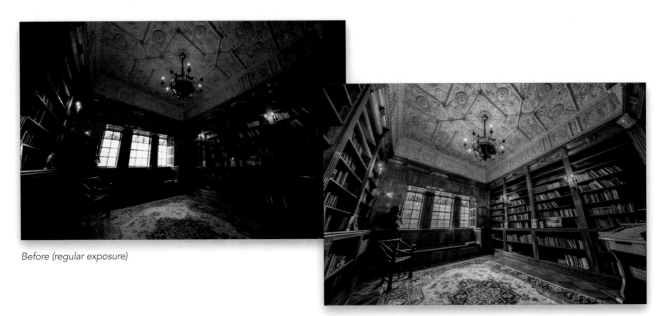

Before (regular exposure)

After

Creating the Tone-Mapped HDR Look

In this project, we're going to create that heavily tone-mapped hyperreal look. Now, this particular look isn't for everybody. So if, instead, you want a hybrid, kind of a half-HDR/half-real, jump to page 205, 'cause here we're setting the amp on 11! (A not-so-subtle reference to the movie *This Is Spinal Tap*.) This is a really quick and easy effect—just a few clicks and you're done (great for people with attention spans like mine, who want it done now without a lot of fuss)—but I'm just warning you now, this is the full-on, "I'm in a Harry Potter fantasy world" style of HDR you're about to learn. Just so you know.

Step One:

Here, I selected three bracketed shots in Bridge (one with normal exposure, one 2 stops underexposed, and one 2 stops overexposed), then went up under the Tools menu, under Photoshop, and chose **Merge to HDR Pro**. After a few moments, the Merge to HDR Pro dialog appears (as shown here; I'm being gratuitous when I say "a few moments," because I timed it and, on my laptop, it took 19 seconds). Anyway, it merges these three images into one single HDR image that looks pretty bad, because it's using the default 16-bit settings, which should be named simply "Bad" for clarity's sake.

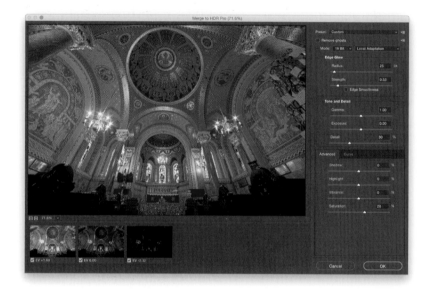

Step Two:

When HDR Pro came out, I made a lot of fun of the presets that came with it because I couldn't find a single image that they didn't look awful on. So, I set out to create a preset of my own that worked pretty consistently for most of the images I tried it on. It took a while, but I came up with one, and Adobe liked it enough that they included it in Photoshop. It's named "Scott5," so choose that from the Preset pop-up menu, then turn on the checkbox for Edge Smoothness, which takes some of the harshness out of the effect (I created that preset before Adobe added Edge Smoothness, so I always turn it on). If you want a little extra "juice" in your HDR image, drag the Strength slider to the right just a smidgen, as shown here where I dragged from the Scott5 default of 0.47 up to 0.57.

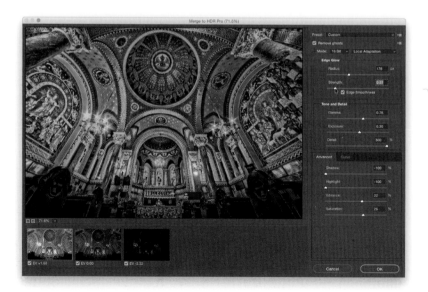

Step Three:

With this preset, there are really only two sliders that I ever need to tweak, and they're both pretty subtle compared to their Camera Raw counterparts with the same names. They are: (1) the Shadow slider (if you drag it to the right, it lightens the darkest areas of your photo, but just barely. It's kinda lame), and (2) the Highlight slider. For indoor shots, I always think of this slider as controlling window light, or any lights visible in the room. For example, if you took an HDR photo in a church (like this) or a house, the Highlight slider would control how bright the windows and lights look—the farther you drag to the right, the brighter they become (as shown here, where I dragged it to -63). Honestly, I usually don't touch anything else, so just click OK to process the HDR and open in it Photoshop (but we're not done, yet).

TIP: Presets Can Look Very Different on Different Photos

How any preset looks is totally dependent on which image you apply it to, so while one might look great on one photo, it can look dreadful on the next. Hey, it is what it is.

Step Four:

To do our final tweaks, go under the Filter menu and choose **Camera Raw Filter**, and it brings up the Camera Raw window. This particular image was a little bright, so to make it just a bit darker I dragged the Exposure slider to the left to –0.15. I also increased the Contrast quite a bit to +44 (I do this for almost every photo, not just HDR images). Lastly, to open the shadows, I dragged the Shadows slider to the right to +53 (as shown here). Click OK to open it back in Photoshop.

(Continued)

Step Five:

The before (normal) image is shown here at the top, and our HDR tonemapped after image is shown in the middle. Even though I'm showing you the final image at this point here, I would take this one step further, since it's a tone-mapped look, and add the finishing moves I go through starting on page 215 later in this chapter. It's just three quick and easy little things, but they make a difference.

The original normal-exposure image

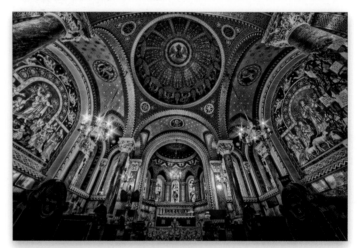

The HDR image after applying the tone-mapped effect and tweaking it in Camera Raw

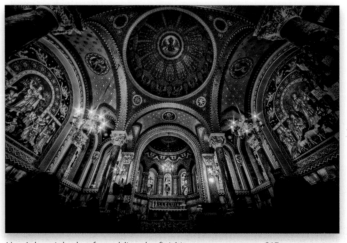

Here's how it looks after adding the finishing moves on page 215

Creating a Blended HDR to Get the Best of Both Worlds

There are great things about HDR (it's amazing how it brings out details and enhances texture in things like wood, tile, metal, etc.), but there are a lot of things that look awful in HDR (trees start to look plastic, white clouds get drop shadows and start to turn black, etc.). So, what if you could create a hybrid, where you get the best things from HDR blended with the best things from a normal single image? Well, this is how to get the best of both worlds by blending the original with the HDR, and best of all, you have full control over how they blend.

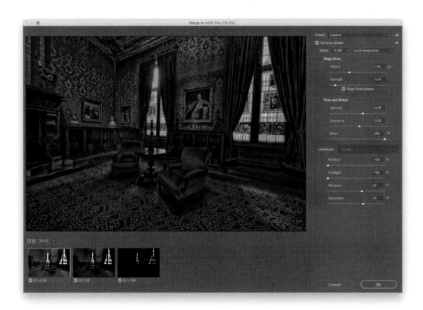

Step One:

Select your images in Bridge, then go under the Tools menu, under Photoshop, and choose **Merge to HDR Pro**. When the Merge to HDR Pro dialog appears, go ahead and choose the Scott5 preset from the Preset pop-up menu at the top right of the dialog. Then, turn on the Edge Smoothness checkbox (as seen here) to reduce some of the harsh edges.

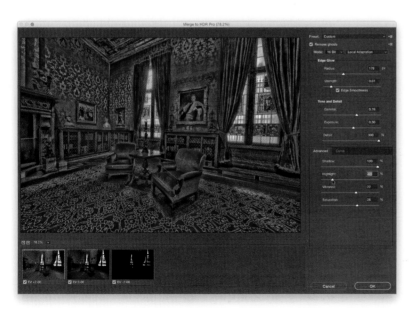

Step Two:

We want this image to be super-HDR'd at this point (don't worry, we'll fix this later), so crank up the Strength slider a bit to +0.61, then down at the bottom, on the Advanced tab, let's open up the shadows as much as possible by dragging the Shadow slider all the way over to the right to +100, and then increase the Highlight setting a bit to make them nice and white (in the windows), but without blowing them out. You really want that Harry Potter fantasy look here, but stay away from the Vibrance and Saturation sliders or you may see Harry himself appear with an onscreen warning that you've gone too far. Now, click OK to open that HDR'd-to-death photo in Photoshop.

(Continued)

Step Three:

Next, go back to Bridge, choose the normal exposure of the three (or five, or seven—whatever you shot) images (the shot that looks regular), and double-click on it so it opens in Camera Raw. You really don't have to do anything to the image unless it looks kinda messed up (so if it's too dark, or something's blown out, or whatever, you can fix that now if you want—it's your call). In this case, I just increased the Exposure a bit and didn't mess with anything else. Go ahead and open this single normal-exposure image in Photoshop.

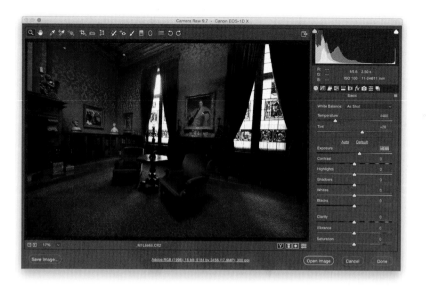

Step Four:

When this regular image appears on-screen, you now have two images open in Photoshop (the HDR and the regular one; both are seen here). Press **Command-A (PC: Ctrl-A)** to select the entire regular image, then press **Command-C (PC: Ctrl-C)** to Copy that image into memory. Now, switch to the HDR image and press **Command-V (PC: Ctrl-V)** to Paste the normal-exposure image directly on top of the HDR image.

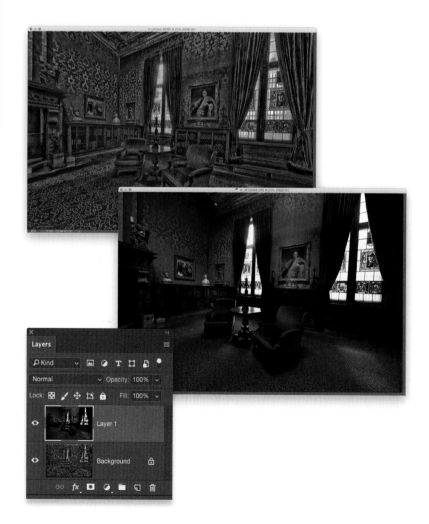

Step Five:

If you shot these bracketed shots on a tripod, there's a pretty good chance that when you paste this regular image on top of the HDR image they will be perfectly aligned with one another. Just toggle the top layer on/off from view a couple of times (by clicking on the Eye icon to the left of the image thumbnail in the Layers panel), and you'll see if they're perfectly lined up (they have to be perfectly lined up for this technique to work). If you handheld your shots, there's a better than average chance they are not lined up perfectly, so if they're not perfectly lined up, in the Layers panel, Command-click (PC: Ctrl-click) on the unselected layer to select them both. Then, go under the Edit menu and choose **Auto-Align Layers**. When the dialog appears (shown here), make sure the Auto radio button is selected, then just click OK. Don't mess with anything else—just click OK and it does its thing.

Step Six:

Now that your images are aligned, you'll have to crop your image in just a tiny bit (using the Crop tool **[C]**) because when Auto-Align does its thing, it leaves little gaps along the edges where it had to nudge things to make it align perfectly. Once it's cropped, go to the Layers panel again and click on the top layer to make it the active layer.

(Continued)

Step Seven:

So, to quickly recap: we've got the regular-exposure image on the top layer (named Layer 1), the HDR image on the bottom layer (named Layer 0 now), and they're perfectly aligned with one another. Now it's blending time. Make sure your top layer in the Layers panel is the active one, then simply lower the Opacity slider on this normal layer to let some of the HDR layer below it start to blend in. Here, I lowered it to 70%, so it's mostly normal image but with 30% of the HDR image showing through. It's a blend of the two but mostly the regular image, so we get the nice detail on the walls and some added detail throughout, but without any of the "funky" HDR stuff. If you think you want more detail, try 50%. If you want less of the HDR look, try 80%—it's totally your call.

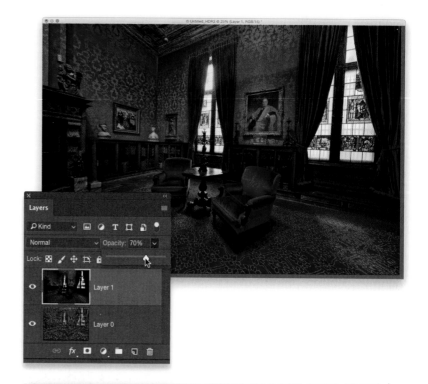

Step Eight:

I usually finish things off by flattening the layers (press **Command-E [PC: Ctrl-E]**), then going under the Filter menu, choosing **Camera Raw Filter**, and tweaking the image a bit. Here, I increased the Contrast a little (to +28), increased the Shadows (to +58), decreased the Highlights to –62, and increased the Clarity a little (to +24), and then I went to the Effects panel and added Post-Crop Vignetting by dragging the Amount slider to –11. That's it.

TIP: Cherry-Picking the HDR

Here, we simply lowered the Opacity of the top layer to let the entire HDR image bleed through a bit, but another strategy is to leave the Opacity at 100% and add a layer mask instead. Then, just paint in black with a soft-edged brush over the areas you want to have more of an HDR look (like the walls, curtains, and chairs). Lower the Opacity of the brush itself (up in the Options Bar) to 50% before you start painting, so the effect is more subtle.

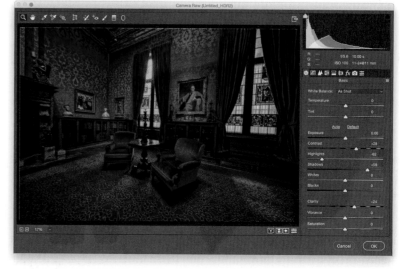

Getting the HDR Look
on a Single Image

If you didn't take bracketed images in your camera, but you still want that HDR look, you can pretty much do the entire thing right in Camera Raw by pushing a few sliders to the max. Here's how it's done:

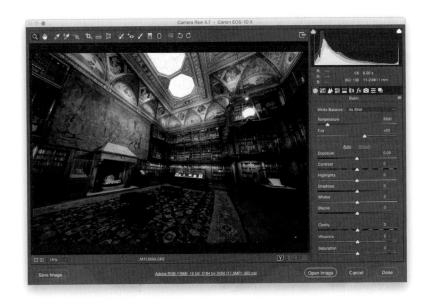

Step One:

Here's the original single-image exposure, and it's the perfect kind of image to apply an HDR look to. There's a wide tonal gap between the bright light coming in the windows and the dark shadows in the rest of the image; plus, things with lots of texture and detail tend to look great as HDR, and if they look great as HDR, they'll look great with an HDR effect applied, even if it's a single image. Start by opening the image in Camera Raw. Here's the basic recipe we follow: crank up the Shadows all the way, crush down the Highlights all the way, add lots of Contrast (all the way), max out the Clarity. To finish off: add some sharpening and maybe a dark edge vignette. Okay, let's try it.

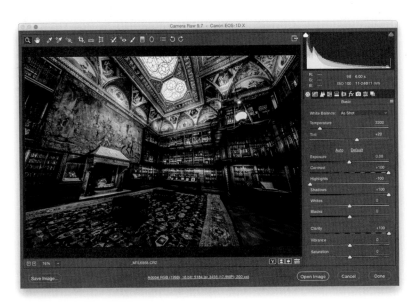

Step Two:

Drag the Contrast slider all the way to the right (to +100). Then, drag the Shadows slider all the way to the right, which tends to make the image look washed out. So, then, drag the Clarity slider to +100. If it wasn't already blown-out outside the windows (or if your room has visible lights), it probably is now, so we always drag the Highlights slider all the way to the left (to –100). So, it's Contrast, Shadows, and Clarity to +100, and Highlights to –100. That's the recipe (save it as a preset in the Presets panel and then it's a one-click effect, right?). And, of course, you could also add the standard finishing effects (on page 215), like vignetting and a soft glow.

(Continued)

The original normal-exposure image

Using just Camera Raw to create the HDR look

The original normal-exposure image

Using just Camera Raw to create the HDR look

The original normal-exposure image

Using just Camera Raw to create the HDR look

How to Get Rid of "Ghosting" Problems

If anything was moving slightly in the scene you were photographing (like water in a lake, or tree branches in the wind, or people walking by, etc.), you'll have a ghosting problem, where that object is either blurry (at best), or you'll actually see a transparent ghost of that part of the image (hence the name), or half a person, and so on. In this handheld photo, there are people moving in the scene and that usually means we'll have some ghosting, but in most cases, fixing that is just one click away. Or maybe two. Either one or two clicks. Max.

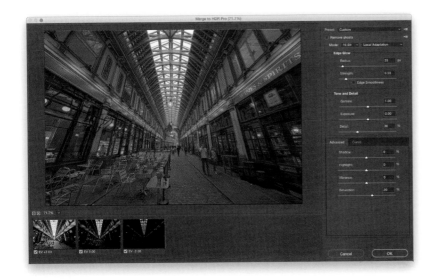

Step One:

Select your images in Bridge, then go under the Tools menu, under Photoshop, and choose **Merge to HDR Pro** to open the HDR bracketed images. You can just use the Default setting (which by the way, almost never looks good), but just so it doesn't look too terrible, turn on the Edge Smoothness checkbox and maybe raise the Detail slider to around 68 (as seen in the next step). Unfortunately for this shot, you can't keep tourists from moving (well, not without duct tape) and, if you look at the couple on the right, you can see some ghosting. You can see what looks like multiple semi-transparent versions of them (which is why it's called ghosting), especially on the woman.

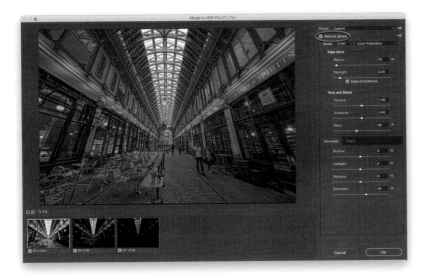

Step Two:

Luckily, fixing this is pretty darn easy: turn on the Remove Ghosts checkbox at the top right of the dialog (shown circled here in red). HDR Pro tries to deal with the ghosting by looking for things that are common to all your exposures to lock onto, and it does a pretty amazing job of it most of the time. If you look at the bottom of the screen you'll see thumbnails of the images that made up your single HDR image, and you'll see a green highlight around one of them. That's the photo it chose as the basis for its ghost removal. It's much improved, right?

(Continued)

Step Three:

So, what do you do if HDR Pro makes the wrong guess? (By the way, this is more common when using JPEGs than RAW images.) If this happens, you can choose which of your bracketed photos you think it should lock onto by clicking through each of those thumbnails in the filmstrip at the bottom of the dialog. If you look back in Step Two, you'll see that it originally chose the thumbnail on the far left. Just click through all three images and see if any of them do a better job of removing the ghosting. Here, I clicked on the second image from the left and it doesn't look much better. The third image looked worse, so the first one is the winner. *(Note: If you shot a multi-photo exposure of something, like waves rushing to the shore, you can actually choose which individual wave you want visible using this same technique, so it's not just for ghosting.)*

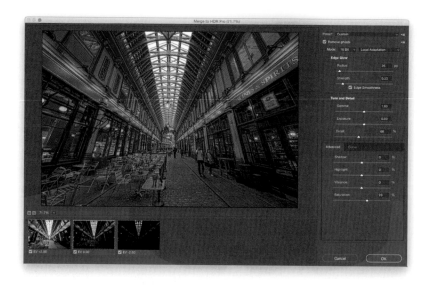

Step Four:

Now, what would you do if the Remove Ghosts checkbox didn't work at all and you still had lots of ghosting? Then you'd use a similar trick to the one you learned in "Creating a Blended HDR" earlier in this chapter. You'd create the regular HDR image first. Then, you'd copy-and-paste the original on top, Option-click (PC: Alt-click) on the Add Layer Mask icon at the bottom of the Layers panel to hide this original image behind a black mask, get the Brush tool **(B)**, and choose a small, soft-edged brush. Set your Foreground color to white and paint over the people that are ghosting, and as you paint, it paints the original people from the single still image back in (it works really well, actually). If the people you just pasted in look "too normal," then start over, but before you copy-and-paste the original on top, apply the single-image HDR look from page 209 to the image first. That way, it will look more HDR when you paint them in (as I did here. I also ended up lowering the Opacity of this layer a bit, too).

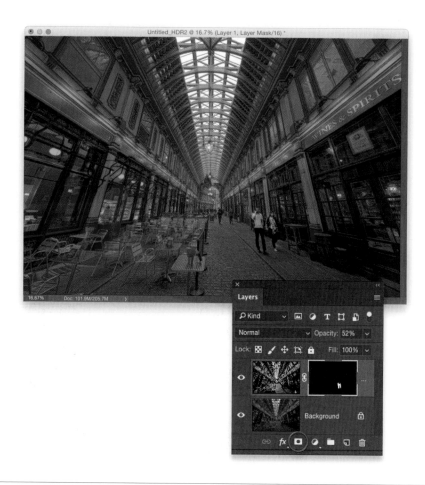

High Pass Sharpening for HDR Images

Although I cover High Pass sharpening in the sharpening chapter, I thought it was important to include it here as its own project, because High Pass sharpening has kind of become synonymous with HDR editing. High Pass sharpening is sometimes called "extreme sharpening," and that's a really good description of what it is. Here, I'm going to show you how to apply it, how to control it afterward, and an optional method that I use myself quite a bit.

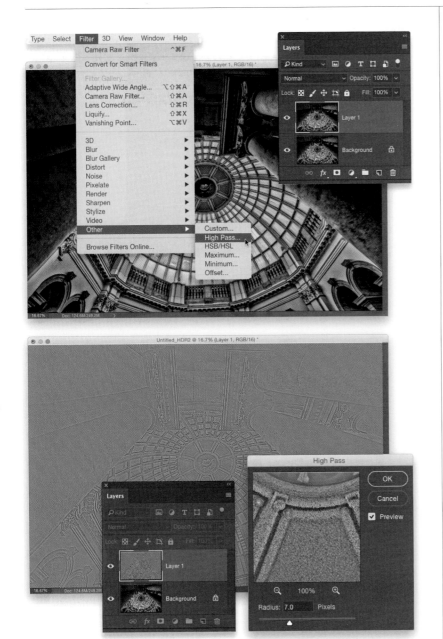

Step One:
Once you've finished creating your HDR image using Merge to HDR Pro, and it's open in Photoshop, start by pressing **Command-J (PC: Ctrl-J)** to duplicate the Background layer. Then, go under the Filter menu, under Other, and choose **High Pass** (as shown here).

Step Two:
When the High Pass filter dialog appears, drag the Radius slider all the way to the left so that everything turns solid gray. Now, drag the slider to the right until you can just start to see the color peek through the solid gray (as shown here)—the farther you drag, the more intense the effect will be (here, as an example, I dragged to 7 pixels, and you can see lots of edge detail starting to appear). When you're done, click OK.

(Continued)

Step Three:

To bring the sharpening into the image, go to the top of the Layers panel and change the duplicate layer's blend mode from Normal to one of these three modes: (1) for medium sharpening, choose Soft Light; (2) for heavy sharpening, choose Overlay; or (3) for just insane sharpening, choose Hard Light (as shown here). If the sharpening seems like it's too much, you can lower the opacity of this duplicate layer. Think of this as the control for the amount of sharpening, so try lowering the Opacity amount (at the top of the Layers panel) to 75% (for 75% of the sharpening), or 50% if that's still too much (as shown in the next step).

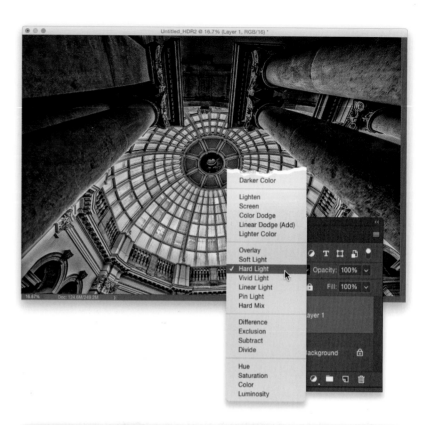

Step Four:

If you just need this level of intense sharpening over particular areas of your photo (like in this case, maybe over the columns but not the dome), just press-and-hold the Option (PC: Alt) key and click on the Add Layer Mask icon at the bottom of the Layers panel (shown circled here) to hide your sharpened layer behind a black mask. Get the Brush tool **(B)**, from the Toolbox, and make sure your Foreground color is set to white. Then, from the Brush Picker in the Options Bar, choose a medium-sized, soft-edged brush and paint over just the parts of the image you want to be super-sharp (here, I painted over just the columns). Once you've painted over those areas, also try the Overlay and Soft Light blend modes to see which of the three you like best.

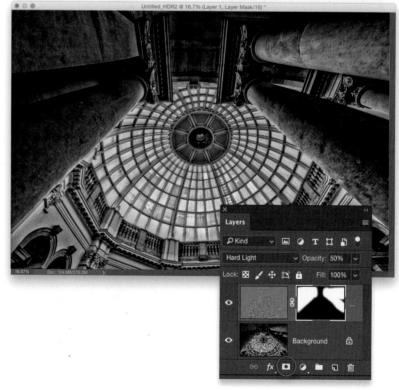

HDR Finishing Techniques
(Vignetting, Sharpening & Soft Glow)

These are totally optional (but very popular) finishing moves for HDR images. I mentioned these effects earlier in this chapter when I applied them to our projects as finishing moves. But, I wanted to put them here separately so that if you wanted to just add one of these finishing techniques, you wouldn't have to go fishing through all those steps to find them.

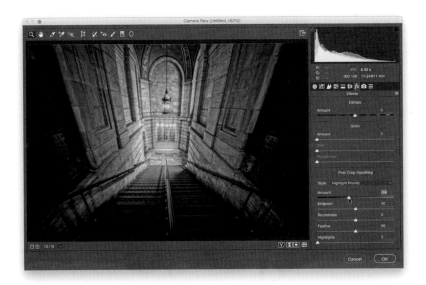

Step One:

Once you've processed your bracketed photos in Merge to HDR Pro, go under the Filter menu and choose **Camera Raw Filter** (this is where we start our finishing moves by adding a dark edge vignette). There are actually two different places to apply vignettes in Camera Raw, but the one that pretty much everybody uses (because it looks the best) is Post Crop Vignetting (designed to be used after you've cropped the image, but you can apply it to an uncropped image, no problem). Click on the Effects icon (the third icon from the right) at the top of the Panel area. In the Post Crop Vignetting section, first make sure **Highlight Priority** is the selected Style (it's the only one that actually looks good), then drag the Amount slider to the left to darken the edges all the way around your image (as shown here, where I dragged to –18).

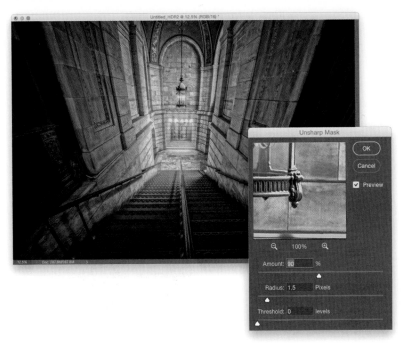

Step Two:

Click OK to open the image in Photoshop. Next, let's sharpen the living daylights out of it. You can use the High Pass sharpening technique we just did, or you can just Unsharp Mask the daylights out of it, using my favorite "sharpen the daylights out of it" setting, which is: Amount 90%, Radius 1.5, and Threshold 0. This is some serious sharpening, so don't apply this to photos of babies, or bunnies, or stuff you don't want to look like it's made of iron (kidding).

(Continued)

Step Three:

To get the soft glow finishing move that's so popular for HDR images, try this: press **Command-J (PC: Ctrl-J)** to duplicate your Background layer, then go under the Filter menu, under Blur, and choose **Gaussian Blur**. Enter 50 pixels for your blur Radius and click OK.

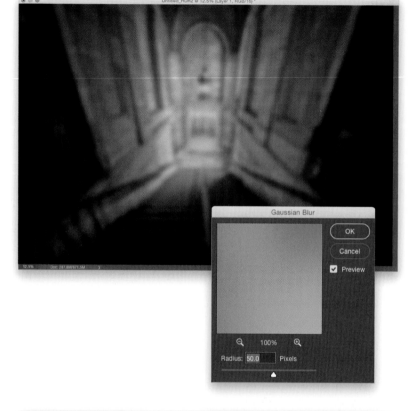

Step Four:

At the top of the Layers panel, lower the Opacity of this blurry layer to 70%. It still looks really blurry, but what gives this the right look is when you change the blend mode of this blurry layer from Normal to **Soft Light**. Now you get that soft glow across the image that takes the edge off the harsh HDR look. Again, all three of these finishing moves are optional, so don't think you have to apply them, but now at least if you do want to apply them, you know how to do it (and I usually do all three to my tone-mapped HDR images. If I'm going for the realistic HDR look, then I'll do the sharpening but I don't generally add the vignette or the blur to soften the look).

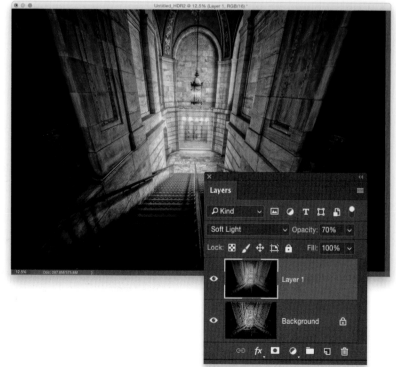

Photoshop Killer Tips

Zooming In Really Tight? There's a Pixel Grid to Help You Out

You won't see this neat little feature unless you zoom in to 600% magnification or more—it's a little pixel grid that appears that makes it visually easier to tell pixels apart when you're zoomed in crazy tight.

It's on by default (give it a try—zoom in crazy tight and see), but if you want to turn it off, just go under the View menu, under Show, and choose **Pixel Grid**.

Creating Realistic-Looking Images Using 32-Bit HDR

Create a realistic-looking HDR, by choosing **32 Bit** from the Mode pop-up menu at the top right of the Merge to HDR Pro dialog. Click the Tone in ACR button, make your standard edits in Camera Raw to make it look good, and click OK to open it in Photoshop. You won't be able to do much to this 32-bit image, so

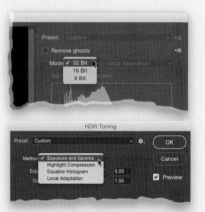

go under the Image menu, under Mode, and choose **8 Bits/Channel**. In the resulting dialog, click Merge, then in the HDR Toning dialog that appears, from the Method pop-up menu, choose **Exposure and Gamma** to get your image looking right again.

Keeping Your Third-Party Plug-Ins from Loading into Photoshop

Before you launch Photoshop, press-and-hold the Shift key. A dialog will appear and, if you click the Yes button, it disables any third-party plug-ins. This can come in handy if you think you're having a problem in Photoshop caused by one. If you restart with them disabled and the problem goes away, you've probably found your culprit.

Saving Time in HDR Pro

The more images you use to create your HDR images, the longer it takes HDR Pro to compile your final image, so this is a case where less is more. I usually use three images, but an interesting tidbit I learned from one of the Photoshop product managers is that, for the best results, you need more darker photos than lighter ones. So, if you don't mind the extra wait, you're better off having just one image with a really bright exposure and four darker ones, than you are with an equal balance.

Editing the Lens Correction Grid

When you use the Lens Correction filter, the first thing you'll notice is that "annoying grid" isn't turned on by default like it used to be (by the way, the only reason it was annoying was because it was turned on by default). Now, not only is it off by default, but you can edit the size and color of the grid itself. When you turn on the Show Grid checkbox at the bottom of the Lens Correction dialog, a Size field and a color swatch become available to

the right of the checkbox. Also, although there is a grid in the Lens Corrections panel of Camera Raw (press **V** to toggle it on/off), you can't change the size or color of that grid.

Renaming Multiple Layers Fast

Want to rename a bunch of layers? Just double-click directly on the first layer's name to highlight it, type in a new name, and then press the **Tab key** to jump to the next layer and its name field will be highlighted, ready to be renamed. The Tab key takes you to the next layer down; to jump back to a previous layer, press **Shift-Tab**.

Location: Sydney Opera House, Sydney, Australia | Exposure: 30 sec | Focal Length: 90mm | Aperture Value: ƒ/8

Problem Child
fixing common problems

This was kind of an obvious title, and I could have gone with "Modern Problems" instead, but I'm pretty sure I used that one in my Lightroom book, so "Problem Child" it is (the title is based on the 1990 movie from Universal Pictures, starring John Ritter, Amy Yasbeck, and Jack Warden). Now, why do we have so many problems with our photos? Well, it's not our fault. It's our camera's fault. You see, the camera doesn't really capture what it is we're seeing in front of us, and that's because as sophisticated as today's digital cameras are at capturing light, they are still way, way, way behind the tonal range of the human eye, so what we're seeing with our eyes is much better than what even the best crazy-high-megapixel camera can capture by a long shot. The human eye definitely is an amazing thing, but you might find it surprising to know that there is an animal species that can more accurately capture color, and tonal changes, far beyond what the human eye can capture. And, as you might expect, the camera companies themselves have spent millions of dollars researching the eye structure of the *Hispaniolan solenodon*, which is only found on the island of Hispaniola. It is said that *H. solenodon's* eye will soon be the key to creating ultra-high-definition sensors that would completely negate ever having to shoot bracketed frames or create HDR images, because their tonal range perfectly exposes for indoors and outdoors at the same time, like the human eye does, but in a much more advanced way. Sony spent considerable time mapping *H. solenodon's* trabecular meshwork canal, but as Sony's own scientists were putting the finishing touches on a sensor that not only surpasses anything currently available, but that even surpasses the human eye, a group of researchers at Leica in Wetzlar, Germany, had a startling discovery. They revealed a working sensor prototype based on the anterior chamber of the eye of the tufted deer, found in damp forest areas of China. Then, and only then, a magical leprechaun appeared. You can take it from here, since I just made the whole thing up, so start with "…then, a magical leprechaun appeared" and throw in some fancy terms from an eye chart you can find on Google.

Fixing Reflections in Glasses

I get more requests for how to fix this problem than probably all the rest combined. The reason is it's so darn hard to fix. If you're lucky, you get to spend an hour or more desperately cloning. In many cases, you're just stuck with it. However, if you're smart, you'll invest an extra 30 seconds while shooting to take one shot with the glasses off (or ideally, one "glasses off" shot for each new pose). Do that, and Photoshop will make this fix absolutely simple. If this sounds like a pain, then you've never spent an hour desperately cloning away a reflection.

Step One:

Before we get into this, make sure you read the short intro up top here first, or you're going to wonder what's going on in Step Two. Okay, here's a photo of our subject with his glasses on, and you can see the reflection in them (pretty bad on the left side, not quite as bad on the right, but it definitely needs fixing). The ideal situation is to tell your subject that after you take the first shot, they need to freeze for just a moment while you (or a friend, assistant, etc.) walk over and remove their glasses (that way they don't change their pose, which they absolutely will if they take their own glasses off), then take a second shot. That's the ideal situation.

Step Two:

I could see right away that we were going to have a reflection in his glasses, so I told him after the first shot not to move his head, and had someone go over and remove his glasses, and then I took another shot.

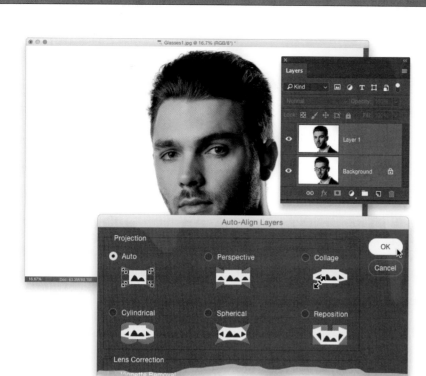

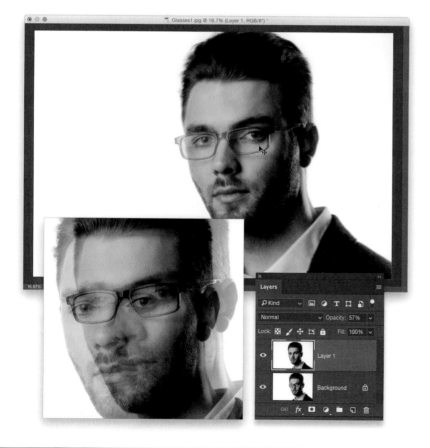

Step Three:

With both images open in Photoshop, get the Move tool **(V)**, press-and-hold the Shift key, and then click-and-drag the "no glasses" photo on top of the "glasses" photo (as I did here). Now, if you planned ahead and took shots with and without the glasses (one right after the other), then you can take a shortcut and use Auto-Align Layers to perfectly match up the two shots. In the Layers panel, Command-click (PC: Ctrl-click) on each layer to select both (as shown here), then go under the Edit menu and choose **Auto-Align Layers**. Leave the Auto option selected and click OK, and in just a few seconds, they will be aligned right on the money. Now, if you did all of this "the right way" in the studio, then you can jump to the second part of Step Six. However, if the shots were taken handheld, and a few minutes apart, we wouldn't be able to use Auto-Align Layers (the subject may have moved too much). We'd have to do it manually (another reason why setting this up the right way in the studio really pays off). So, we'll take a look at what to do if this happens.

Step Four:

You need to be able to "see through" the top layer, so you can see his eyes on the bottom layer (that way, you can line them up). So, start by going to the Layers panel and lowering the Opacity of the top layer to around 50% or 60% (as seen here). Now, with the Move tool, position the eyes on the top layer as close as you can get to those on the bottom layer.

(Continued)

Step Five:

If your subject's position changed at all (maybe their head tilted or their shoulders moved), you might need to rotate the top photo, so the eyes match up better. So, press **Command-T (PC: Ctrl-T)** to bring up Free Transform, then zoom out (to shrink the size of your image window), and pull out the corners of the image window, so you see some of the dark gray canvas area around your image (as seen here). Now, when you move your cursor outside the Free Transform bounding box, it will change into a two-headed rounded arrow, so you can click-and-drag in a circular motion to rotate the top layer. (*Note:* You may need to move your cursor inside the bounding box to reposition the top layer, as well.)

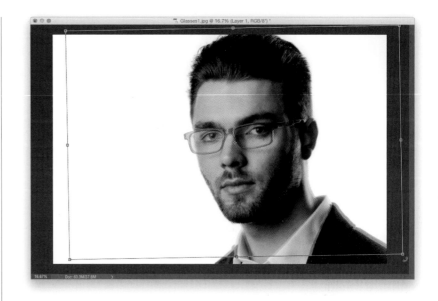

Step Six:

Once it looks pretty well lined up, press the **Return (PC: Enter) key** on your keyboard to lock in your rotation, then raise the Opacity of this top layer back to 100%. Now, all we really need from the image on the top layer is the area that appears inside his frames. So, press-and-hold the Option (PC: Alt) key and click on the Add Layer Mask icon at the bottom of the Layers panel to hide this rotated layer behind a black layer mask (as shown here).

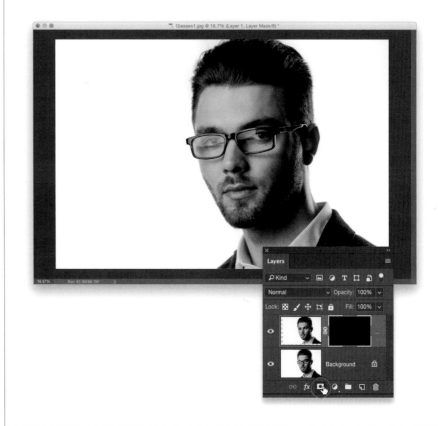

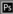

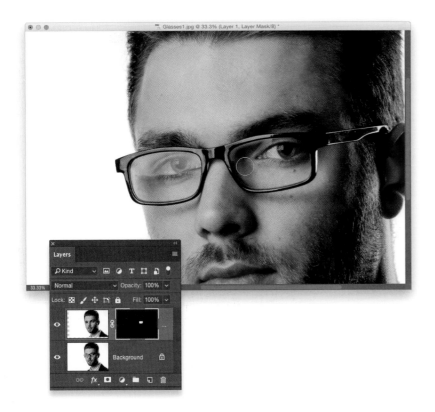

Step Seven:
Now, with your Foreground color set to white, get the Brush tool **(B)**, choose a small, soft-edged brush from the Brush Picker up in the Options Bar, then simply start painting over the lens on the right, and it reveals the version of his eye without the glasses on (as seen here). What you're doing is revealing the top layer, but just where you want it.

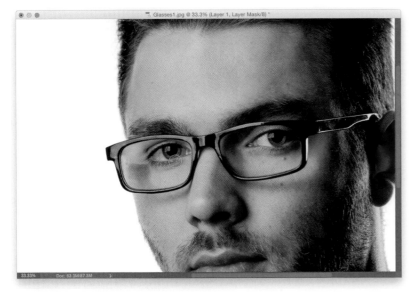

Step Eight:
Once the eye on the right is done, do the same thing for the eye on the left. Make sure you use a small brush and be careful not to accidentally paint over any of the frames. If you do make a mistake, no biggie, just press **X** to switch your Foreground color to black and paint the frames back in. Now, remember, this whole process would be made a whole lot easier (you could skip Steps Four and Five altogether) if you remember, once you get a look you like in the studio, to have your subject freeze, remove their glasses, and take another shot. Then, Auto-Align Layers can do its thing and save you a lot of time and trouble. A before and after are shown on the next page.

(Continued)

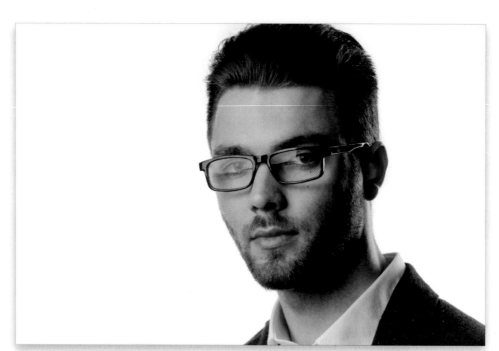

Before (with the reflections in his glasses)

After (the reflections are gone)

Fixing Group Shots the Easy Way

Group shots are always a challenge because, without a doubt, somebody in the group will be totally hammered (at least, that's been the experience with my family. You know I'm kidding, right?). Okay, the real problem is that in group photos there's always one or more people who blinked at just the wrong time, or forgot to smile, or weren't looking at the camera, etc. Of course, you could just take their expression from another frame and combine it with this one, but that takes a lot of work. Well, at least it did before the Auto-Align Layers feature. This thing rocks!

Step One:

Here's a group shot where one of the subjects (the boy on the right) wasn't looking at the camera.

Step Two:

Of course, with group shots, you take as many shots as the group will endure, and, luckily, a few frames later, we have one where the boy looks great. But, we can't use this shot, because now the man on the left isn't smiling and one of the other men has his eyes closed. So, the idea here is to take the boy from this shot and combine him with the first photo to make one single group photo where they're all smiling, have their eyes open, and are looking at the camera.

(Continued)

Step Three:

Start by opening both photos in Photoshop and dragging them into the same document: get the Move tool **(V)**, press-and-hold the Shift key, and click-and-drag the photo where the boy looks good over on top of the other photo, where he's not looking at the camera (it will appear as its own layer in the other document, as you can see in the Layers panel shown here).

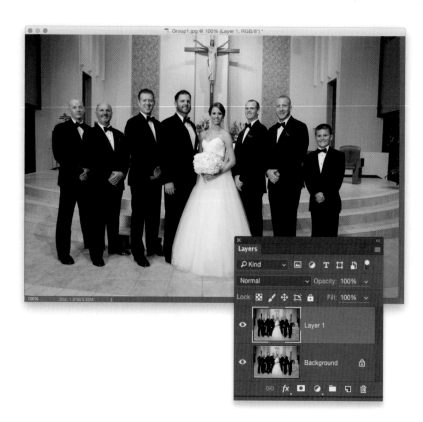

Step Four:

Usually, just pressing-and-holding the Shift key will help the photos line up pretty well (especially if the shots were taken with your camera on a tripod), but if you handheld the shots, or if your subjects moved a bit, you'll need Photoshop to line them up precisely for you. You do this by going to the Layers panel, Command-clicking (PC: Ctrl-clicking) on both layers to select them (as shown here), then going under the Edit menu and choosing **Auto-Align Layers**. When the Auto-Align Layers dialog appears, leave Auto selected at the top, and then click OK to have Photoshop align the two layers for you (and it usually does a pretty darn amazing job, too!).

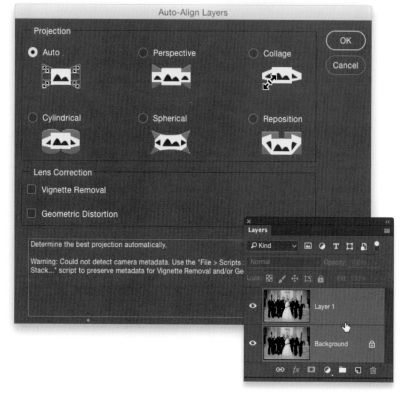

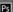

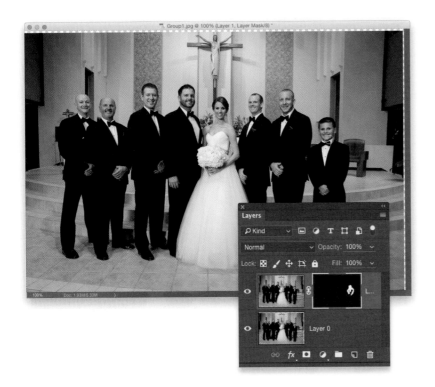

Step Five:

Now that they're aligned, click on the top layer in the Layers panel to make it the active layer. Press-and-hold the Option (PC: Alt) key and click on the Add Layer Mask icon at the bottom of the Layers panel to hide the top layer (with the boy looking at the camera) behind a black layer mask. Now, get the Brush tool (**B**), choose a medium-sized, soft-edged brush from the Brush Picker in the Options Bar, and with your Foreground color set to white, paint over the boy's head. As you do, it reveals the good version of him where he's looking at the camera (as shown here). Keep painting until his head, jacket, and basically as much as you need, look natural in the photo. When you're done, get the Crop tool (**C**) and crop the image down to size. The final is shown below.

Before: The boy isn't looking at the camera

Before: The man on the left isn't smiling and another has his eyes closed

After: Parts of the two photos are combined to make one perfect group shot

Liquify Is Now Re-Editable
(and It Has a Handy Tool!)

I do a lot of portrait retouching (heck, I even wrote a best-selling book on the topic, but if you think I'm going to plug my *Professional Portrait Retouching Techniques for Photographers Using Photoshop* book here in this book, man are you right). Anyway, one feature on every retoucher's wish list was the ability to apply Liquify as a smart object, so we could edit or undo our Liquify retouches anytime. This is available in the Creative Cloud version of Photoshop. What wasn't on our radar was the handy Smooth tool, which helps hide our Liquify retouches.

Step One:

To use Liquify as a smart object, start by converting your image layer into a smart object layer (either go under the Filter menu and choose **Convert for Smart Filters**, or go to the Layers panel, Right-click on the Background layer, and choose **Convert to Smart Object**, as shown here).

Step Two:

Now, choose **Liquify** from the Filter menu and make any changes you want (here, we'll use the Forward Warp tool **[W]**—the first tool at the top of the Toolbox—to fix the indentations in the left sleeve of our subject's coat). Use a smaller brush to nudge those areas outward/inward until it looks nice and even (like you see here). When you're done, click OK and that layer now appears as an editable smart filter layer with a layer mask attached (so, if you wanted to, you could hide any part of the Liquify edit you just made by painting over that area in black).

Step Three:
If you decide maybe you went a bit too far in Liquify, normally you'd have to start over from scratch. But, since you made this a smart object first, you can reopen the image with your retouches still "live," so you can edit them. To do this, just double-click directly on the word "Liquify" (shown circled in red here) directly below the smart filter layer in the Layers panel, and it reopens the layer in Liquify. Now all your edits are not only in place, they're editable. For example, if you want to undo just part of your last edit (let's say you wanted to undo the changes you made on the lower part of the sleeve), you can just get the Reconstruct tool (**R**; the second tool from the top in the Toolbox) and paint over that area to return it to the original look while leaving the rest of your edits as-is.

Step Four:
Okay, so that's the smart object part (easy enough, right?). Now let's look at the Smooth tool (**E**; it's the third tool down in the Toolbox). You'd generally use this tool if you see that an edit you made with one of the other tools looks rippled or obviously retouched. The Smooth tool actually works kind of like the Recon-struct tool, but instead of bringing the full original image back where you paint, it only brings back part of it. The first pass with the tool undoes "part" of your retouch; another pass undoes a little more. So, you can use it with a small brush for a more realistic retouch. (*Note:* we'll look at the Liquify filter again in Chapter 10, where we'll do some portrait retouching with it.)

Removing Stuff Using Content-Aware Fill

When people talk about "Photoshop magic," Content-Aware Fill is one of those things they're talking about. Even after using this feature for a couple of years now to get rid of distracting things in my images, it still amazes me more often than not with the incredible job it does. The fact that it's incredibly easy to use at the same time really makes it a powerful, and indispensable, tool for photographers.

Step One:
Here, we have a couple sitting on some rocks, and they distract from our subject (the lighthouse), so ideally we'd like them out of the shot.

Step Two:
First, to have Content-Aware Fill remove the couple, just get the Lasso tool **(L)**, or whichever selection tool you're most comfortable with (like the Quick Selection tool, Pen tool—whatever), and draw a selection around them. Once your selection is in place, you can help Content-Aware Fill do its thing by expanding that selection outward by 4 or so pixels. So, go under the Select menu, under Modify, and choose **Expand**. When the Expand Selection dialog appears (shown here), enter 4 pixels, click OK, and your selection grows outward by that much.

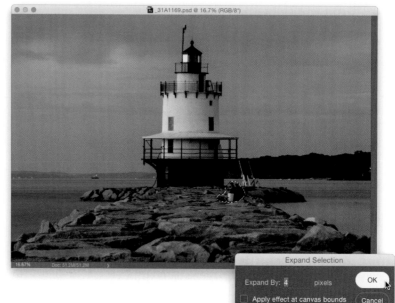

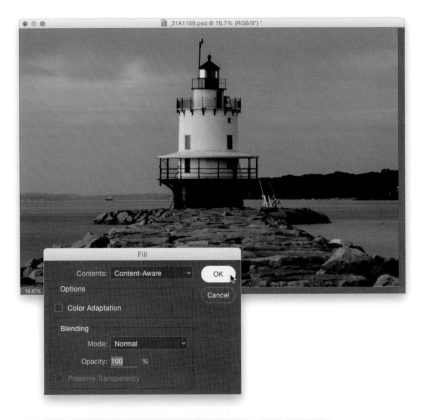

Step Three:

Next, go under the Edit menu and choose **Fill**. When the Fill dialog appears, choose **Content-Aware** from the Contents pop-up menu (as seen here). Now, just click OK, sit back, and prepare to be amazed (I know—it's freaky). Not only is the couple gone, but it also patched the rocks pretty darn perfectly beneath them (that's why it's called "Content-Aware" Fill. It's aware of what is around the object you're removing, and it does an intelligent filling in of what would normally just be a big white hole in your image). Go ahead and deselect by pressing **Command-D (PC: Ctrl-D)**.

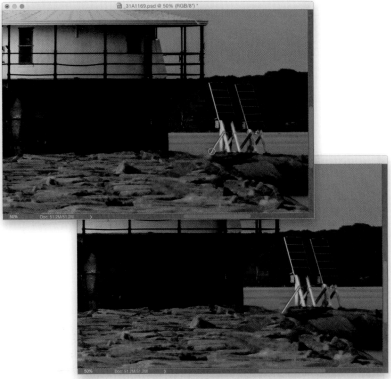

Step Four:

One area it didn't fill perfectly is the brace coming down from the solar panel stand that was partially behind one of the people, so we'll have to fix that manually using the Clone Stamp tool. Get the Clone Stamp tool **(S)** from the Toolbox, Option-click (PC: Alt-click) on what's left of the brace and paint down (as seen here at the top. I also went around and cleaned up the rocks, as well). Now, you will fall deeply in love with Content-Aware Fill if you can come to peace with the fact that it won't work perfectly every time. But, if it does 70% or 80% of the work for me (in removing something I don't want), that means I only have to do the other 20% (or maybe 3%, like in this case), and that makes it worth its weight in gold. If it does the entire job for me, and sometimes it surely does, then it's even better, right? Right. Also, it helps to know that the more random the background is behind the object you want to remove, the better job Content-Aware Fill generally does for you.

(Continued)

Step Five:

Content-Aware Fill is pretty amazing when it works, but like any other tool in Photoshop, it doesn't work 100% of the time on every single type of photo and every situation. When I use Content-Aware Fill, I usually wind up using the Spot Healing Brush along with it, because it has Content-Aware healing built in. The Patch tool (the Healing Brush's cousin that works better for removing large objects) also has Content-Aware capabilities now. Let's open another image (the shot here) and use all of these tools together to remove the grate, the white object below it, and the pipe next to the window.

Step Six:

A lot of times you don't have to do as accurate a selection as we just did when removing the people in the previous project. For the white object, just take the regular ol' Lasso tool (L), draw a loose selection around it (as shown here), then go under the Edit menu and choose Fill. When the Fill dialog comes up, make sure Content-Aware is selected in the Contents pop-up menu, then click OK, and press Command-D (PC: Ctrl-D) to Deselect (you'll see in the next step that it's gone, and it did a great job of filling in the bricks). If part of its fix doesn't look great, simply select that area and try again.

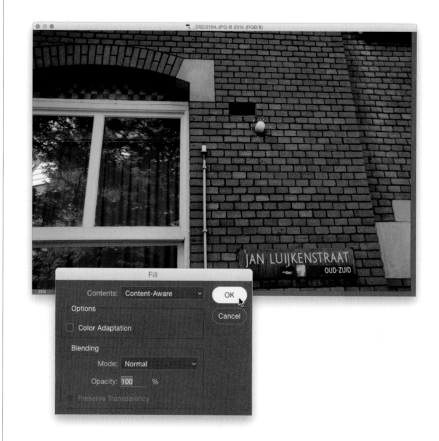

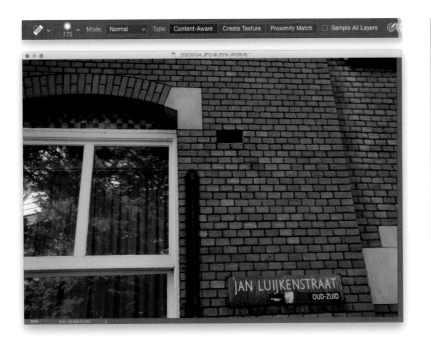

Step Seven:

Take a look at where the white object used to be. It's outta there! Let's switch to the Spot Healing Brush tool **(J)** for the pipe next to the window. You literally just make your brush size a little bigger than the pipe, paint over it, and Photoshop uses the Content-Aware technology to remove it (when I release the mouse button, a second later that will be gone, too!). *Note:* The regular Healing Brush tool (the one where you have to choose the area to sample from by Option-clicking [PC: Alt-clicking]) does *not* have the Content-Aware technology. Only the Spot Healing Brush tool and the Patch tool have it (but you may have to turn it on for the Patch tool—it's on by default with the Spot Healing Brush).

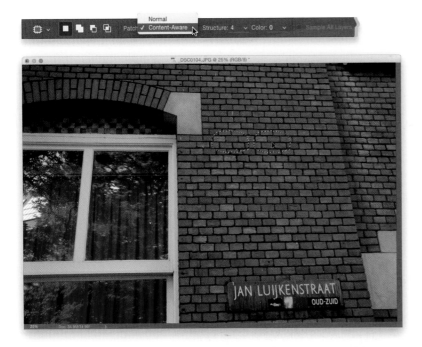

Step Eight:

Now, let's use the Patch tool (press **Shift-J** until you have it). You use it initially just like the Lasso tool: click-and-drag a loose selection around the object you want to remove (the grate, here), then click your cursor inside that selected area and drag it to a nearby clean area (you'll see a preview inside the selected area of what your patch will look like). Then, when you release the mouse button, it snaps back and the grate is removed. I use the Patch tool for removing larger objects like this (I also used it to remove the white object's shadow). If you want it to use the Content-Aware technology, in the Options Bar, choose **Content-Aware** from the Patch pop-up menu (as shown here). By the way, using the Content-Aware option won't always be better than the regular Patch tool healing—it just depends on the image. So, if you don't like the results of one, try the other. We're not done here yet, though.

(Continued)

Step Nine:

Here's the result of dragging the selection to the right and lining up the bricks. When it snapped back, it did a great job (I liked the Content-Aware setting better than Normal, here). If it doesn't work, just press **Command-Z (PC: Ctrl-Z)** to Undo your patch, then Command-D (PC: Ctrl-D) to Deselect, and you can try Content-Aware Fill or the Spot Healing Brush instead.

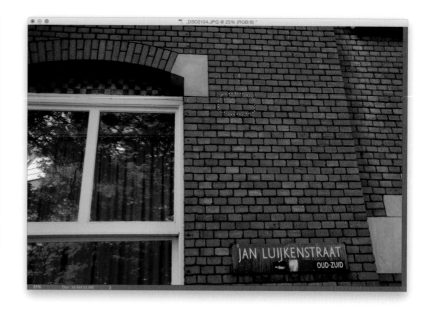

Step 10:

Let's take care of one last thing. Switch back to the Spot Healing Brush (press **Shift-J** until you have it), then paint over the shadow area in the top right (as shown here).

TIP: Fixing Bad Repairs

We were lucky in this photo, but in a lot of cases, the objects you want to remove are in close proximity to other objects you want to keep. Then, when you try to patch something, it doesn't patch your hole with background, it patches your hole with something in the foreground (imagine if, when we used Content-Aware Fill, it filled the white object with the window? It happens more often than you'd think). To get around that, put a selection around what you want to tell Photoshop is "off limits" for using as a patch, then save that as a selection (under the Select menu, choose **Save Selection**, then click OK). Now, it will avoid that area when choosing areas to pull fill from.

Step 11:

You can see here, the Spot Healing Brush and the Patch tool did a great job on the wall. Before and After images are shown below.

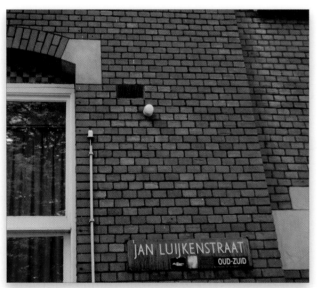

Before

After

Moving Stuff Without Leaving a Hole by Using Content-Aware Move

This is another one of those tools that makes you just scratch your head at the math that must be going on to perform the mini-miracle of letting you select something, then move it someplace else in your image, and Photoshop automatically repairs the area where it used to be. This doesn't work for every image, every time, and it's one of those tools you won't be reaching for every day, but when you need it, and it does its thing perfectly, your jaw hits the floor. It can be finicky sometimes, but I'll show you a few things to help it help you.

Step One:
Here's the image we're going to work on, and in this one, we want to move the light fixture closer to the door.

Step Two:
From the Toolbox, grab a selection tool that you're comfortable with and draw a selection around the object(s) you want to move (in this case, the light, the bracket holding it, and the plug and socket). It doesn't have to be a perfect selection, but get fairly close. Once your selection is in place, you can usually get better results from Content-Aware Move by expanding your selection outward by 4 or so pixels. So, go under the Select menu, under Modify, and choose **Expand**. When the Expand Selection dialog appears (shown here), enter 4 pixels, click OK, and your selection grows outward by that much.

TIP: Draw Selections with Content-Aware Move
You can use the Content-Aware Move tool to draw your selections, just like you would with the Lasso tool.

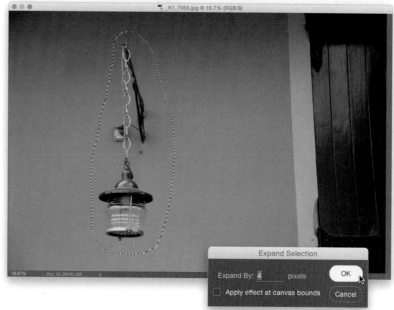

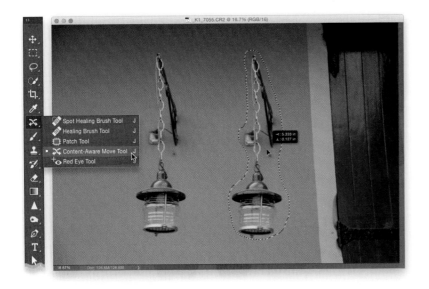

Step Three:

Next, go to the Toolbox, and get the Content-Aware Move tool (as shown here—it's nested in the same menu as the Healing Brush tool and Patch tool; or just press **Shift-J** until you have it). Now, click on your selected objects and drag them closer to the door (as shown here). The original of them will stay in the in the same position until you confirm the move.

Step Four:

Release your mouse button and press **Return (PC: Enter)**. It's going to take a few moments for the magic to happen (depending on how large your file size is), but then you'll see that not only are your objects moved, but the hole that would normally have been left behind is instead totally patched and filled (as shown here). However, don't deselect quite yet. Leave your selection in place—especially if it didn't work well—because while it's still selected, you can change how Photoshop creates the background texture and color that blends with your move. You do this from the Structure and Color settings up in the Options Bar. What's nice is, since your selection is still in place, you can choose a differ-ent setting from those options and it will re-render your move. So, all you have to do is try each one at different settings and choose the one that looks the best (again, I do this only if there's a problem). Also, the higher the number you choose, the more Photoshop uses of the actual real background to create the texture or color blending. This looks more realistic in some cases, but it can make the move look weird in others, so it's best to try both high and low numbers if it just doesn't look right. (*Note*: If needed, you can also switch to the Spot Healing Brush and clean up any stray areas it left behind.)

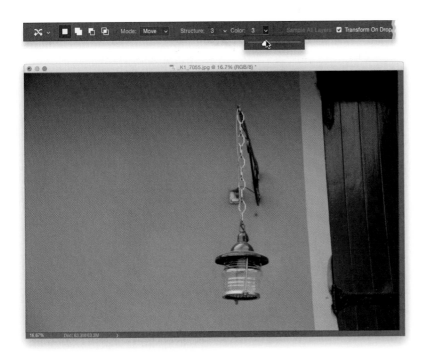

Photoshop Killer Tips

Using Shadows/Highlights Like an Adjustment Layer

Well, it's not technically an adjustment layer, but it acts and performs exactly like one. If you choose **Convert for Smart Filters** before choosing **Shadows/Highlights**, you get many of the same benefits as an adjustment layer, like being able to go back and adjust the settings later and having a layer mask. Also, if you double-click on the little adjustment sliders icon to the right of the name, it brings up a dialog where you can change the blend mode and opacity; you can click the Eye icon to turn the adjustment on/off; and finally, you can delete it anytime during your project.

Changing the Position of Your Lens Flare

When you use the Lens Flare filter (found under the Filter menu, under Render) it puts the flare in the center of your image, but you can actually choose the position for your flare center (which changes the look of your flare quite a bit) by just clicking-and-dragging the flare center within the filter's Preview window. By the way, a great way to apply this filter is to add a new layer, fill it with black, then run the filter, change its layer blend mode to **Screen**, and it will blend in with your image, so you can drag it wherever you'd like (if an edge shows, add a layer mask and paint over the edges in black with a huge, soft-edged brush).

Not Sure Which Blend Mode Is the Right One?

Then just press **Shift-+** to toggle through all the layer blend modes one-by-one, so you can quickly find out which one looks best to you.

How to Change the Order of the Brushes in the Brush Picker

Go under the Edit menu, under Presets, and choose **Preset Manager**. When the dialog opens, by default it's set to display all your brushes, so now all you have to do is click-and-drag them into the order you want them. When you've got everything in the order you want, click the Done button.

Photoshop Killer Tips

Changing the Color of Your Guides

Want to change the color of those guides you drag out from the rulers? Just pull out a guide, then double-click directly on it, and it brings up the Preferences dialog for Guides, Grid & Slices, where you can choose any color you'd like. You can also press **Command-K (PC: Ctrl-K)** and click on Guides, Grid & Slices on the left.

What That Fill Field Does

In the Layers panel, right below the Opacity field is the Fill field, which has had Photoshop users scratching their heads since it debuted. It only kicks in when you have a layer style applied to a layer, like a drop shadow or bevel. If you have something on a layer and you apply a drop shadow to it, then lower the Opacity amount, the object and its shadow both fade away, right? But if you lower the Fill amount only, the object starts to fade away, but the drop shadow stays at 100% opacity.

The Hidden Shortcut for Flattening Your Layers

There technically isn't a keyboard shortcut for the Flatten command, but I use a standard shortcut for flattening my image all the time. It's **Command-Shift-E (PC: Ctrl-Shift-E)**. That's actually the shortcut for Merge Visible, so it only works if you don't have any hidden layers, but I usually don't, so it usually works.

Customizing the HUD Pop-Up Color Picker

You can have a heads-up display color picker appear onscreen when you're using the Brush tool by pressing **Command-Option-Control (PC: Alt-Shift)** and **clicking (PC: Right-clicking)**. And, did you know you also get to choose which type and size of HUD you want? Press **Command-K (PC: Ctrl-K)** to bring up Photoshop's preferences, click on General on the left, then up near the top of the General preferences is a HUD Color Picker pop-up menu for choosing your style and size.

Changing Brush Blend Modes on the Fly

If you want to change the blend mode for your current brush without traveling up to the Options Bar, just **Control-Shift-click (PC: Shift-Right-click)** anywhere in your image, and a pop-up menu of Brush tool blend modes appears.

Creating Cast Shadows

To create a cast shadow (rather than a drop shadow), first apply a Drop Shadow layer style to your object (choose Drop Shadow from the Add a Layer Style icon's pop-up menu at the bottom of the Layers panel, change your settings, and click OK), then go under the Layer menu, under Layer Style, and choose **Create Layer**. This puts the drop shadow on its own separate layer. Click on that new drop shadow layer, then press **Command-T (PC: Ctrl-T)** to bring up Free Transform. Now, press-and-hold the Command (PC: Ctrl) key, grab the top center point, and drag down at a 45° angle to create a cast shadow (like your shadow is casting onto the floor).

Copying Layer Masks from One Layer to Another

If you've created a layer mask, and you want that same mask to appear on a different layer, press-and-hold the Option (PC: Alt) key and just drag-and-drop that mask onto the layer where you want it. It makes a copy, leaving the original intact. If you want to remove the mask from one layer and apply it to another, then don't hold the Option key and, instead, just click-and-drag the mask to the layer where you want it.

Location: Devil's Punchbowl, Otter Rock, Oregon | Exposure: 0.5 sec | Focal Length: 14mm | Aperture Value: *f*/22

Special Edition
special effects for photographers

Didn't we already have a chapter on special effects, back in the Camera Raw chapter? Well, you're right. Thanks for catching that, so now there's no need for even more Photoshop special effects. After all, who wants more cool stuff you can do to your photos, right? Good call. I'll drop it from the book. See, now don't you wish you hadn't been such a Mr. Smarty McNuggets Pants with your, "Oh, you've already done that!" and "This is redundant crapola" and "Where can I get 50% off a footlong sub?" Well, not so fancy now, are ya there, eh McNuggets? Okay, let's get back to the important stuff, which is how I came up with the name for this chapter title and, I have to tell ya, I kinda had to bend the sacred naming rules a little to get this one past the International Counsel for Extended Daytime-Teachers Educational Association (or ICED-TEA, for short). So, here's what I did: I couldn't find a movie named Special Edition, but there were a bunch of movies that had the term "Special Edition" added in rental or DVD releases

and I figured that was close enough, so I went with it, and if you have a problem with that, take it up with the folks at ICED-TEA. I have to say, they're actually pretty open-minded folks over there (I've had to testify in my fair share of chapter naming fiasco cases, and it's not pretty). While the ICED-TEA folks are pretty lenient, you do not want to cross the folks at the Tonal Institute Geo Hyper Tech Association for Stable Shutterspeeds (I don't recommend using their acronym—they're really touchy about it). They act like they have a stick up their butt or something. Anyway, if you think they're bad (and trust me, they can be a pain in the Association for Stable Shutter-speeds), whatever you do, make nice with the folks over at the Association of Noise Gamma Ratio Yield Bracketing Over Watermark Export to Lightroom Studio group. They don't take this stuff sitting down, and if they catch you breaking the rules, they will drop all over you, and that really stinks.

Desaturated Skin Look

This is just about the hottest Photoshop portrait technique out there right now, and you see it popping up everywhere, from covers of magazines to CD covers, from print ads to Hollywood movie posters, and from editorial images to billboards. It seems right now everybody wants this effect (and you're about to be able to deliver it in roughly 60 seconds flat using the simplified method shown here!).

Step One:

Open the photo you want to apply this trendy desaturated portrait effect to. Duplicate the Background layer by pressing **Command-J (PC: Ctrl-J)**. Then duplicate this layer using the same shortcut (so you have three layers in all, which all look the same, as shown here).

Step Two:

In the Layers panel, click on the middle layer (Layer 1) to make it the active layer, then press **Command-Shift-U (PC: Ctrl-Shift-U)** to Desaturate and remove all the color from that layer. Now, lower the Opacity of this layer to 80%, so just a little color shows through. Of course, there's still a color photo on the top of the layer stack, so you won't see anything change onscreen (you'll still see your color photo), but if you look in the Layers panel, you'll see the thumbnail for the center layer is in black and white (as seen here).

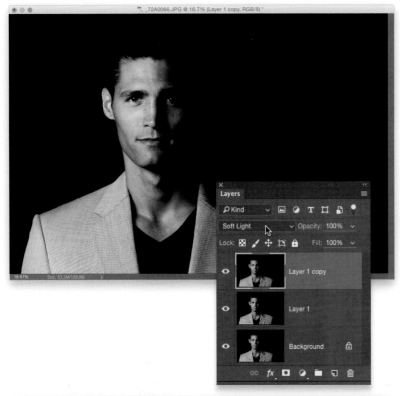

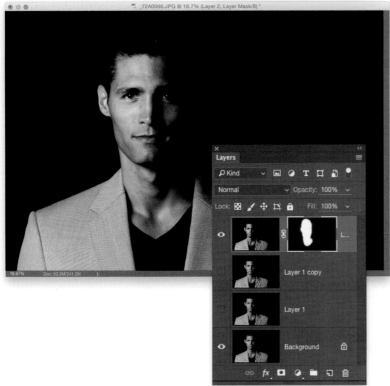

Step Three:
In the Layers panel, click on the top layer in the stack (Layer 1 copy), then switch its layer blend mode from Normal to **Soft Light** (as shown here), which brings the effect into play. Now, Soft Light brings a very nice, subtle version of the effect, but if you want something a bit edgier with even more contrast, try using Overlay mode instead. If the Overlay version is a bit too intense, try lowering the Opacity of the layer a bit until it looks good to you, but honestly, I usually just go with Soft Light myself.

Step Four:
Our last step is to limit the effect to just our subject's skin (of course, you can leave it over the entire image if it looks good, but normally I just use this as a skin effect. So, if it looks good to you as-is, you can skip this step). To limit it to just the skin, press **Command-Option-Shift-E (PC: Ctrl-Alt-Shift-E)** to create a merged layer on top of the layer stack (a merged layer is a new layer that looks like you flattened the image). You don't need the two layers below it any longer, so you can hide them from view by clicking on the Eye icon to the left of each layer's thumbnail (like I did here), or you can just delete them altogether. Now, press-and-hold the Option (PC: Alt) key and click on the Add Layer Mask icon at the bottom of the Layers panel to hide our desaturated layer behind a black mask. Press **D** to set your Foreground color to white, get the Brush tool **(B)**, choose a medium-sized, soft-edged brush from the Brush Picker in the Options Bar, and just paint over his face, hair, and neck (or any visible skin) to complete the effect. If you think the effect is too intense, just lower the Opacity of this layer until it looks right to you. That's it!

High-Contrast Portrait Look

The super-high-contrast, desaturated look is incredibly popular right now, and while there are a number of plug-ins that can give you this look, I also wanted to include this version, which I learned from German retoucher Calvin Hollywood, who shared this technique during a stint as my special guest blogger at my daily blog (www.scottkelby .com). The great thing about his version is: (1) you can write an action for it and apply it with one click, and (2) you don't need to buy a third-party plug-in to get this look. My thanks to Calvin for sharing this technique with me, and now you.

Step One:

Open the image you want to apply a high-contrast look to. Let's start, right off the bat, by creating an action to record our steps, so when you're done, you can reapply this same look to other photos with just one click. Go to the Actions panel, and click on the Create New Action icon at the bottom of the panel. When the New Action dialog appears, name this "High-Contrast Look" and click the Record button. Now it's recording every move you make...every step you take, it'll be watching you (sorry, I just couldn't resist).

Step Two:

Make a copy of your Background layer by pressing **Command-J (PC: Ctrl-J)**. Now, change the blend mode of this duplicate layer to **Vivid Light** (I know it doesn't look pretty now, but it'll get better in a few more moves).

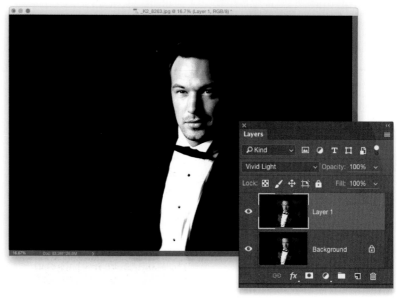

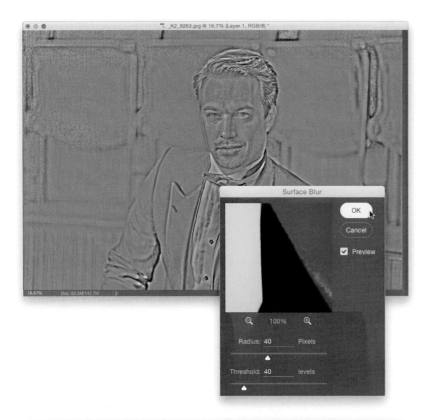

Step Three:
Now press **Command-I (PC: Ctrl-I)** to Invert the layer (it should look pretty gray at this point). Next, go under the Filter menu, under Blur, and choose **Surface Blur**. When the dialog appears, enter 40 for the Radius and 40 for the Threshold, and click OK (it may take a while for this particular filter to do its thing, so be patient. Adobe did, though, update this filter so that it works faster for 16-bit images).

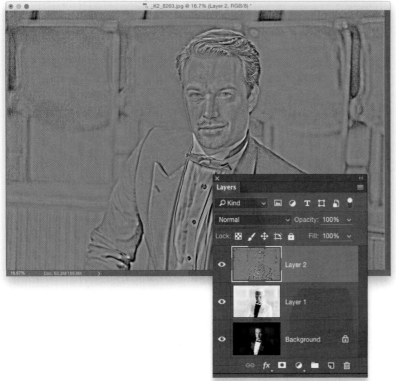

Step Four:
We need to change the layer's blend mode again, but we can't change this one from Vivid Light or it will mess up the effect, so instead we're going to create a new layer, on top of the stack, that looks like a flattened version of the image. That way, we can change its blend mode to get a different look. This is called "creating a merged layer," and you get this layer by pressing **Command-Option-Shift-E (PC: Ctrl-Alt-Shift-E)**.

(Continued)

Step Five:

Now that you have this new merged layer, you need to delete the middle layer (the one you ran the Surface Blur upon), so drag it onto the Trash icon at the bottom of the Layers panel. Next, we have to deal with all the funky neon colors on this layer, and we do that by simply removing all the color. Go under the Image menu, under Adjustments, and choose **Desaturate**, so the layer only looks gray. Then, change the blend mode of your merged layer (Layer 2) to **Overlay**, and you can start to see the effect taking shape. Now, head back over to the Actions panel and click on the square Stop Recording icon at the bottom of the panel, because what we're going to do next is optional.

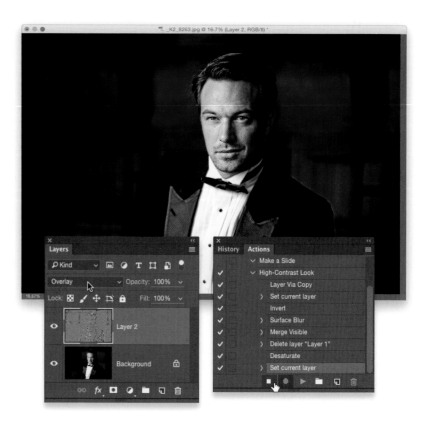

Step Six:

This high-contrast look looks great on a lot of stuff, but one area where it doesn't look that good (and makes your image look obviously post-processed) is when you apply this to blurry, out-of-focus backgrounds, like the one you see here. So, I would only apply it to our subject and not the background. Here's how: Option-click (PC: Alt-click) on the Add Layer Mask icon at the bottom of the Layers panel to hide the contrast layer behind a black mask (so the effect is hidden from view). With your Foreground color set to white, get the Brush tool **(B)**, choose a medium-sized, soft-edged brush, and paint over just our subject to add the high-contract effect there.

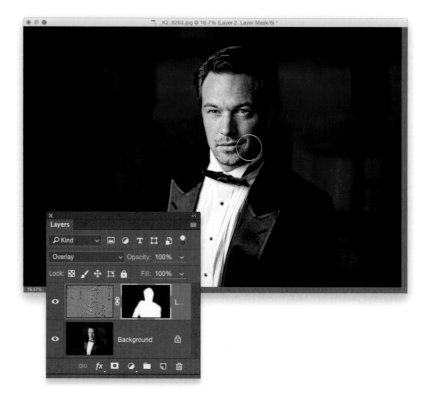

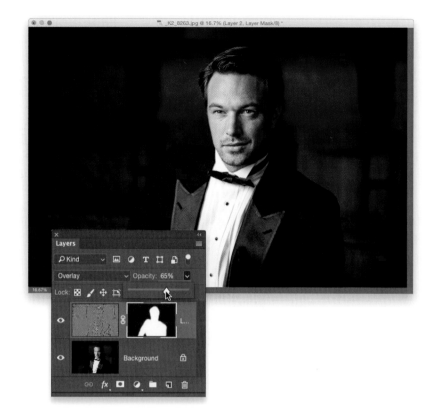

Step Seven:

Finally, go to the Layers panel and lower the Opacity of this layer until it looks more natural, as shown here at 65%. Now, you can flatten the layers and sharpen it using Unsharp Mask (see Chapter 11. Here, I used Amount: 120, Radius: 1, Threshold: 3) to finish off the effect. A before/after is shown below. Remember: you created an action for this, so now you can apply this effect to other images with just one click, then add the layer mask, if needed.

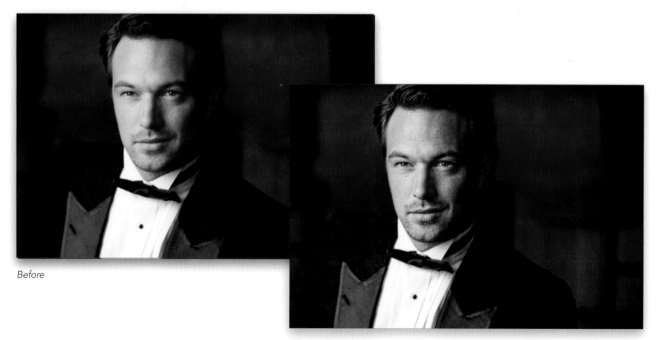

Before

After

Dreamy Focus Effect
for People and Landscapes

This is an effect I get asked about a lot, because I use it a lot. The particular thing I get asked is, "How do you get that look where your image looks sharp, but soft at the same time?" Well, it's actually really simple, but don't tell anybody it's this simple, because I'd prefer that people thought I had to pull off some serious Photoshop magic to make this happen. LOL!

Step One:

The sharpness of this effect comes from sharpening the image right up front, so I usually save this effect for when I'm about to save the file (in other words, I usually save the sharpening for the end, but in this case, there's another move that happens after the sharpening, so let's start with the sharpening first). Go under the Filter menu, under Sharpen, and choose **Unsharp Mask**. When the dialog appears, enter 120% for the Amount, set the Radius to 1.0, and set the Threshold to 3 for some nice punchy sharpening. Click OK.

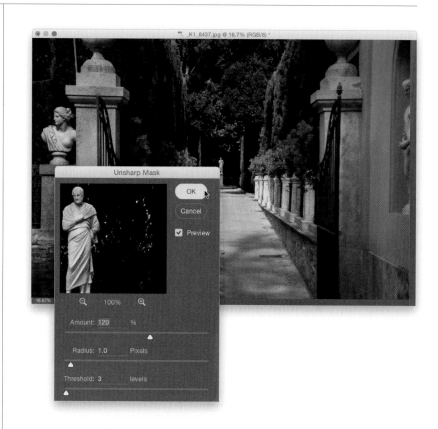

Step Two:

Duplicate this sharpened layer by pressing **Command-J (PC: Ctrl-J)**.

Step Three:

Now, go to the Filter menu, under Blur, and choose **Gaussian Blur**. When the filter dialog appears, enter 25 pixels for the Radius (you may have to go to 35 pixels or higher if you have a 24-megapixel or higher camera. Don't worry so much about the number, just make sure your image looks at least as blurry as this one does), and click OK.

Step Four:

Finally, go to the Layers panel and change the Opacity amount of this blurred layer to 30% (as shown here), and that completes the effect. Now, I know what you're thinking, "Scott. Seriously. Is that all there is to it?" Yes, and that's why it's best we keep this just between us. ;-)

Tilt Shift Effect (Using the Blur Gallery)

The Blur filter gives you a really easy way to create the miniaturization effect you see all over the web, here a photo is transformed to look like a tiny toy model (well, think of it more like an architectural model). Using this filter is easy *if* (this is a big if) you have the right type of photo. Ideally, you'd use one where you photographed from a high point of view, looking downward, and the higher you are, and the steeper the angle, the better it helps sell the idea that you're looking down on a scale model.

Step One:

Open the image you want to apply the effect to (be sure to read the intro above to make sure you use the right type of image, or this effect will look pretty lame. Of course, as always, you can download the image I'm using here from the book's downloads page mentioned in the introduction). Now, go under the Filter menu, under Blur Gallery, and choose **Tilt-Shift** (as shown here).

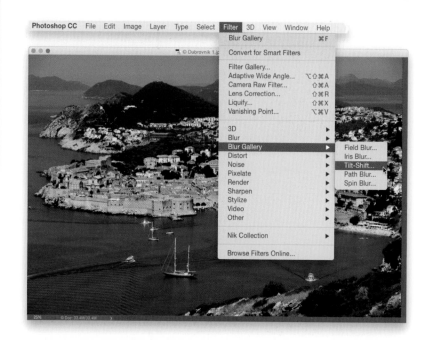

Step Two:

When you use any of the filters in the Blur Gallery, you'll use interactive, onscreen controls to work with your images. Tilt-Shift places a round pin in the center of your image, and above and below that are two solid lines, and then two dotted lines. The solid lines show you the area that will remain in focus (the focus area), and the area between each solid line and dotted line is transition, where it fades from sharp to blurry. The wider the distance between the solid and dotted lines, the longer it takes to go from sharp (inside the solid line) to totally blurry (outside the dotted line). *Note:* To remove a pin, just click on it and hit the Delete (PC: Backspace) key on your keyboard.

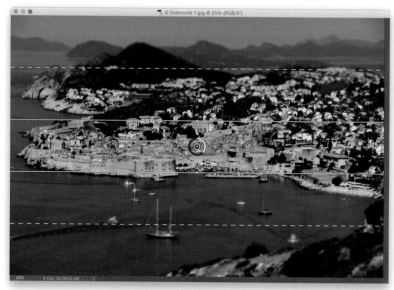

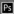

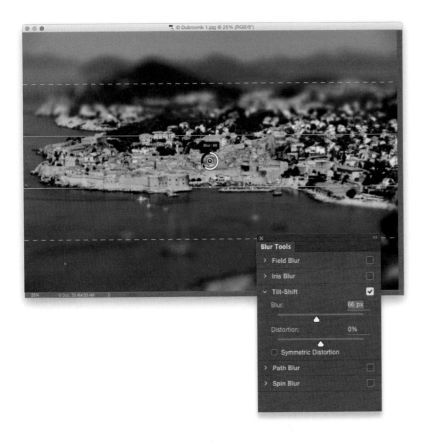

Step Three:

You control the amount of blur by clicking on the gray part of the ring around the pin, and dragging around the ring. As you drag, the ring turns white to show you how far you've gone, and the actual amount of blur appears in a little pop-up display at the top of the ring (as seen here, where I dragged to 66). I totally dig adjusting the blur right on the image this way, but if it gets on your nerves, you can use the Blur slider in the Blur Tools panel that appears over on the right side of your workspace.

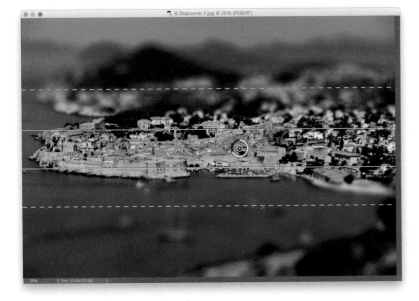

Step Four:

When you're going for this tiny models look, I think it looks better if you compress both of the focus areas—making the in-focus area smaller and the transition area smaller. Here's how: First, click on the pin and move it to the right a bit (as seen here). Then, click directly on the top solid line and drag inward toward the round pin thingy in the middle (and yes, thingy is the official name given by the International Board of Unsure Naming, or the IBUN). Get it pretty close. Now, do the same thing with the bottom solid line, moving it up toward the round pin thingy. Next, drag the center of the top dotted line in closer to the top solid line, and then do the same to the bottom dotted line (as shown here).

(Continued)

Step Five:

If you want to rotate your in-focus area (and blur, and the whole shebang), move your cursor over the white center dot on the solid line above the pin, and it will turn into a two-headed rotate arrow. Click-and-hold on that white dot and rotate by dragging your cursor left/right. Easy peasy. There are a few more options you'll want to know about: The first is the Distortion slider over in the Blur Tools panel, under Tilt-Shift. This lets you change the shape of the blur. If you turn on the Symmetric Distortion checkbox, it makes your blur look really bad and distorted. I personally haven't come up with a reason why I'd ever turn this on, unless I was angry at my photo. Another set of controls is in the Effects panel: The top one lets you increase the highlights in the blur area, which can be nice for some outdoor portraits, but it's a very sensitive slider—if you drag too far, it looks like someone dropped a highlights grenade into your image, so use it sparingly.

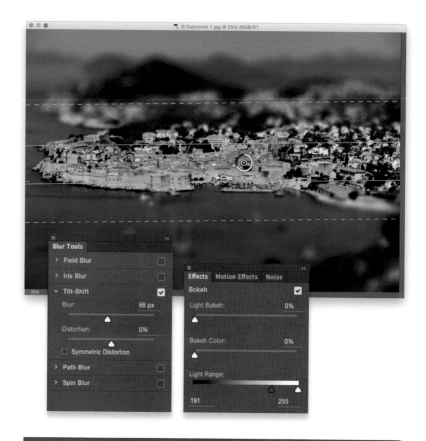

Step Six:

There are a few more controls up in the Options Bar: One is the Focus amount, and it's set at 100% (sharp focus) by default. The lower you set it, the more it makes the in-focus area blurry (I haven't found a use for this). Next is the Save Mask to Channels checkbox, which lets you save the area you've masked (using this tool) to a channel (in the Channels panel), in case you want to edit it later (to add noise to it, or remove all the color, etc.). If you reload that channel, the masked area becomes selected. Lastly, there's a High Quality checkbox, which gives you a better quality blur, but it takes longer to apply. Some handy shortcuts: press **P** to hide the blur (press it again to bring it back), and press-and-hold **H** to hide your round pin thingy and all the lines from view. Click OK at the end of the Options Bar. Here's the final image with the Tilt-Shift effect applied.

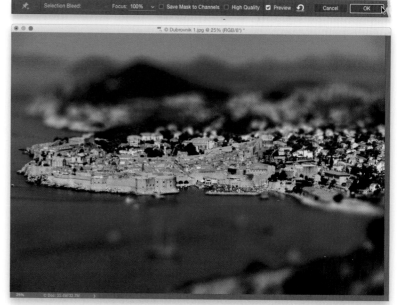

Iris & Field Blur (or How to Fake the 85mm f/1.4 Look)

This is a really cool feature, because it lets you add a super-shallow depth-of-field effect to your image after the fact, and it lets you place the focus point, and the blur, right where you want it (but doesn't give you the miniature effect like the Tilt-Shift Blur does).

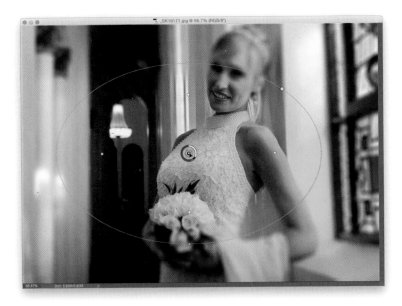

Step One:

Start by opening the photo you want to add a background blur to (like you shot it at a wide-open aperture, like f/1.4 or f/1.8). Now, go under the Filter menu, under Blur Gallery, and choose **Iris Blur** (as shown here). The area to the left of the bride in this image is a little blurry, but we want to make it all a lot blurrier, so she stands out even more.

Step Two:

When you choose Iris Blur, it adds an oval border to the center of your photo, as seen here, and you'll use this oval to determine how much of the image stays in focus, and which parts get blurry (the area in the center of the oval will be in focus and then it'll transition to blurry closer to the edge of the oval). Move your cursor anywhere inside the oval and a set of onscreen controls appear. At the center is a little round pin—click-and-drag directly on that to move the oval anywhere you'd like. The area inside the four larger white dots shows you the area that will remain in sharp focus (the focus area), and the area between those four dots and the solid oval-shaped border is the transition area, where it fades from in-focus to blurry. If you click-and-drag the white dots in toward the center, it shrinks the area that's in focus, so it's a long, smooth transition to blurry on the edges. If you pull them outward, it widens the in-focus area and the transition is shorter and more abrupt.

(Continued)

Step Three:

We want our focus squarely on the bride, so we're going to move our oval, make it thinner (so it's closer to her body), and we're going to rotate it to the left so it matches her pose. To shrink in the sides of the oval, click on the small dot on either side of the oval and drag inward toward the bride. Now, take that same dot and drag downward a bit, and it rotates the oval. To move it, click on the pin and drag the oval over to the right a bit. To stretch the oval out longer, click on one of the top or bottom small dots on the oval and just drag it out (as shown here). You can reshape or rotate the oval any time to fit whatever shape you need (within the constraints of an oval, of course). So, here we have our tall, thin oval positioned over our bride. By default, it applies a slight blur to everything outside this oval.

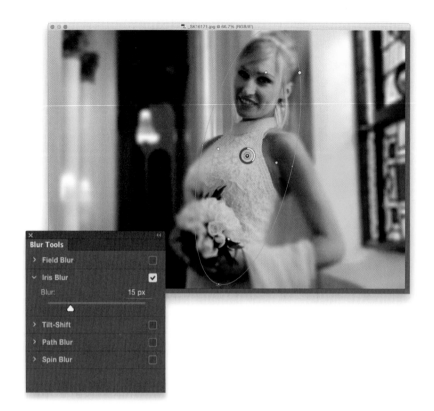

Step Four:

To increase or decrease the amount of blur, click on the gray part of the ring around the pin and drag to the left/right, and as you drag, it increases/decreases the amount of blur (I dragged to 16 px. Of course, you could always just use the Blur slider in the Blur Tools panel, on the right side of your workspace, but where's the fun in that?). Once I did that, I noticed that the top of her head was still really blurry, and the oval wasn't exactly in the right spot, and it wasn't big enough. No worries, just click-and-drag the oval out wider (as seen here), click on the pin and drag the oval over to the right a bit, so it fits better over her, and lastly, click-and-drag one of the large white dots out toward the oval a bit (as shown here) to have more of her inside the oval in focus. Ahhh, that looks better.

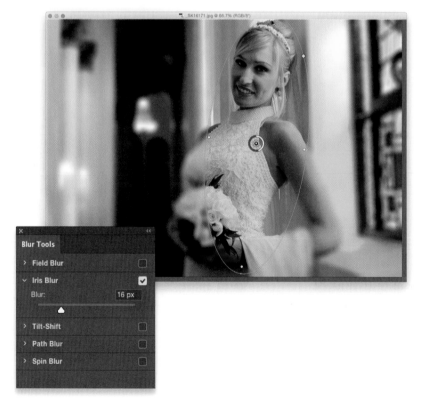

Step Five:

If there are other areas you want in focus, just add more pins. All you have to do is click once anywhere outside the oval, and it creates a new oval with the same amount of blur as your original oval (that's handy!). So, for example, if you wanted more of her arm to be in focus, too, just click on it to add another oval (as seen here), then shrink it down to size and position it over her arm. Want more of her flowers in focus? I added another one down there, too (you can see a third pin there). So, how long did all those blur pins take to create? Just seconds. Each one takes one click to create and one or two clicks to position, so don't let all those dots on the bride throw you—this is easy stuff. One last thing: once you hit the **Return (PC: Enter) key** to apply your blur effect, you can control the amount of blur after the fact by immediately going under the Edit menu and choosing **Fade Blur Gallery**. Lower the Opacity to around 70% and see how that looks (pretty sweet, right?). Below is a before/after, but we're going to move on to another blur filter now.

Before

After

(Continued)

Step Six:

Okay, on to Field Blur. I use this to create gradient blurs (mostly because I can't figure out anything else to do with it that I can't do with the Iris Blur). Open a new image and choose **Field Blur** from the Filter menu, under Blur Gallery. It places a pin in the center of your photo (as seen here) that blurs your entire image. Ummm…yeah…that's helpful. To increase the amount of blur (as if), click on the gray part of the ring around the pin and drag to the left (just like you did with the Iris Blur). Well, it's a start. But the idea here is to add a second pin and make that have 0% blur.

Step Seven:

Click on the subject's face to add a second pin, then click on the gray part of the ring and drag around to the right until your blur is set to 0 (as seen here), and the area beneath that pin will now be in focus. I know what you're thinking: this sure seems like just another version of the Iris Blur. I know it seems like that, but that's only because it kinda is. However, the next step will show you where it differs (well, at least somewhat).

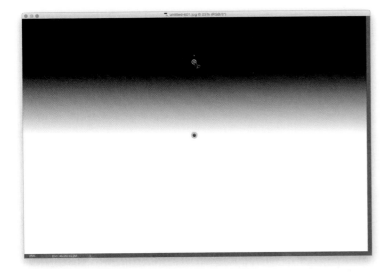

Step Eight:

Press and hold the letter **M** and it shows you a preview of the mask created by these pins. The black area is completely in focus, the gray area (as it moves down) is partially in focus, and then the area in white is completely out of focus. So, from top to bottom, what you're seeing is the top in focus and then it graduates down to blurry. But, it won't look quite like what you see here, until you drag the top (focused) pin to the right a bit. As you drag, you'll see the mask change live, so getting it set up like this will take you all of 2 seconds. When you're done positioning the pin, let go of the M key.

Step Nine:

When you're done, click the OK button (up in the Options Bar) and the effect is applied. You can see how the top of the image is in focus, and by the time you get to her hands, it's already out of focus. Perhaps not the most amazing effect in Photoshop, but at least if you need it, now ya know.

Fashion Toning Using Photoshop's Color Lookup Adjustment Layer

You see color toning and film-look effects just about everywhere you look these days in fashion photography, and you can recreate this look using Photoshop's built-in Color Lookup tables (they instantly remap the colors in your image to create some pretty cool color effects, inspired by the lookup tables used in movie making and video). There aren't a lot of controls to play around with—most of these are pretty much "one-trick ponies," where you choose a look and you either like the effect or not—but what's nice is it's available as an adjustment layer, so you can control the amount of toning (or just tone the background using the built-in layer mask).

Step One:

Open the photo you want to apply a Color Lookup effect to. Then, go to the Layers panel, click on the Create New Adjustment Layer icon at the bottom of the panel, and choose **Color Lookup** from the pop-up menu (as shown here), or you can click on the last icon in the second row of the Adjustments panel. This opens the Color Lookup options in the Properties panel (shown here). There are three different sets of effects, and you make your choice from any of the three pop-up menus (you can only apply one at a time, but you can add multiple adjustment layers if you really feel you need to stack two).

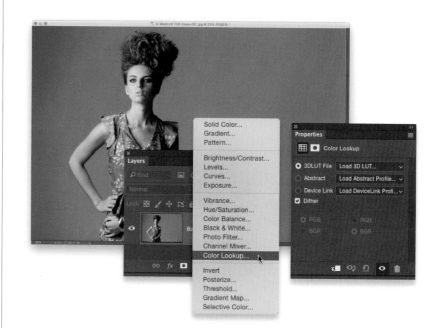

Step Two:

Let's start with the top one: Click on the pop-up menu to the right of 3DLUT File, and you can see there's a long list of "toning looks." Everything from B&W to Traditional Film looks to split toning. Here, I chose Soft_Warming.look (I recommend you try them all because, depending on the image, they can look very different). At this point: (1) if the effect seems too intense, you can lower the layer's Opacity; (2) you can change the layer's blend mode to control how this effect blends with the image; or (3) you can press **Command-I (PC: Ctrl-I)** to Invert the layer mask, which hides the effect behind a black layer mask, then take the Brush tool **(B)** and, with your Foreground color set to white, just paint the effect right where you want it to appear.

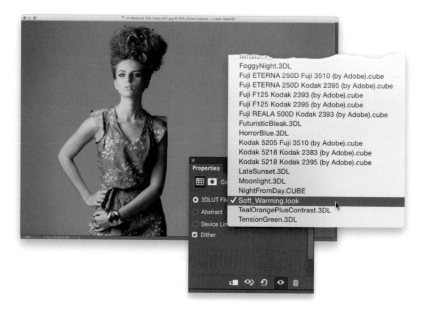

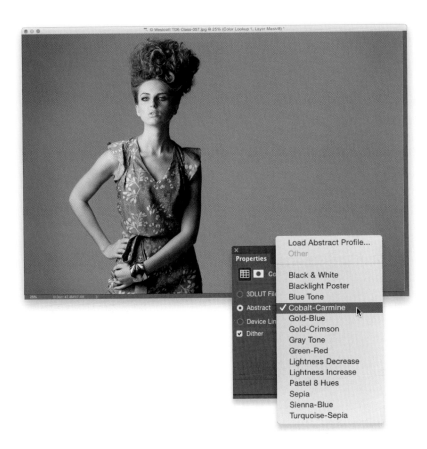

Step Three:

Now, let's go to the next set down in the Properties panel: Abstract. Click on the pop-up menu to its right to see all your choices. Here, I chose Cobalt-Carmine, which I think is another good choice for this image. *Note:* There are a few effects that have extra options. For example, from the 3DLUT File pop-up menu we used in Step Two, choose **NightFrom-Day.CUBE** and some new options appear at the bottom of the Properties panel. Since they're radio buttons, all you can do is choose one button on the left and one on the right, and as you click on them, they create variations of the look you chose. Also, there are a few handy buttons across the bottom of the Properties panel: The one I use the most is the Eye icon, which toggles the Color Lookup adjustment layer on/off (and saves you a trip up to the Layers panel). If you click on the first icon from the left, it makes the effect only affect the layer directly below it (and not all the layers below it, like normal). The next icon over (the eye with an arrow) is a before/after, which is pretty similar to turning the layer on/off with the Eye icon. The next icon (the curved arrow) just resets the entire panel to its defaults.

Step Four:

Let's try the last set, called "Device Link," and you can see its choices here (from the pop-up menu). I chose RedBlueYellow to get the look you see here. One last thing: If you choose the top choice in any of these pop-up menus, it opens an Open dialog, so you can load a profile. However, these aren't easy to find (I don't know anyone who has one outside of people working in movies), so just hit Cancel if that dialog appears (since most folks don't have these, it makes you wonder why it's not the last choice in each menu, right? Don't get me started).

Sculpting Using the Updated Liquify Filter

Liquify has been the professional retoucher's go-to filter for years now, because it does something that's really quite remarkable—it lets you move your subject's features around like your subject was made of a thick molasses-like liquid, and that lets you fix a myriad of issues. Outside of doing that (which is a totally manual, but actually pretty fun process), Adobe has integrated some truly amazing features based on using facial recognition. So, it kind of "selects" areas of your subject's face for you (like their eyes, nose, mouth) and lets you tweak them in a very natural way (and it's so easy to use—you're going to dig this!).

Step One:

Open the image you want to retouch (here, we have a nice headshot), then go under the Filter menu and choose **Liquify** (or press **Command-Shift-X [PC: Ctrl-Shift-X]**), which brings up the dialog you see here. There's a toolbar along the left and controls for editing on the right, which include individual sliders for controlling facial features (based on automatic facial recognition).

Step Two:

Liquify recognizes facial features like eyes, the nose, mouth, jawline, and face height and width, and automatically selects those areas and assigns them to sliders. So, you can immediately begin making adjustments without having to paint or make any selections—the sliders are already active and ready to go. Here, we'll start by adjusting the eyes using the Eyes sliders, in the Face-Aware Liquify section (click on the right-facing arrow to it's left to reveal these options), making them a bit bigger using the Eye Size slider. You can adjust eye width and height, as well as the tilt and the space between the eyes (which will close the gap between her eyes) by dragging to the left, as seen here, where I dragged the Eye Distance slider to –27.

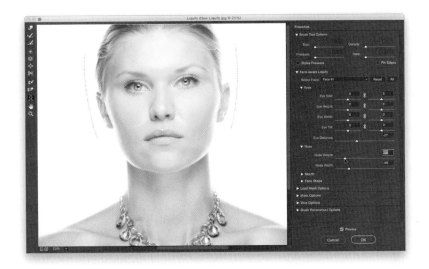

Step Three:

Below the Eyes options are the options for adjusting the nose, where you can adjust the height and width of a nose. We'll adjust both, making her nose less wide by dragging the Width slider to the left (to –55), and lowering the height of it by dragging the Height slider quite a bit over to the left (to –68).

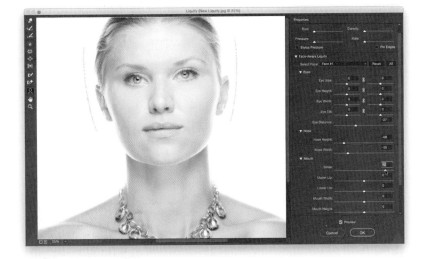

Step Four:

Now let's see if we can turn her frown into a little bit of a smile. Liquify handles this one pretty darn well for most images—just click on the right-facing triangle to the left of Mouth to reveal those options, then drag the Smile slider to the right (as shown here, where I dragged it to 74), and it turns up the edges of the mouth and adjusts the surrounding cheek, as well (as seen here). You can adjust the upper lip (dragging to the right enlarges it; dragging to the left tucks it in) and the lower lip (dragging to the right tucks it inward; dragging to the left lowers it and makes it larger), as well as the mouth width and height (in this image, the Mouth Height slider opens the space between her lips).

TIP: Liquify Recognizes Multiple Faces

If there's more than one person in your image, you can choose which face to work on from the Select Face pop-up menu at the top of the Face-Aware Liquify options.

(Continued)

Step Five:

Instead of using the sliders, you also can click-and-drag directly within the image to make these same changes. With the Face tool **(A)** selected in the toolbar, move your cursor over the image, and you'll see selections (lines) appear over individual areas of the face. Just click-and-drag within these areas to make adjustments. Let's adjust her jawline and shape of her face, here. Move your cursor over her face and you'll see a thin line appear around it (as seen here) letting you know that this area is "selected." Click on the line down by her jaw and drag inward to adjust her jawline (as you move your cursor around the her face, tool tips will pop-up telling you which areas will be adjusted). Here, you'll see that, in the Face Shape section, the Jaw-line slider moved to –55.

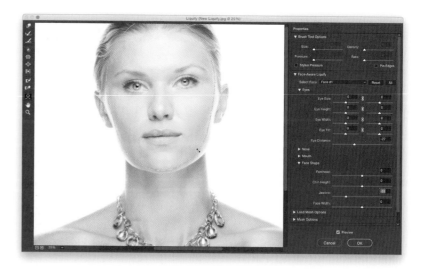

TIP: Hiding Selections

To hide the selections (lines) that appear over your subject when making Face-Aware Liquify adjustments, just turn off the Show Face Overlay checkbox in the View Options section.

Step Six:

To make her head less "round," let's extend her forehead. In the Face Shape section, drag the Forehead slider all the way to the right (as seen here). Let's also expand the jawline back out a bit (to –38), and then adjust the Face Width a bit, as well (to –37).

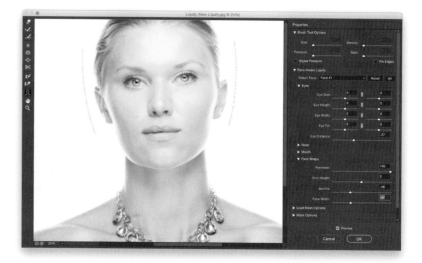

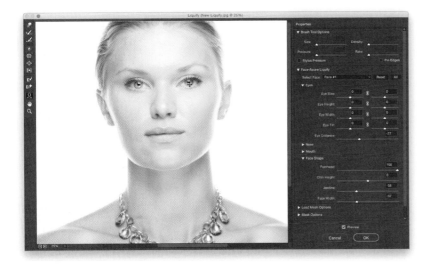

Step Seven:

You can also use the facial recognition to move parts of the face by clicking-and-dragging directly on the part you want to move. For example, move your cursor over her eye on the right and you'll see lines appear around the eye, letting you know that this area is selected. Now, just click-and-drag that area downward and it moves that eye down a bit (as shown here, where I'm dragging downwards to align the eye on the right with the one on the left).

TIP: See a Before/After of Your Liquify Adjustments

To see a before/after of the adjustments you've made, turn the Preview checkbox (at the bottom right) off/on or just press the **P key**.

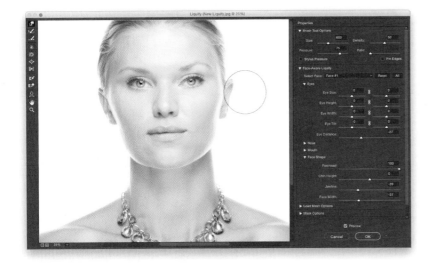

Step Eight

Besides making automatic facial adjustments, my other most-used tool is the Forward Warp tool (**W**; its the first tool in the toolbar), and this is the one that lets you move your subject around like they were a thick liquid (like molasses). But, the secrets to using it effectively are: (1) make your brush size the size of what you want to move, and (2) make subtle movements with it (just kind of nudge things around, and you'll get great results). So, get this tool from the toolbox, make your brush size around the size of her ear on the right (use the **Bracket keys** on your keyboard, to the right of the letter P, to quickly make your brush bigger or smaller), then gently nudge that ear over to the left to tuck it in a bit (as shown here).

(Continued)

Step Nine:

Typical things you'd do with the Forward Warp tool would be to adjust individual parts of the lips, eyebrows (like I'm doing here where I'm pushing the eyebrow on the right down just a bit to match the one on the left), clothes, or dozens of other tweaks that this tool is perfect for.

TIP: Visual Brush Resizing in Liquify

Here's another quick way to jump up to a much larger or down to a smaller brush size: on a Mac, press-and-hold **Option-Control** and **click-and-drag** your cursor left/right to resize it onscreen. On a PC, press-and-hold the **Alt key,** and then **Right-click-and-drag** left/right.

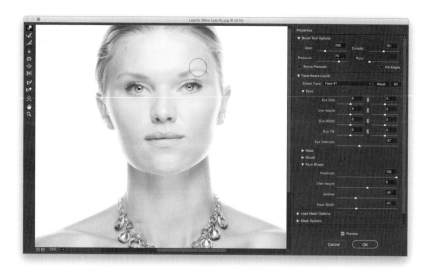

Step 10:

When making big adjustments to one area, you run the risk of moving another nearby area. Luckily, you have the ability to freeze any part of the image you don't want to move while you're moving areas right around it. For example, when pushing in her ear, if it started pushing in the side of her face at the same time, you can freeze that side of her face and those areas won't move no matter how far you tuck in that ear because it's frozen. You do this using the Freeze Mask tool (**F**; it's the eighth tool down in the toolbar). Here, I painted with the Freeze Mask tool over the side of her face (the area you paint over appears in a red tint, as seen here. *Note:* If you don't see the red mask, in the View Options section, turn on the Show Mask checkbox). Now that area in red is protected and can't be messed up while you're adjusting a nearby area. When you're done (or to erase any area you accidentally painted over), switch to the Thaw Mask tool (**D**; it's the next tool down in the toolbox) and paint away that red tinted area.

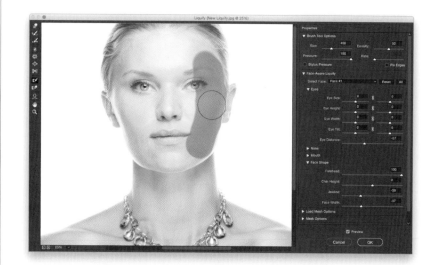

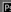

Step 11:

Let's finish things up by going back to the eyes. In the Eyes section, let's first increase the size. Since we want to adjust the size of both eyes, click on the link icon between the two Eye Size fields, so the adjustment is made to both eyes. Then, increase the left Eye Size to 14 and the right Eye Size field will adjust right along with it. Finally, let's increase the eye height, but since we want different settings for each, we won't click on the link icon, here. Now, drag the left Eye Height slider to the left to around −40, and then drag the right Eye Height field to the right to around 54 (as shown here). A before and after is shown below.

Before

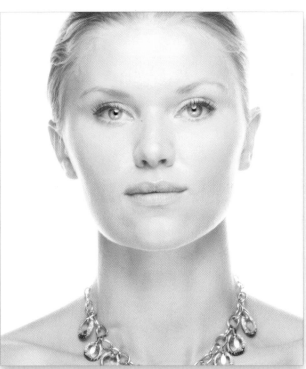

After

Lens Flare Look

This effect has come back into vogue in a big way (it was big years ago, then it went away, now it's back. The very definition of fashion, right?). Luckily, it's super-quick and easy (my favorite type of technique).

Step One:
Start by opening an image you want to add a Lens Flare effect to (as seen here). Create a new blank layer by clicking on the Create a New Layer icon at the bottom of the Layers panel.

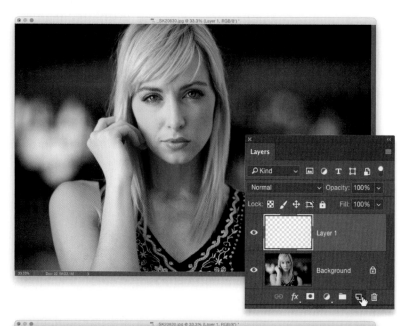

Step Two:
Press **D** to set your Foreground color to black, then press **Option-Delete (PC: Alt-Backspace)** to fill this new layer with solid black. Now, go under the Filter menu, under Render, and choose **Lens Flare**, which brings up the dialog you see here. There are four different styles of lens flare, but the one I see most often is the first one (the 50–300mm Zoom). The Brightness slider controls... wait for it...wait for it...okay, obviously it controls the brightness of the lens flare (I left it set to 100%, here). Now, click OK to apply this Lens Flare effect to your black layer (as seen here).

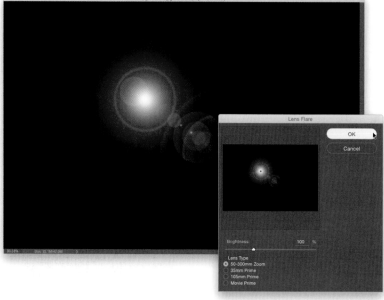

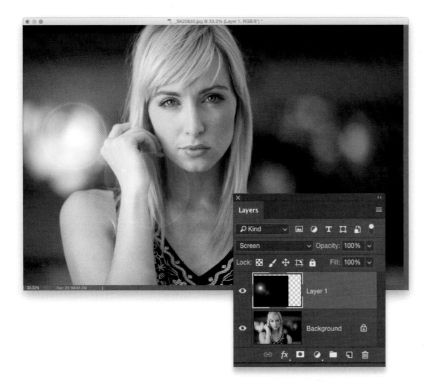

Step Three:

Of course, at this point, you've just got a lens flare on a black layer—we need to get it to blend in with our image. Easily done. Just go the Layers panel and change the layer blend from Normal to **Screen**. As soon as you do that— BAM!—the lens flare appears (as seen here), but it's going to appear in the center of your image. So, get the Move tool **(V)** from the Toolbox, click on the lens flare right on your image, and drag it where you want it (here, I dragged it to the left side of her head).

TIP: Changing the Position of the Lens Flare Rings

When the Lens Flare dialog is open, if you click on the little + (crosshair) in the center of the little preview window, you can drag it, and as you do, it changes the order and location of the lens flare rings.

Step Four:

When you move the Lens Flare layer like this, there is something you're probably going to run into, and that's a visible edge. Here's why: let's pretend we never added the lens flare and it was just a black layer. If we got the Move tool and dragged the black layer around, you'd see the edges of the black rectangle. So, after we add the lens flare and change the mode to Screen, while those edges aren't nearly as visible, there's a good chance they're there. So, click on the Add Layer Mask icon at the bottom of the Layers panel, and then press **X** to set your Foreground color to black. Get the Brush tool **(B)** from the Toolbox, choose a large, soft-edged brush from the Brush Picker up in the Options Bar, and then paint over those edge areas, so they blend in smoothly with the rest of the image. One last thing: if the effect seems too intense, you can just lower the Opacity of this layer until it looks right (here, I lowered it to 75%). Okey dokey—that's it.

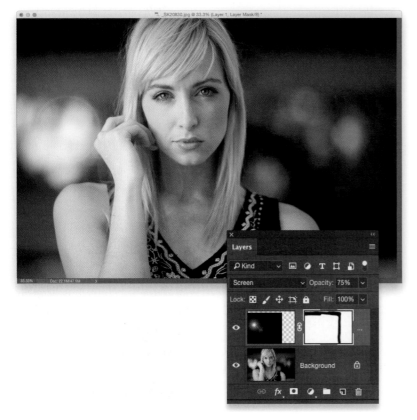

Turning a Photo into an Oil Painting in One Click

This filter was in Photoshop a while back, then Adobe took it out for a while, but then added it back, but in a different place. What it does is it turns your photo into an oil painting in literally just one click—it's literally is a one-click process (because as soon as you open the Oil Paint filter—boom—it's an oil painting before you even touch a single slider). You are going to love how simple this really is.

Step One:

Open an image you want to turn into an oil painting. Here's a shot I took in Iceland. I did a little HDR on this image, but we're going to turn it into an oil painting in one click. Go under the Filter menu, under Stylize, and choose **Oil Paint**. (*Note:* If Oil Paint is grayed out for you, go under the Photoshop [PC: Edit] menu, under Preferences, and choose Performance. In the Graphics Processor Settings section, click on the Advanced Settings button and, in the dialog that appears, make sure the Use OpenCL checkbox is turned on. If this option is grayed out, your version of OpenCL is not supported to use this filter.)

Step Two:

That's it. Once you choose Oil Paint, you've got an oil painting. Well, you'll need to turn on the Preview checkbox (near the top of the dialog) first to see the effect on your image. Now, the default settings, here, aren't too bad, but you can mess around with the options in this dialog to see if you can get better results.

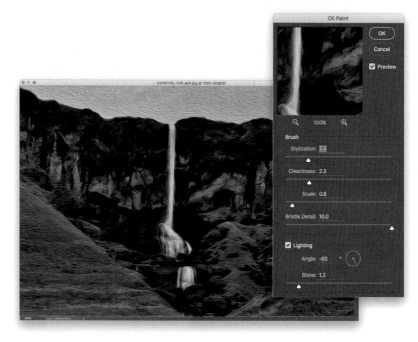

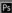
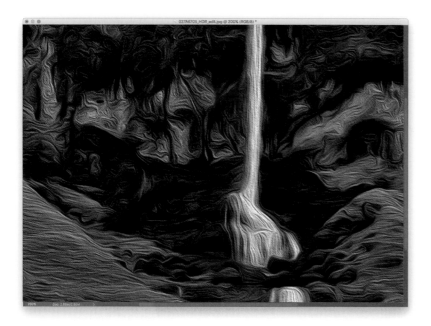

Step Three:

Before you start dragging sliders, I would make sure you zoom in on your image, so you can clearly see the effect as you're tweaking it (and before you apply it). So, press **Command-+** [plus sign; **PC: Ctrl-+**]) to zoom in.

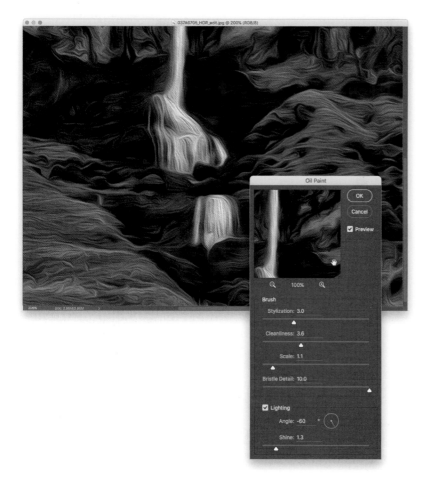

Step Four:

The Stylization slider controls your stroke style—drag this to the left for thick strokes or to the right for smoother ones (for high-res images, you'll want to use a higher amount). Drag the Cleanliness slider to the left for short, heavy brush strokes or to the right for longer, smoother ones. The Scale slider determines the thickness of the paint—drag it to the left for a thin coat or to the right for a thicker one. And, dragging the Bristle Detail slider to the right will help bring out detail.

(Continued)

Step Five:

Finally, in the Lighting section, you can adjust the angle of the light, as well as its shine (brightness). You can see all the settings I used here, and the after image below. That's it. Oil Paint—awesome and easy.

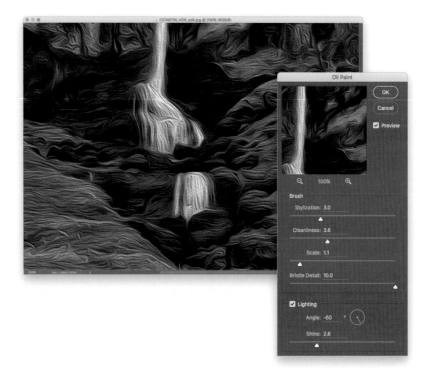

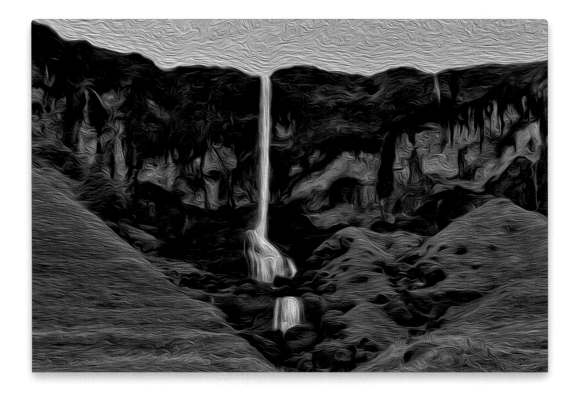

My Three-Click Method for Converting to B&W
(If You're Already in Photoshop)

Some of the best techniques unfold when you least expect it, and this technique is a perfect example. I was working on a completely different technique when I stumbled upon this and I fell in love, and now you're only three clicks away from a nice, crisp, high-contrast B&W image (if you're already in Photoshop. Otherwise, I would do it in Camera Raw, because you have more control [see Chapter 5]). Plus, I'll show you how you can tweak your conversion, along with a variation, with just a couple more clicks. It's a B&W clicking lovefest.

Step One:

Open the color photo you want to convert into a high-contrast B&W image. You start by pressing the letter **D** to set your Foreground color to black and your Background color to white, and then in the Adjustments panel, click on the Gradient Map icon (it looks like a horizontal gradient—it's shown circled in red here).

Step Two:

Once you click that icon, the Gradient Map options appear in the Properties panel, but you don't have to do anything there. Not a bad B&W conversion, eh? Believe it or not, just the simple act of applying this black-to-white gradient map will almost always give you a much better conversion than choosing Grayscale from the Image menu's Mode submenu, and I feel it's generally even better than both the default and Auto settings in the Black & White adjustment. However, we can add another click or two and take this conversion up a big notch.

(Continued)

Step Three:

Now you're going to add some con-trast the easy way. Click on the Levels adjustment layer icon in the Adjustments panel (it's the second icon in the top row). Here's the good news: when the Levels options appear in the Properties panel, you're not actually going to adjust the Levels. All you need to do is change the layer blend mode of this adjustment layer from Normal to **Soft Light** (at the top of the Layers panel, as seen here) and look how much more contrasty, and just generally yummy, this photo looks now. If choosing Soft Light for the par-ticular photo you're working on doesn't add enough contrast, then try Overlay mode instead (it's more contrasty). Okay, that's it—three clicks and you're done. Now, if you're feeling "clicky," there is a way to tweak your conversion if you really feel like it (not necessary usually, but in case you want to, I'll show ya).

Step Four:

In the Layers panel, click on the Gradient Map adjustment layer (the middle layer) to make it active. Now, click directly on the gradient in the Properties panel, which brings up the Gradient Editor dia-log. Once it appears, click once directly in the center, right below the gradient ramp (as shown circled here) to add a color stop (it looks like a little house) right below your gradient. Don't click OK yet. At this point, your image will look really dark, but that's okay—we're not done yet.

Step Five:

Double-click directly on that color stop you just created and Photoshop's Color Picker appears (seen here). Click-and-drag your cursor all the way over to the left side of the Color Picker, right up against the edge (as shown here), and pick a medium gray color. As you slide up and down that left side, let go of the mouse button and look at your photo. You'll see the midtones changing as you drag, and you can stop at any point where the image looks good to you. Once you find a spot that looks good (in our case, one in the center), click OK to close the Color Picker (don't close the Gradient Editor, just the Color Picker at this point, because there's another tweak you can do. Of course, this is all optional [you could have stopped back at Step Three], but now we have some extra editing power if we want it).

Step Six:

Once you're back at the Gradient Editor, and your color stop is now gray, you can drag that middle gray stop around to adjust the tone of your image (as shown here). What's weird is you drag the opposite way that the gradient shows. For example, to darken the photo, you drag to the right, toward the white end of the gradient, and to lighten the photo, you drag left toward the dark end. Freaky, I know. One other thing: unlike almost every other slider in all of Photoshop, as you drag that color stop, you do not get a live preview of what's happening—you have to release the mouse button and then it shows you the results of your dragging. Click OK, and you're done.

(Continued)

Step Seven:

Here's a quick variation you can try that's just one more click: go to the Layers panel and lower the Opacity of your Gradient Map adjustment layer to 82% (as shown here). This bleeds back in a little of the color, and gives a really nice subtle "wash" effect (compare this slightly-colored photo with the full-color photo in Step One, and you'll see what I mean. It's kinda nice, isn't it?). A before and after is shown below, but it's just the three-click version (not all the other tweaking we added after the fact).

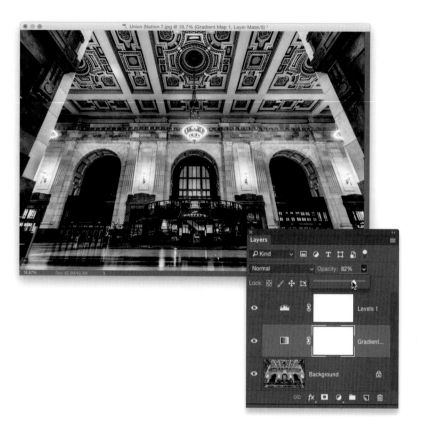

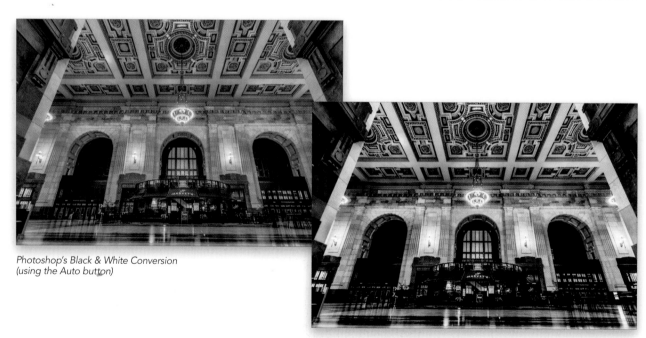

Photoshop's Black & White Conversion (using the Auto button)

Scott's "Three-Click Method" (using just the three clicks, not the extra tweaking)

Quadtoning for Richer B&Ws

If you've ever wondered how the pros get those deep, rich-looking B&W photos, you might be surprised to learn that what you were looking at weren't just regular B&W photos, instead they were quadtones or tritones—B&W photos made up of three or four different grays and/or brown colors to make what appears to be a B&W photo, but with much greater depth. For years, Photoshop had a bunch of very slick presets buried somewhere on your computer, but luckily, now they're just one click away.

Step One:

Open the photo you want to apply your quadtoning effect to (the term quadtoning just means the final photo will use four different inks mixed together to achieve the effect. Tritones use three inks, and do I really have to mention how many duotones use?). Quadtoning effects seem to look best with (but are not limited to) two kinds of photos: (1) landscapes, and (2) people. But, here, we're going to apply it to an image of an old car.

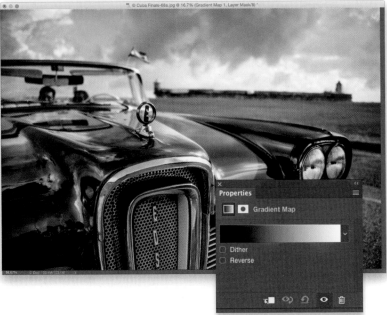

Step Two:

To create a quadtone, you'll have to convert to Grayscale mode first, but by now you know what a flat-looking B&W photo that creates, so instead try this (from a few pages ago): Press the letter **D** to set your Foreground and Background colors to their defaults of black and white, then click on the Gradient Map icon in the Adjustments panel. When the Gradient Map options appear in the Properties panel, you don't need to make any changes. Now, you can convert this image to Grayscale mode by going under the Image menu, under Mode, and choosing **Grayscale**. It will ask you if you want to flatten your layers, so click the Flatten button. (It will also ask you if you want to discard the color info. Click Discard.)

(Continued)

Step Three:

Once your photo is in Grayscale mode, the Duotone menu item (which has been grayed out and unchoosable) is now open for business (if you're in 8-bit mode). So, go under the Image menu, under Mode, and choose **Duotone**. When the Duotone Options dialog appears (shown here), the default setting is for a one-color Monotone (a cruel joke perpetrated by Adobe engineers), but that's no big deal, because we're going to use the built-in presets from the pop-up menu at the top. Here, you'll literally find 137 presets (only 116 on a PC; I counted). Now, you'd think they'd be organized by duotones first, tritones, then quadtones, right? Nope—that makes too much sense (in fact, I'm not sure they're in any order at all).

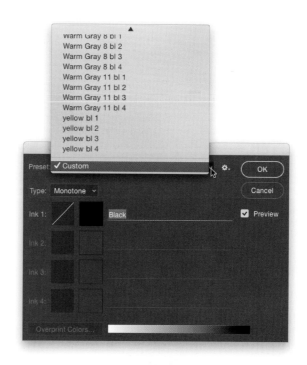

Step Four:

I thought I'd give you a few of my favorites to get you started: One I use often is named "Bl 541 513 5773" (the Bl stands for black, and the three sets of numbers are the PMS numbers of the three other Pantone colors used to make the quadtone). How about a nice duotone? It uses black and it adds a reddish brown to the mix. It's called "478 brown (100%) bl 4," and depending on the photo, it can work really well (you'll be surprised at how different these same quadtones, tritones, and duotones will look when applied to different photos). There's a nice tritone that uses black and two grays, named "Bl WmGray 7 WmGray 2." We'll wrap things up with another nice duotone—this one's named "Warm Gray 11 bl 2," and gives you the duotone effect shown here. Well, there you have it—four of my favorites (and don't forget, when you're done, convert back to RGB mode for color inkjet printing).

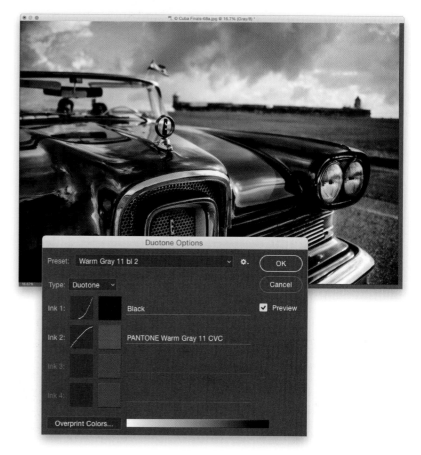

Photographic Toning Effects
(from Sepias to Split Tones)

One of the most under-used adjustment layers has got to be the Gradient Map. For years, I've only used it for one thing—it makes a pretty mean black-and-white conversion in just one click (well, provided that your Foreground color is black and your Background color is white when you choose Gradient Map). Anyway, Adobe worked with photographer Steve Weinrebe to add 38 photo-toning and split-toning presets to the Gradient Map feature, making it an even better tool that nobody uses. I hope that changes today.

Step One:
Open the photo you want to apply a photo-toning effect to. Then, go to the Layers panel and click on the Create New Adjustment Layer icon at the bottom of the panel, and choose **Gradient Map** from the pop-up menu (as shown here), or you can click on the last icon, on the bottom row, of the Adjustments panel.

Step Two:
As soon as you choose Gradient Map, it applies the default gradient, which as I said above, makes a pretty darn sweet one-click B&W image (as long as your Foreground and Background colors are set to black/white, respectively, before you choose Gradient Map). Okay, to be able to load the Photo Toning presets, you need to go to the Properties panel and click directly on the gradient itself (as shown here).

(Continued)

Special Effects for Photographers | Chapter 10 | **277** ◂

Step Three:

This brings up the Gradient Editor (seen here), and if you click on the little "gear" icon at the top-right corner of the Presets section, a pop-up menu appears. Choose **Photographic Toning** from this menu (as shown here). A dialog will appear asking if you want to replace the current default set of gradients with the ones you are loading. I chose OK, because (1) it's easier to work with them if they're not added to the existing set, and (2) you can always get back to the default gradients by simply choosing **Reset Gradients** from this same pop-up menu. Once they're loaded, now the fun begins, because all you have to do is click on any one of these gradients and it updates your image live, so you can just start clicking until you find one you like. Here's one called Sepia-Selenium 3 (it's the fourth one in the third row). ‌

Step Four:

So, now you're pretty much window-shopping for the look you like—click a gradient, and if it's not the look you're looking for, click the next one. For example, here I chose Sepia-Cyan (perhaps not my first choice, but I did want to show you the variety of what's here). This one has more of a split-tone look, with a cyan color in the shadows and a yellowish color in the highlights. Make sure you try out some of the ones in the top row—there are some really useful duotone/sepia tone looks up there, and like most Adobe presets, the best, most-useful ones are near the beginning, and the farther they are down on the list, the less useful they are. One more cool thing: because these are adjustment layers, you can reduce the intensity of the effect by simply lowering the opacity of the adjustment layer (over in the Layers panel), and you can also change the layer blend mode (try Linear Burn on this shot) for even more looks.

If You're Really, Really Serious About B&W, Then Consider This Instead

I saved this for the last page, because I wanted to share all my favorite techniques for doing B&W using just Photoshop's tools, and although I still use those techniques from time to time, it would be pretty disingenuous of me if I didn't tell you what I do most of the time, which is: I use Silver Efex Pro 2, a black-and-white plug-in that is part of the Google Nik Collection. Almost all the pros I know use it as well, and it's absolutely brilliant (and super-easy to use). You can download the entire Nik Collection for free from www.google.com/nikcollection and see for yourself. Here's how I use it:

Step One:

Once you install Silver Efex Pro 2, open the image you want to convert from color to B&W, then go under Photoshop's Filter menu, under Nik Collection, and choose **Silver Efex Pro 2**. When the window opens, it gives you the default conversion (which isn't bad all by itself), and a host of controls on the right side (but honestly, I literally never touch those controls).

Step Two:

The magic of this plug-in is its B&W (and duotone) presets. They're listed along the left side of the window, complete with a small preview of how the effect will look, but here's where I always start: on their High Structure preset. Eight times out of 10, that's the one I choose, because it has its own high-contrast, sharpened look that is wonderful for so many images. However, if I'm converting a portrait, I'll often wind up using a different preset, because High Structure can be too intense when your subject is a person. So, I click on the top preset in the list, and then click on each preset below it until I find one that looks good to me, then I click OK in the bottom-right corner and I'm done. That's all I do. It's fast, easy, and it looks fantastic. That's just what I want.

Photoshop Killer Tips

How to Open Multiple JPEGs or TIFFs in Camera Raw from Bridge

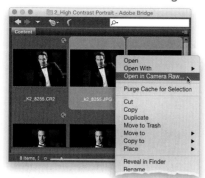

Opening multiple RAW photos from Bridge is easy—just select as many as you want, and then double-click on any one or Right-click and choose Default Application, under Open With. The problem is that doesn't work for JPEG or TIFF images. But, it's easy to open them in Camera Raw from Bridge, as well. Select multiple JPEG or TIFF images in Bridge, Right-click on any one, and choose **Open in Camera Raw** or you can just press **Command-R (PC: Ctrl-R)**.

Tip for Wacom Tablet Users

If you use a Wacom tablet for retouching, there are two buttons that keep you from having to jump to the Brushes panel when you need to control pressure-sensitive opacity or size. These two buttons appear in the Options Bar when you have a brush tool selected (they look like circles with a pen on them), and clicking them overrides the current settings in the Brushes panel, so it saves you a trip to the Opacity or Size controls to turn those two on first.

If Photoshop Starts Acting Weird…

…or something doesn't work the way it always did, chances are that your preferences have become corrupt, which happens to just about everyone at one time or another, and replacing them with a new factory-fresh set of preferences will cure about 99% of the problems that you'll run into with Photoshop (and it's the very first thing Adobe's own tech support will tell you to fix), so it's totally worth doing. To rebuild your preferences, go ahead and quit Photoshop, then press-and-hold Command-Option-Shift (PC: Ctrl-Alt-Shift) and launch Photoshop (keep holding them

down). A dialog will pop up asking if you want to Delete the Adobe Photoshop Settings File. Click Yes, and chances are, your problems will be gone.

Super-Fast Temporary Tool Switching

This is one Adobe introduced back in CS4, but few people knew it was there. They're called Spring Loaded Tools, and what they let you do is temporarily access any other tool while you're using your current tool. When you're done, Photoshop automatically switches back. Here's how it works: Let's say you have the Brush tool, but you need to put a Lasso selection around an area, so you don't paint outside of it. Just press-and-hold the L key (for the Lasso tool), and your Brush tool temporarily

switches to the Lasso tool. Make your selection, then let go of the L key and you're back to the Brush tool. This is a huge time and trouble saver.

Designing for a Cell Phone or Tablet?

Then you'll be happy to know that there are a bunch of built-in presets for the most common sizes of mobile device screens. From the File menu, choose New, then click on **Mobile** at the top of the New Document dialog, and then choose the size you need from the Blank Document Presets.

Save Time When Saving

When you click on the Save Image button in the bottom left of the Camera Raw window, it brings up the Save Options dialog, but if you don't need to make any changes to your settings, you can skip this dialog altogether by pressing-and-holding the Option (PC: Alt) key before clicking the Save Image button. Hey, every click you save, counts.

Assigning More RAM to Photoshop

You can control how much of your computer's installed RAM actually gets set aside just for Photoshop's use. You do this within Photoshop itself, by pressing **Command-K (PC: Ctrl-K)** to bring up Photoshop's

Preferences, then click Performance in the list on the left side of the dialog. Now you'll see a bar graph with a slider that represents how much of your installed RAM is set aside for Photoshop. Drag the slider to the right to allocate more RAM for Photoshop (the changes don't take effect until you restart Photoshop).

Shortcuts for Changing the Order of Layers

I use these a lot, because it saves a trip over to the Layers panel dozens of times a day. To move your current layer up one layer (in the stack of layers), press **Command-]** (Right Bracket key; **PC: Ctrl-]**) and of course to move down, you'd use the same shortcut with the Left Bracket key **([)**. To move the current layer all the way to the top, add the **Shift key**. Of course, you can't move anything below the locked Background layer.

Duplicate Multiple Layers at Once

Pressing **Command-J (PC: Ctrl-J)** is not only the fastest way to duplicate a layer, it is also the fastest way to duplicate multiple layers. Just go to the Layers panel,

Command-click (PC: Ctrl-click) on the layers you want duplicated to select them, then use that same shortcut to duplicate all the selected layers.

If You Mess Up In Liquify, Try This

If you want to start over from scratch, click the Reset button at the top of the top of the Face-Aware Liquify options. If you want to just undo a step or two, you can use the same multiple undo shortcut you normally use in Photoshop: every time you press **Command-Option-Z (PC: Ctrl-Alt-Z)**, it undoes another step.

Location: Bronte Beach, Sydney, Australia | Exposure: 0.4 sec | Focal Length: 12mm | Aperture Value: ƒ/22

Sharp Tale
sharpening techniques

Wait a minute. Wait a minute! Isn't it supposed to be *Shark Tale*, the DreamWorks animated movie with Will Smith and Renée Zellweger? Hey, look, typos happen. I see them in *The New York Times* and *The Wall Street Journal*, so it can surely happen here, even though we run an incredibly thorough process where teams of grammarsticians at university-level research labs in Gstaad, Geneva, Fresno, Bordeaux, and Osaka work night and day to ensure that every word (or at the very least, every third word) in this entire document has most of the components to form adequately spelled words, with just a hint of grammar and sentence form. And, we believe that the properly structured sentence is really a state of mind. A state of existential being where the letter and form congeal and become one. This frees us from the old-fashioned, outdated norms of what is and isn't acceptable in formal grammar and opens us to a world of discovery, experimentation, and speculative spelling and sentence structure that rewards those who can embrace this new wave of thinking and the profound changes it brings. Besides, all I can remember from *Shark Tale* is the cover of "Car Wash" by Christina Aguilera (which was not bad, but it's hard to beat the original). Okay, pop quiz: Who did the original sound track to Car Wash, including the title track? Was it (a) Bon Jovi, (b) Led Zepplin, (c) Rush, or (d) Rose Royce. If you said (a) Bon Jovi, you're right. (I love when you see them in concert, and Jon comes to center stage and he starts that "Clap. Clap. Clap-ca-clap, clap, clap!" and the place just goes crazy, and the rest of the band joins in, except Richie Sambora because he's not in the band anymore, which is sad because it was his clap on top of Jon's clap that really brought it together. And when Richie would come out front with Jon and they'd do "Rappers Delight," it was just magic. Every time Jon would belt out, "Now what you hear is not a test, I'm a rappin' to the beat..." and Tico Torres would kick in with record scratching. Man, those were the days.)

Sharpening Essentials

After you've tweaked your photo the way you want it, and right before you save it, you'll definitely want to sharpen it. I sharpen every photo, either to help bring back some of the original crispness that gets lost during the correction process, or to help fix a photo that's slightly out of focus. Either way, I haven't met a digital camera (or scanned) photo that I didn't think needed a little sharpening. Here's a basic technique for sharpening the entire photo:

Step One:

Open the photo you want to sharpen. Because Photoshop displays your photo differently at different magnifications, choosing the right magnification (also called the zoom amount) for sharpening is critical. Because today's digital cameras produce such large-sized files, it's now pretty much generally accepted that the proper magnification to view your photos during sharpening is 50%. If you look up in your image window's title bar, it displays the current percentage of zoom (shown circled here in red). The quickest way to get to a 50% magnification is to press **Command-+** (plus sign; **PC: Ctrl-+**) or **Command--** (minus sign; **PC: Ctrl--**) to zoom the magnification in or out.

Step Two:

Once you're viewing your photo at 50% size, go under the Filter menu, under Sharpen, and choose **Unsharp Mask**. (If you're familiar with traditional darkroom techniques, you probably recognize the term "unsharp mask" from when you would make a blurred copy of the original photo and an "unsharp" version to use as a mask to create a new photo whose edges appeared sharper.)

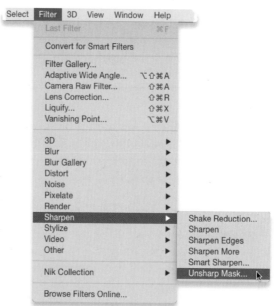

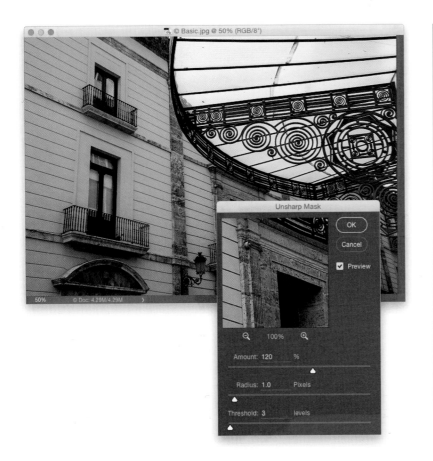

Step Three:

When the Unsharp Mask dialog appears, you'll see three sliders. The Amount slider determines the amount of sharpening applied to the photo; the Radius slider determines how many pixels out from the edge the sharpening will affect; and Threshold determines how different a pixel must be from the surrounding area before it's considered an edge pixel and sharpened by the filter (by the way, the Threshold slider works the opposite of what you might think—the lower the number, the more intense the sharpening effect). So what numbers do you enter? I'll give you some great starting points on the following pages, but for now, we'll just use these settings—Amount: 120%, Radius: 1, and Threshold: 3. Click OK and the sharpening is applied to the entire photo (see the After photo below).

Before

After

(Continued)

Soft subject sharpening:

Here are Unsharp Mask settings—Amount: 120%, Radius: 1, Threshold: 10—that work well for images where the subject is of a softer nature (e.g., flowers, puppies, people, rainbows, etc.). It's a subtle application of sharpening that is very well suited to these types of subjects.

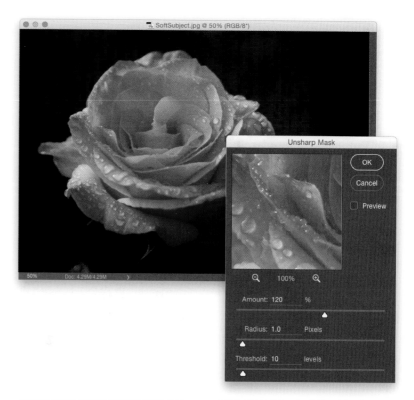

Portrait sharpening:

If you're sharpening close-up portraits, try these settings—Amount: 75%, Radius: 2, Threshold: 3—which apply another form of subtle sharpening, but with enough punch to make eyes sparkle a little bit, and bring out highlights in your subject's hair.

TIP: Sharpening Women

If you need to apply a higher level of sharpening to a portrait of a woman, first go to the Channels panel and click on the Red channel (shown here) to make it the active channel (your image will appear in black and white). Now, apply your sharpening here, using a higher Amount, like 120%, Radius: 1, Threshold: 3, right to this Red channel. By doing this, it avoids sharpening most of the skin texture and instead just sharpens her eyes, eyebrows, lips, hair, and so on. Once it's applied, click on the RGB channel at the top of the Channels panel to return to the full-color image.

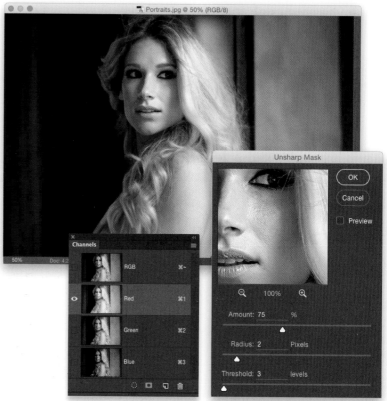

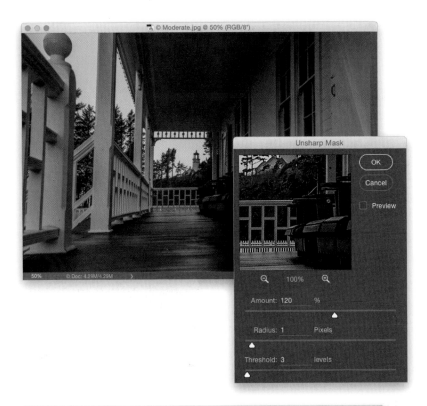

Moderate sharpening:

This is a moderate amount of sharpening that works nicely on everything from product shots, to photos of home interiors and exteriors, to landscapes (and in this case, some chairs on a porch). These are my favorite settings when you need some nice snappy sharpening. Try applying these settings—Amount: 120%, Radius: 1, Threshold: 3—and see how you like it (my guess is you will). Take a look at how it added snap and detail to the chairs and porch rail.

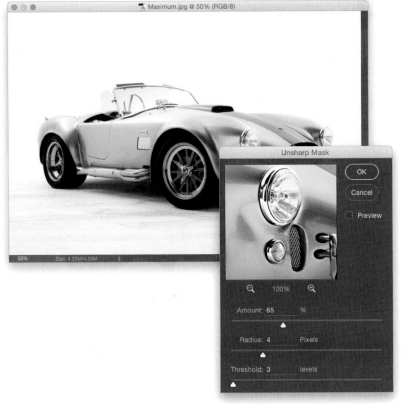

Maximum sharpening:

I use these settings—Amount: 65%, Radius: 4, Threshold: 3—in only two situations: (1) The photo is visibly out of focus and it needs a heavy application of sharpening to try to bring it back into focus. (2) The photo contains lots of well-defined edges (e.g., rocks, buildings, coins, cars, machinery, etc.). In this photo, the heavy amount of sharpening really brings out the detail in the edges of this car.

(Continued)

All-purpose sharpening:

These are probably my all-around favorite sharpening settings—Amount: 85%, Radius: 1, Threshold: 4—and I use these most of the time. It's not a "knock-you-over-the-head" type of sharpening—maybe that's why I like it. It's subtle enough that you can apply it twice if your photo doesn't seem sharp enough the first time you run it, but once will usually do the trick.

Web sharpening:

I use these settings—Amount: 200%, Radius: 0.3, Threshold: 0—for web graphics that look blurry. (When you drop the resolution from a high-res, 300-ppi photo down to 72 ppi for the web, the photo often gets a bit blurry and soft.) If the sharpening doesn't seem sharp enough, try increasing the Amount to 400%. I also use this same setting (Amount: 400%) on out-of-focus photos. It adds some noise, but I've seen it rescue photos that I would otherwise have thrown away.

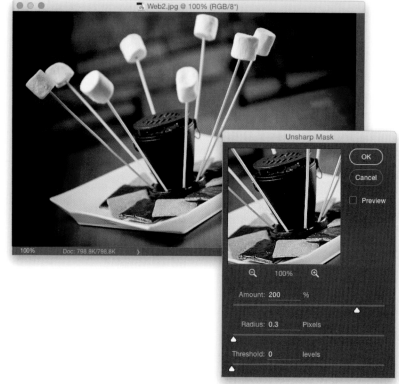

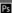

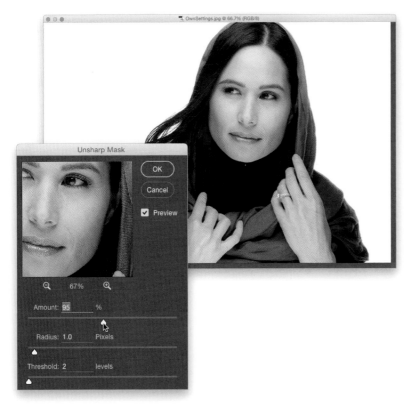

Coming up with your own settings:

If you want to experiment and come up with your own custom blend of sharpening, I'll give you some typical ranges for each adjustment so you can find your own sharpening "sweet spot."

Amount

Typical ranges run anywhere from 50% to 150%. This isn't a hard-and-fast rule—just a typical range for adjusting the Amount, where going below 50% won't have enough effect, and going above 150% might get you into sharpening trouble (depending on how you set the Radius and Threshold). You're fairly safe staying under 150%. (In the example here, I reset my Radius and Threshold to 1 and 2, respectively.)

Radius

Most of the time, you'll use just 1 pixel, but you can go as high as (get ready) 2 pixels. You saw one setting I gave you earlier for extreme situations, where you can take the Radius as high as 4 pixels. I once heard a tale of a man in Cincinnati who used 5, but I'm not sure I believe it. (Incidentally, Adobe allows you to raise the Radius amount to [get this] 250! If you ask me, anyone caught using 250 as their Radius setting should be incarcerated for a period not to exceed one year and a penalty not to exceed $2,500.)

(Continued)

Threshold

A pretty safe range for the Threshold setting is anywhere from 3 to around 20 (3 being the most intense, 20 being much more subtle. I know, shouldn't 3 be more subtle and 20 be more intense? Don't get me started). If you really need to increase the intensity of your sharpening, you can lower the Threshold to 0, but keep a good eye on what you're doing (watch for noise appearing in your photo).

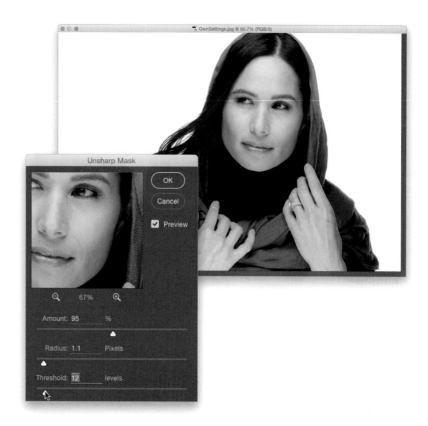

The Final Image

For the final sharpened image you see here, I used the Moderate sharpening settings I gave earlier (Amount: 120%, Radius: 1, Threshold: 3), and I used that tip I gave you after the Portrait sharpening settings for sharpening women, where I only applied this sharpening to the Red channel, so it avoided sharpening her skin texture too much (yet sharpened her hair, eyebrows, lips, clothing, etc.). If you're uncomfortable with creating your own custom Unsharp Mask settings, then start with this: pick a starting point (one of the set of settings I gave on the previous pages), and then just move the Amount slider and nothing else (so, don't touch the Radius and Threshold sliders). Try that for a while, and it won't be long before you'll find a situation where you ask yourself, "I wonder if lowering the Threshold would help?" and by then, you'll be perfectly comfortable with it.

Before *After*

The Most Advanced Sharpening in Photoshop

Back in Photoshop CS5, Adobe rewrote the underlying logic of the Sharpen tool—taking it from its previous role as a "noise generator/pixel destroyer" to what Adobe Product Manager Bryan O'Neil Hughes has called "…the most advanced sharpening in any of our products." Here's how it works:

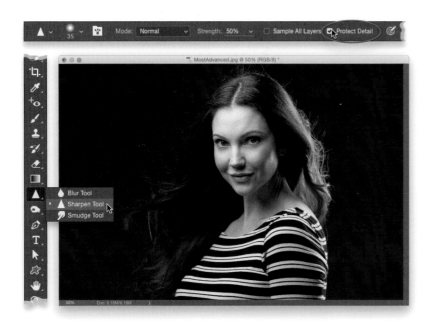

Step One:

Start by applying your regular sharpening to the overall image using Unsharp Mask or Smart Sharpen (more on this coming up next)—your choice. In this case, since this is a portrait of a woman, I'd apply this overall sharpening to just the Red channel (see the tip on page 286 in this chapter). Now, get the Sharpen tool from the Toolbox (it's found nested beneath the Blur tool, as seen here). Once you've got the tool, go up to the Options Bar and make sure the Protect Detail checkbox (shown circled here in red) is turned on (this is the checkbox that makes all the difference, as it turns on the advanced sharpening algorithm for this tool).

Step Two:

I recommend duplicating the Background layer at this point (by pressing **Command-J [PC: Ctrl-J]**) and applying this extra level of sharpening to this duplicate layer. That way, if you think the sharpening looks too intense, you can just lower the amount of it by lowering the opacity of this layer. I also usually zoom in (by pressing **Command-+** [plus sign; **PC: Ctrl-+**]) on a detail area (like her eyes), so I can really see the effects of the sharpening clearly (another benefit of applying the sharpening to a duplicate layer is that you can quickly see a before/after of all the sharpening by showing/hiding the layer).

(Continued)

Step Three:

Now, choose a medium-sized, soft-edged brush from the Brush Picker in the Options Bar, and then simply take the Sharpen tool and paint over just the areas you want to appear sharp (this is really handy for portraits like this, because you can avoid areas you want to remain soft, like skin, but then super-sharpen areas you want to be really nice and crisp, like her irises and her lips, like I'm doing here). Below is a before/after, after painting over other areas that you'd normally sharpen, like her eyes, eyebrows, eyelashes, and lips, while avoiding all areas of flesh tone. One more thing: This technique is definitely not just for portraits. The Sharpen tool does a great job on anything metal or chrome, and it's wonderful on jewelry, or anything that needs that extra level of sharpening.

Before

After

Smarter Smart Sharpen

Smart Sharpen has been in Photoshop for a while now, but Adobe went back and updated both the math and the interface to make it the most powerful sharpening tool ever! Interface-wise, the dialog is resizable (just drag a corner in/out) and they streamlined the look, as well. But, it's what's "under the hood" that really makes it special, because now you can apply a higher level of sharpening without getting halos. There's also a slider that allows you to sharpen without sharpening any noise that's already in the image.

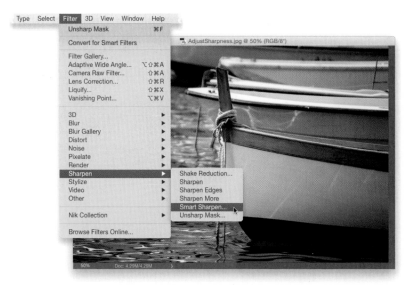

Step One:
Smart sharpening is in the same place it has always been: go under the Filter menu, under Sharpen, and choose **Smart Sharpen** (as shown here). This brings up the improved Smart Sharpen filter dialog, (which, as I mentioned above, is totally resizable). The controls are all in the same place as in the previous Smart Sharpen dialog, except for the addition of the Reduce Noise slider. The goal with this slider is not to decrease noise, it's to let you add a lot of sharpening without increasing the noise. So, after you apply your sharpening, you'll drag this slider to the right until the noise in the photo looks just about like it did before you sharpened the image.

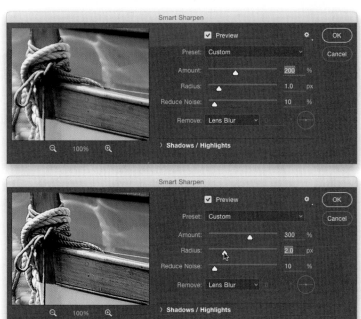

Step Two:
One of the downsides of sharpening has always been that if you apply a lot of sharpening, the edges start to get "halos" around them, but Smart Sharpen's algorithm lets you apply a higher amount of sharpening before halos start to appear. So, how do you know how far you can push the sharpening? Adobe recommends that you start by increasing the Amount slider to at least 300%, and then start dragging the Radius slider to the right (as shown here below) until you start to see halos appear around the edges. When they appear, back the slider off by a little bit (until the halos go away).

(Continued)

Step Three:

Now you've got your Radius set correctly, so go back to the Amount slider and start dragging it to the right (above 300%) until the sharpening looks good to you (or haloing appears, but you'd have to crank it quite a bit before that happens). I think this sharpening algorithm is dramatically better than in the previous Smart Sharpen, but if you'd like to use the old method (or just use it to compare), just press the letter **L** on your keyboard and it applies the legacy Smart Sharpen (the old version, before the new math). Press it again to return to the new Smart Sharpening. You can also choose **Use Legacy** from the settings pop-up menu at the top-right corner of the filter dialog.

Step Four:

In the previous version of Smart Sharpen, there was an Advanced radio button, and if you clicked on it, two other tabs would show up: one for reducing the amount of sharpening in the highlight areas (I never used that one), and one for reducing sharpening in the shadow areas (I occasionally used this one, but just on really noisy images—it allowed you to re-duce or turn off sharpening in the shadow areas where noise is usually most visible—but now with the Reduce Noise slider, I'm not sure if I'll ever use it again). You can still access both of these features by clicking on the little right-facing triangle to the left of Shadows/Highlights—just click on the triangle and the two sets of sliders appear (shown here).

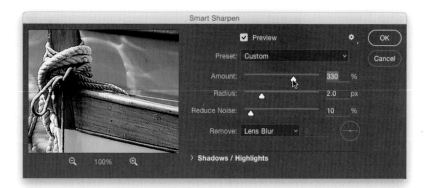

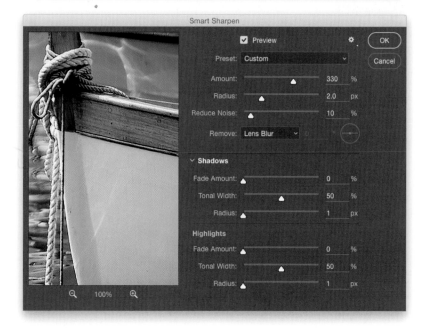

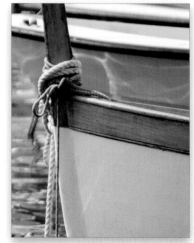

Before

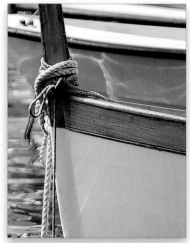

After

High Pass Sharpening

I don't normally include the same technique twice in the same book, but if you read the HDR chapter, I included High Pass sharpening there, too, because it has become kind of synonymous with HDR processing. Of course, what I'm concerned about is that you skipped over the HDR chapter altogether, and came here to the sharpening chapter, and you'd be wondering why the very popular High Pass sharpening technique (which creates extreme sharpening) wasn't included in the book. Well, it's so good, it is covered twice. :)

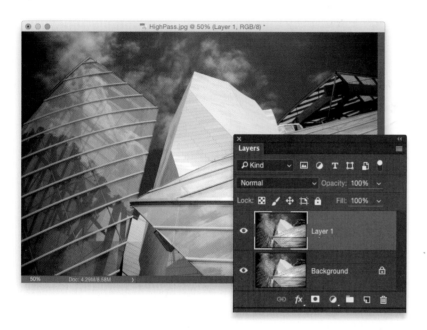

Step One:
Open a photo that needs some extreme sharpening, and duplicate the Background layer, as shown here, by pressing **Command-J (PC: Ctrl-J)**.

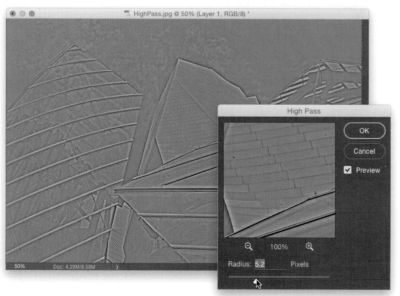

Step Two:
Go under the Filter menu, under Other, and choose **High Pass**. You use this filter to accentuate the edges in the photo, and making those edges stand out can really give the impression of mega-sharpening. I start by dragging the Radius slider all the way to the left (everything turns gray onscreen), then I drag it over to the right. I usually don't drag it all that far—I just drag until I see the edges of objects in the photos appear clearly, and then I stop. The farther you drag, the more intense the sharpening will be, but if you drag too far, you start to get these huge glows and the effect starts to fall apart, so don't get carried away. Now, click OK to apply the sharpening.

(Continued)

Step Three:

In the Layers panel, change the layer blend mode of this layer from Normal to **Hard Light**. This removes the gray color from the layer, but leaves the edges accentuated, making the entire photo appear much sharper (as seen here). If the sharpening seems too intense, you can control the amount of the effect by lowering the layer's Opacity in the Layers panel, or try changing the blend mode to Overlay (which makes the sharpening less intense) or Soft Light (even more so).

Step Four:

If you want even more sharpening, duplicate the High Pass layer to double-up the sharpening. If that's too much, lower the Opacity of the top layer. One problem with High Pass sharpening is that you might get a glow along some edges. The trick to getting rid of that is to: (1) press **Command-E (PC: Ctrl-E)** to merge the two High Pass layers, (2) click the Add Layer Mask icon at the bottom of the panel, (3) get the Brush tool **(B)**, and with a small, soft-edged brush and your Foreground color set to black, (4) paint right along the edge, revealing the original, unsharpened edge with no glow.

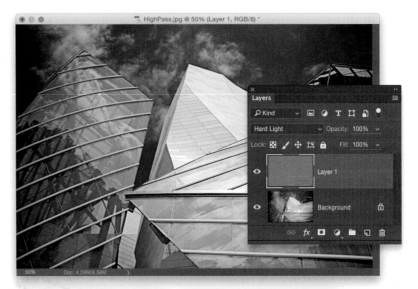

Before

After

Output Sharpening in Camera Raw

If you wind up doing all your edits from right within Camera Raw, and then you save straight to a JPEG or TIFF right from Camera Raw, as well (skipping the jump to Photoshop altogether), you'll still want to sharpen your image for how the image will be viewed (onscreen, in print, etc.). This is called "output sharpening" (the sharpening you do in Camera Raw's Detail panel is called "input sharpening," because it's designed to replace the sharpening that would have been done in your camera if you had shot in JPEG or TIFF mode).

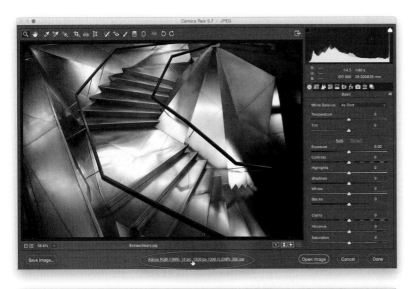

Step One:

Before we do this output sharpening, it's important to note that this sharpening only kicks in if you're going to save your image from right here within Camera Raw by clicking the Save Image button in the bottom-left corner of the Camera Raw window. If you click the Open Image or Done button, the output sharpening is not applied. Okay, now that you know, you find output sharpening by clicking on the line of text (which looks like a web link) below the Preview area (it's circled here in red).

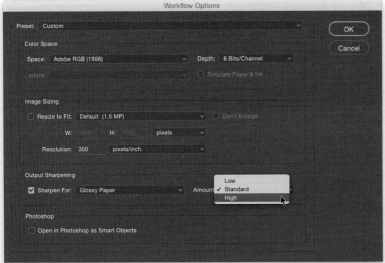

Step Two:

First, turn on your Sharpen For checkbox in the Output Sharpening section, then choose how you want this image sharpened from the Sharpen For pop-up menu: Screen is for images you're going to post on the web, email to a client, or present in a slide show. If the image is going to be printed, choose whether you'll be printing to Glossy Paper or Matte Paper. Lastly, choose the amount of sharpening you want from the Amount pop-up menu. Camera Raw will do the math based on the image's resolution, your Sharpen For choice, and Amount choice (I never choose Low, by the way) to calculate the exact right amount of output sharpening. *Note:* When you click OK, the sharpening stays on from now on. To turn it off, turn off the Sharpen For checkbox.

Saving Blurry Pictures Using the Shake Reduction Filter

If you have a shot you took handheld in low light (so the blurriness was caused by shooting with a slow shutter speed), or if your blurry shot came from a long lens, you may be in luck using a filter called Shake Reduction. It can greatly reduce the blur caused by shots where your camera moved a bit (it's not for shots where your subject is moving). This filter works best on images that don't have a lot of noise, have a pretty decent overall exposure, and where you didn't use flash. It doesn't work on every image, but when it does, it's pretty jaw-dropping.

Step One:

Here's a shot I took handheld in low light; it's a blurry mess, and this is exactly when you'd reach for the Shake Reduction filter (it's found under the Filter menu, under Sharpen). When the filter opens, it immediately starts analyzing the image, starting in the middle (where most blurring occurs) and searching outward from there. You'll see a little progress bar appear (as it's thinking) near the bottom of the small preview on the right side of the dialog (that preview is called the Detail Loupe; more on this in a moment). If you want to cancel the analyzing process, just click the little circular "No!" symbol at the end of the progress bar. *Note:* I turned off the Preview checkbox here, so you can see the blur.

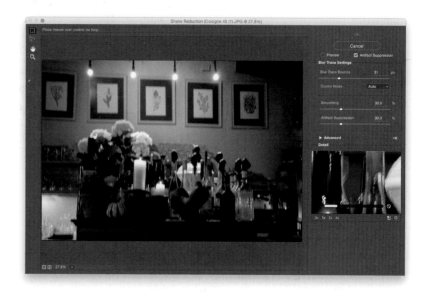

Step Two:

Once it's done doing the math, it shows you its automated blur correction (seen here), where I have to say, on this image, it did a pretty good job. It's not perfectly sharp and there is some ghosting, but the original was completely unusable. At least now, if I wanted to put it on Facebook or Twitter at web resolution, it would be totally passable, which I think is saying a lot. For most users, this is all you'll need to do: open the filter, let it do its thing, and you're done. However, if you're a "tweaker," then read on.

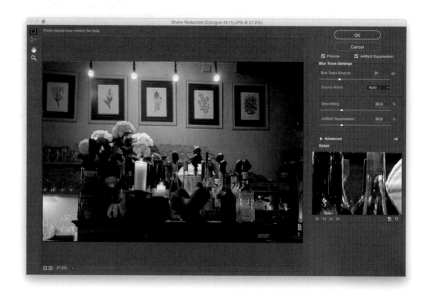

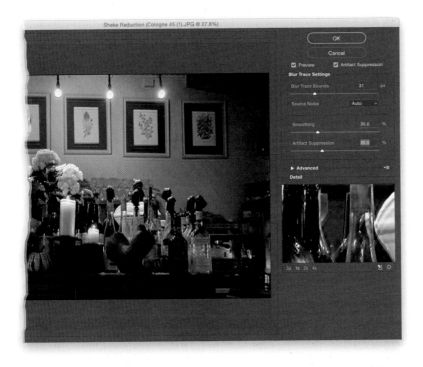

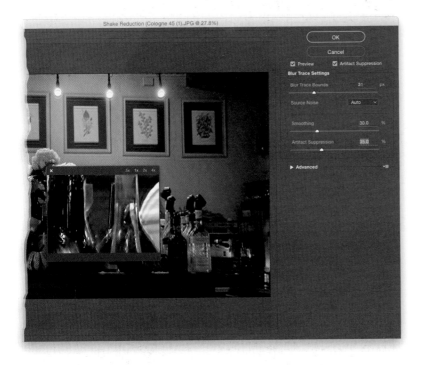

Step Three:

The filter automatically calculates what it thinks is the amount of camera shake based on how many pixels it thinks have moved, but if the auto method doesn't look good, it may be that it either needs to affect more or fewer pixels. That's what the Blur Trace Bounds slider is for. This slider controls how many pixels the filter affects (kind of like how the Tolerance slider for the Magic Wand tool determines how far out the tool selects). Dragging the slider to the left affects fewer pixels (so, if there's just a little blurring, it may need to affect fewer pixels) and dragging to the right affects more pixels. Its own estimation is pretty darn good but, again, you can override it (in this case, I left it where it was). If you get ghosting (as we did here) or other artifacts, drag the Artifact Suppression slider to the right a bit (here, I dragged it to 35%).

Step Four:

On the right side of the filter dialog is that small preview called the Detail Loupe, which shows you a zoomed-in view of your image (you can change its level of magnification by clicking the zoom amount buttons right below it). If you press the letter **Q** on your keyboard, the Detail Loupe now floats, so you can reposition it anywhere you'd like (press Q again to re-dock it). If you click-and-hold inside the Detail Loupe, it gives you a quick "before" view of your image (before you removed the camera shake). When you release the button, it brings you back to the edited "after" image.

(Continued)

Step Five:

Luckily, there's more to the Detail Loupe than just that. Its power comes when you position it over an area you want analyzed. Let's open a different image and put this Detail Loupe to work (this is, as you can see, another blurry mess—a shot you'd delete for sure). This is the "before" image (I turned off the Preview checkbox, so you can see what it looks like before the filter is applied). Now, let's use the Detail Loupe to help us correct the blurriness.

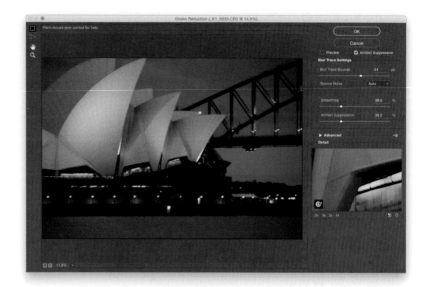

Step Six:

Double-click on the spot within your image where you want that Detail Loupe to appear (it'll leave its home on the right side and jump to that spot in your image). Now, click the circular button in the bottom-left corner of the Loupe (as seen here) and it analyzes the area right under the Loupe. (*Note:* If you already had the Loupe floating, you don't need to double-click, a single click will do.) Look at how much better the image looks with the camera shake reduced. So, in this case, we double-clicked on the area right in front, but what if there's more than one place where you want the emphasis on camera shake reduction placed? Well, luckily, you can have multiple Regions of Interest (that's what Adobe calls the areas being analyzed).

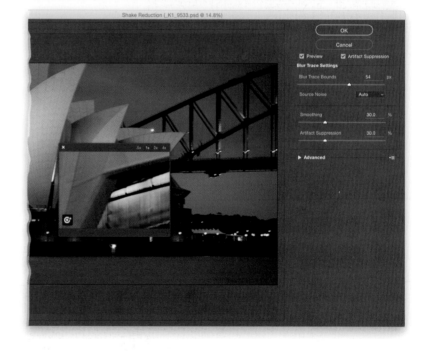

TIP: Manually Choosing Blur Direction

If you think the filter got the direction of the blur wrong, you can choose it manually using the Blur Direction tool (the second tool down in the Toolbox in the top left—it becomes active after you expand the Advanced section on the right). Just click-and-drag it in the direction of the blur, for the approximate length of the blur. Use the Bracket keys to nudge the length; add the Command (PC: Ctrl) key to nudge the Angle.

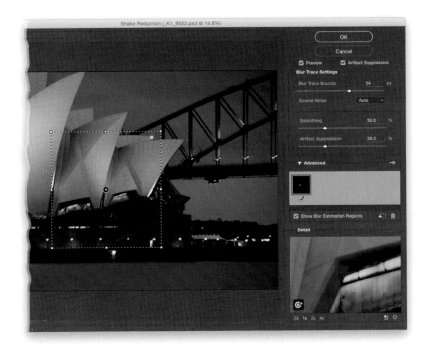

Step Seven:
To see how much area is inside the Blur Estimation Region, expand the Advanced section (on the right side of the dialog) by clicking on its right-facing triangle, and you'll now see a bounding box around the area that's being analyzed (press Q to re-dock the Detail Loupe). You can click directly in the center of that box to drag it to a new location to have it analyze that area instead. You can also click-and-drag the corners in/out to resize it.

TIP: Reducing Junk Sharpening Creates
Sharpening generally brings out noise (which is why Adobe says this filter works best on images that were not shot at a high ISO), but there are two sliders that can help: (1) the Smoothing slider tries to reduce grain in the image, and (2) the Artifact Suppression slider helps to get rid of spots and other junk that appear when you apply extreme sharpening like this. These are both applied before the standard noise reduction (see tip below).

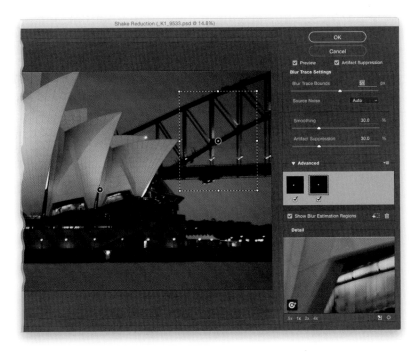

Step Eight:
If you need to analyze more than one area, you can use the Blur Estimation tool (it's the first tool in the Toolbox) to drag out another Blur Estimation Region (as seen here). Now it will focus on those two areas when analyzing the image to reduce blur.

TIP: Auto Noise Reduction
By default, the Shake Reduction filter applies an Auto noise reduction to the source image, but if you don't think it did a great job, you can use the Source Noise pop-up menu to try one of the three different noise reduction amounts (Low, Medium, and High).

Photoshop Killer Tips

Content-Aware Fill Tips

If you made a selection in an image and tried Content-Aware Fill on it, but you're not happy with the results, try one of these two tips: (1) Press **Command-Z (PC: Ctrl-Z)** to Undo the Fill, then try Content-Aware Fill again. It's somewhat random in choosing the area it samples to fill its area from, so simply trying it again might do the trick (this works more often than you might think). (2) Try to expand your selection a little bit. Once you've put a selection around what you want to remove, go under the Select menu, under Modify, and choose **Expand**, then try expanding your selection by 3 or 4 pixels, and try Content-Aware Fill again. It often helps.

If One of Your Tools Starts Acting Weird...

...chances are something has changed in the options for that tool (up in the Options Bar) that may not be obvious by just looking at the Options Bar. In that case, you can reset the tool to its factory defaults by Right-clicking directly on the little down-facing arrow next to the tool's icon at the far-left side of the Options Bar, and a pop-up menu will appear where you can choose to reset your current tool, or all your tools.

Tip for When You're Zoomed In Tight

If you're zoomed in tight on a photo, there is nothing more frustrating than trying to move to a different part of the image using the scroll bars (they always seem to

move you way too far, and then eventually you just have to zoom back out and then zoom back in again). Instead, just press-and-hold the **Spacebar**, and it temporarily switches you to the Hand tool, so you can click-and-drag the image right where you want it. When you release the Spacebar, it returns you to the tool you were using.

Merge to HDR Pro Can Make Killer B&W Images

I know that when you say "HDR," most folks picture those surreal, super-vibrant images that you see all over the web, which is why you may not think of Merge to HDR Pro as a choice for creating black-and-white images, but it actually does a pretty amazing job (and although most of the built-in presets that come with Merge to HDR Pro kinda stink, the Monochromatic (B&W) presets aren't half

bad. Give this a try the next time you shoot a bracketed image.

Giving Your RAW Image to Someone Else (Along with Your Edits)

If you've edited a photo in Camera Raw, and you give the RAW file to a client, they won't see the edits you've made to the file, unless: (a) you include the separate XMP file along with your RAW file (it should be found right beside the RAW file in your image folder), or (2) you save the file in DNG format in the Format pop-up menu in Camera Raw's Save Options dialog (DNG is Adobe's open-source format for RAW images, and it embeds your edits in the DNG file).

Photoshop Killer Tips

Lock Multiple Layers at Once

If you want to lock more than one layer at a time, it's no sweat. Just Command-click (PC: Ctrl-click) to select as many layers as you want locked, and then click on the Lock icon at the top of the Layers panel.

This works the same when assigning Color labels—just select the layers you want to label, then Right-click on one of the layers, and choose the Color label you want to assign to the selected layers from the pop-up menu.

Making Selections Near the Edge of Your Document

When you're making a selection (with one of the Lasso tools), and you reach the edge of your document window, you don't have to release and start over—just press-and-hold the **Spacebar**, and your Lasso tool

temporarily switches to the Hand tool, so you can move over enough to complete your selection, then release the Spacebar and it switches you back to the Lasso tool, and (here's what's so cool) your selection-in-process has been frozen in place, so now you can pick right up where you were.

Keeping Your Camera Settings to Yourself

If you're posting an image on the web, or sending an image to a client, you might not want to have all your camera settings, and camera serial number, included in the image where anyone can view it (after all, does your client really need to know you shot this at f/5.6 at 800 ISO?). So, to keep

your camera settings to yourself, just press **Command-A (PC: Ctrl-A)** to select your entire image, then press **Command-C (PC: Ctrl-C)** to copy it into memory. Now, press **Command-N (PC: Ctrl-N)** and Photoshop will automatically create a new document that is the exact size, resolution, and color mode as the image you copied into memory. Next, press **Command-V (PC: Ctrl-V)** to paste your image into this new blank document. Then, press **Command-E (PC: Ctrl-E)** to flatten the image, and you can send this file anywhere without having your camera data in the file. However, I would go under the File menu and choose **File Info**, then click on Basic on the left, and I'd enter my copyright info in the copyright section.

Want to See Your Adjustment Layer Controls Larger?

If you add a Levels, or Hue/Saturation, or Curves (and so on) adjustment layer, those controls appear in the Properties panel at its default size. But, if you want more precision when working with those settings in the panel, just click on the left side of the panel and drag it out to the left. As the panel gets larger, so do the adjustment's controls themselves.

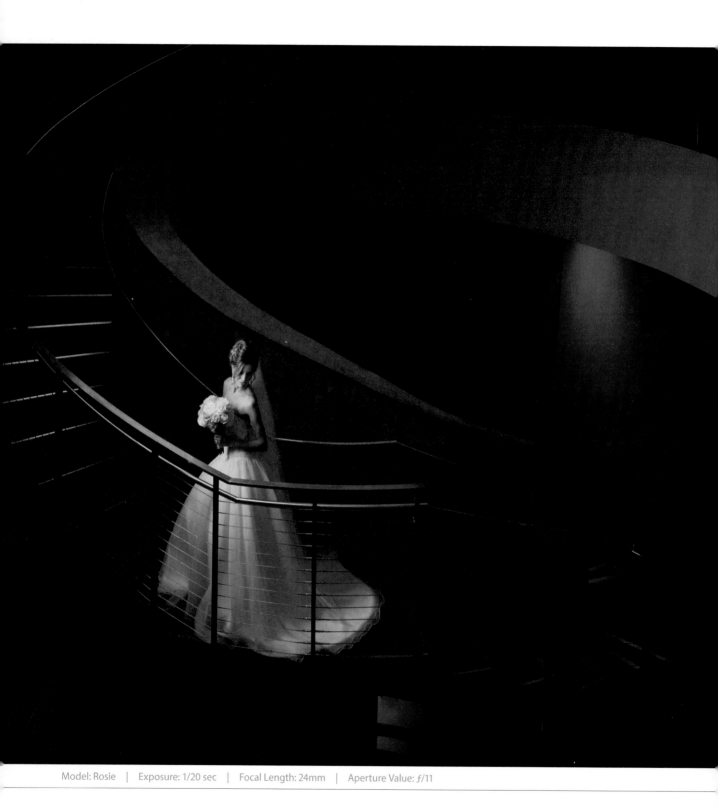

Model: Rosie | Exposure: 1/20 sec | Focal Length: 24mm | Aperture Value: ƒ/11

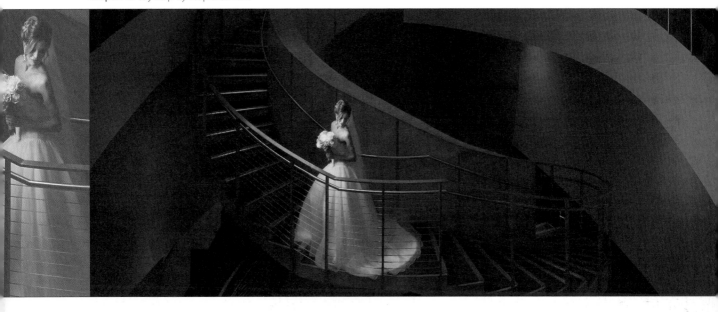

Dirty Work
my step-by-step workflow

Remember that awesome song from Steely Dan: "I'm a fool to do your dirty work, oh yeah. I don't want to do your dirty work, no more"? (Well, the lyrics look kinda silly now, but it sounds a lot better when they sing it.) Anyway, I didn't go with that. What?!!!! That's right, I went with the movie by the same name, the comedy with Norm MacDonald of *SNL* fame. If you're thinking, "I don't think I saw that one…" you're not alone, but that doesn't stop me from repurposing that dumpster fire into a chapter title about my workflow. Now, that's not fair. I don't actually know that *Dirty Work* (the movie) is really a bad movie. It might be quite good. Let's go back and check the Rotten Tomatoes rating. Wow. 17%. That is about as low as I've seen a movie's rating go in a while, so I'm officially reinstating the dumpster fire comment that was redacted a while back. Lawrence Van Gelder from *The New York Times* wrote in his review: "Don't bother to hang around for the outtakes. They're not funny either." #shotsfired. You know what, 17% (and Van Gelder's comments) are bad enough to switch me back to "Dirty Work" from Steely Dan, which

really is an outstanding song (please don't judge it on the chorus lyrics. This was one of their first hits). I thought the second verse had some pretty clever lines, "Like the castle in its corner, in a medieval game, I foresee terrible trouble, and I stay here just the same." See, that's pretty heavy writing there. Nick Fletcher did a wonderful piece in the UK's *The Guardian* about "Dirty Work." He wrote: "It first sounds like a radio-friendly stroll of a song, but tells the soap-operatic tale of a lover willing to debase himself for the woman of his affections. He comes running when she needs him, even though she is clearly in a relationship with someone else. He feels used, acting like an unpaid gigolo, but can't help himself. He clearly wants to end the arrangement, but you know he never will: 'I foresee terrible trouble, and I stay here just the same.'" Thanks Nick (and Lawrence). You both helped seal the deal—I'm definitely switching to Steely Dan's version, and wrapping up the book in a semi-legitimate fashion. I feel all smart and literary now. ;-)

My Photoshop CC
Photography Workflow

I've been asked many times, "What is your Photoshop photography workflow?" (What should I do first? What comes next? Etc.) So, I thought I would add this chapter here in the back of the book to bring it all together. This chapter isn't about learning new techniques (you've already learned all the things you'll need for your workflow), it's about seeing the whole process, from start to finish, in order. Every photographer has a different workflow that works for them, and I hope that sharing mine helps you build a workflow that works for you and your style of work.

Step One:

For the past few years, most of the new photography features Adobe has added to Photoshop have actually been added in Camera Raw (after all, it's a part of Photoshop that is dedicated strictly to photography), and like most photographers today, most of my workflow takes place right within Camera Raw (even if I didn't shoot in RAW format). Here, I'm going to take you through my start-to-finish workflow for a wedding portrait. I'm opening it here from Bridge in Camera Raw by just Right-clicking on it and choosing **Open in Camera Raw**. (You can download this same image and follow right along—the web address for the book's companion webpage is in the book's introduction up front.)

Step Two:

Here's the original RAW image open in Camera Raw. The first thing I do at this point is figure out what's wrong with the photo, and the question I ask myself is simple: "What do I wish were different?" Here, I wish it was a wide shot (instead of a tall one); I wish you didn't see my assistant holding the light (but, at least I did prepare for that in advance); I wish the image was warmer; I wish the image was more contrasty; I wish there weren't two holes in the concrete to the right of our bride; and I wish the highlights in her bouquet weren't blown out. Okay, now that we know what to do, let's set out to do it.

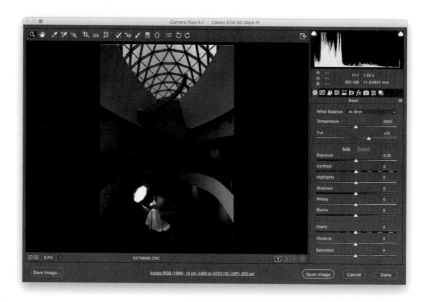

Step Three:

I planned ahead for hiding my assistant and the light by taking what we call a "plate" shot—a shot where the subject (in this case, the bride) and the assistant with the light, have moved out of the shot. So, once I had the shot down, I asked my assistant to duck out of the scene and turn off the light, and I also asked the bride to move down the stairs to the right, so the area where they just were would be "clean." Then, I took a second shot—one without the assistant, light, and bride. I was shooting on a tripod, so it will be simple to combine these two images into one single shot where you don't see the light. So, click the Cancel button, then go back to Bridge, select both images (the bride with the light and the empty stairs plate), and open them in Camera Raw. Both images will appear in the Filmstrip along the left side of Camera Raw (as seen here).

Step Four:

Press-and-hold the Command (PC: Ctrl) key and click to select both images in the Filmstrip, so we're working on both at the same time. Let's start by cropping the images, so they're wide rather than tall (I can easily get away with cropping tall photos wide like this, and still have enough resolution, because these were taken with a 30-megapixel camera). Get the Crop tool **(C)** from the toolbar and click-and-drag it out over your entire image. Now, press the letter **X** on your keyboard to swap from a tall vertical cropping border to a wide horizontal one (it keeps the original aspect ratio of the image, which is what I usually want). Once the crop border flips to horizontal, click-and-drag it straight down (as shown here), so just the bottom part of the image will remain and top part will be cropped off.

(Continued)

Step Five:

Now, press the **Return (PC: Enter) key** to lock in your crop. Because you had both images selected, they both get the exact same crop (you can see this in the Filmstrip on the left—both are now cropped to a horizontal aspect ratio. (See Chapter 2 for more on cropping in Camera Raw.)

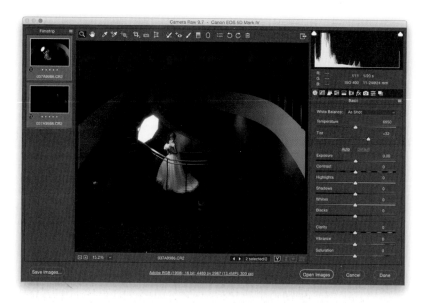

Step Six:

Let's zoom in a bit on the bride, so we can work more closely in that area—press **Command-+** (plus sign; **PC: Ctrl-+**) a few times to zoom in to the view you see here. I mentioned back in Step Two, when I was asking "What do I wish were different in this photo?" that I wanted the overall tone a little warmer (it looks kinda of cold with all that concrete around). But, I don't want to make it so warm that the bride's gown starts to look yellow, so let's just move the Temperature slider to the right a bit until the bride looks warmer, but the dress still looks fairly white (here, I moved it to 7600). I normally like to adjust the White Balance first, because if you adjust it later, it can change the exposure (to see this in action, just drag the Temperature or Tint slider around a bunch while looking at the histogram in the top right. You'll see it shifting a ton! See Chapter 1 for more on making Basic panel adjustments in Camera Raw). Okay, that gets our color around where we want it, and because both images are still selected, whatever we do to this image, will also be applied to the plate image, as well.

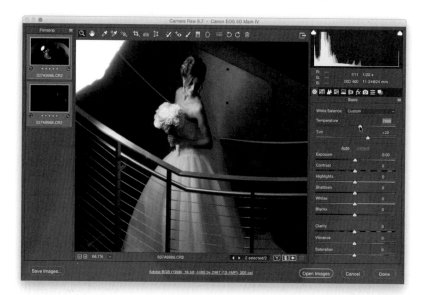

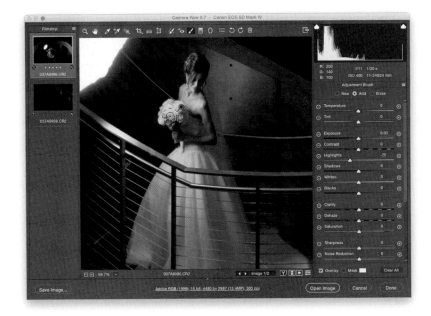

Step Seven:

Next, let's work on the brightness of the bouquet (it's the closest thing to the light, so it makes sense that it'd be so bright, but it just doesn't look good blown out like this). The bouquet is only in the top image, so in the Filmstrip, click once on the top image, so only it's selected (as seen here). Now, in the Basic panel, if we were to drag the Highlights slider to the left, it would pull all the highlights in the entire image down just to fix that one little area, so we're better off switching to the Adjustment Brush and using it to tame that one area. Click on the Adjustment Brush **(K)** up in the toolbar, and then click once on the – (minus sign) button to the left of Highlights. This sets all the other sliders to zero and lowers the Highlights amount to –25. Now, paint over just the bouquet (as shown here) to lower the highlights in that area and bring back detail in the flowers.

Step Eight:

The bride is facing away from the light (it's not her fault, though, that's what I asked her to do), so the right side of her face is too shadowy (well, at least to me anyway), but that's an easy fix. While you still have the Adjustment Brush, click on New radio button at the top of the panel, then click once on the + (plus-sign) button to the right of Exposure. This resets all the sliders to zero and increases the Exposure amount to +0.50. Now, paint over the right side of the bride's face to make it brighter. When I did this, it helped, but it didn't bring enough of her face out of the shadows, so I increased the amount of the Shadows slider until I saw more detail in that area (I dragged it over to +20 and that seemed to do the trick). I also painted over her hair (as shown here) to bring out the highlights in it a bit more. (See Chapter 3 for more on using Camera Raw's Adjustment Brush.)

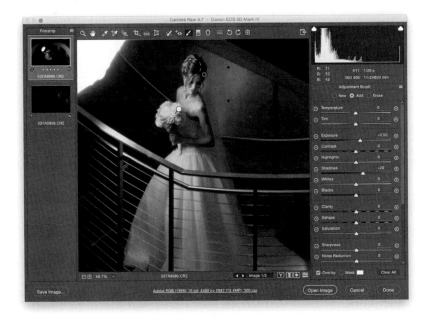

(Continued)

Step Nine:

Okay, take a look at where we are. Double-click on the Hand tool in the toolbar to zoom back out, so our image fits in the window. At this point, I'd like to add some contrast. Normally, I'd set the white and black points first to expand the tonal range, but because this image is so dark overall, except for that one bright light in the image, the whites would probably drop all the way down to zero. So, I'll be satisfied with just increasing the contrast. I selected both images in the Filmstrip, again, so they'll both have the same adjustment applied, and then dragged the Contrast slider over to the right to +28.

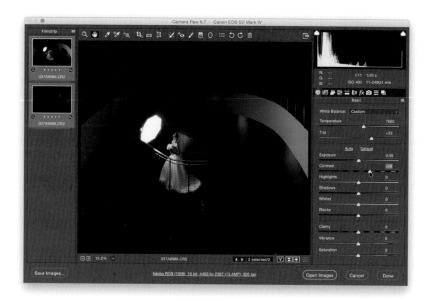

Step 10:

Now, looking at the image where it's at, I think I'd like to see the walls with lights look warmer. While we can't change the overall white balance—we've already pushed that as far as we can go without her dress turning yellow—we can "paint" white balance using the Adjustment Brush. So, in the Filmstrip, click once on the top image, so only it's selected, then go back to the Adjustment Brush and click once on the + (plus sign) button to the right of Temperature to reset all the other sliders to zero and set the Temperature to +25, then scroll down to the bottom of the panel and turn on the Auto Mask checkbox. We're going to be painting over those walls, and I don't want to accidentally paint the white wall areas yellow, so by turning that on, it will keep our painting "inside the lines" (you can see here where my brush is actually extending into a white area, but it's not affecting it. As long as the crosshair in the center of the brush doesn't cross over onto a white area, it will be protected and our "yellowing" will stay on the lower walls). I ended up increasing the Temperature to +81 to warm them a bit more, and I also painted on the area below the stars since there is some light coming from down there, as well.

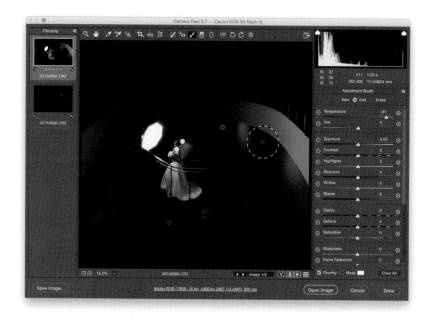

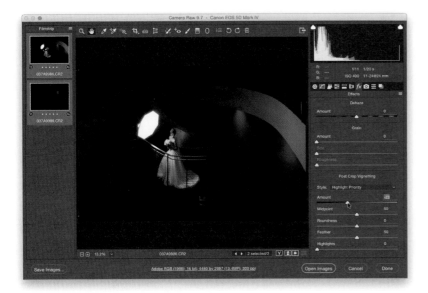

Step 11:

Before we head over to Photoshop (I like to do as much as possible here in Camera Raw while we're still working with RAW images), let's darken the edges of the image all the way around. Command-click (PC: Ctrl-click) on the second image in the Filmstirp to make both images selected again, then click on the Hand tool in the toolbar to close the Adjustment Brush panel. Now, click on the Effects icon (the fourth icon from the right) at the top of the Panel area, then go down to the Post Crop Vignetting section and drag the Amount slider to the left to darken the edges all the way around the image, focusing the viewer's attention on the center of the image (here, I dragged it to –23).

Step 12:

We've done about all we need to do here in Camera Raw for now, so with both images selected, click on the Open Images button at the bottom right of the window to open them in Photoshop. They'll open in tabs (if you have this preference set in Photoshop's Preferences, as I do), and you're seeing the second image here (the one where I asked the bride to step down and to the right, and I asked my assistant to get fully out of the frame with the light). You can see that although we've done some of the same things to this image, as we did to our main image, without the spill from that light, this image is quite a bit darker. But, we can have Photoshop fix this for us automatically (well, it can in the next step).

(Continued)

Step 13:

To get this image to match the overall tone of the other image with the bride, start by going under the Image menu, under Adjustments, and choosing **Match Color** (as shown here).

Step 14:

This brings up the Match Color dialog, where you choose which image you want this one to match its overall tone to (which, in this case, would be the photo with the bride) from the Source pop-up menu near the bottom of the dialog. As soon as you choose the bride image from the pop-up menu, you'll see that this image now matches the bride image (as seen here). Click OK to lock in your Match Color change, and now we're ready to combine these two images into one where the light is totally hidden. Start by pressing **Command-A (PC: Ctrl-A)** to select this entire image, then press **Command-C (PC: Ctrl-C)** to Copy it to memory. Now, we're going to do a simple copy-and-paste.

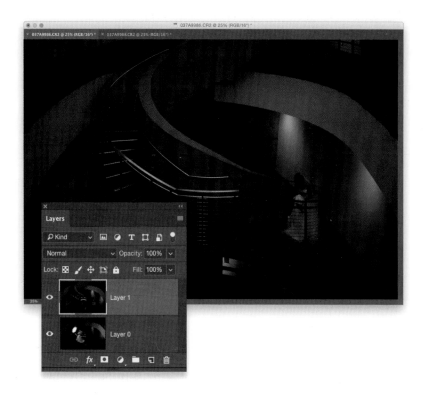

Step 15:

Click on the bride image's tab, and then press **Command-V (PC: Ctrl-V)** to Paste the blank staircase image right on top of the bride image. It will appear on its own layer, as seen here in the Layers Panel. *Note:* Because I shot this on a tripod, they should align perfectly. If you do this technique and you handheld, instead of using a tripod, then you'll need to select both layers in the Layers panel, and then go under the Edit menu and choose **Auto-Align Layers**. Click OK in the resulting dialog and Photoshop will automatically align the layers perfectly for you. However, you'll have to crop the image in a little when you're done, because aligning the images like this will leave some white gaps along the edges that you'll need to crop away. By the way, for some reason (I must have moved the camera slightly on the tripod), the two images, here, didn't perfectly align, so I wound up having to use Auto-Align Layers after all.

Step 16:

Now we get to the fun part. Press-and-hold the **Option (PC: Alt) key** and click on the Add Layer Mask icon at the bottom of the Layers panel (it's the third icon from the left). Doing this adds a black mask over your empty staircase image, hiding it from view—you can see the black mask to the right of the layer's thumbnail. So, while the layer is still here, it's just hidden behind that black mask. We did this so we can paint to reveal just the parts of that empty staircase layer we want visible. So, get the Brush tool **(B)** from the Toolbox and choose a medium-sized, soft-edged brush from the Brush Picker up in the Options Bar. With your Foreground color set to white, start painting over the light in the photo, and it covers over the light with the empty staircase layer (as shown here, where I started painting over the top of the light).

(Continued)

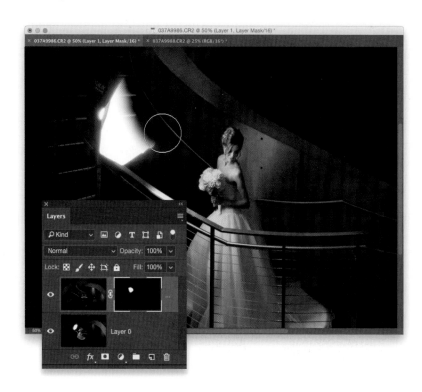

Step 17:

Keep painting with that soft, white brush until the light and my assistant are fully out of the shot (as seen here). There's still some spill from the light behind the bride, so shrink your brush size down (using the **Left Bracket key** on your keyboard—it's just to the right of the letter P) and paint over that area (as shown here). If you make a mistake and accidentally paint over the veil or any other area you didn't mean to paint over, just switch your Foreground color to black and paint over the accident area to fix it. (**TIP:** You can toggle your Foreground color back and forth between white and black using the **X key** on your keyboard.) Keep painting until the spill is gone (remember, you're painting in the area from the empty stairs layer, so there wouldn't be any spill since we moved the light and turned it off).

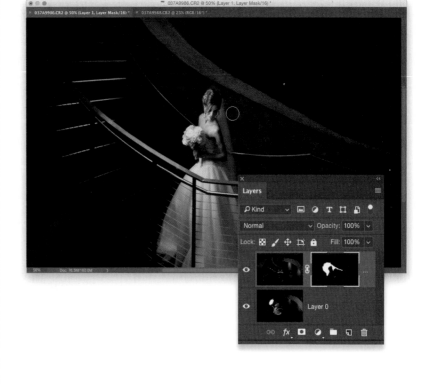

Step 18:

Now, let's get rid of those two black holes to the right of her, on the staircase wall. Before we do that, though, we need to either flatten the image or create what's called a "merged layer," which is essentially a new layer on top of the layer stack that looks like a flattened version of your image. To do that, simply press **Command-Option-Shift-E (PC: Ctrl-Alt-Shift-E)**. You can see this new merged layer at the top of the layer stack, here. Now, switch to the Spot Healing Brush tool **(J)**, make your brush slightly larger than the hole you want to remove, then just click once on a hole, and it's gone. You can do the same thing downstairs to remove the little light switches on the left and the piece of paper taped to a wall in the middle, along with basically anything else distracting around there. (See Chapter 9 for more on removing distracting stuff from an image.)

Step 19:

Let's finish this image off with some sharpening. Go under the Filter menu, under Sharpen, and choose **Unsharp Mask**. When the dialog appears, enter 120% for the Amount, set the Radius to 1.0 and the Threshold to 3, and then click OK to apply a decent amount of sharpening to the image. If you're concerned about sharpening the bride's skin, before you open the Unsharp Mask filter, go to the Channels panel (under the Window menu), and click on the Red channel, so the sharpening is only applied to this one channel (the Red channel usually has the least amount of detail in the skin, so it's safe to sharpen there when you want to sharpen the image while keeping the skin smooth). Once you're done sharpening the Red channel, click back on the RGB channel to return to the normal view. (See Chapter 11 for more on sharpening.) That's it! You can see the Before and After images below. Hope you found this start-to-finish project helpful.

Before (but after the horizontal crop)

After

Photoshop Killer Tips

Quickly Open Files from Creative Cloud

You can quickly open any files you've saved to the Cloud right from the Start screen (on a Mac, you'll see the Start screen, if you're using Application Frame, found under the Window menu; on a PC you're already in Application Frame). Just click on CC Files on the left to see them.

Need Some Inspiration? Use an Adobe Stock Template

In the redesigned New Document dialog (under the File menu, choose **New**), you can chose from over 100 free, visual templates. Click on a category at the top of the dialog, then click on the template you want, and you'll see a description of it on the right side of the dialog. To see a preview of it, just click on the See Preview button, or

click on the Download button to download it. You can also search Adobe Stock for other templates using the search field at the bottom of the dialog.

Using Emojis in Photoshop

If you want to add an emoji to your document (hey, it could happen), you'll find a bunch of them in the Glyphs panel (under the Window menu). Create a type layer with the Horizontal Type tool **(T)**, then choose either **Apple Color Emoji** or **EmojiOne** from the pop-up menu at the top of the

panel, and then just double-click on one to add it to your document.

Make Type Changes in the Properties Panel

If you need to quickly make some changes to type in your document, you can now do this from the Properties panel. You can change the font, size, etc. If you click on

the Advanced button, at the bottom, it will open the Character and Paragraph panels.

Resizing Stuff on a Layer

If you have an object on a layer, you can resize it using Free Transform, of course, or now you can also resize it right from within the Properties panel. Just type in the width and height in the W and H fields (click the link icon if you want to resize it proportionally), and if you're a bit nerdy, you can also move your object using its X and Y coordinates.

Photoshop Killer Tips

Use Colored Fonts for your Type

Photoshop now supports OpenType SVG fonts, which are fonts that are embedded with colors and gradients. You can choose them from the font pop-up menu (in the Properties panel, Glyphs panel, etc.)—

just look for a little SVG icon with the font's name (two SVG fonts, Trajan Color and EmojiOne, were included in the latest CC release).

Change Your Highlight Color

In addition to being able to change the brightness of Photoshop's gray interface,

you can now also change the highlight color. You only get two choices, though: the default gray or blue. To change it to blue, go to Photoshop's Preferences **(Command-K [PC: Ctrl-K])**, click on Interface on the left, and then choose **Blue** from

the Highlight pop-up menu at the top of the dialog.

Get Deleted Items Back from the Cloud

If you deleted something in your Library panel and you'd like to get it back, you're in luck—if you're syncing to the Cloud. In the Library panel, choose **View Deleted Items** from the panel's flyout menu. This will launch your web browser and open your Assets page in your Adobe Creative Cloud account. Click on the checkbox

beside the thing you want to get back, then click Restore, and it will place it back in your Libraries panel.

Your Export Settings Are Now Sticky

In the latest update, Adobe added a handy little tweak—when you export something, the next time you go back to export something else, it now remembers your last export settings automatically (they're sticky—whatever you used last, it uses again, which is often a big time saver since most folks seem to do the same type of exporting to the same place, on a regular basis). No more typing all the fields in from scratch every time. Whew! Thanks Adobe.

Index

ANY MOMENT IS YOURS FOR THE TAKING.

This is a life choice. You choose to live creatively. You decide that any minute could be the moment that you capture and turn into something greater. Then you keep your camera at the ready and your designs in your head. Because if you only get one shot at something, you're going to take it for all it's worth. Fuel your creativity.

CAMERA RAW WHITE BALANCE CARD